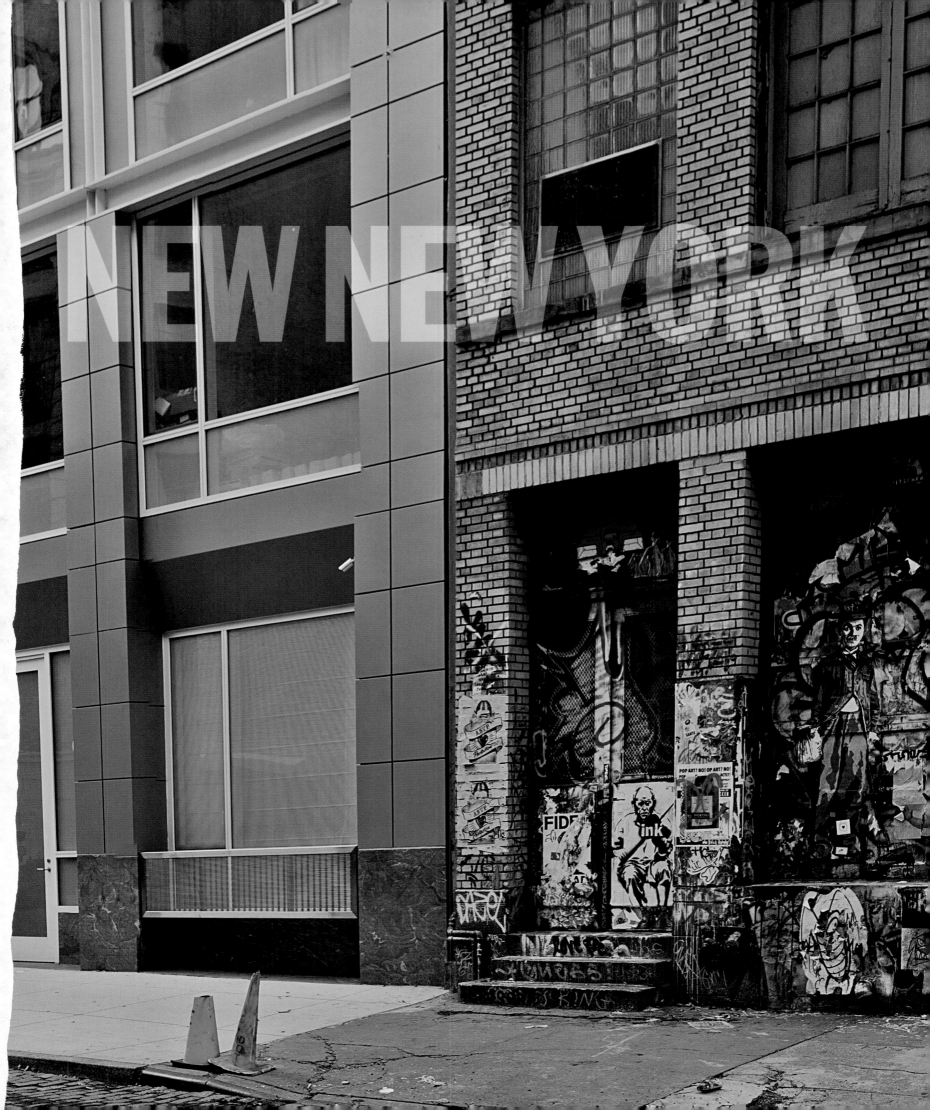

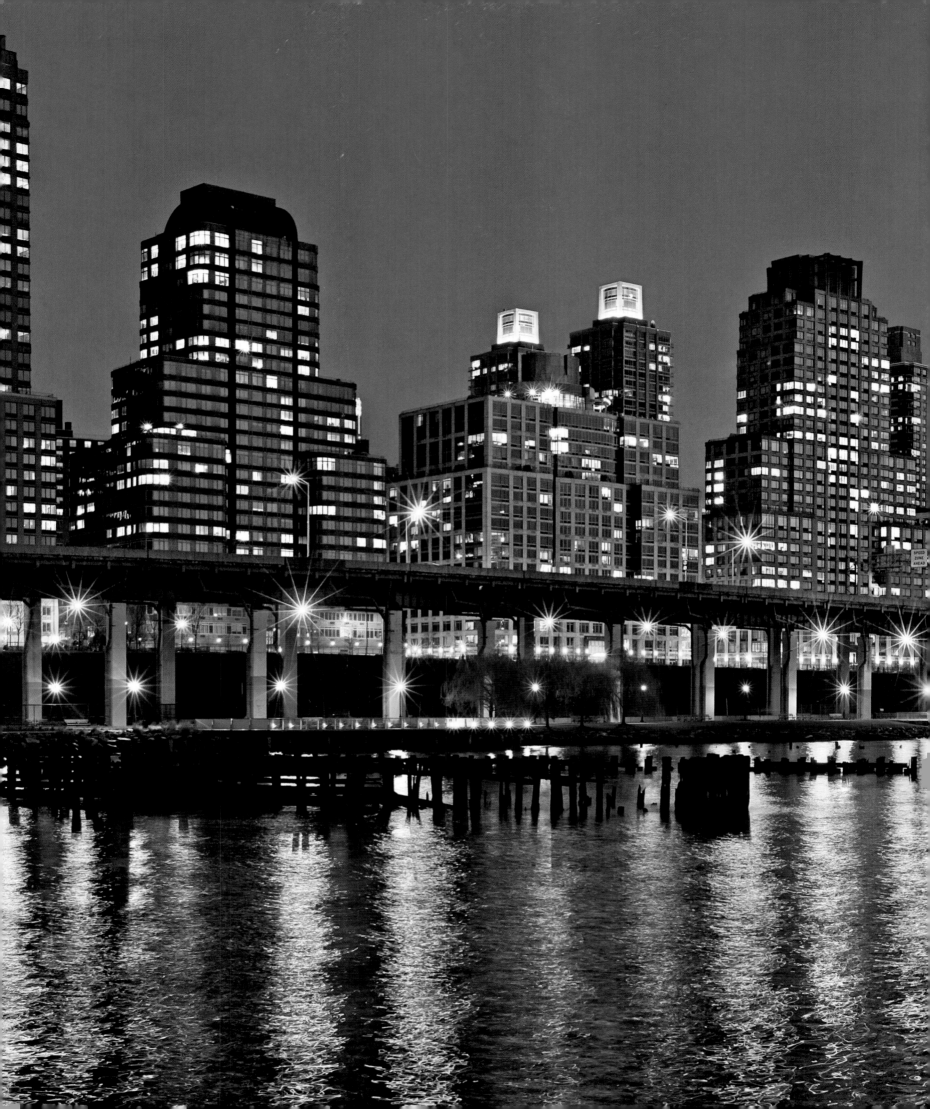

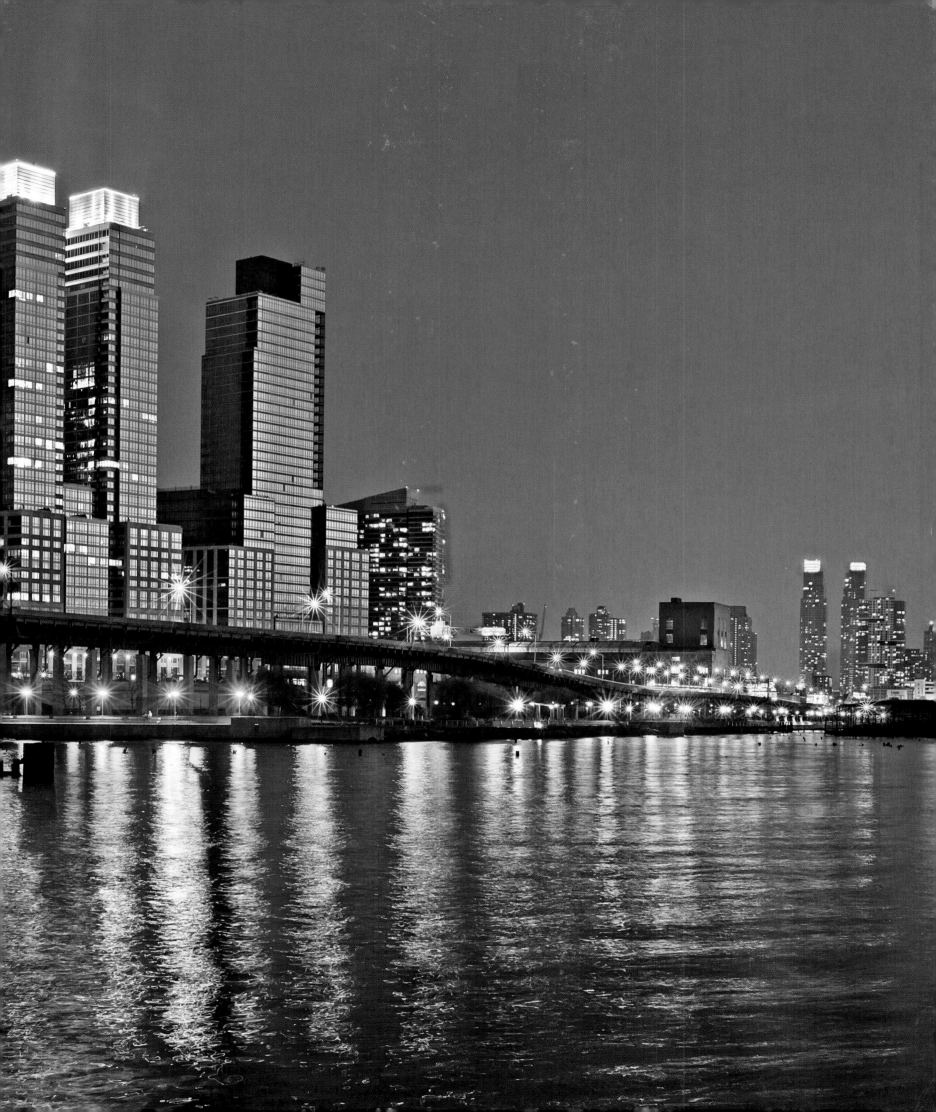

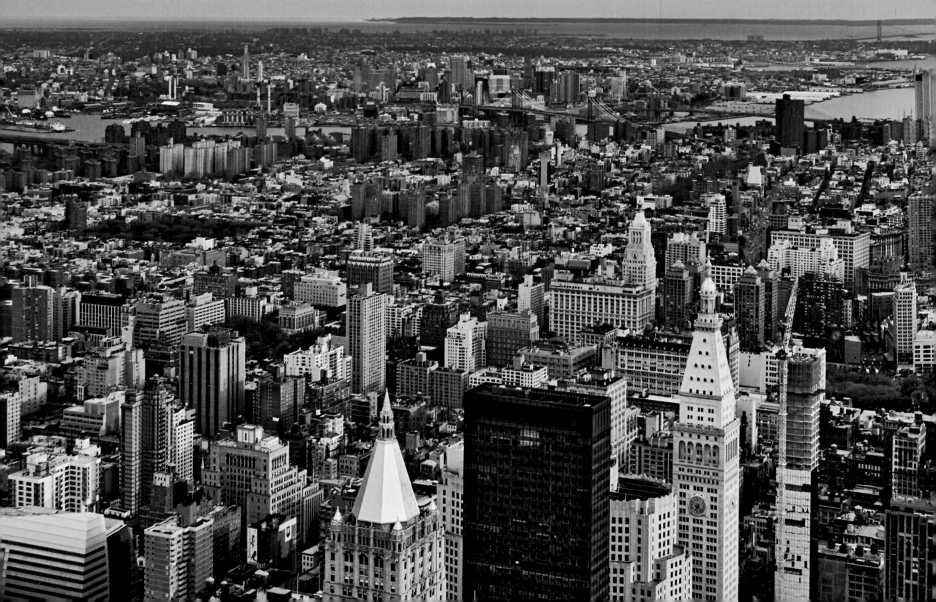

NEW NE

ESSAY BY PHILIP NOBEL

W YORK

PHOTOGRAPHS BY JAKE RAJS

THE MONACELLI PRESS

To Amy for loving
To Mark and Jules for caring
To Chloe and Olivia for sharing

I would like to thank the following people and institutions
for their kindness and assistance in helping to make this book
possible: Steve Correal, Lewis Cortellezi, Steve Dailey, Will Dailey,
Michael Goldstein, Mark and Ellie Gordon, Mark Miller, Glen Miller,
Joseph Guglietti, Alex Kozyrski, Gianfranco Monacelli, Janina
Rajs, Sara Cobb, Jules Solo, Mark Speed, Vicki Tencati, Frances,
Tim, Benjamin, and Guiliana Wagner, Elizabeth White.

All the great architects, landscape architects, and artists
whose work is portrayed.

And most important, my wonderful family; Amy, Chloe, Jack,
Olivia, Sean, and Grace.

Copyright © 2011 The Monacelli Press, a division of
Random House, Inc.
Photographs © 2011 Jake Rajs
Essay © 2011 Philip Nobel

Published in the United States of America by
The Monacelli Press, a division of Random House, Inc.

The Monacelli Press and the M design are trademarks
of Random House, Inc.

ISBN: 978-158093-305-6
Library of Congress Control Number: 2011928008

Designed by Joseph Guglietti

Printed in China
10 9 8 7 6 5 4 3 2 1
First edition

www.monacellipress.com

CONTENTS

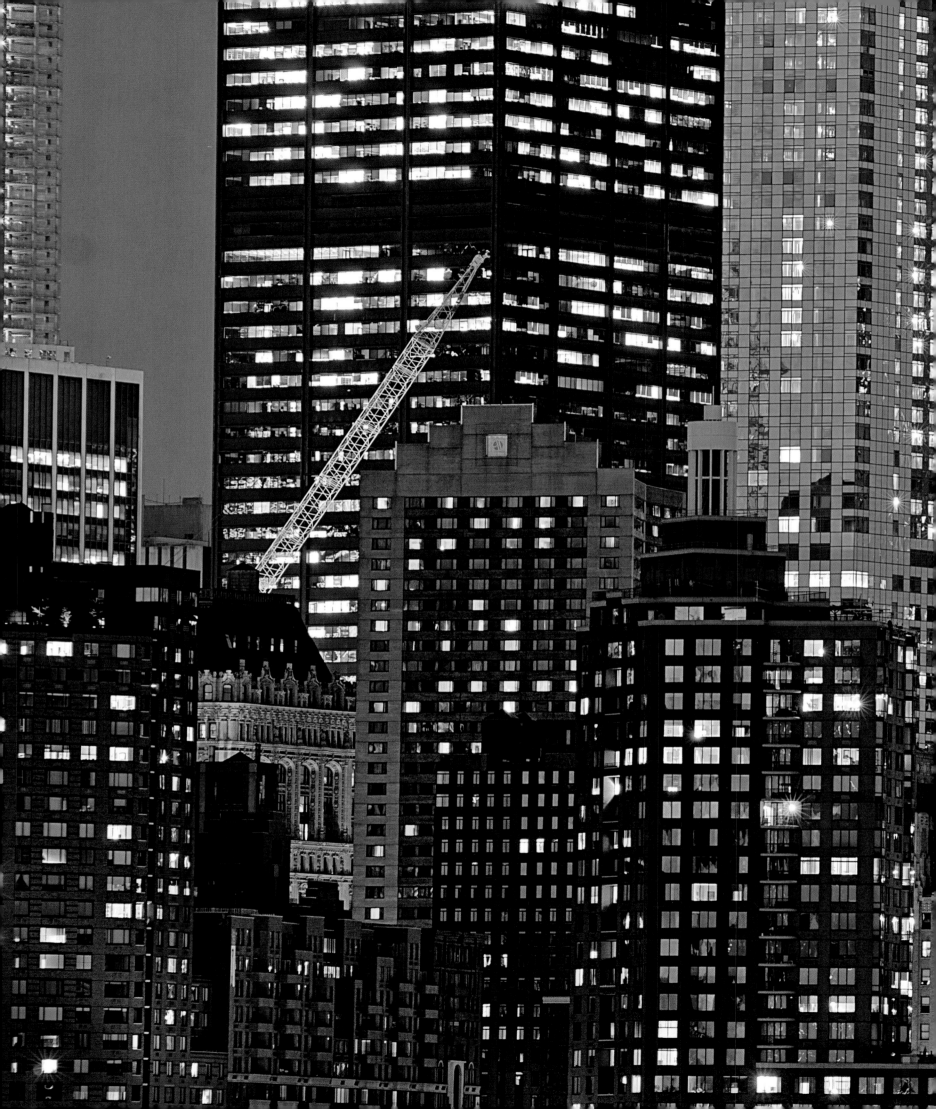

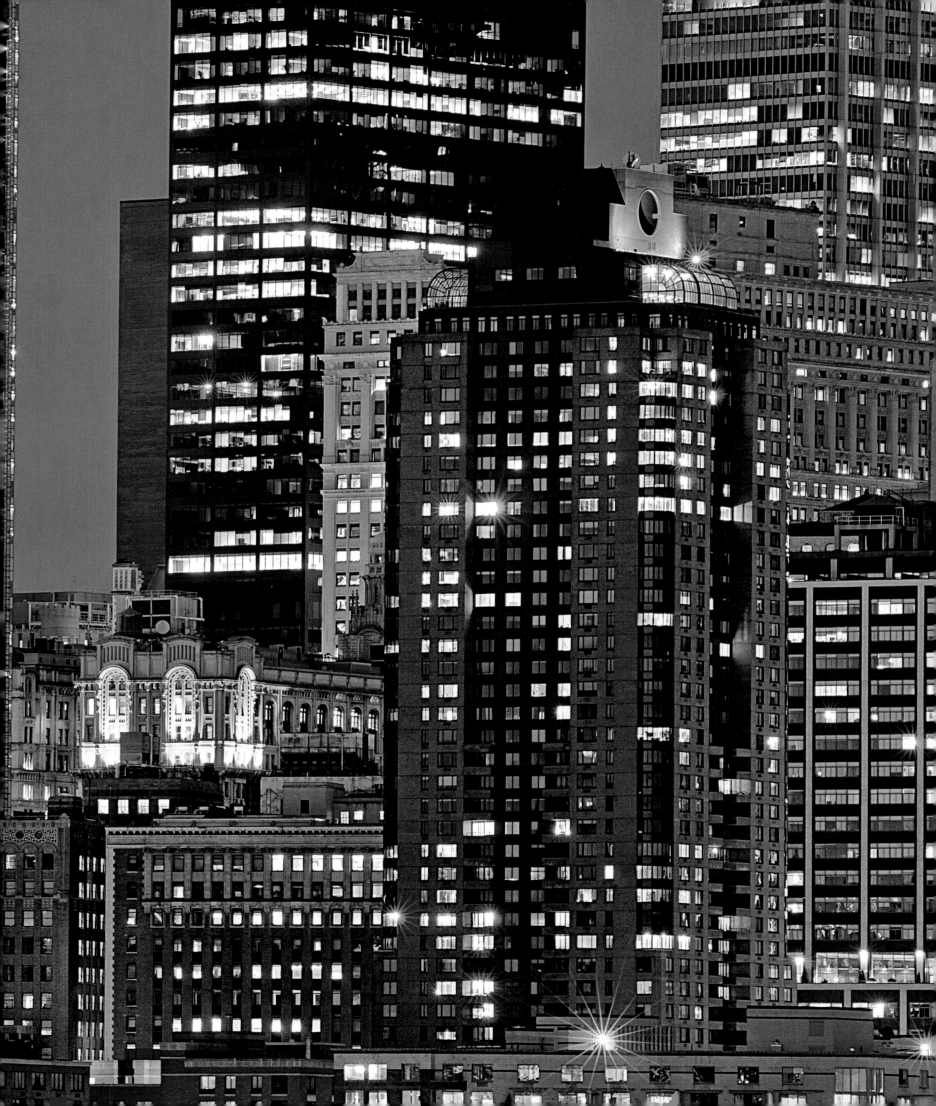

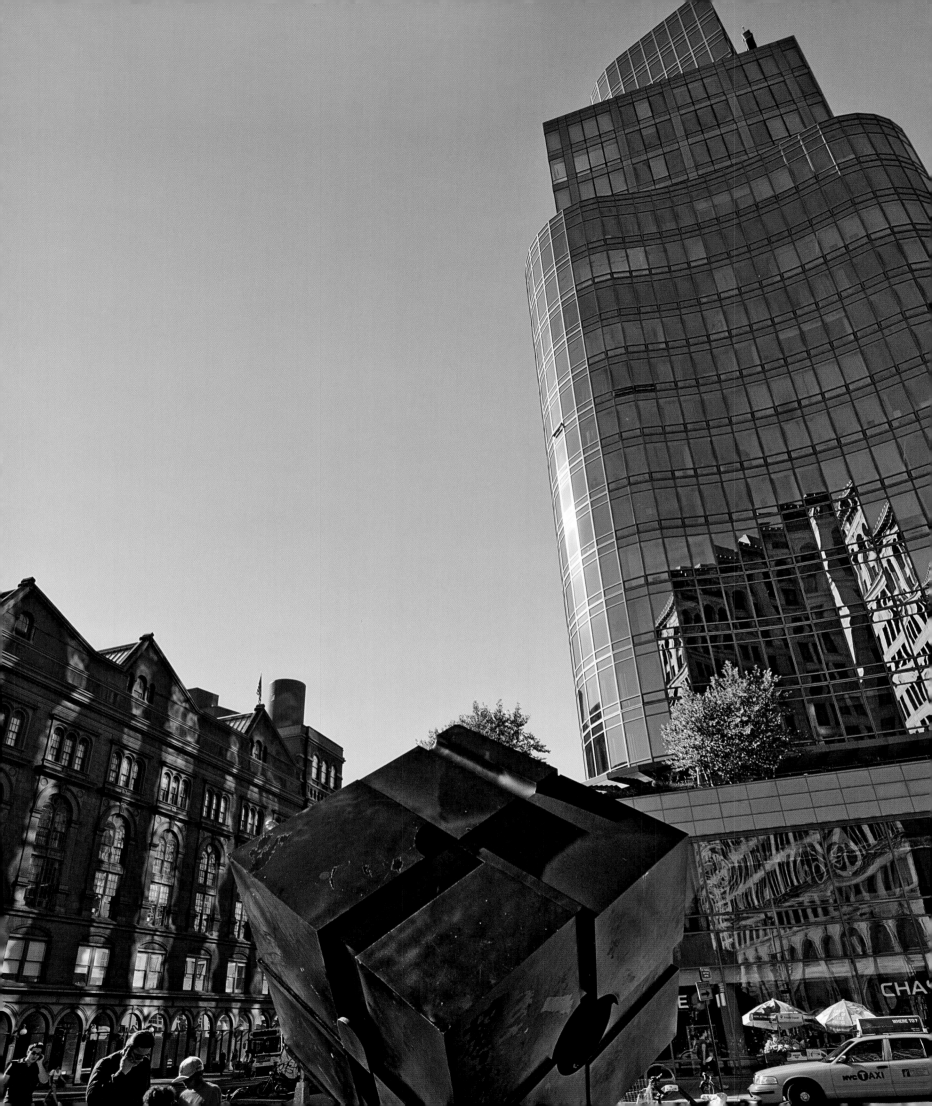

The Living City

NEW YORK'S HABIT OF REINVENTION

By Philip Nobel

IF YOU'VE MADE IT ANYWHERE, *you must make it here*. That was the attitude of New York at the turn of this century toward the work of the world's greatest architects. Watching as other places were enhanced with the newest and best buildings, the city examined itself, regretted the absence of novel structures that capture the imagination, and it began to summon the architects famous for making them: the greats of the profession, young and old, none of whom had yet made a mark on New York. Those architects heeded the call; they have come in droves, changing the city into a showcase of contemporary architecture—a crucial part of what is new in New York today.

It was not always so. As recently as 2000, it was a major event when a corporate cafeteria was completed on a low floor of a Times Square skyscraper—an astonishing buzz accompanied the opening of the private space in the Condé Nast headquarters. Newspapers and magazines ran reviews of it at a length and intensity that would have done justice to a world's-tallest tower on the skyline or a concert hall on a public square. Something extraordinary had happened: Frank Gehry, that son of Los Angeles and toast of the world, had finally built something in Manhattan.

The heights of excitement reached then over an intensively decorated lunch room (for it was no more) had a lot to do with its architect; two years after the opening of his Guggenheim Museum in Bilbao, Gehry was at the top of his game, the brightest star in a profession increasingly defined by its roster of stars, and anticipation was mounting that he would someday focus his attention here. But the reaction had as much to do with the peculiar habits and psychology of New York: the city goes

about building and rebuilding itself in its own timeworn way—often at the mercy of risk-averse developers and the reliable, unchallenging architects they favor—and its citizens, at least that portion of the whole that is conscious of the architecture around them, had at the time succumbed to a sense that the place was becoming second-rate. We watched as striking new buildings were completed in smaller, less dynamic cities all over the world. We fretted as paragons of the local scene—Richard Meier, say—were given the opportunity to share their particular genius with the suburbs of Rome but not Fifth Avenue or Chelsea. We coveted distant work by notable architects based abroad—British technologists, surreal young Dutch, Japanese masters of the minimal, intellectual French—who seemed to be defining the public presence of the new century everywhere but in the city that had so long served, that prides itself in serving, as the measure of cultural novelty for the world. A new era was dawning, a new breed of architects was proposing a thousand new looks for it, and the city with new in its name was still building itself out of old stuff. A certain cadre in New York lamented, *Why can't we have the new stuff here?*

Flash forward a decade to October 2010 and the opening of Norman Foster's Sperone Westwater Gallery. The high, narrow construction on the Bowery is a solid example of the innovation-minded modernism that has earned Foster a reputation for reliable good taste and decades of city-shaping commissions from Berlin to Hong Kong. The building even has a flashy, look-at-me-Manhattan feature—a huge red elevator running up and down the facade behind a wall of glass—that should have had cameras uploading and local pundits pounding out raves on their keyboards at first glance. Reviews were written; obeisance was paid to Foster's ample fame. But there was a decided lack of the lovable, neurotic, excessive carnival of adulation that New York City can conjure in an instant for the big events that really catch its fancy. One of the most celebrated architects on the planet had built an interesting new building downtown and we heard hardly a peep.

Of course by 2010, Manhattan already had a Foster: the diamond-trussed headquarters of the Hearst Corporation on Eighth Avenue. It also had two new Gehrys, two quirky residential towers by the French architect Jean Nouvel, and a pair of Renzo Pianos, out of one issued each day, no less, the crucial musings of the *New York Times*. A gorgeous glass-fronted apartment building designed by the hip Swiss duo Herzog & de Meuron had settled in three blocks north of the Foster gallery. One block to the south was the shimmering new home of the New Museum, the first New York building by Kazuyo Sejima and Ryue Nishizawa, doing business as SANAA, a firm whose faraway work (Japan, Ohio) had long stirred local jealousies. By then Manhattan even had its first three Richard Meiers (and Brooklyn a massive fourth). Local art-scene legends Liz Diller, Ric Scofidio, and Charles Renfro were updating the mid-century modern mishmash of Lincoln Center—and with James Corner, a landscape architect, the office had reimagined a defunct elevated railbed on the West Side as a

Austrian Cultural Foundation, 11 East 52nd Street, Raimund Abraham.

OVERLEAF
Times Square

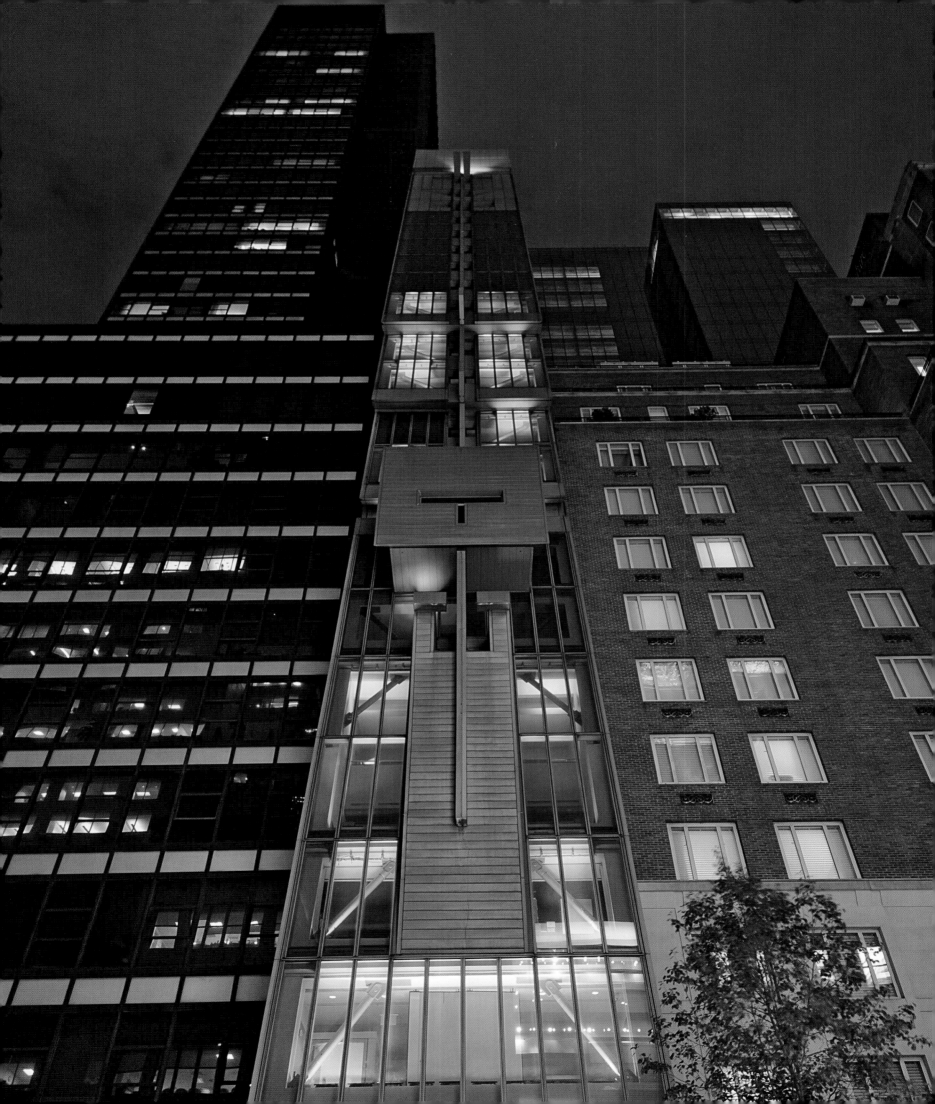

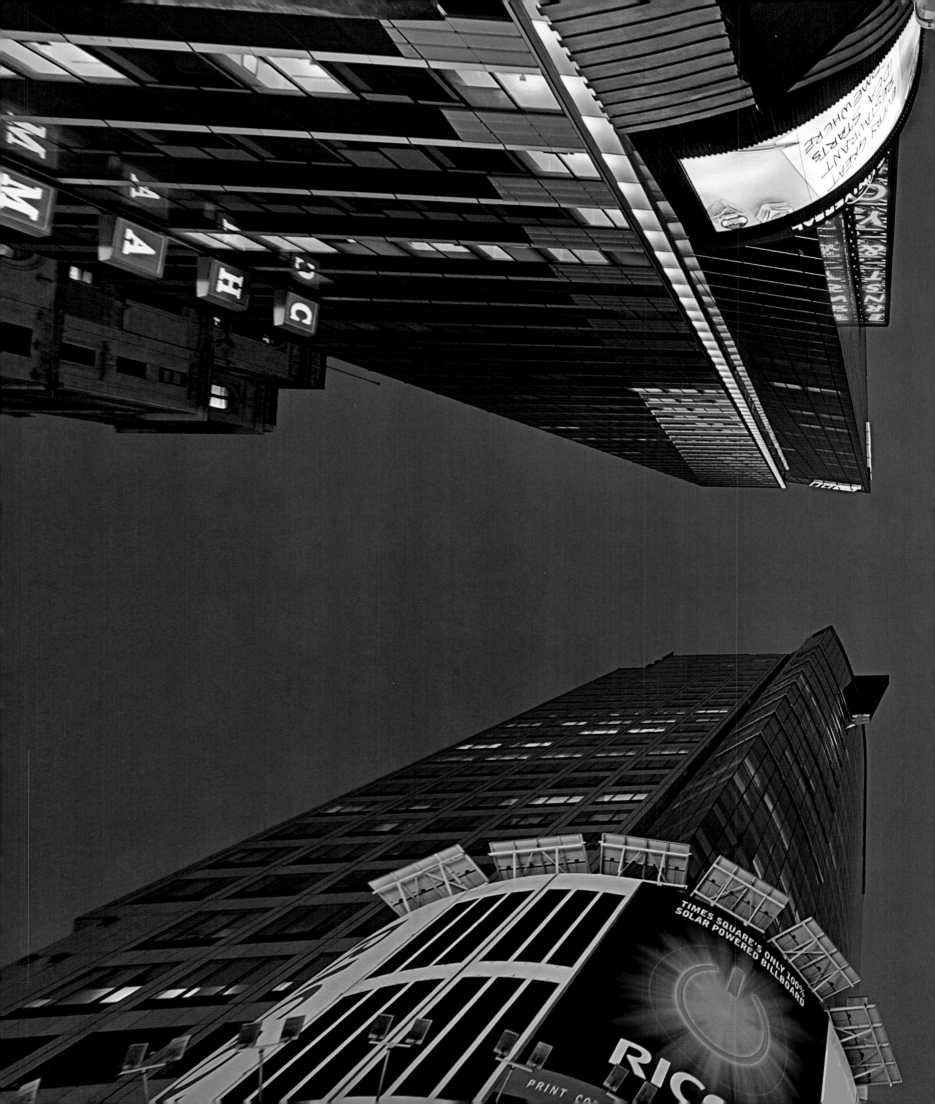

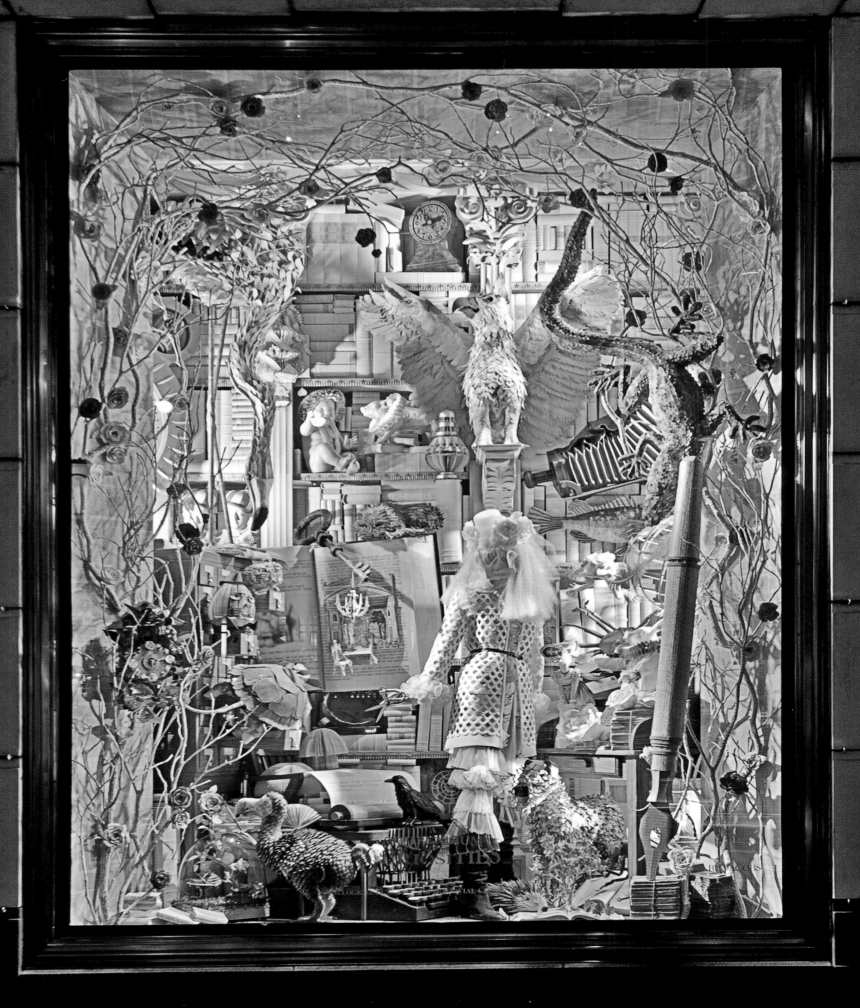

popular destination for high-minded strolling. Stalwart New York firm Polshek Partnership (now Ennead Architects) straddled the High Line, as the new park is known, with a striking neobrutalist hotel. Even Shigeru Ban and Neil Denari, designers with hard-won reputations for reclusiveness—and what says genius more?—did their part, each building a residential condominium in West Chelsea. Bernard Tschumi, known as a revolutionary when he first moved to the city decades before, had completed his first commercial project in Manhattan, a curious blue glass tower on the Lower East Side. The California maverick Thom Mayne, famous for his radically layered constructions, realized his first New York building not too far away on Cooper Square; next door, Carlos Zapata, a slick Miami-bred stylist, offered up a twisted hotel. Both rose in the shadow of the late Charles Gwathmey's most outré local building, a condo on Astor Place that was his last, best attempt to keep up with the bubbling international scene. Those final four downtown novelties were each but a stone's throw from the Norman Foster gallery. It was lost in the crowd.

IN AN INSTANT, New York City, Manhattan in particular, had gone mad for what is perceived to be the cutting edge in architecture at a scale not seen since builders first traded brick and stone for steel and glass in the decades after World War II. Judged by the informal precepts of the media-architectural complex—that great design equals great explosions of eye-catching form by a select group of accepted "greats"—the city could now hold its head high. Higher at least than many thought possible during the design doldrums of the late 1990s.

What happened? How had New York City gone from bypassed observer to eager participant in what amounts to a global competition between cities to build the coolest buildings? Certainly economics played a role, as it must for this deeply contingent art, one that is forever dependent on the timely infusion of capital; many of the projects that popped up around town in the last ten years owe their existence to the real estate boom (their stillborn siblings to the bust). But ready financing alone cannot account for the new, shared sensibility, the wholesale transformation of collective taste, that coursed from design studios to boardrooms to job sites on its way to being made visible in hundreds of new buildings that have altered the look and feel of the city. What changed?

It is important to remember here the writing of Herbert Muschamp, the outspoken architecture critic of the *New York Times* who died in 2007. "Lunch will be garnished with genius," he wrote in his review of Gehry's Condé Nast cafeteria in April 2000, and it was the importation of such architectural genius to Manhattan that defined his mission. In essay after strident, strangely compelling essay, Muschamp wove attacks on the culture and practices of New York developers with pleas to the client-class to recognize—to allow themselves to "desire" as he often put it—the work of a specific group of aesthetically adventurous architects he promoted. In that way—by embracing novel, high-

impact architecture—and in that way alone, he would argue, could New York maintain its status as a culture capital in the globalized world. The city still lacks a significant project by Muschamp's great love, Rem Koolhaas, to gaze at and adore (here we trail Rotterdam and Seattle and Beijing). Iraqi-born, London-based Zaha Hadid, another of Muschamp's critical darlings, is glaringly unrepresented as well. Hometown hero Peter Eisenman has not yet been given a crack at his native Manhattan. But the current state of the city, intercut as it is with glamorous designs from members of an elite he specifically championed, is in part the late critic's million-word legacy: we are living in Herbert's world.

A second factor in the city's sea change is of a very different nature—not the work of one man but of the civic body reacting to crisis with one mind. Calls for involving fresh architectural thinking in the reconstruction of Ground Zero were heard within days of the attack on the World Trade Center. Gehry himself was in the city on September 11, 2001, and he visited the barricaded perimeter of the devastation soon after with his client Thomas Krens, director of the Guggenheim Museum. Giddy rumors spread that the two had designs on the place. Muschamp's appeals for the deployment of what he called "progressive architects" reached a fevered pitch. Still, the first formal efforts to rede-velop the site fell into that older, truer New York pattern: a developer hiring a trusted firm (in this case Larry Silverstein and Skidmore, Owings & Merrill) to solve the problem from the special per-spective of big business. That, of course, given the communal pain, could not stand; New Yorkers and the world demanded an appropriate symbolic response, a healing gesture. But who could deliver it? What was the alternative to what everyone then referred to as "business as usual"? Only the stars. That was all that architecture culture could offer: an either/or choice between the large, conservative bureaucratic offices and the flashy, globe-trotting designers who were always seen as artists first.

On Bowery: Sperone Westwater Gallery, Foster + Partners; New Museum, Kazuyo Sejima and Ryue Nishizawa, SANAA.

I have argued elsewhere at length that a third way, combining creativity and competence, surface and soul, might have gotten better results; despite the attention given its design; despite the presence now of steel and concrete that will become a museum, an office tower, and a train station by various name-brand architects; despite even the possibility of a Gehry on the site, Ground Zero is not shap-ing up to be a great inspiration. Taken as a whole, it will be of, rather than alien to, the native building culture of Manhattan. That may be the best result: we don't want to see the blow to the city that could change its ancient ways. Still, throughout the course of the famously convoluted and con-tentious process to redevelop the site, in one supersaturated media event after another, the city was exposed to something new: avant-garde designers selling avant-garde designs in expert fashion. It sparked a craving.

Would New York City open itself at last to the work of cutting-edge architects? Many of the develop-ment battles that did so much to protract the debate over the future of Ground Zero revolved around that question. Whether they were better equipped than standard-issue architects to solve the raft of

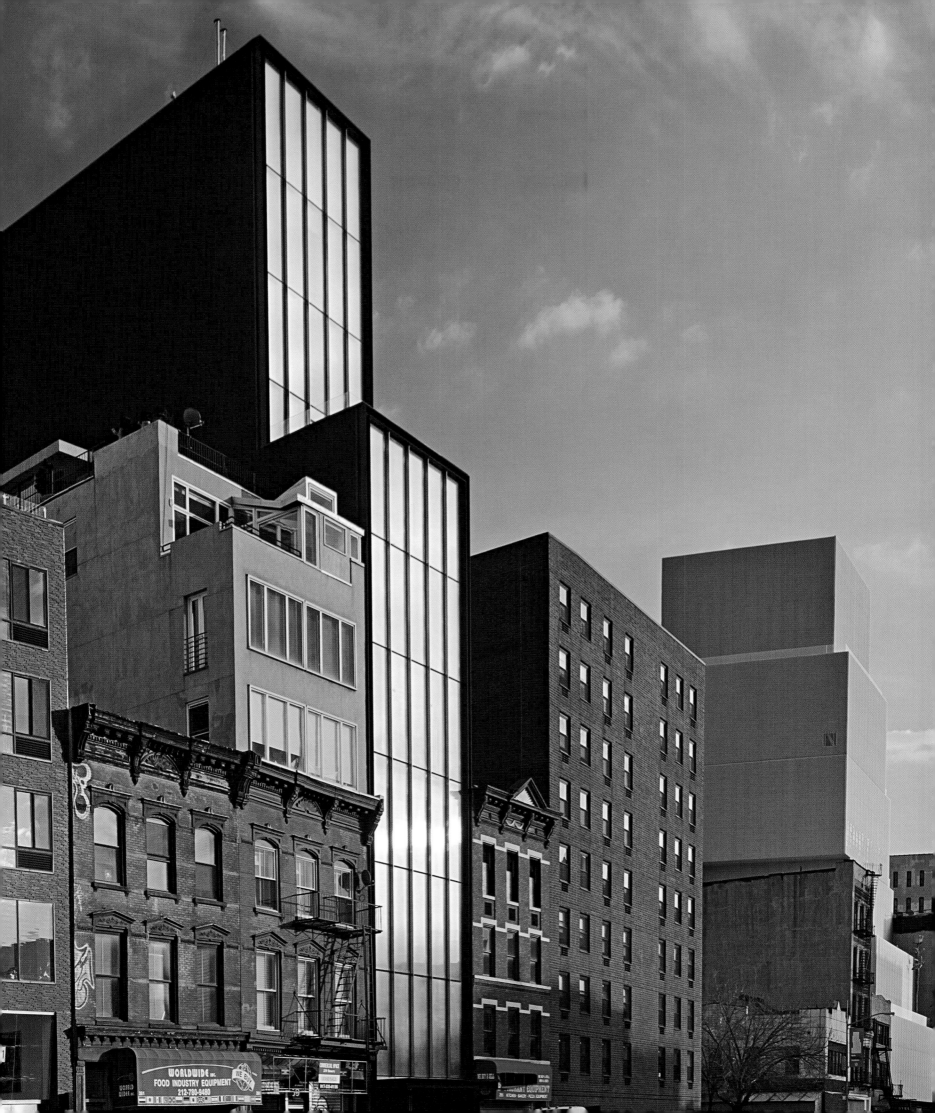

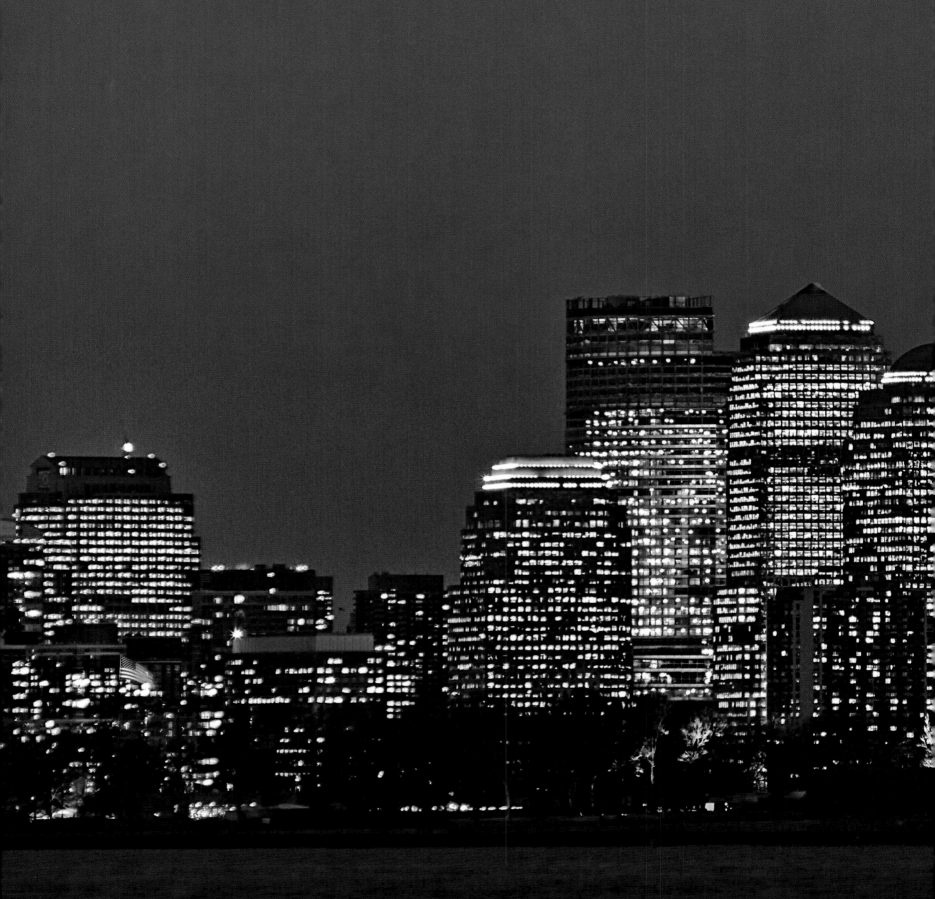

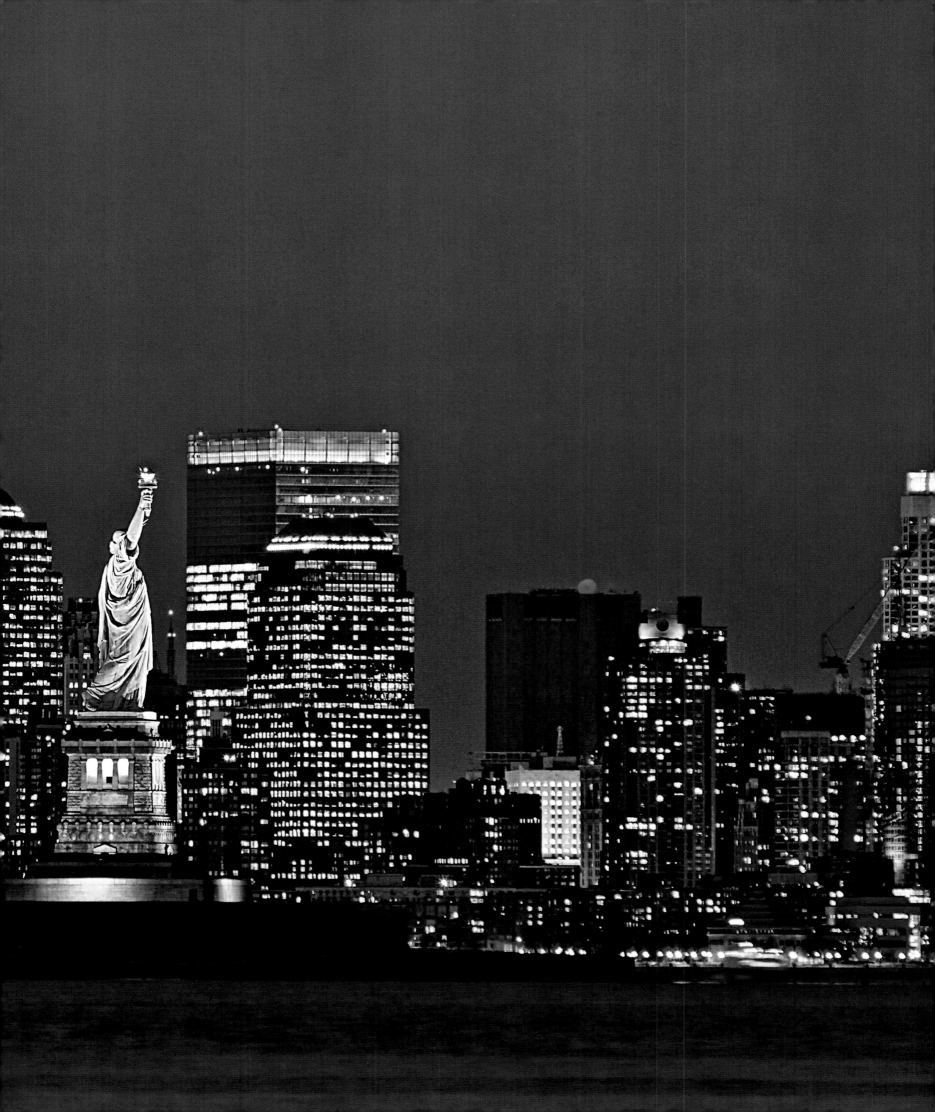

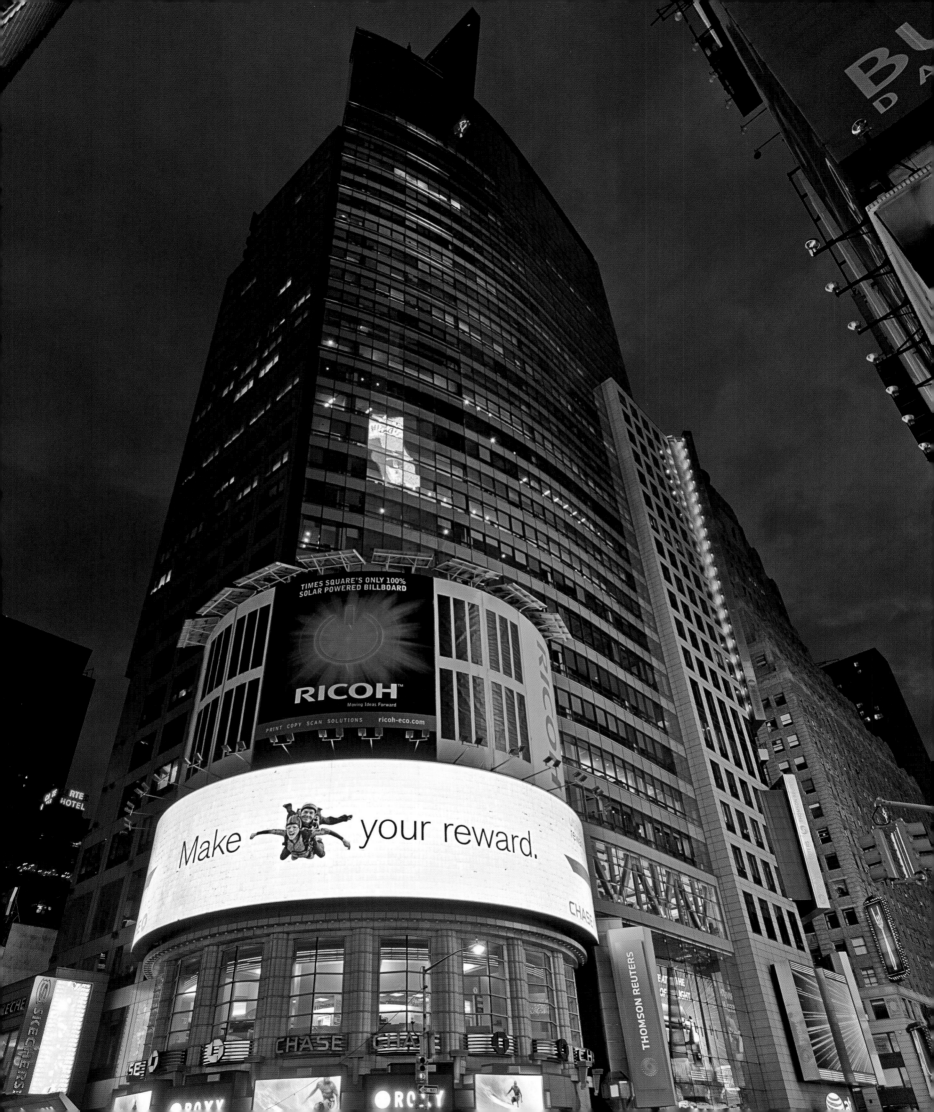

physical and emotional problems at the site was a question less often asked. In the end it was largely moot; SOM retained the commission for the major building, Freedom Tower, now known, in homage, as One World Trade Center. With its gently tapering glass facades and exceptional height, that building will be a stirring sight when it tops out, certainly at dawn and dusk, but it will not likely challenge observers' preconceptions about what is possible in architecture. Perhaps nothing at Ground Zero will. Still, the high-profile involvement there of that other kind of architect—most of all through the vocal presence of Daniel Libeskind, who for a time controlled the master plan of the new World Trade Center—got surprising results in surprising places. In the years that followed, evidence piled up at construction sites all over town: New York's developers sensed the dramatic shift in public taste. They shed old habits. Stars were sought out and hired. Star buildings rose. The results, some glorious, some not, some nearly so, fill these pages.

It remains to be seen whether the new architecture of New York will make a better New York; none of the buildings so well captured here by Jake Rajs can match the Department of Transportation's recent creative work—taking over major streets with bike lanes and pedestrian plazas—in catalyzing a salutary transformation of public life; none can equal the esthetic reach of the city's coordinated newsstand and bus shelter program (or even the authorless decision to swap LEDs for incandescent bulbs in traffic lights). No structure, however brilliant, can reshape the city as profoundly as the miles of new parks that have opened along the Hudson and East Rivers. Moored in place, lording over a single corner (at most four), a given work of architecture is at a disadvantage to change the world. Not even a wholesale shift in architectural taste, however stunning and universal, can compete with planning policy as a factor in urban transformation. And the nature, the quality of individual buildings matters far less in New York than elsewhere.

Here lies one secret of New York City. In any smaller place (and in this sense they are all smaller), a new building is always, proportionally, that much more of an addition to the skyline. In Boston or Philadelphia or Seattle, one very poorly conceived building might actually "ruin" the look and feel of the city. There isn't enough mitigating context to compensate for an architect's bad day. The balancing *mass* isn't there. But it's not just size that insulates New York from the foibles of those who would add to it—and here, like a casual tourist, I really mean Manhattan—but shape. Our single word city doesn't do much to help us distinguish between the many forms an instance of urbanism can take. The French do better, with two. The word *ville* connotes a default urban condition, like most of Paris; it means what we mostly mean when we say *city*. A second term, *cité*, like the eponymous island in the Seine, is reserved for places that are built up as unified architectural compositions, seamless conglomerations, bastions of buildings that read as a single construction. The outer boroughs, where they aren't nakedly suburban, tend strongly to *ville*—an uninterrupted conurbation;

brownstone Brooklyn is a good example. Manhattan, of course, is all *cité*. The entire island, river to river, is the work, the whole, the object that bears interrogation by the eye, the subject of the story, the thing a resident cherishes, what visitors come to see.

Any new building in Manhattan—and this applies equally to a glassy midblock condo and the tower rising at Ground Zero that will be the tallest in the land—is, when seen in context, mere ornament. A bauble among baubles. A knickknack on the shelf. In the images that follow you will find everywhere the power of that shelf—what everyone simply calls, though there are several of them, "the grid." Manhattan is an unforgiving place to build. Observers sometimes speak of an architect being defeated by New York—not just by the political hurdles, the labor unions, the difficult site conditions (bridging this or that bit of infrastructure, hemmed in on all sides by whatever came before), the clashing, entitled neighbors, the absurd expense—but in some occult way by the city itself. What defeats architects, all of them in time, is the grid: the relentless reiteration of Manhattan's primal fact, the powerful reassertion of the whole's priority over the parts, a force that puts even the most extravagant building in its place. To marvel at the Flatiron Building, to revel in the clashing angles of Times Square, is to recognize the power of the grid in the breach by exalting Broadway's crisscrossing aberration. Grand Central Terminal, too: it is a unique carbuncle, sited as it is, breaking every rule, in the center of Park Avenue. The grid has a life of its own. March 22, 2011, marked the 200th anniversary of the adoption of the Commissioner's Plan, the map that laid out, in an unprecedented act of optimism and hubris, Manhattan's numbered streets and avenues, the emphatically stretched rectangles of its endless blocks. The Internet crackled that day with birthday wishes—a telling focus of celebration by those who understand what makes New York New York. *It's the grid, stupid*, the hive-mind seemed to say. *Long may it reign.*

The Hotel on Rivington, Grzywinski + Pons.

OVERLEAF
Waterfall installation by Olafur Eliasson at the Brooklyn Bridge.

TODAY THE GRID is host to a new New York—shinier, curvier, pointier, and with a much fancier architectural pedigree than the previous New York, itself one of so many old New Yorks stretching back to the city's first stirrings as a playground for ambition. The new New York is prone to bold gestures where its predecessor liked to play it safe. It is urbane, fashion-conscious, worldly. It revels in uncanny surface effects. It has moments of surpassing beauty. It is a bit more like other places. Above all, it is photogenic. But look close in these photographs and you will see another New York. Not old. Not new. The eternal New York: built from the ground up to outlast any momentary eruption of difference, laid out from scratch to live always as an armature for what comes next.

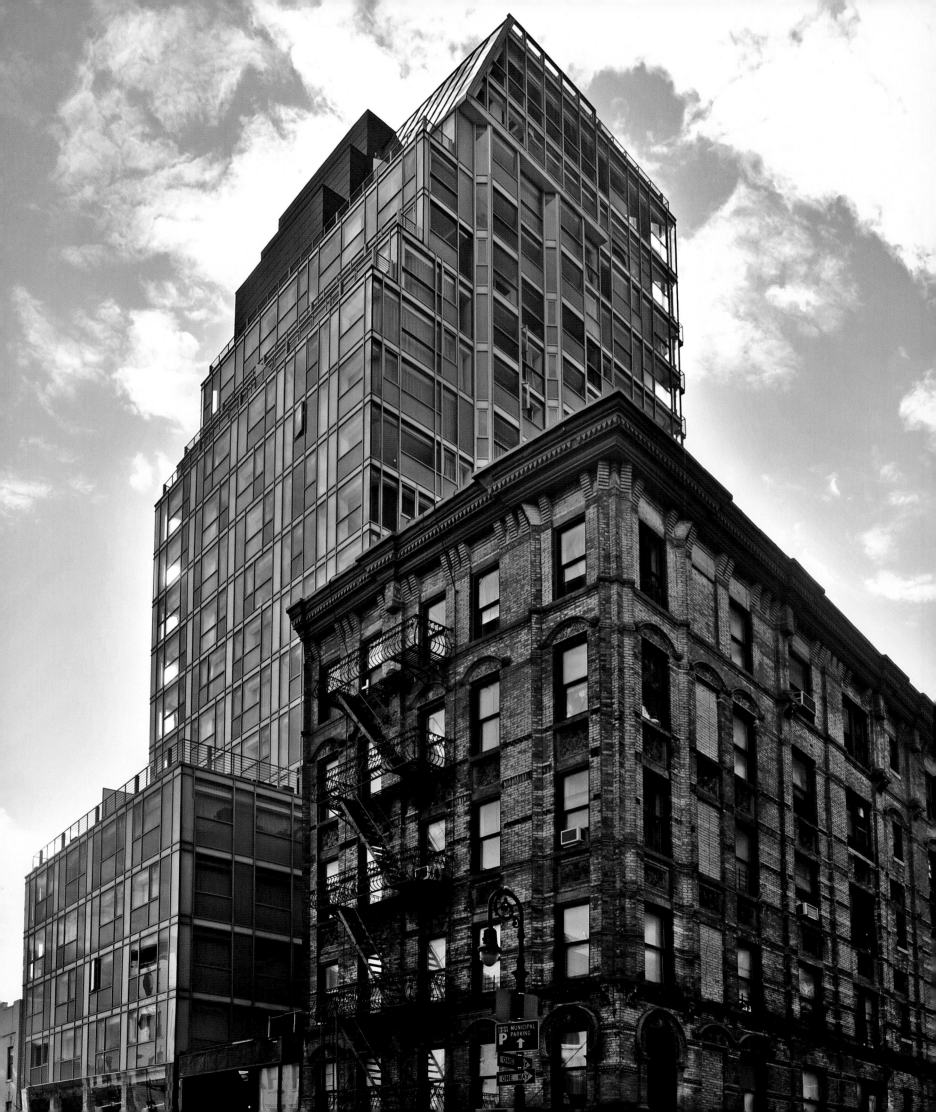

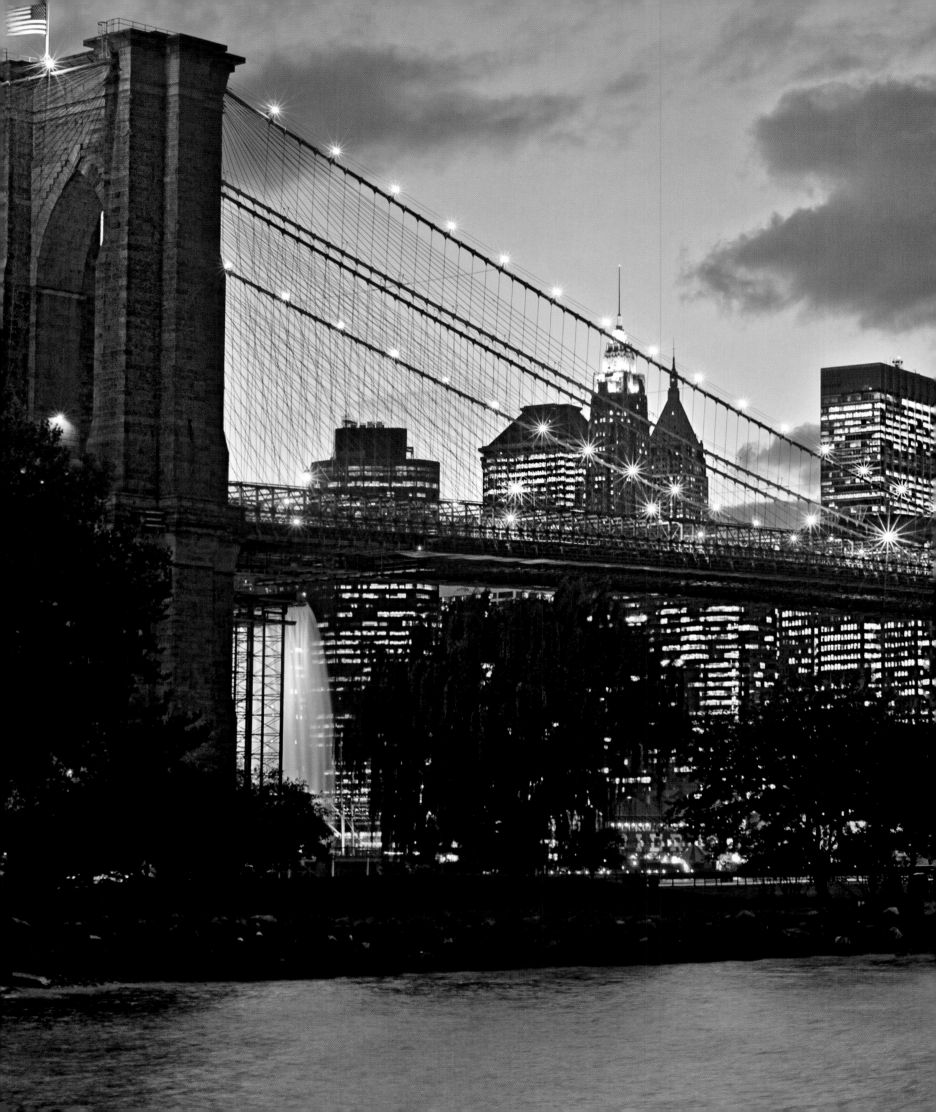

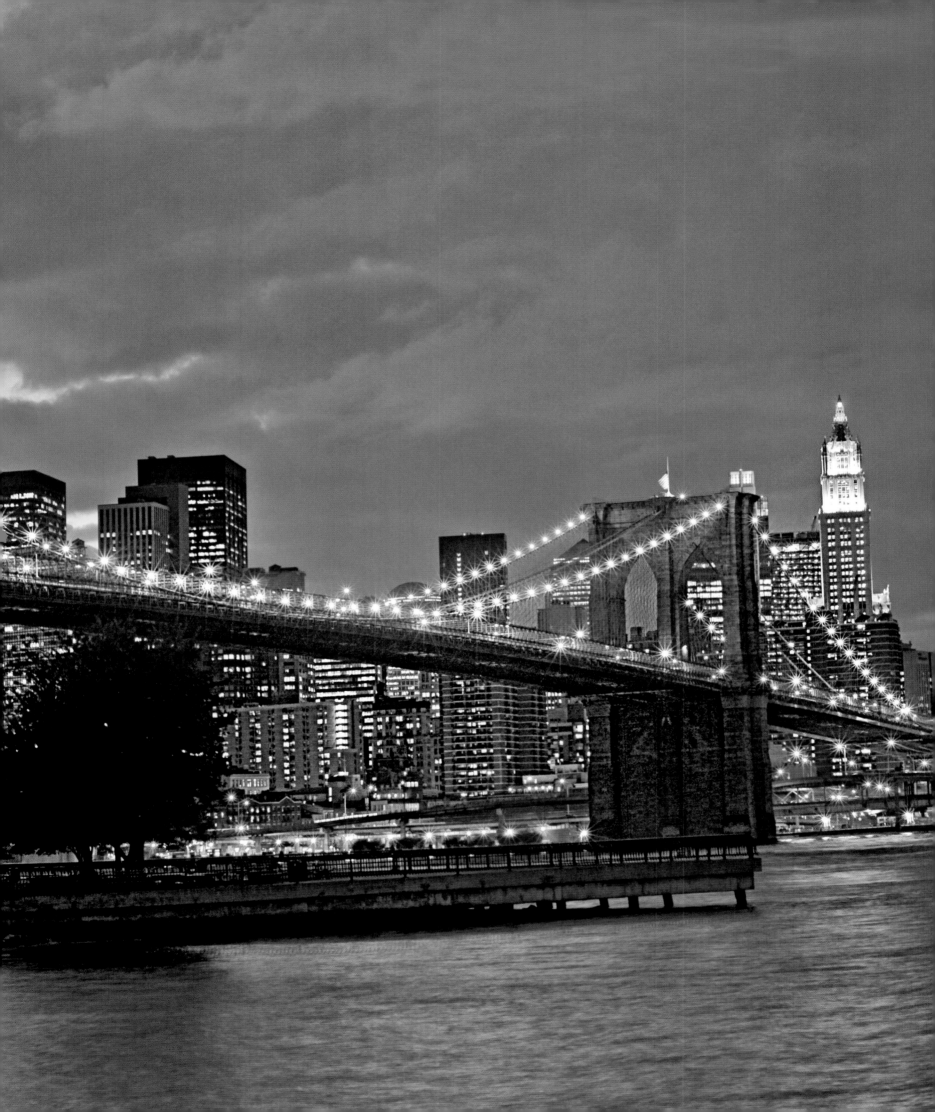

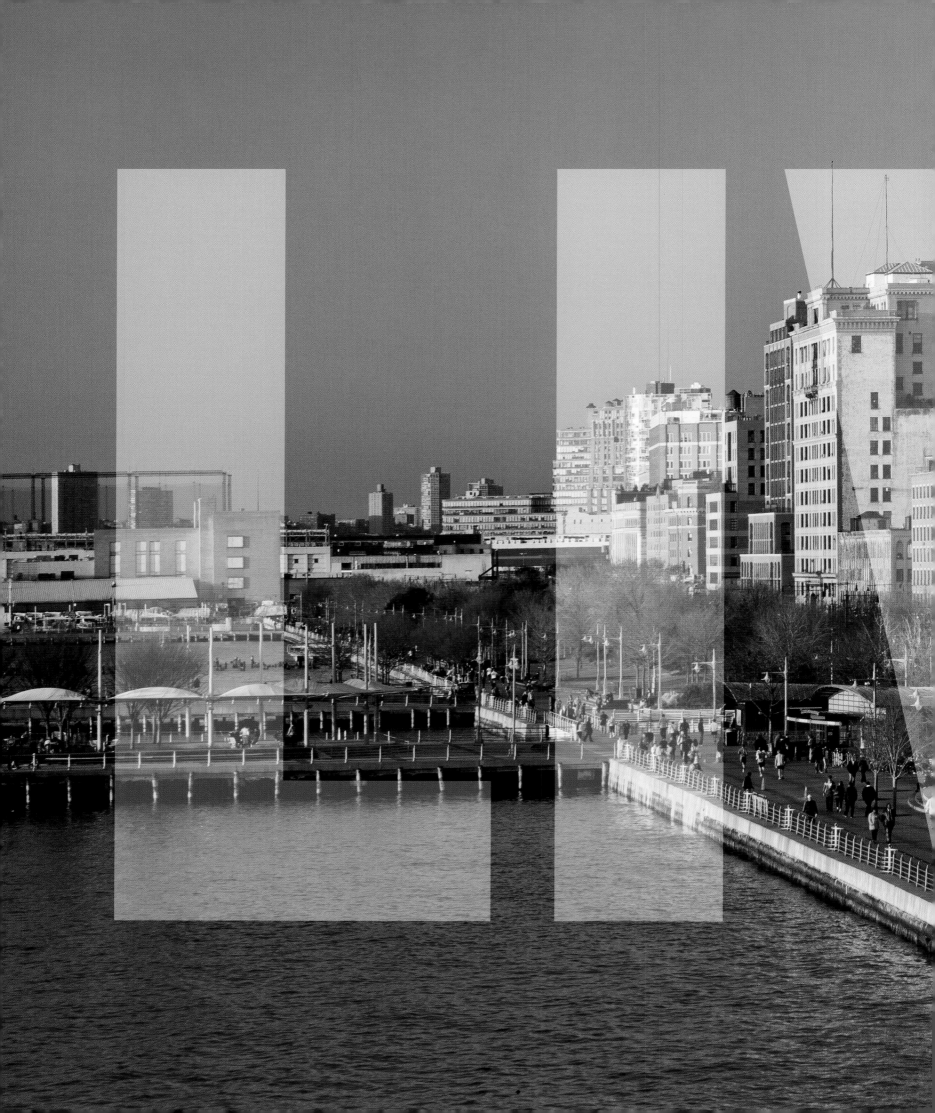

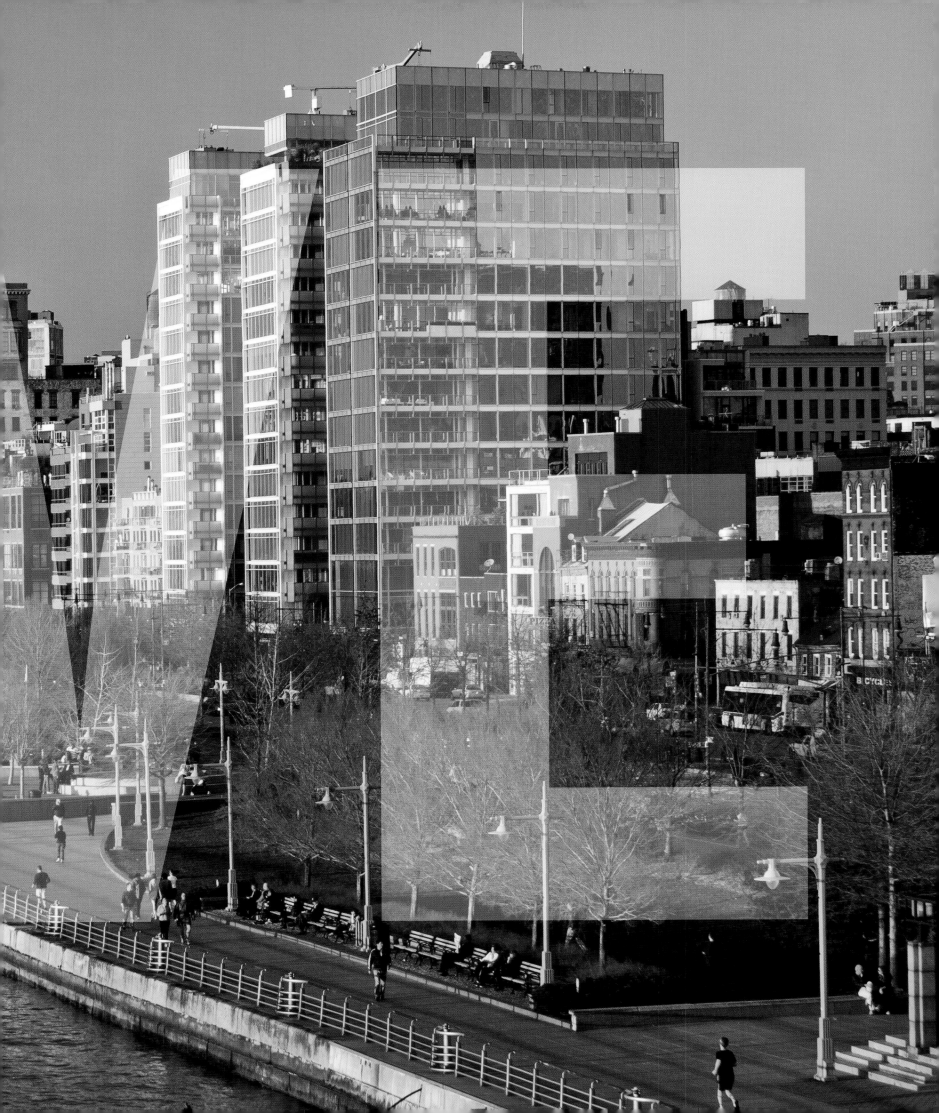

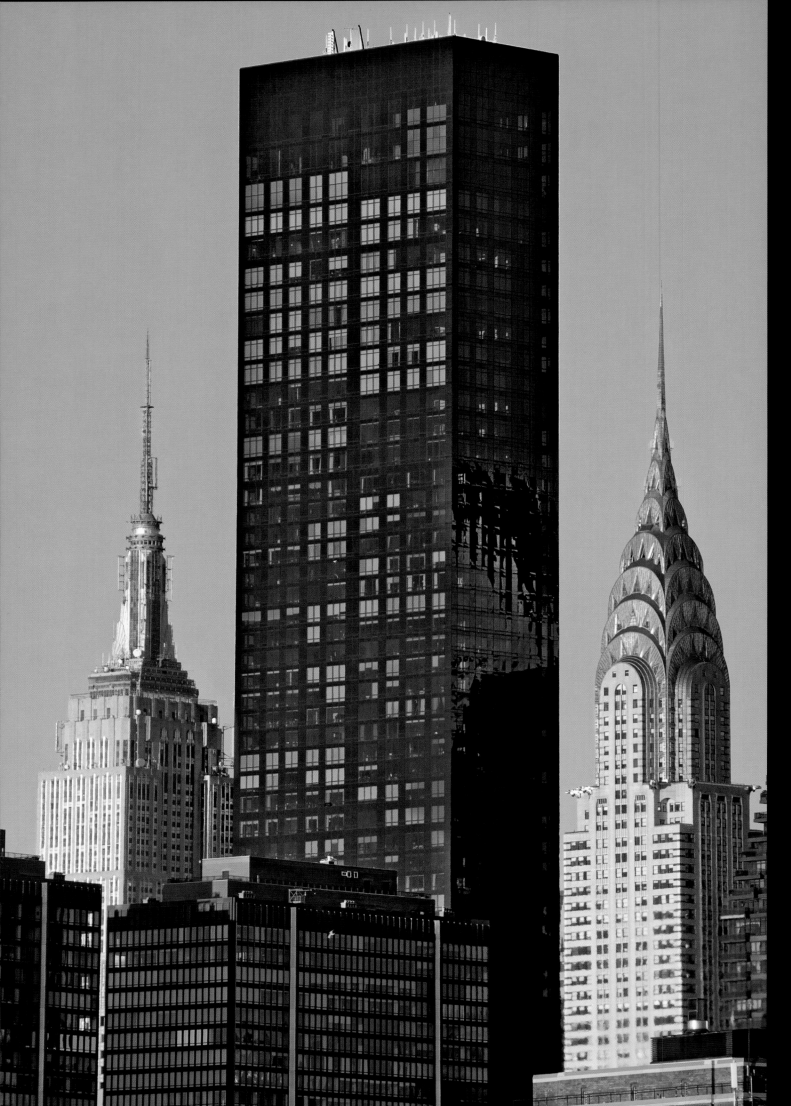

LEFT
Trump World Tower, Costas Kondylis & Associates, flanked by the Empire State Building and the Chrysler Building.

RIGHT
One York, TEN Arquitectos.

OVERLEAF
View northwest from the High Line with IAC Building, Gehry Partners; 100 Eleventh Avenue, Ateliers Jean Nouvel; and 520 West 19th Street, Selldorf Architects.

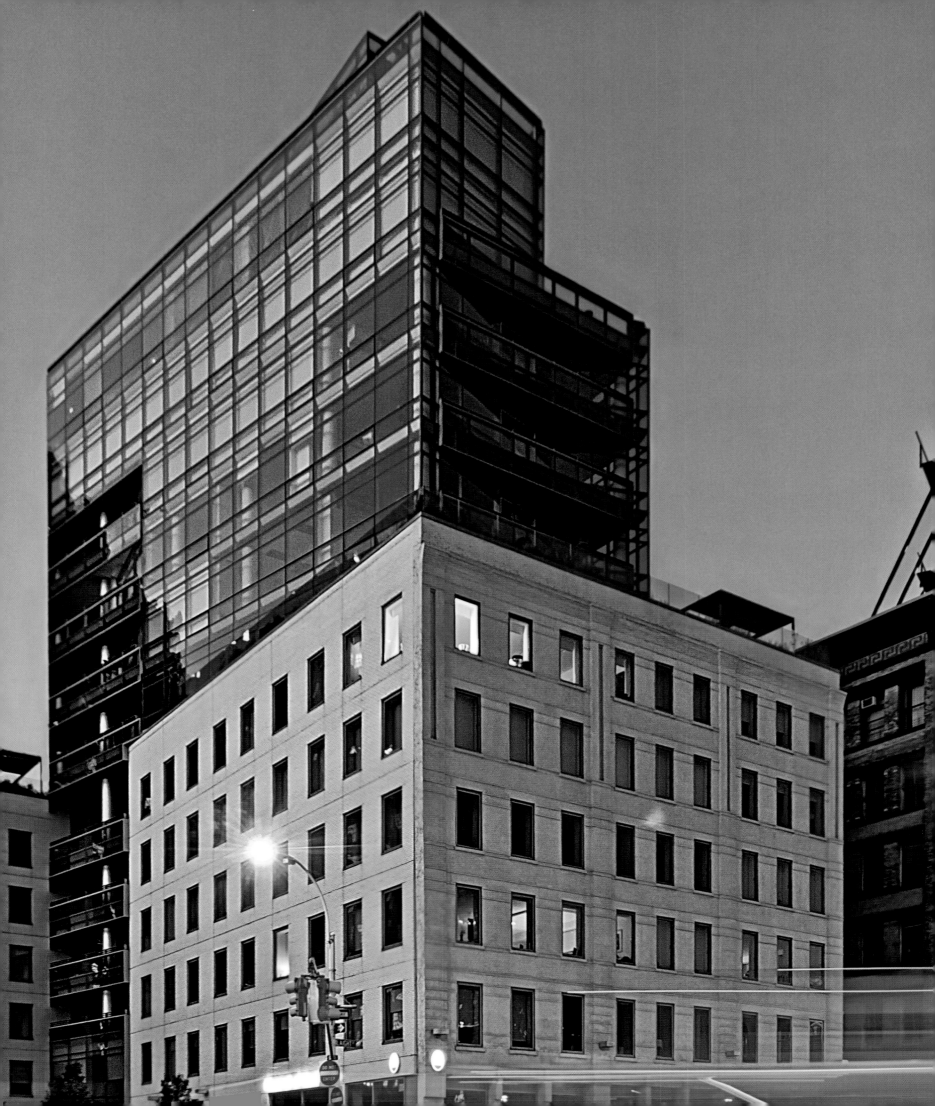

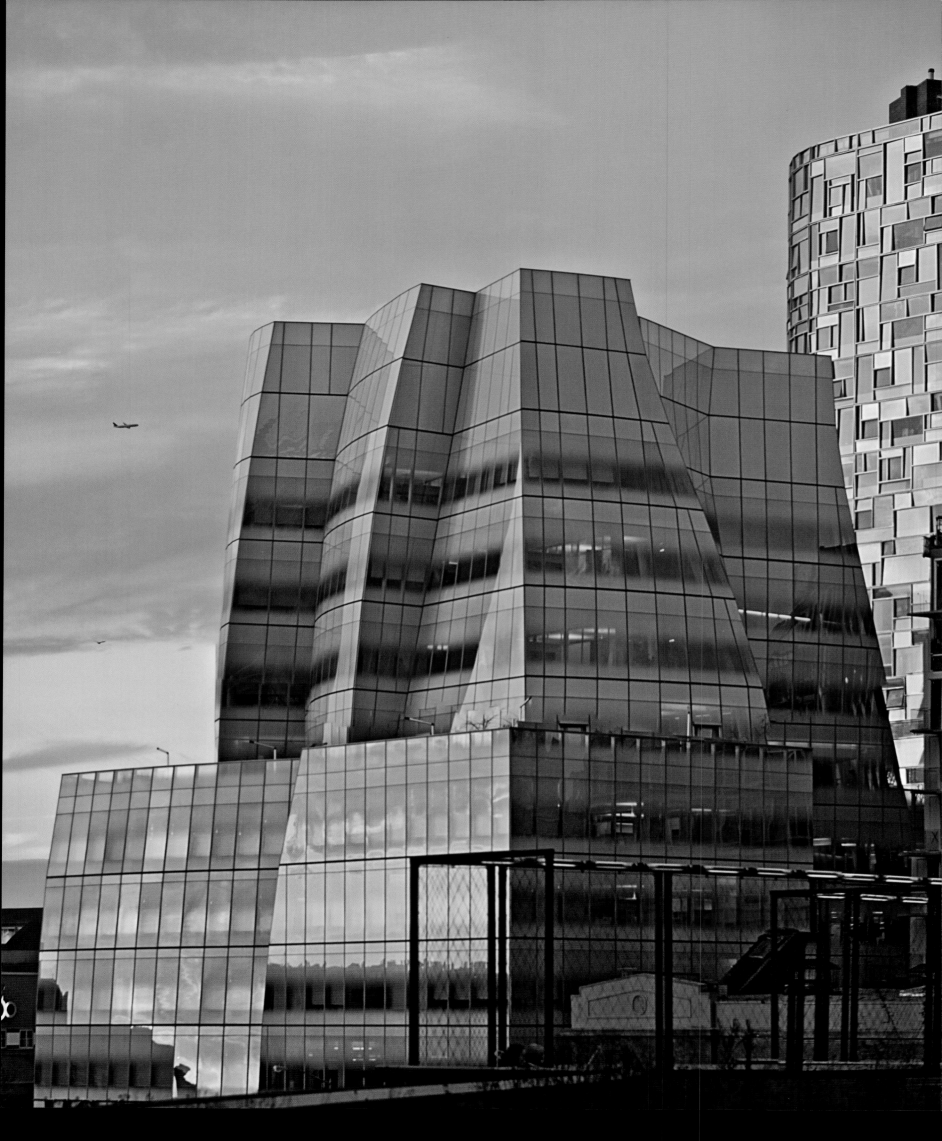

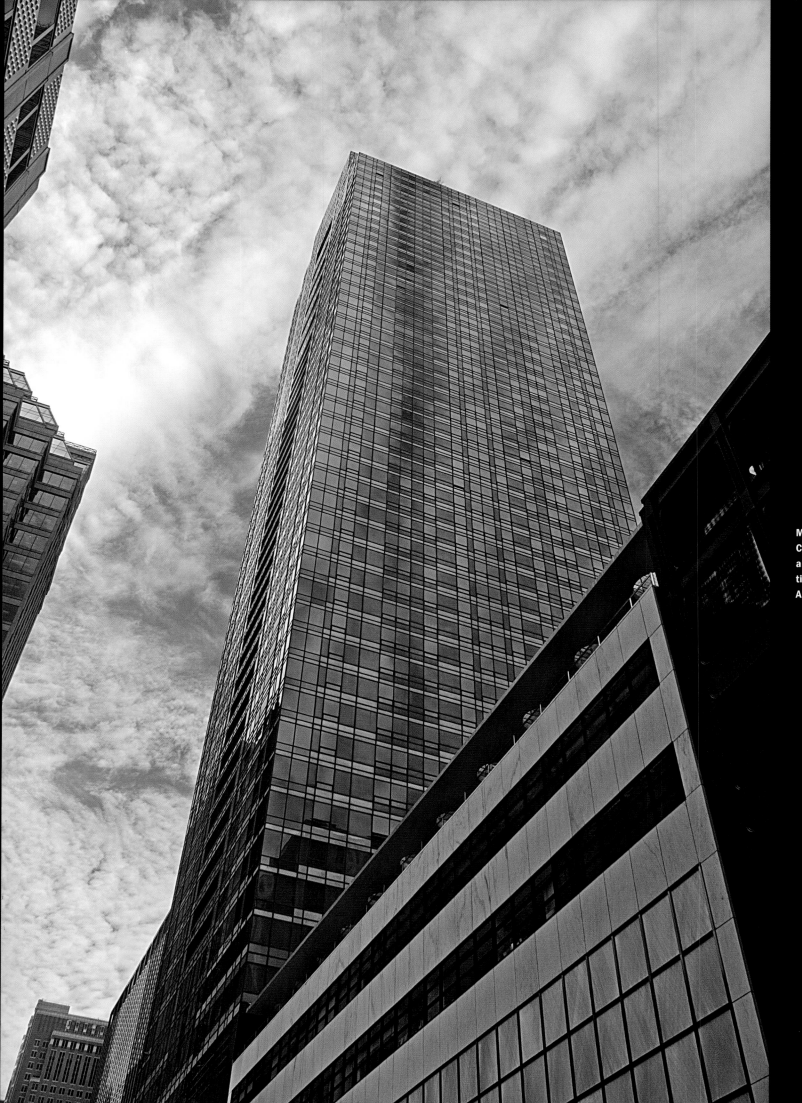

Museum Tower, Pelli Clarke Pelli; facade and lobby renovations Taniguchi Architects.

34

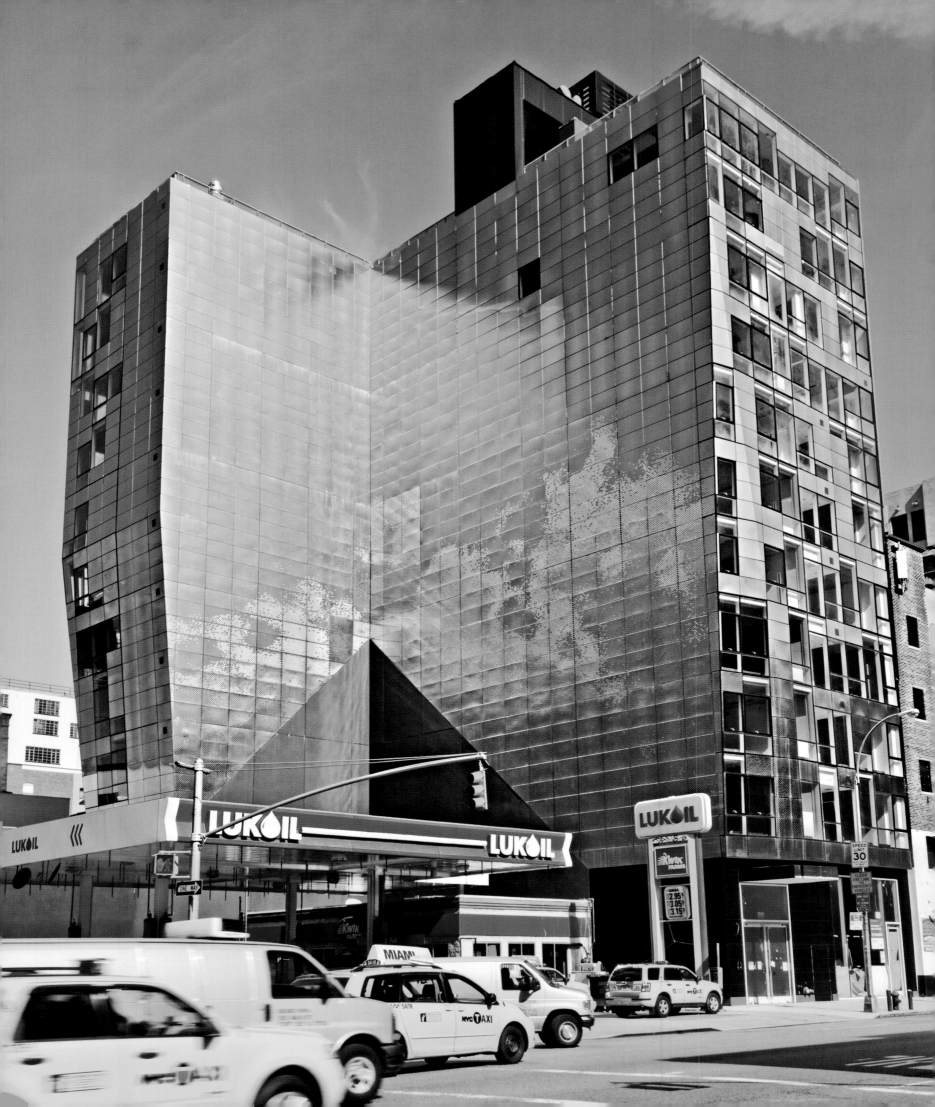

245 Tenth Avenue,
Della Valle
Bernheimer.

OVERLEAF
Palazzo Chupi,
Julian Schnabel,
between 173 and
176 Perry Street,
Richard Meier &
Partners.

37

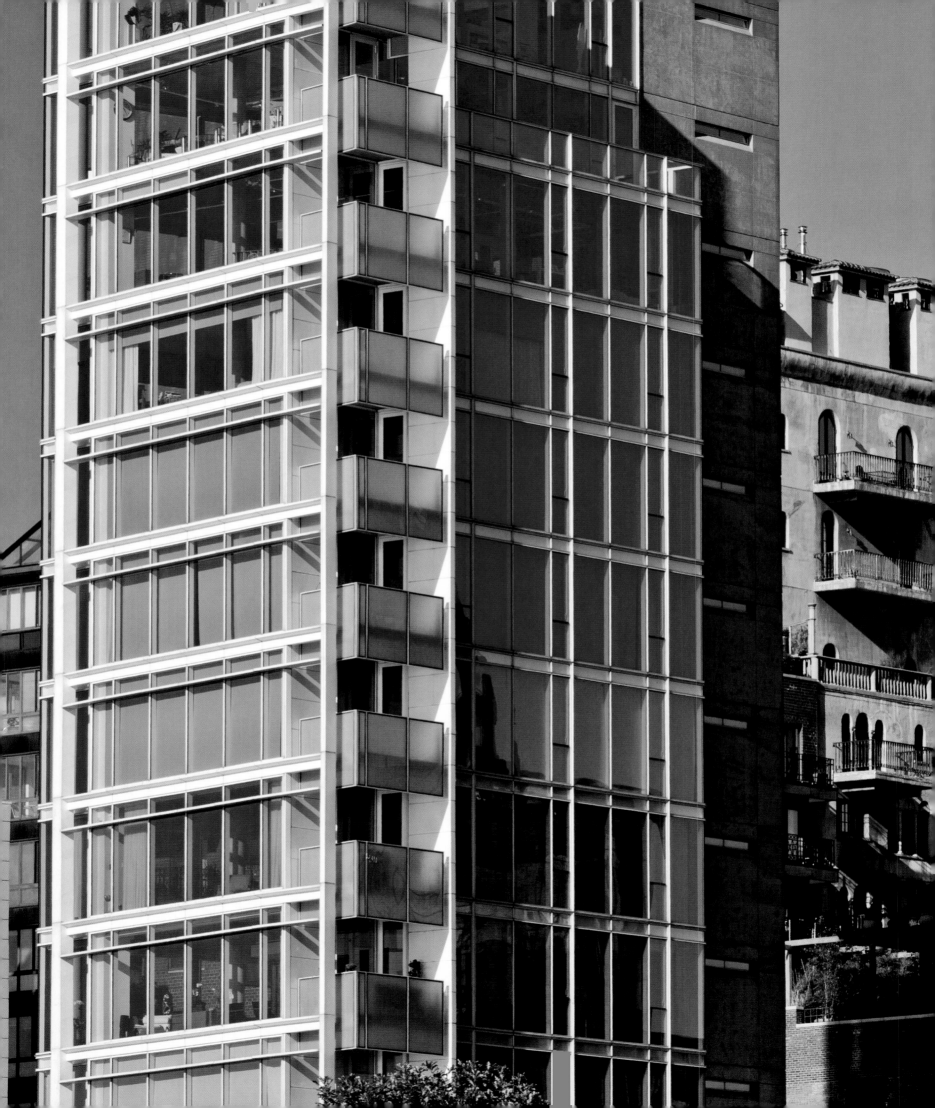

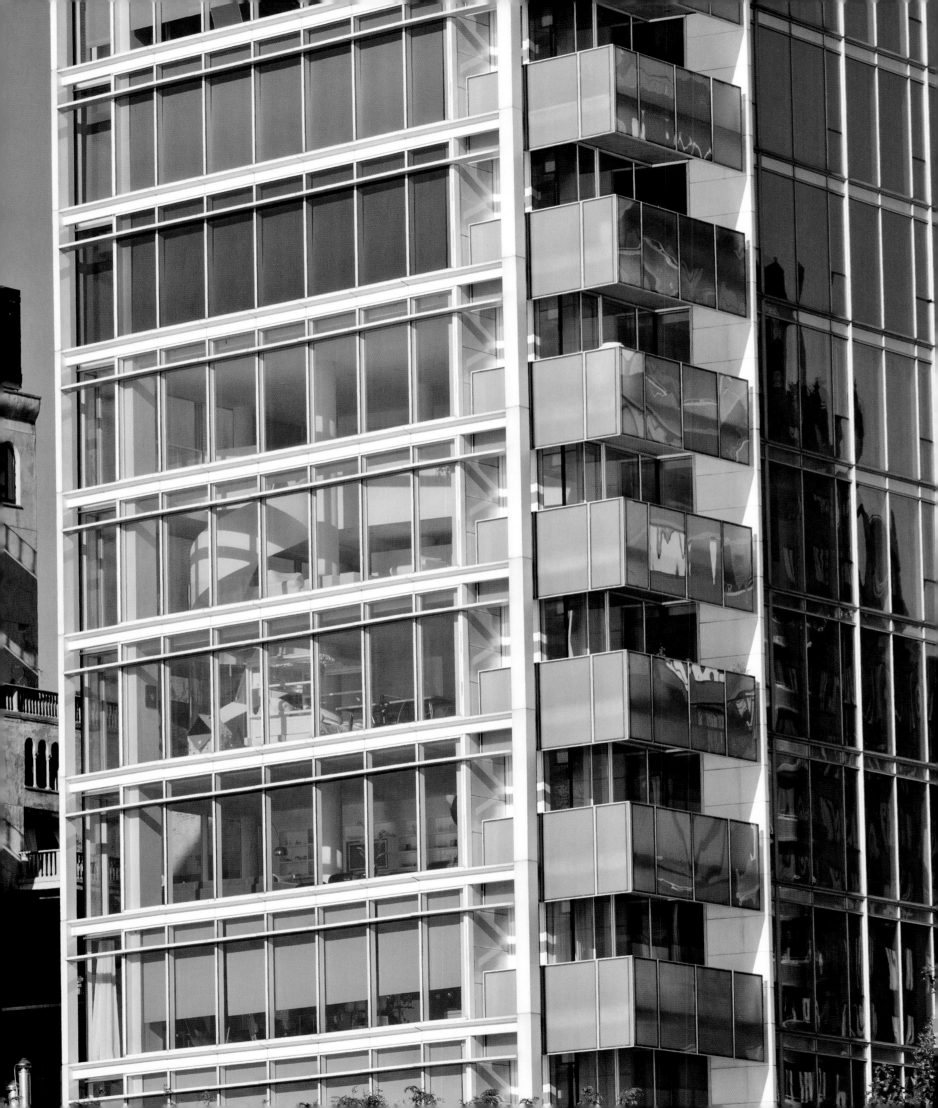

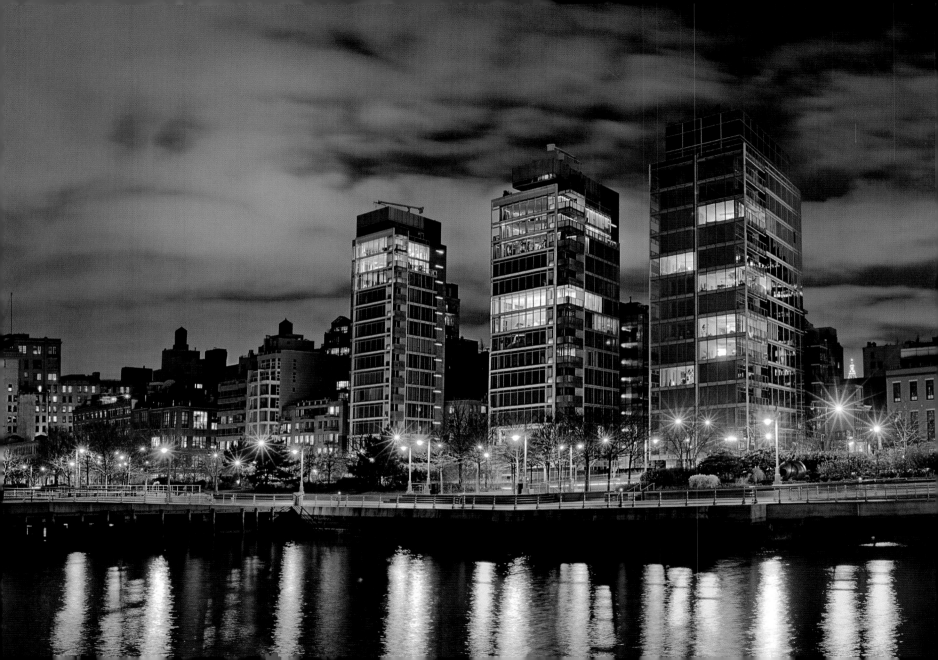

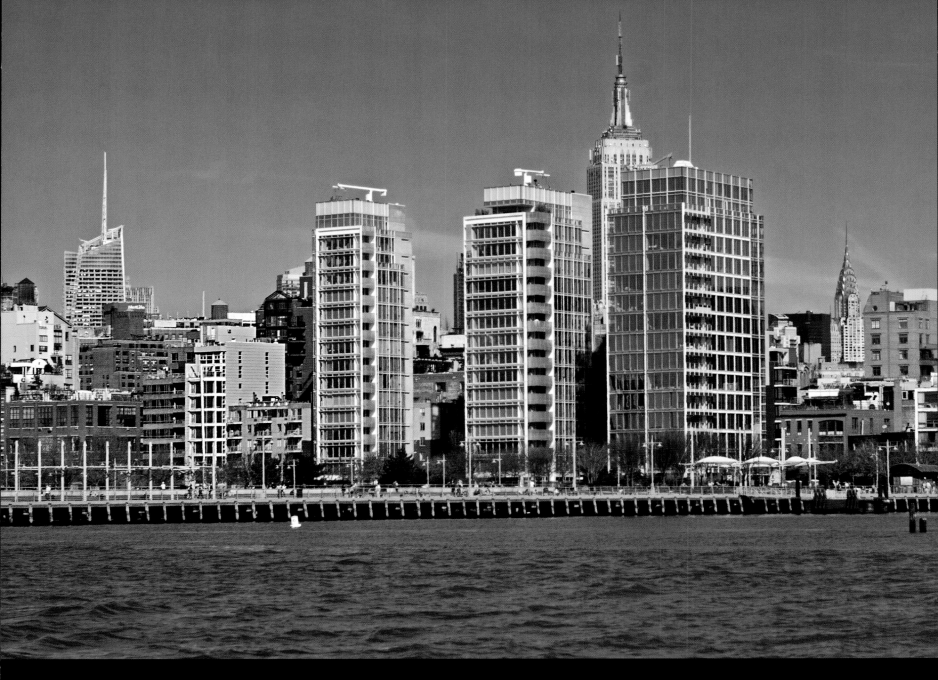

173 and 176 Perry
Street, 165 Charles
Street, Richard Meier

Astor Place,
Gwathmey Siegel &
Associates.

OVERLEAF
Condominiums,
McCarren Park,
Williamsburg,
Brooklyn.

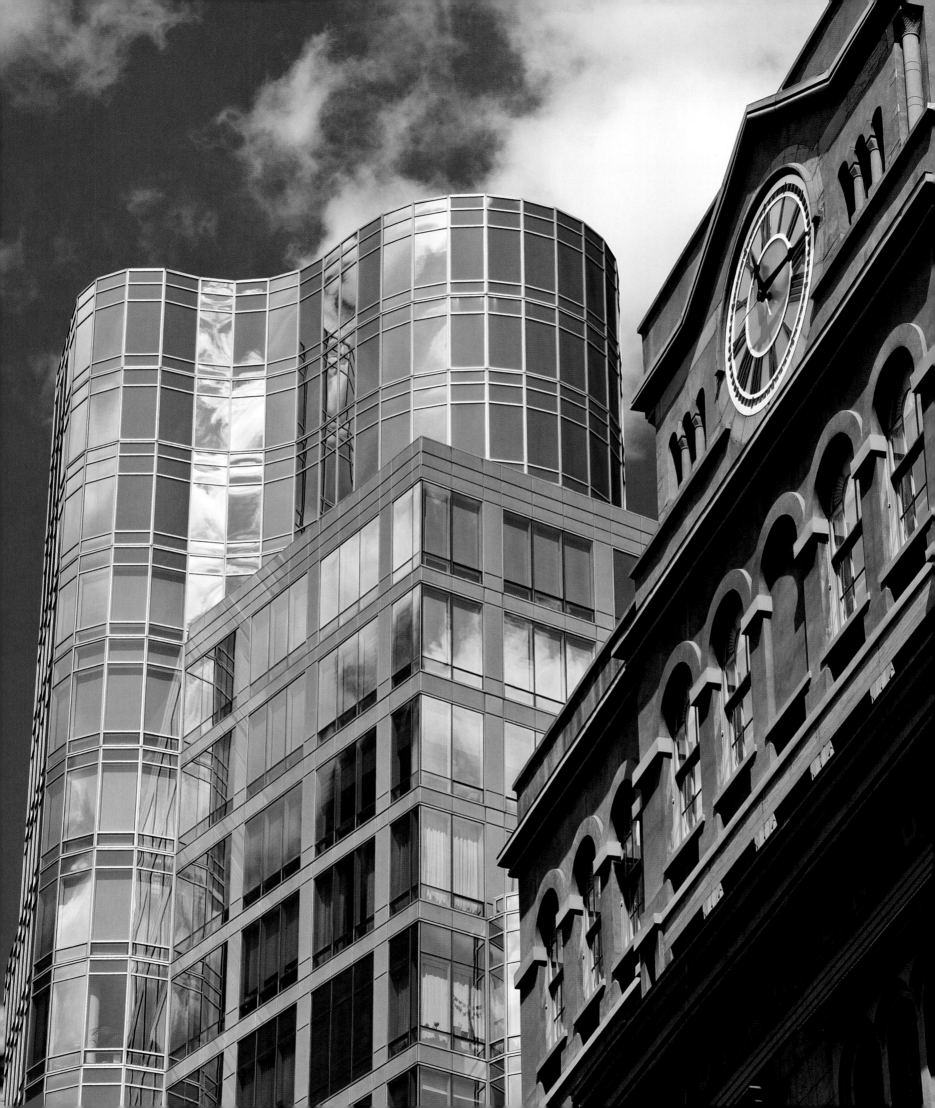

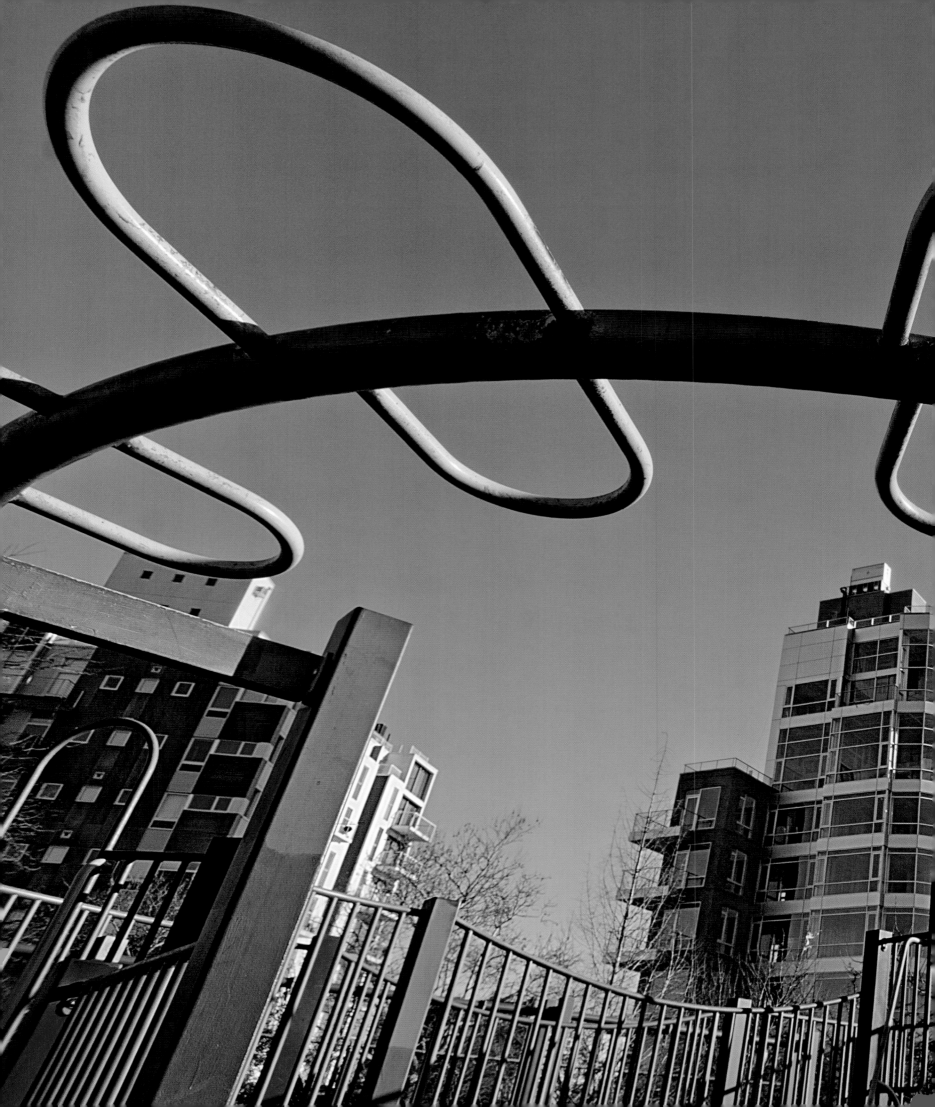

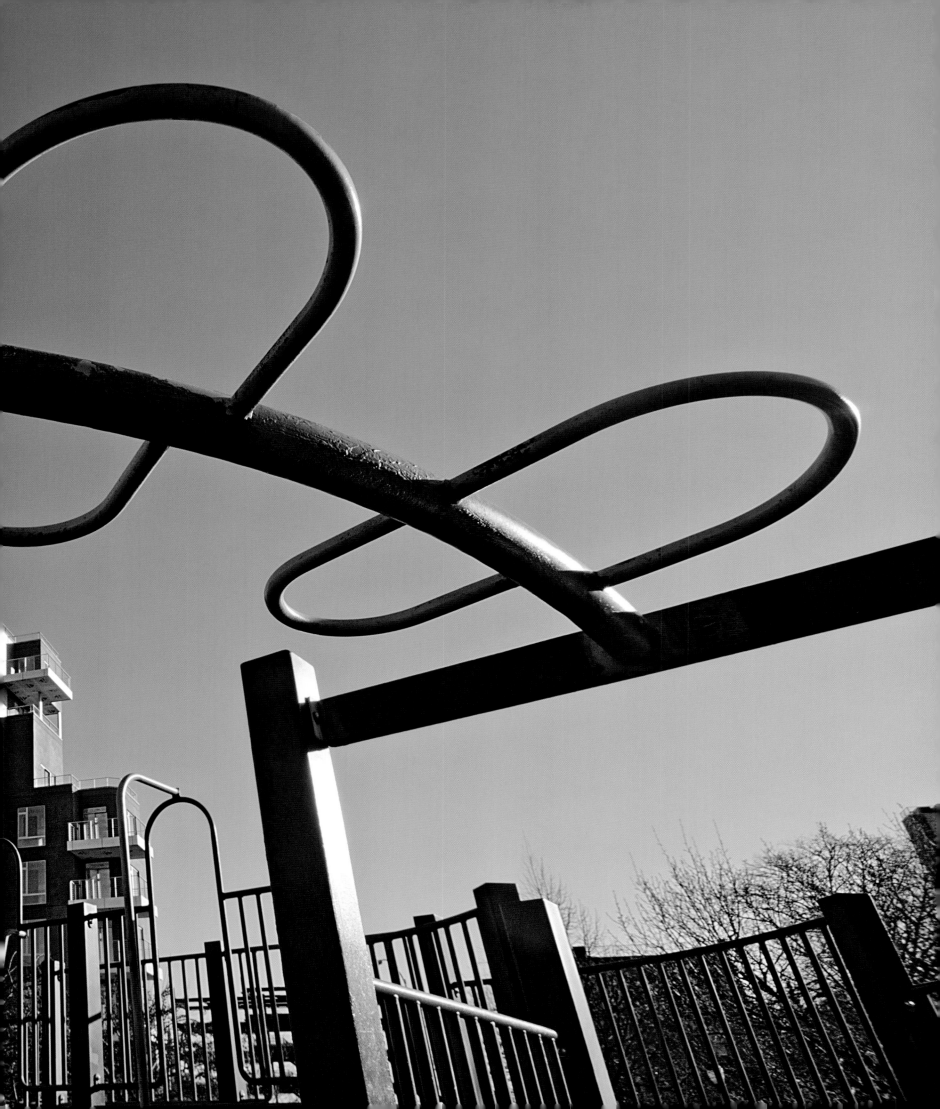

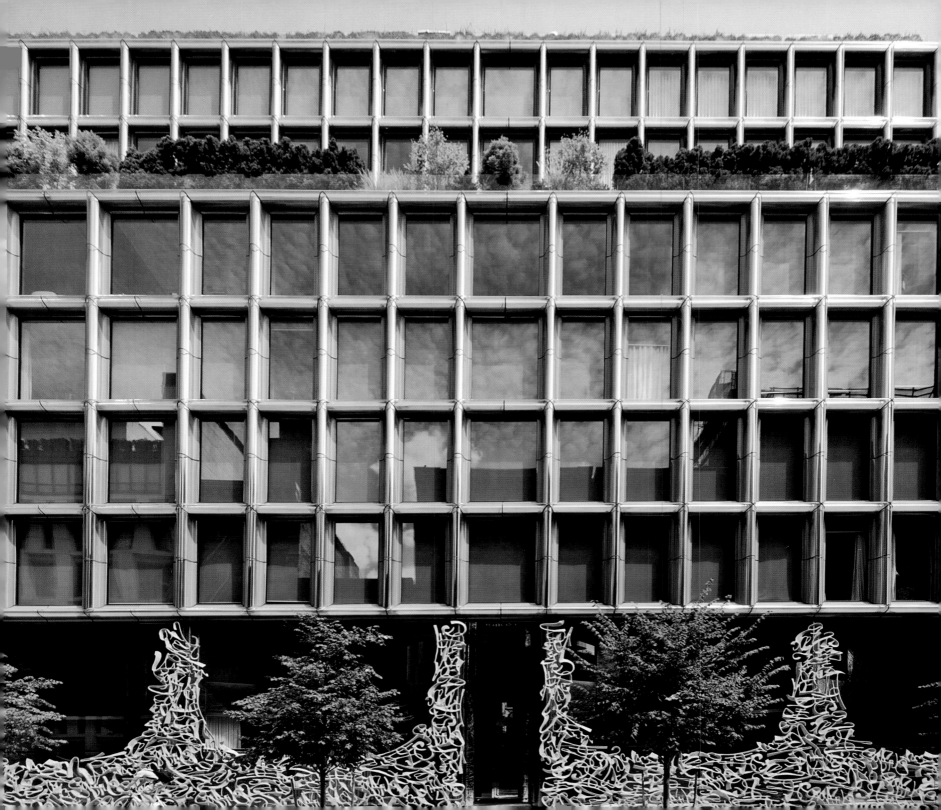

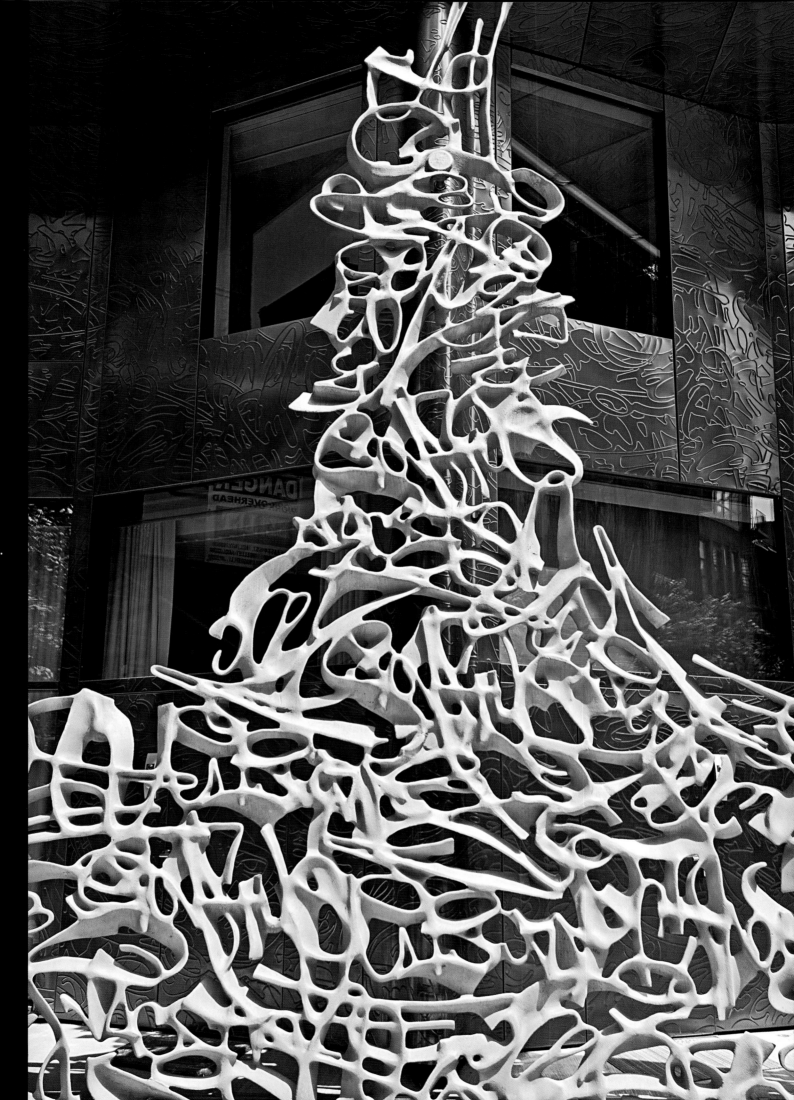

40 Bond Street,
Herzog & de Meuron.

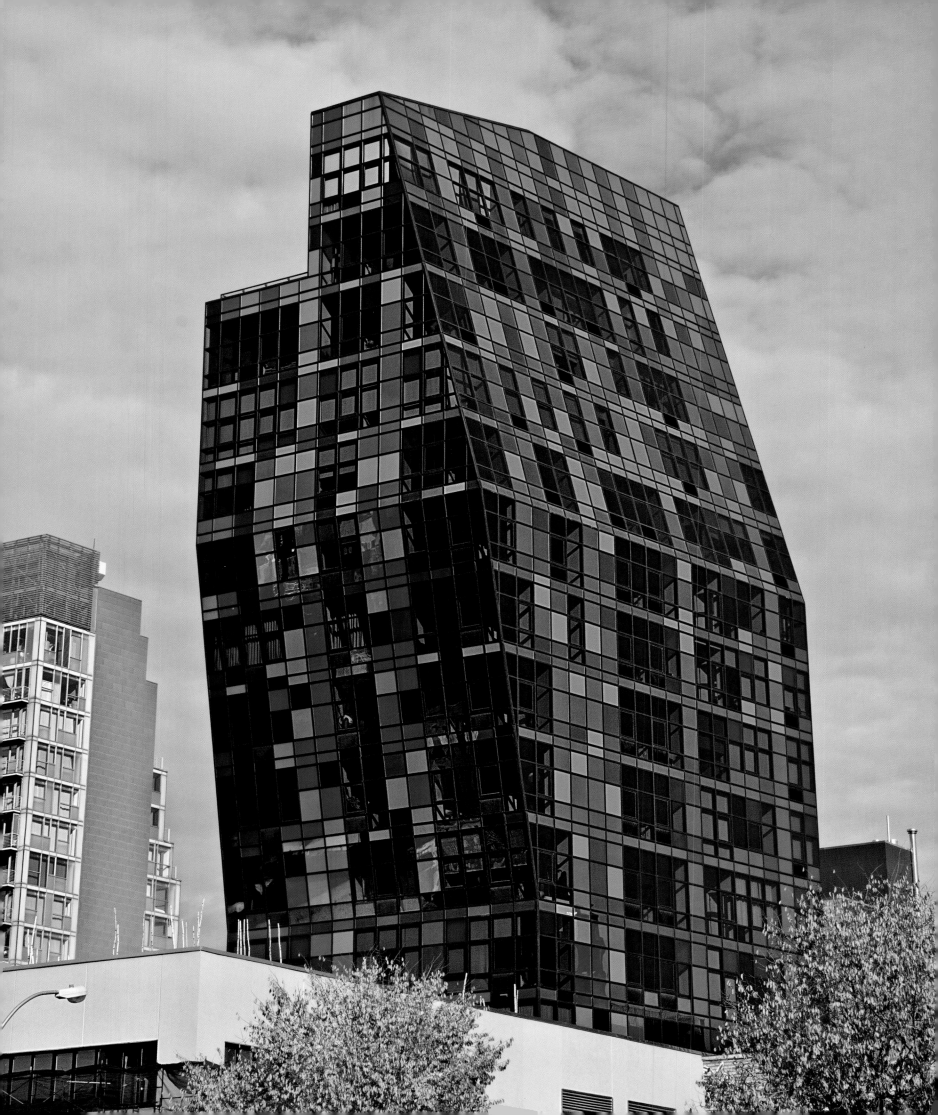

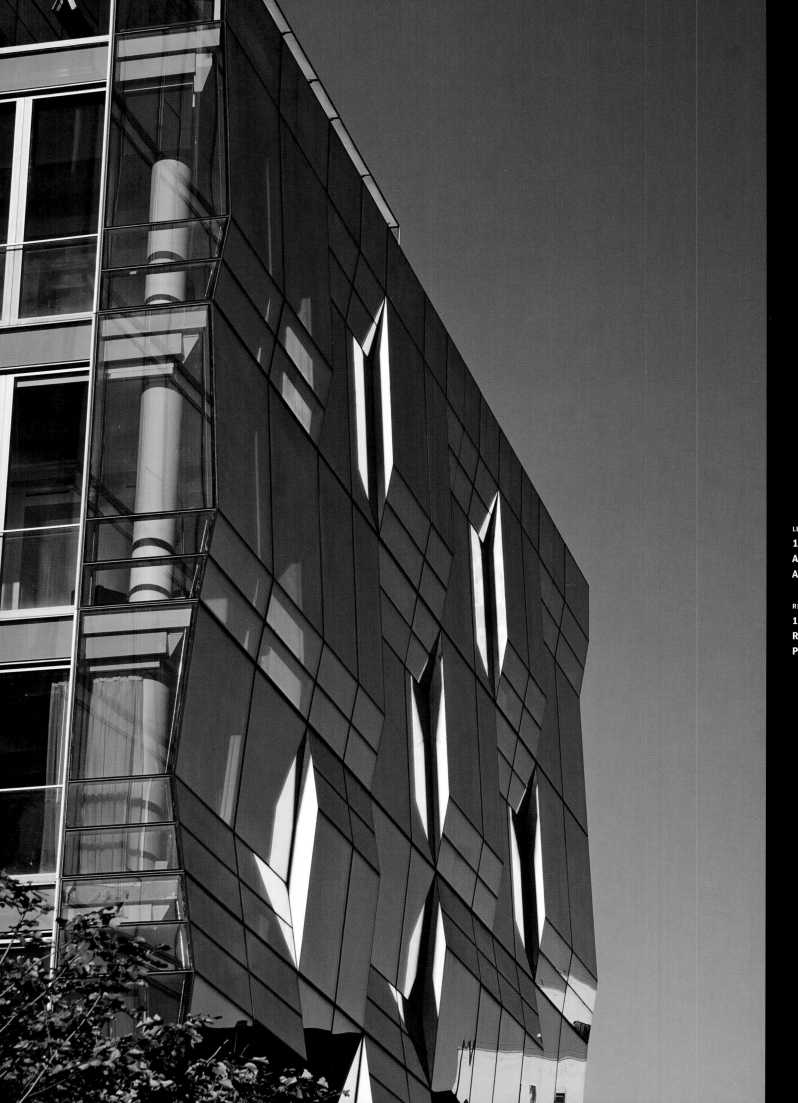

LEFT
**166 Perry Street,
Asymptote
Architecture.**

RIGHT AND OVERLEAF
**173 Perry Street,
Richard Meier &
Partners.**

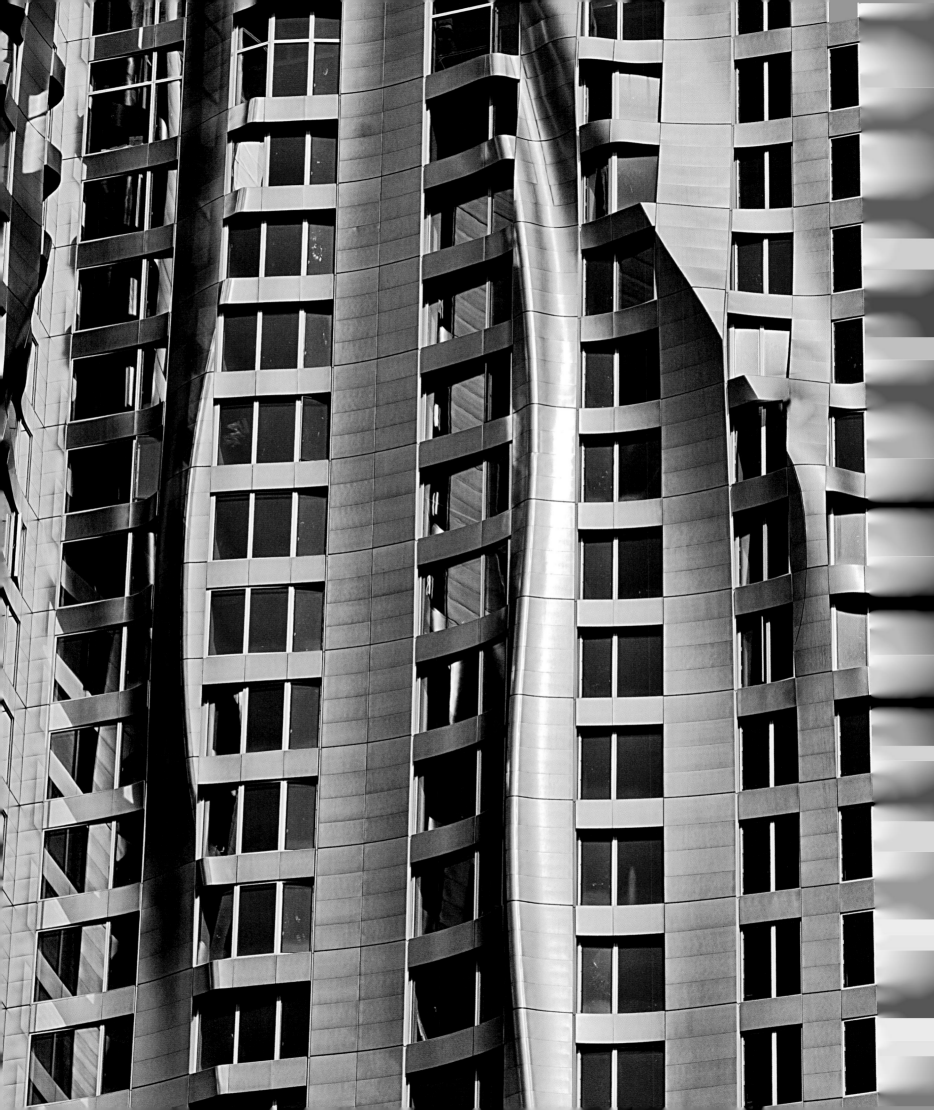

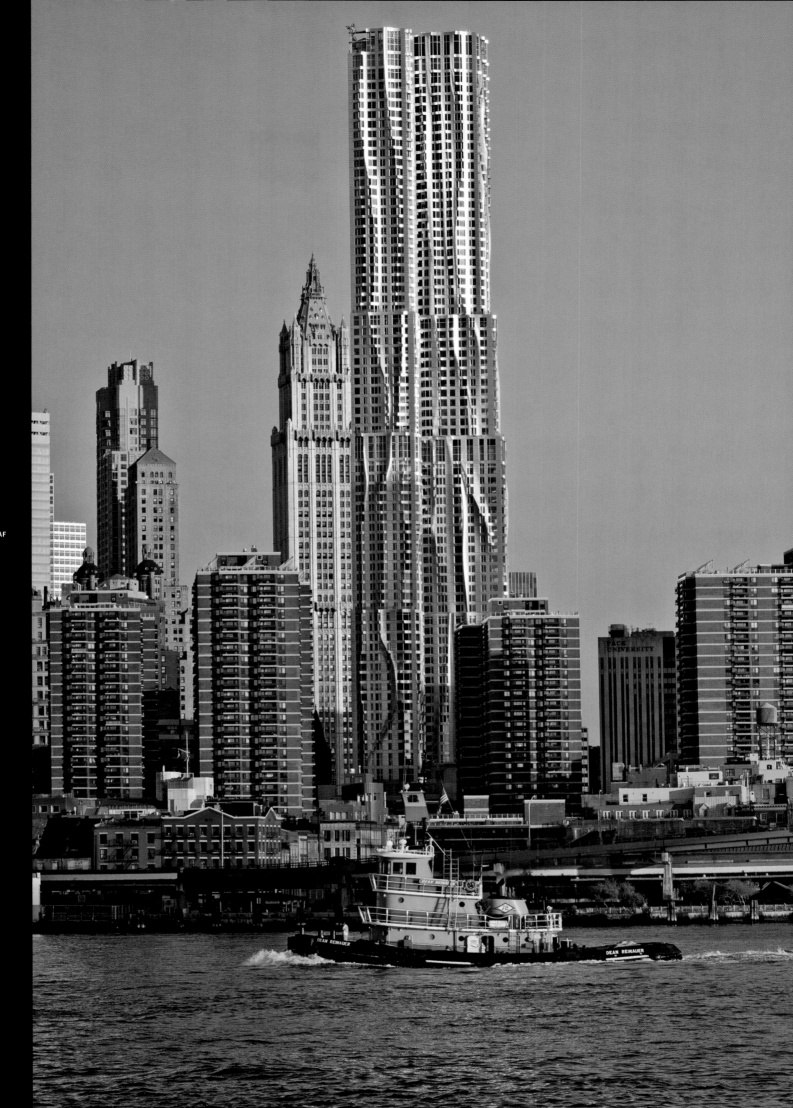

**8 Spruce Street,
Gehry Partners.**

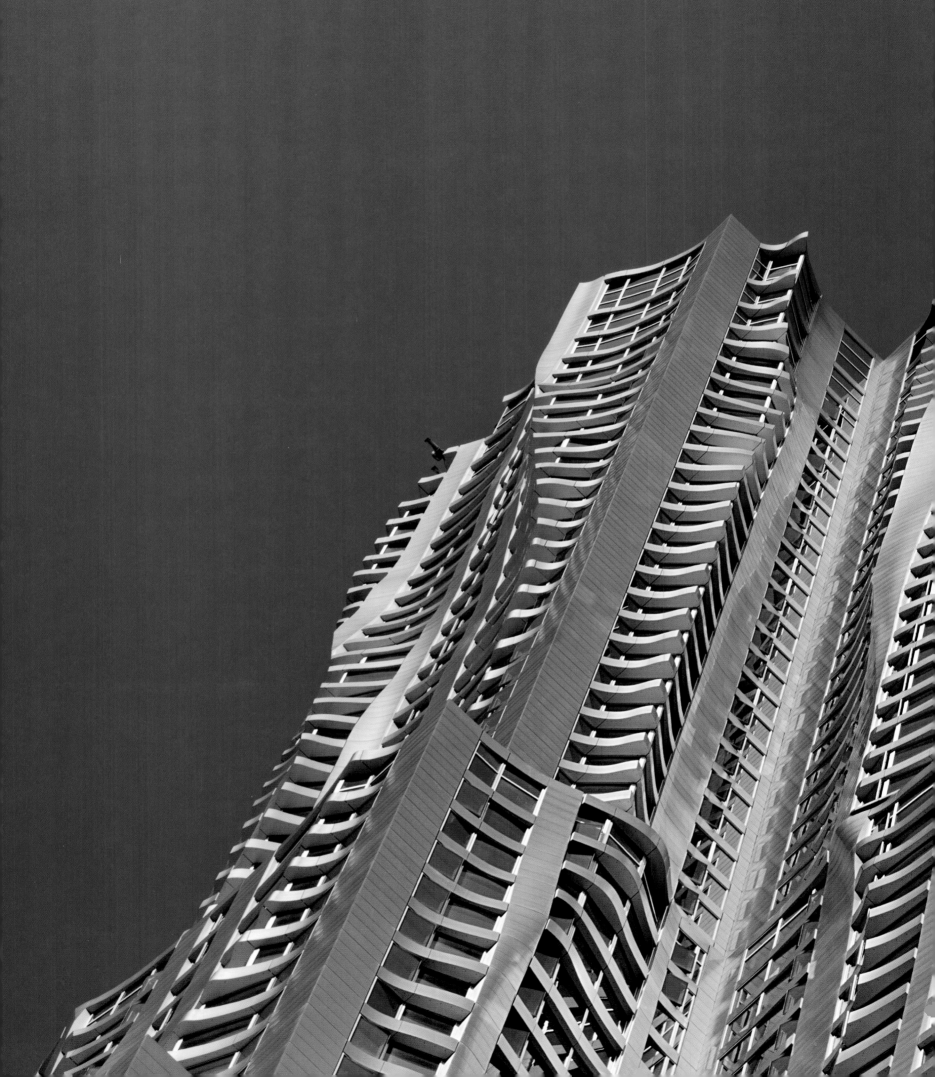

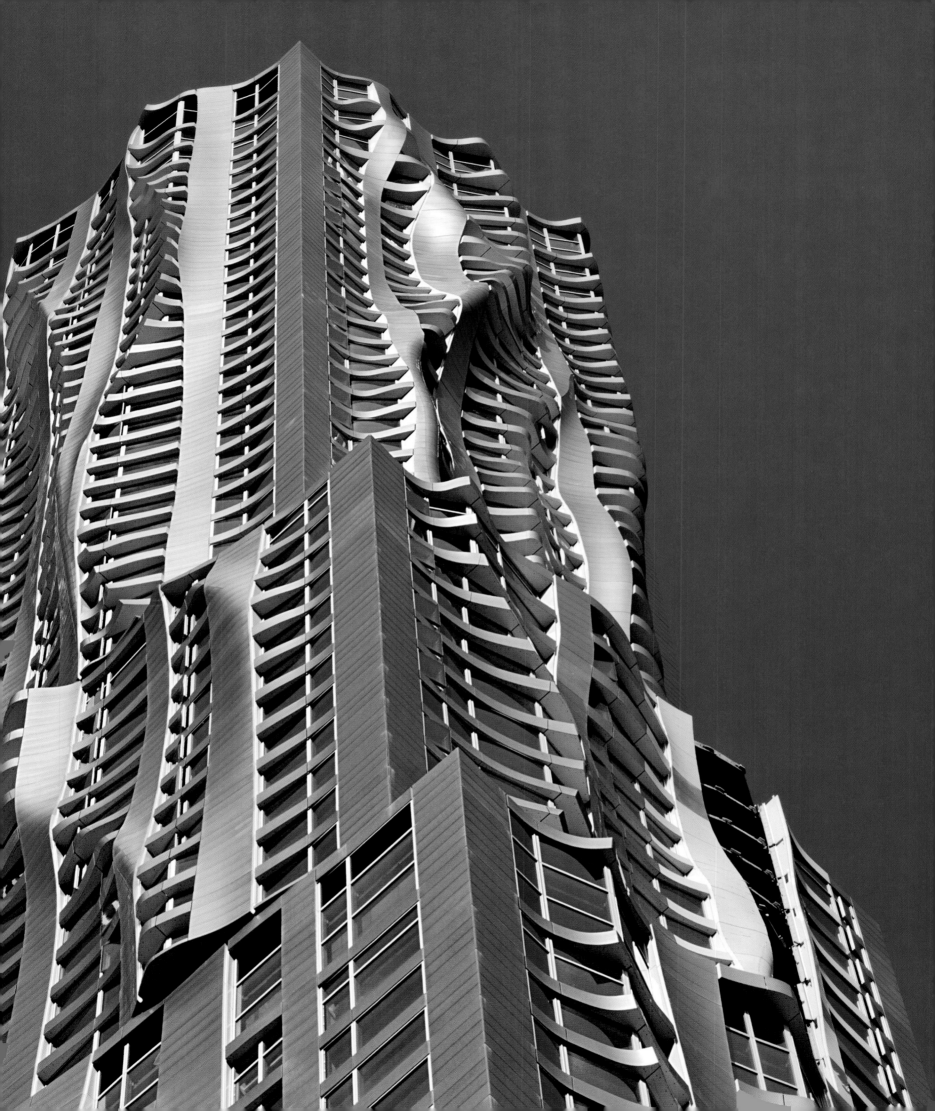

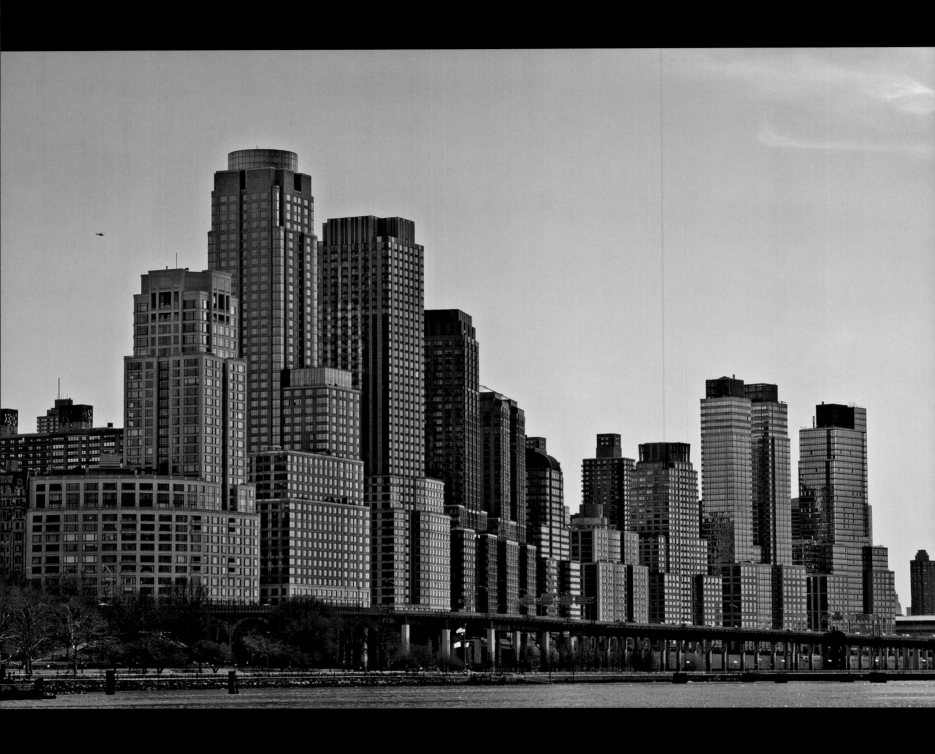

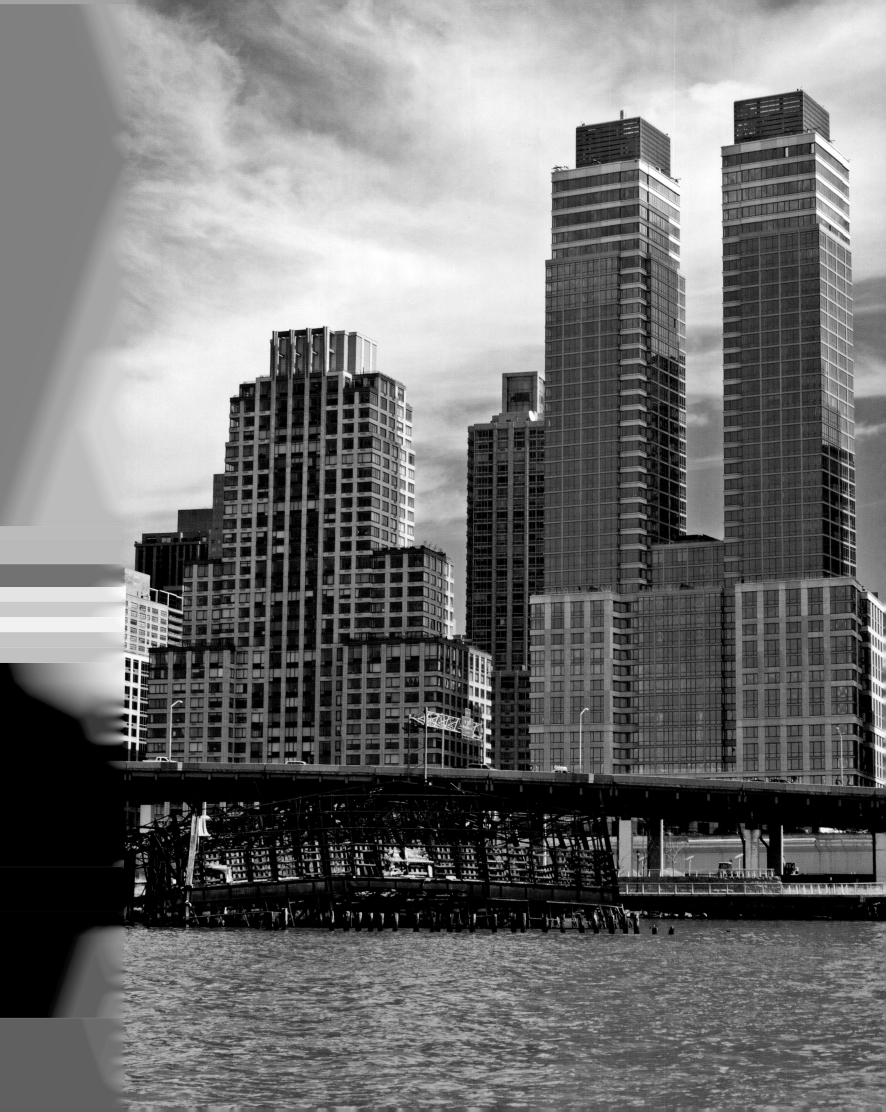

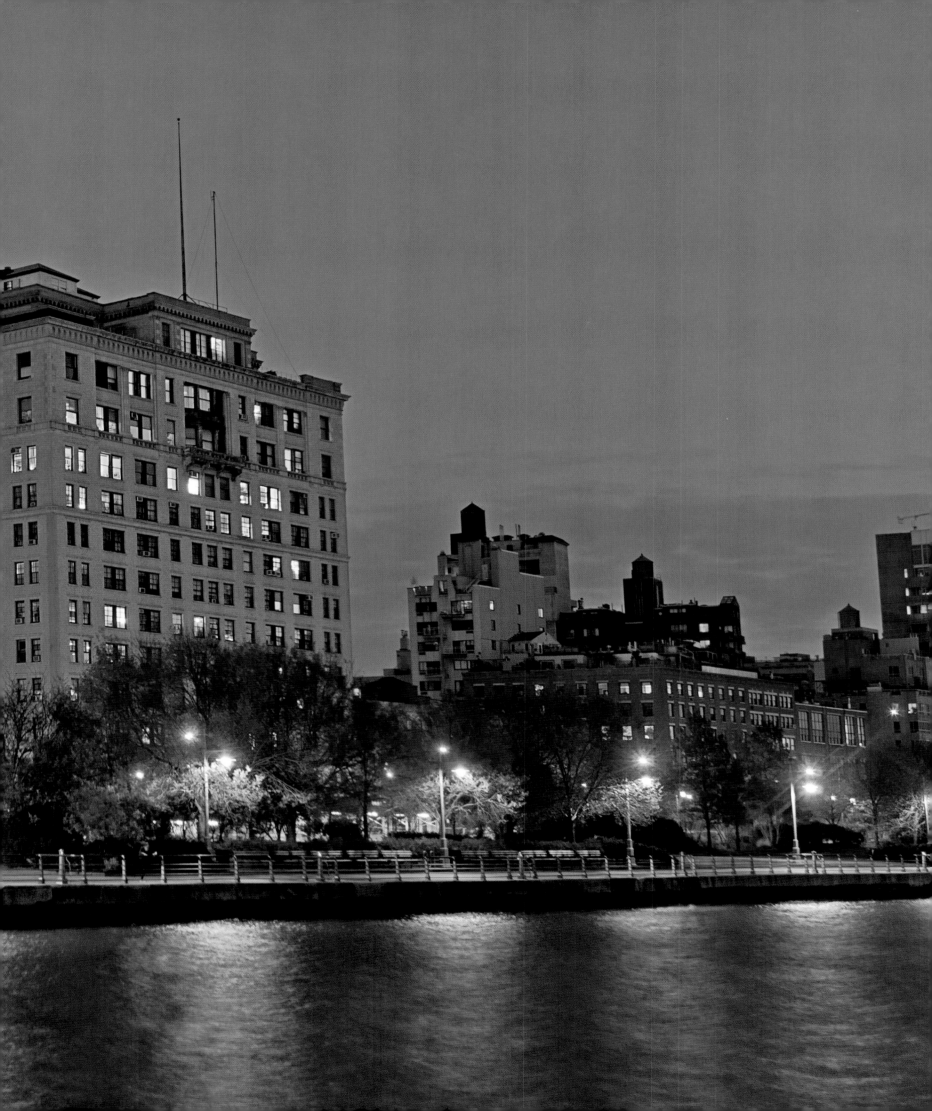

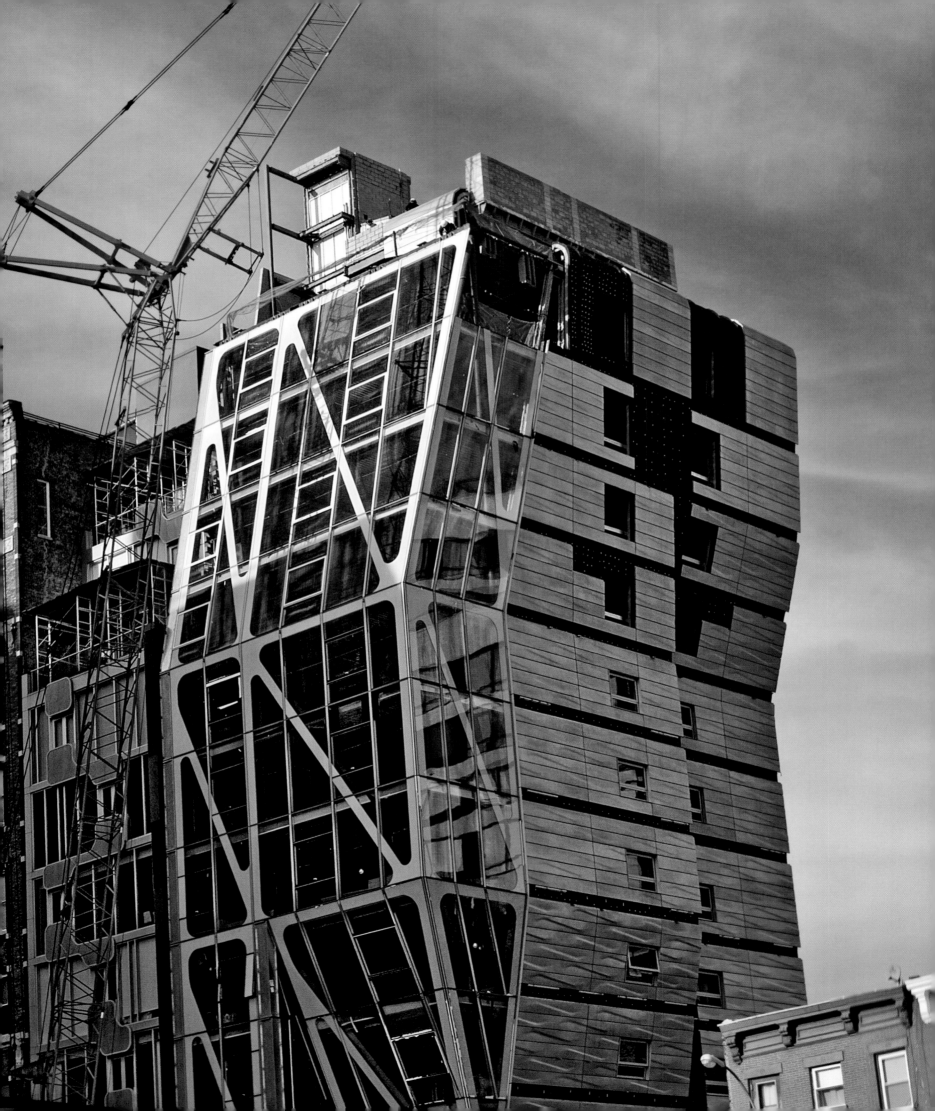

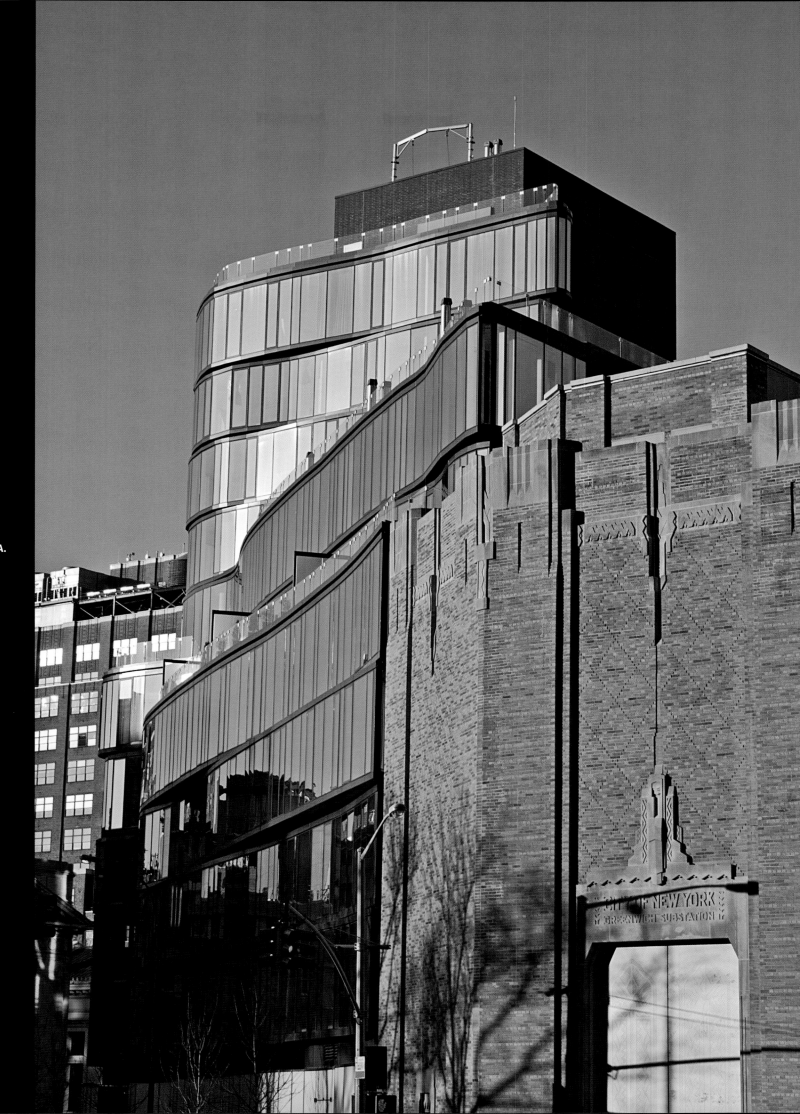

63

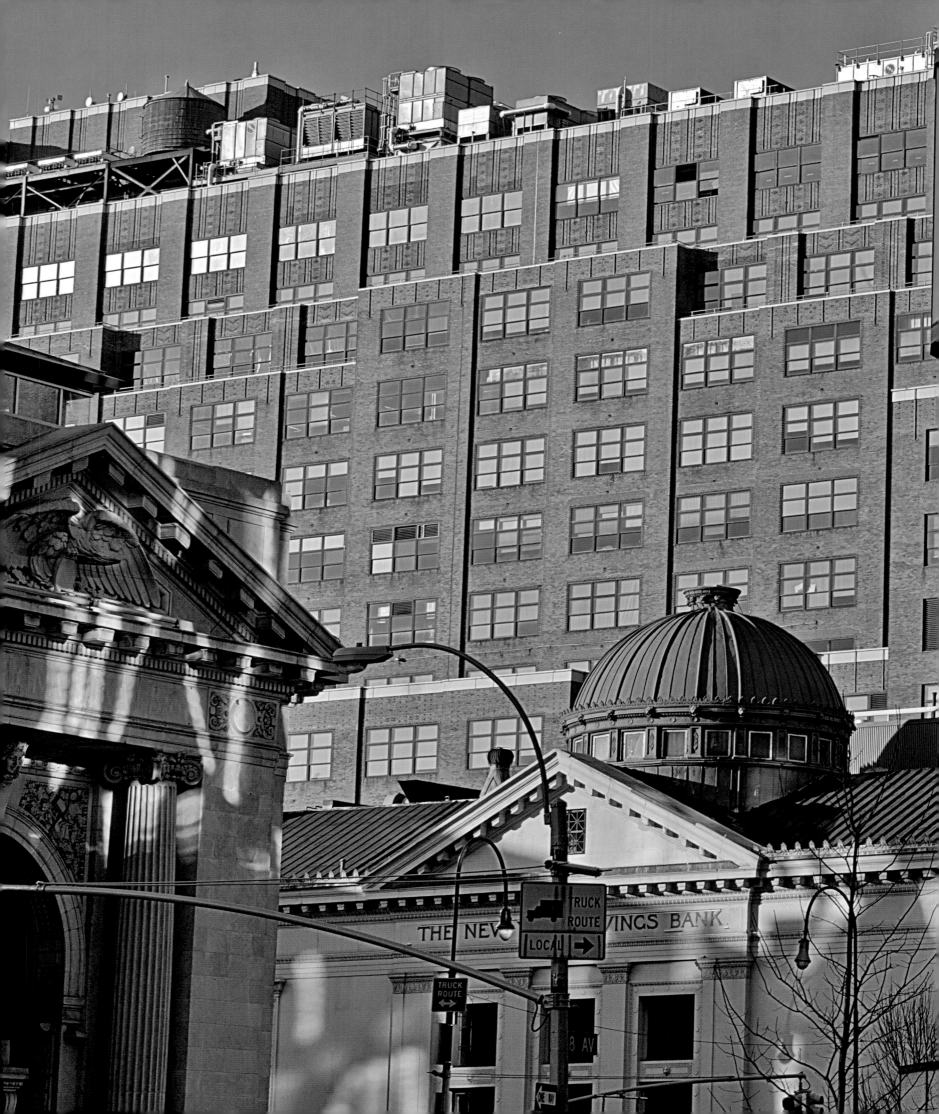

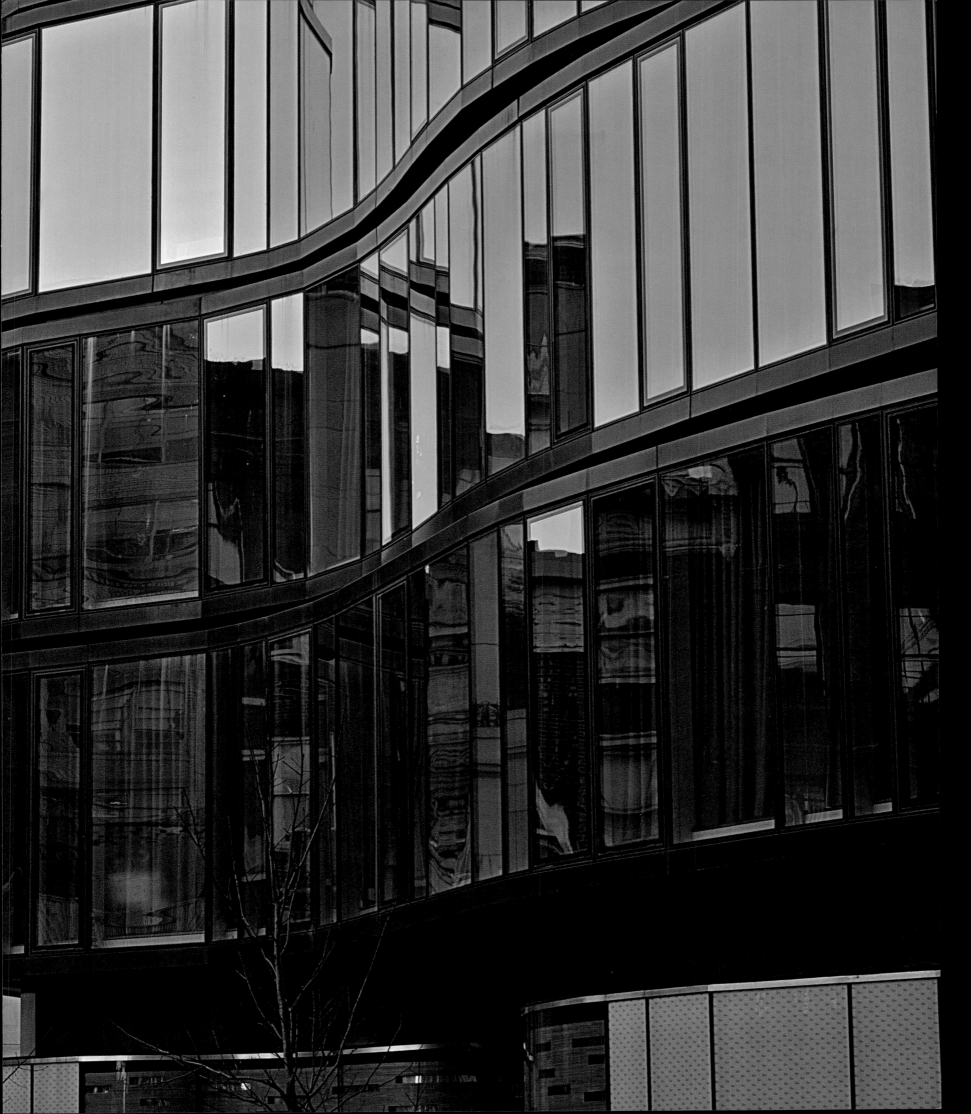

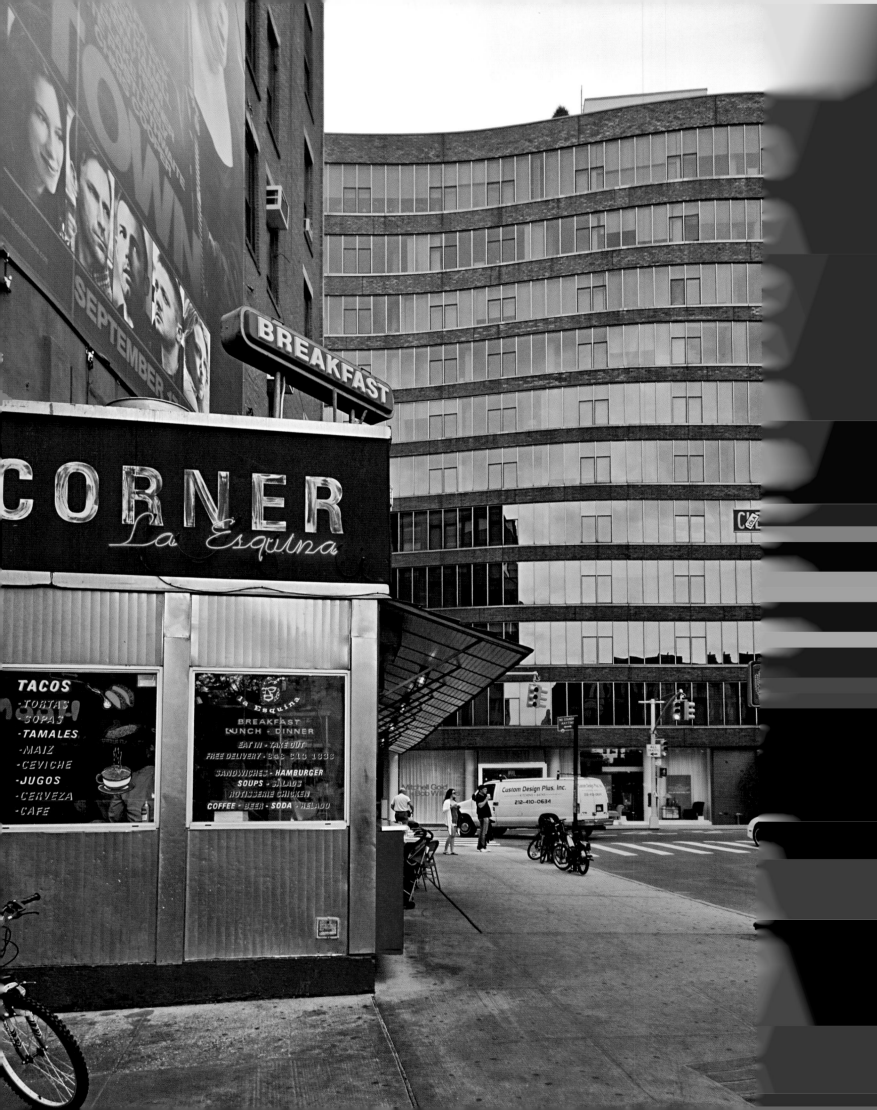

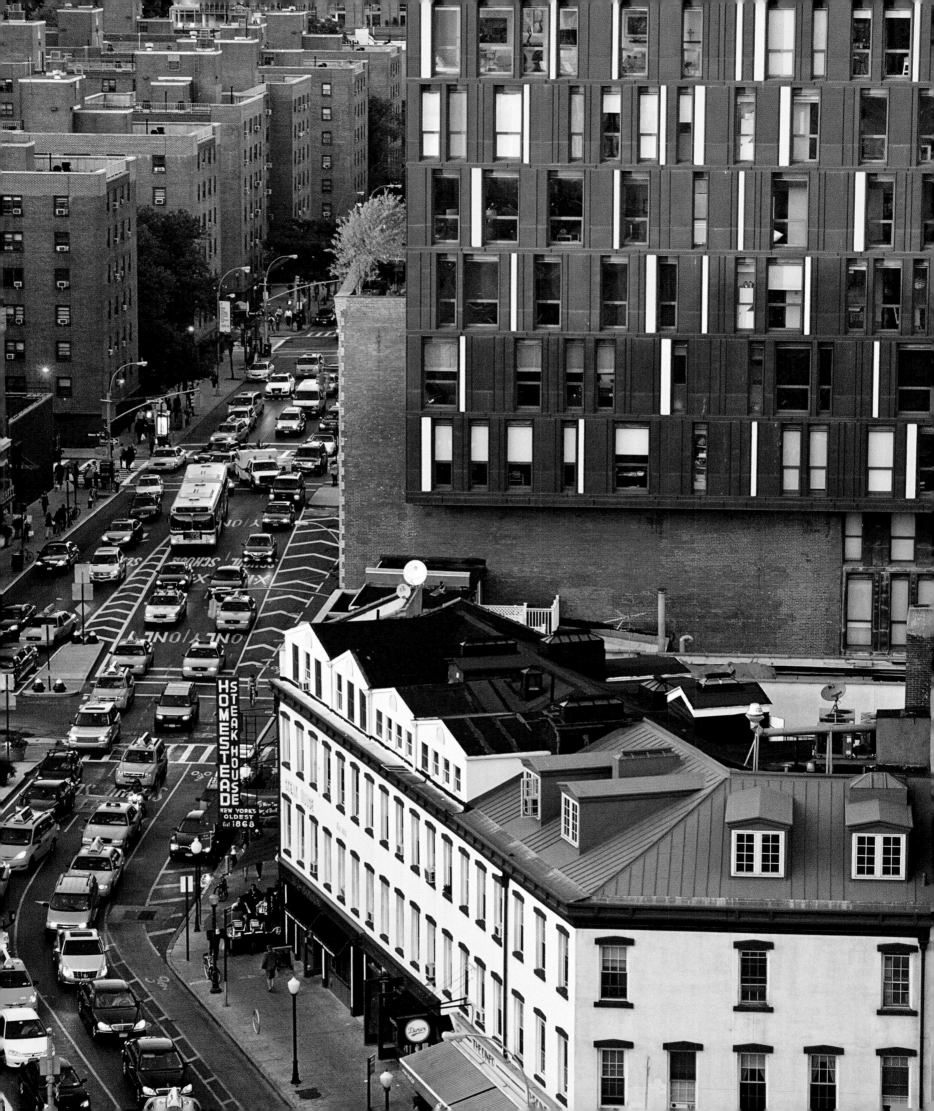

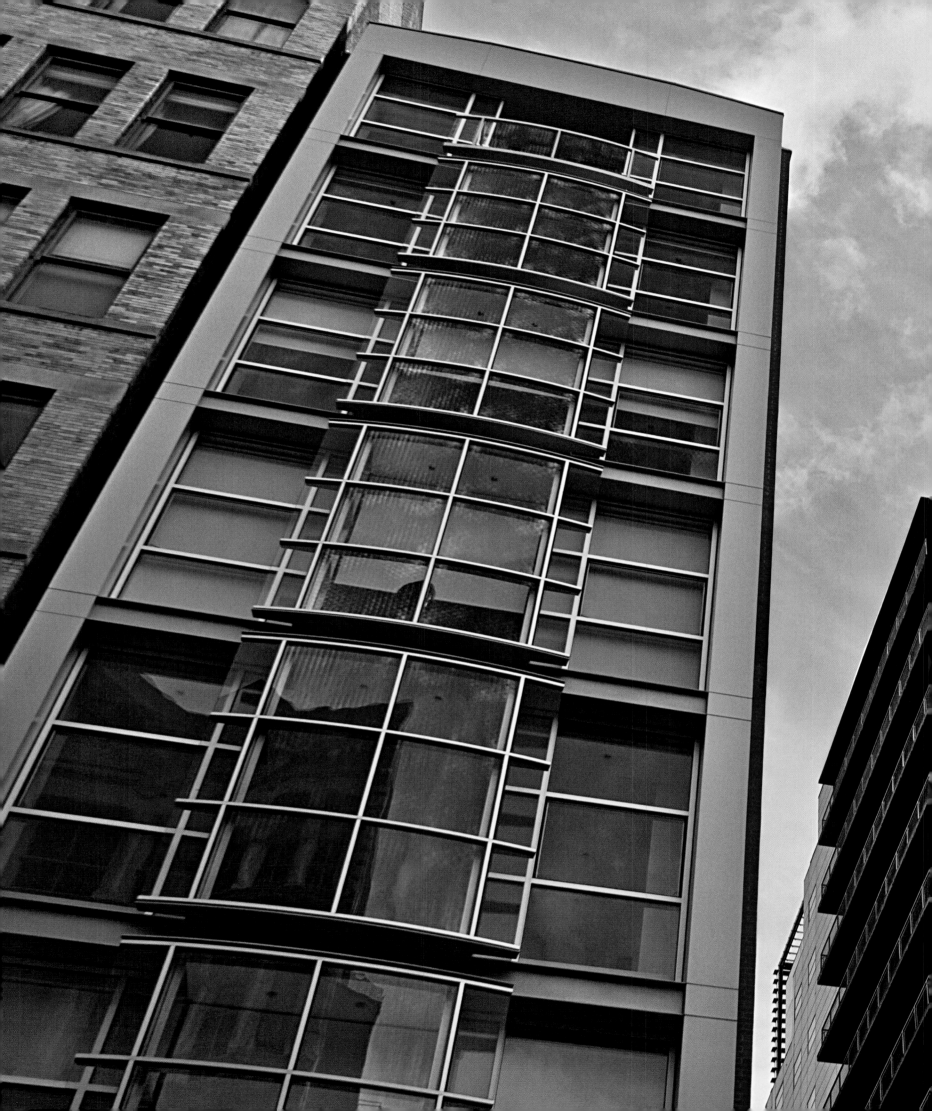

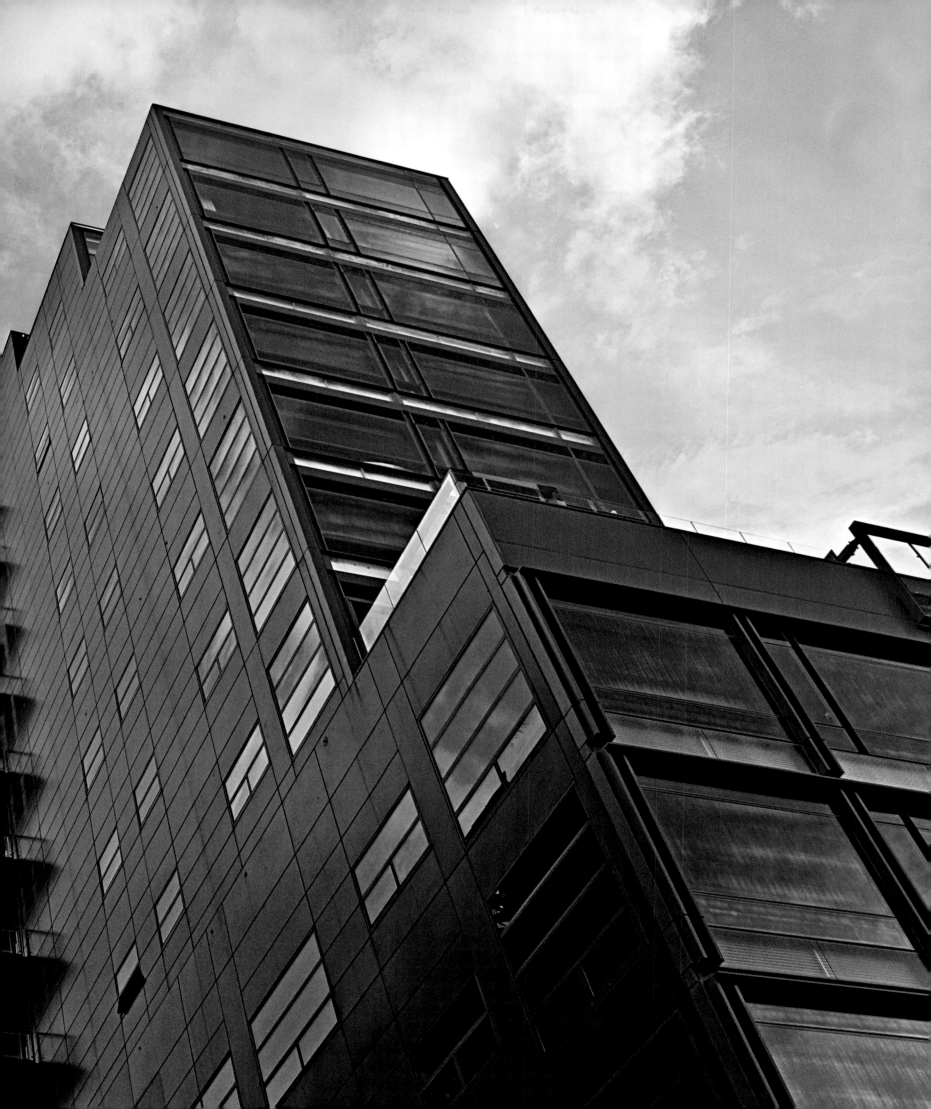

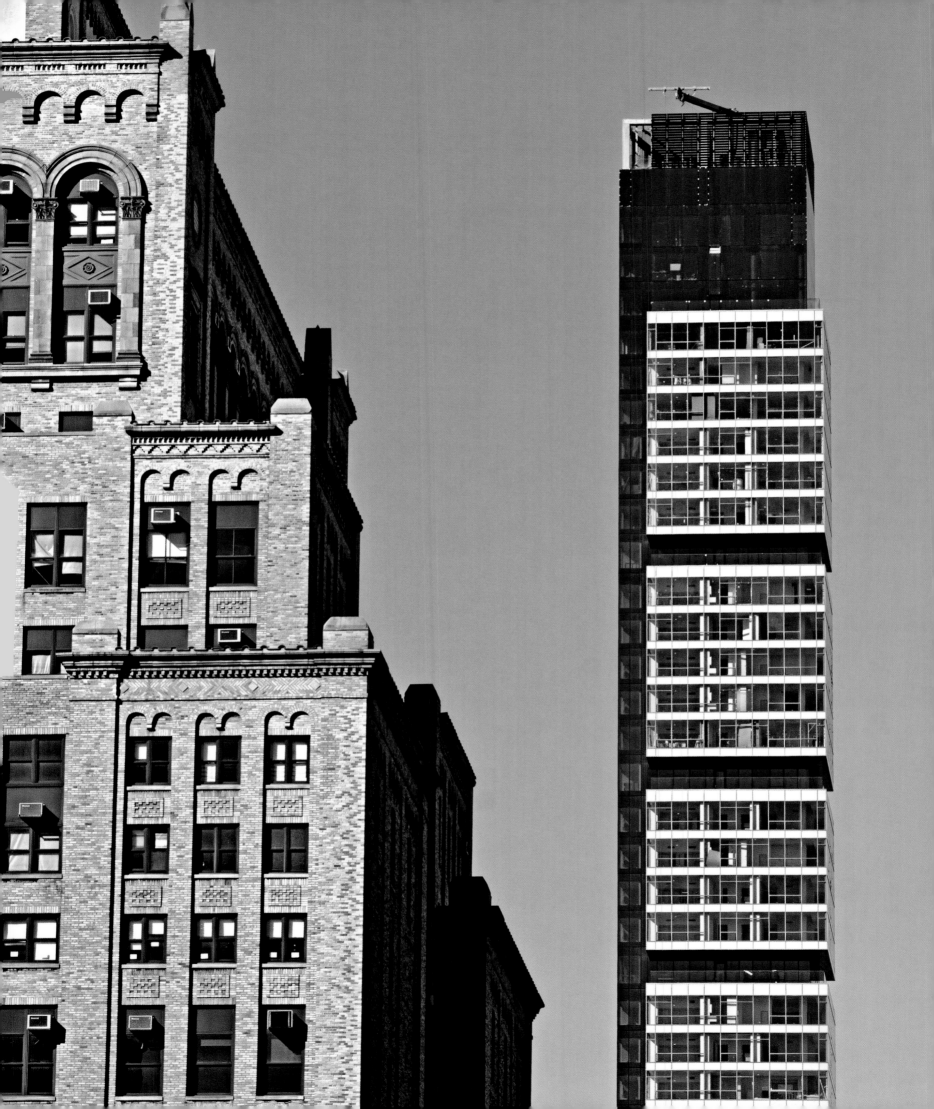

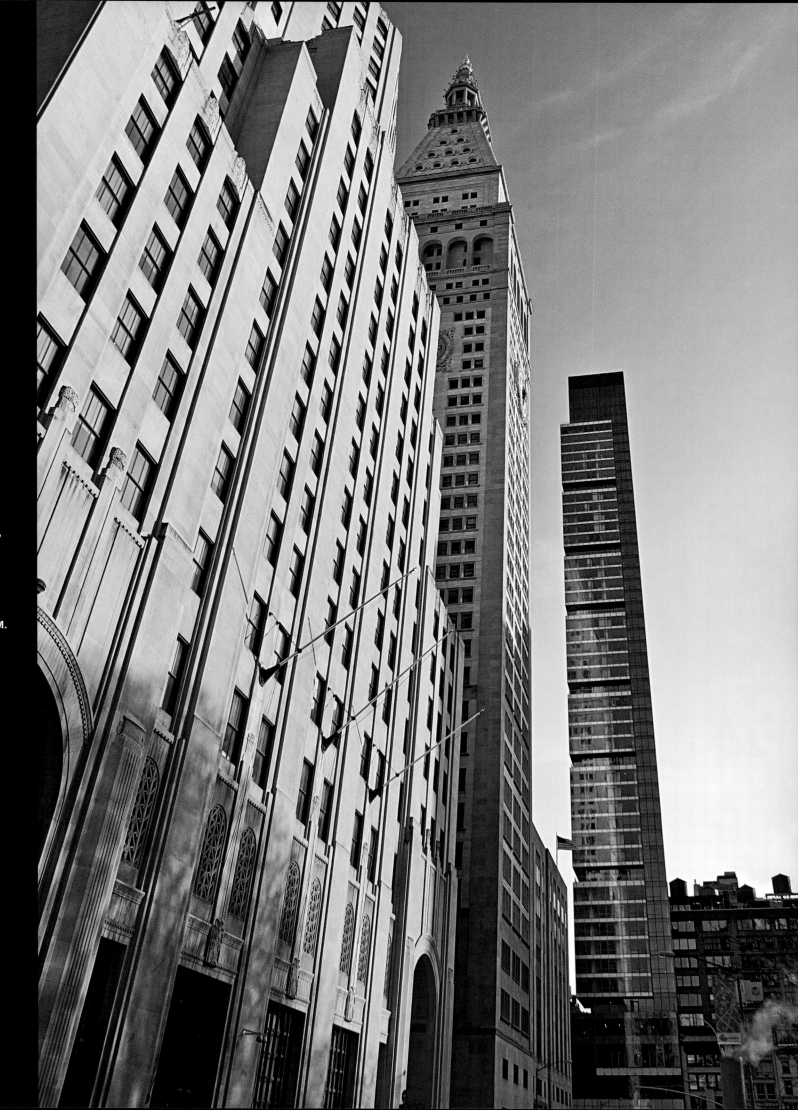

One Madison Park,
Cetra Ruddy.

OVERLEAF
Superior Ink Town
Houses, Bethune
Street, Robert A. M.
Stern Architects.

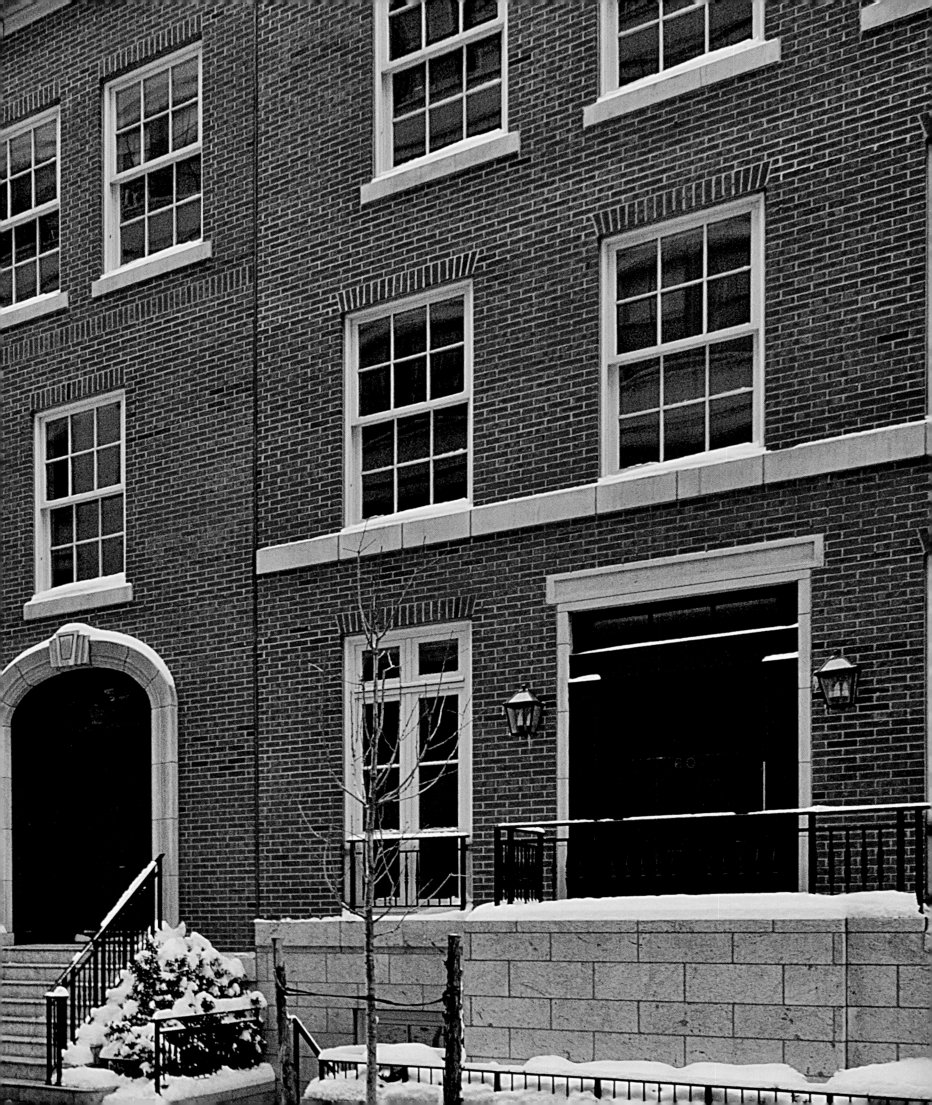

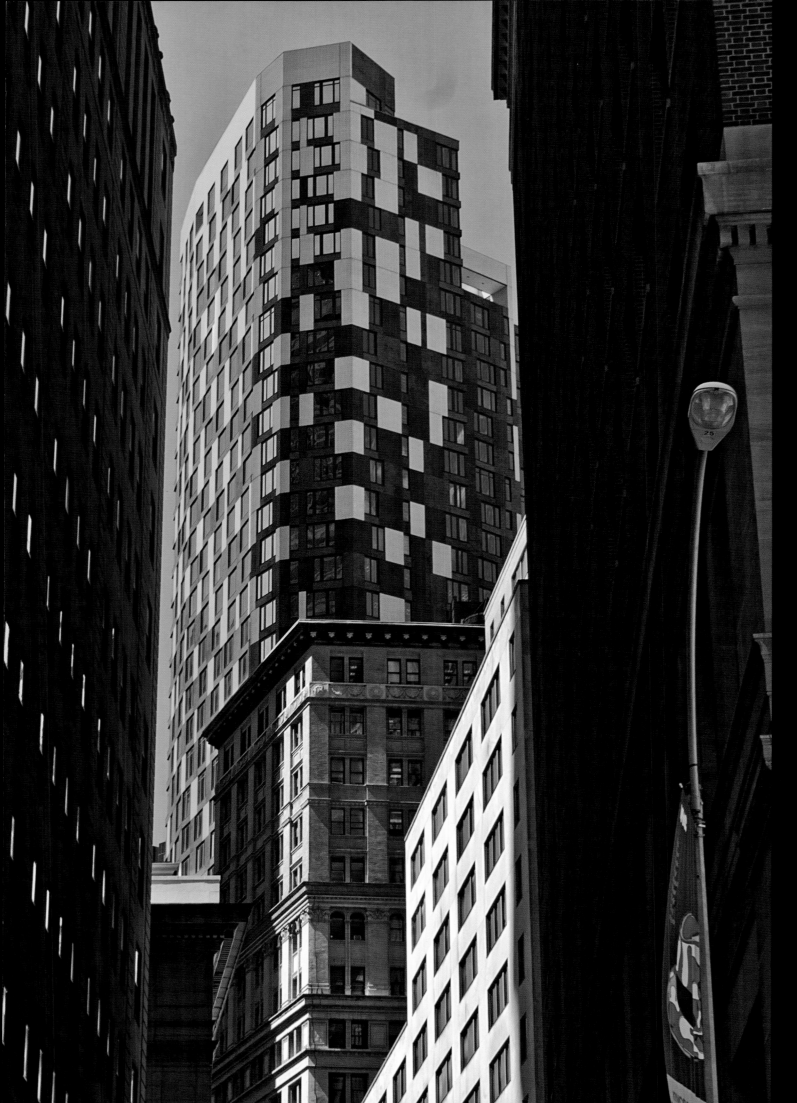

15 William Street,
Tsao & McKown
Architects.

OVERLEAF
Lorimer Street,
Williamsburg,
Brooklyn.

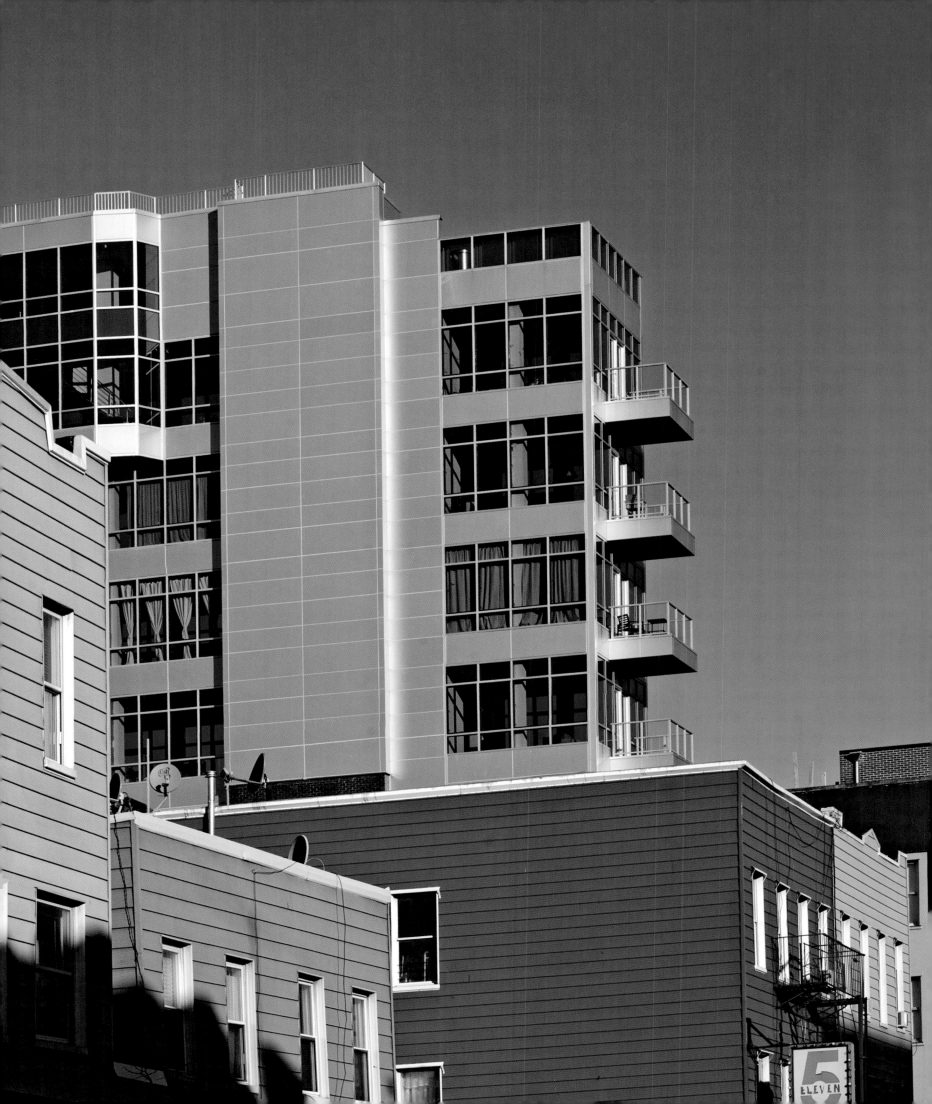

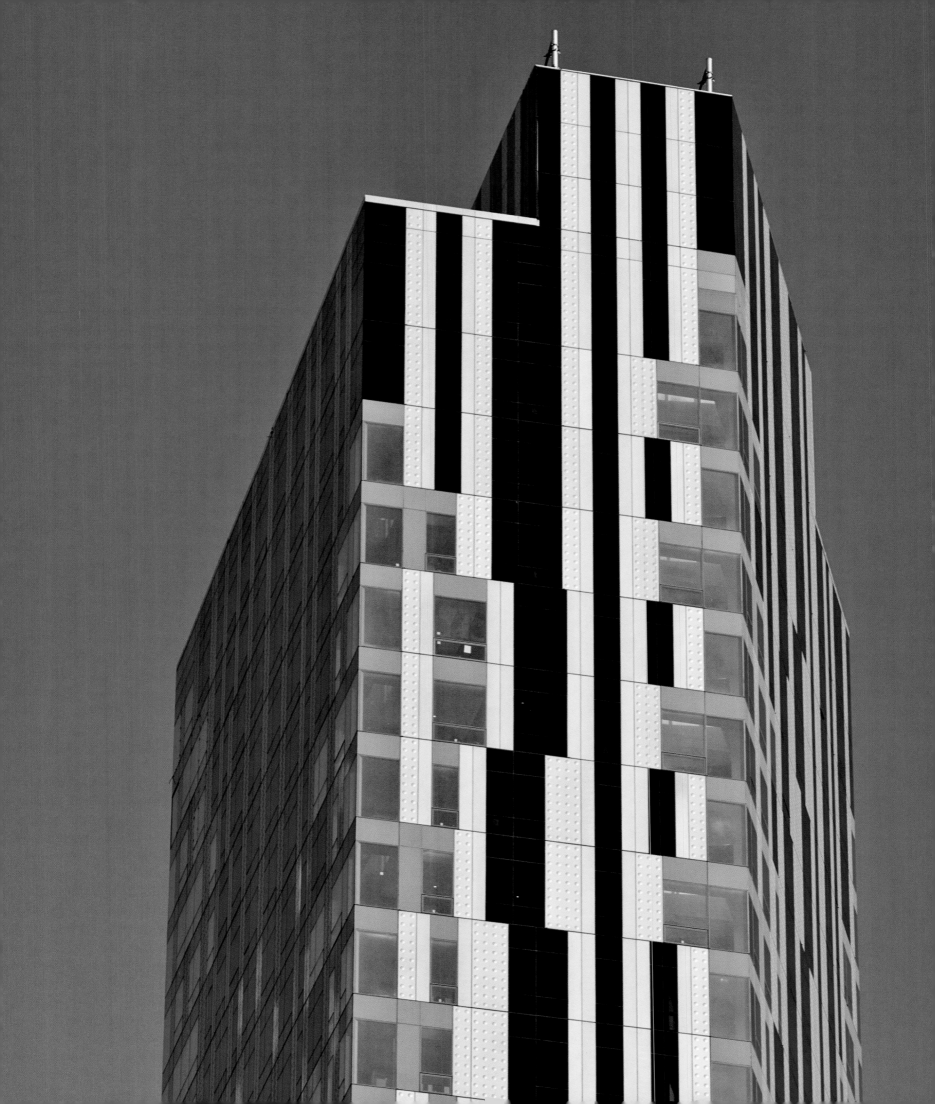

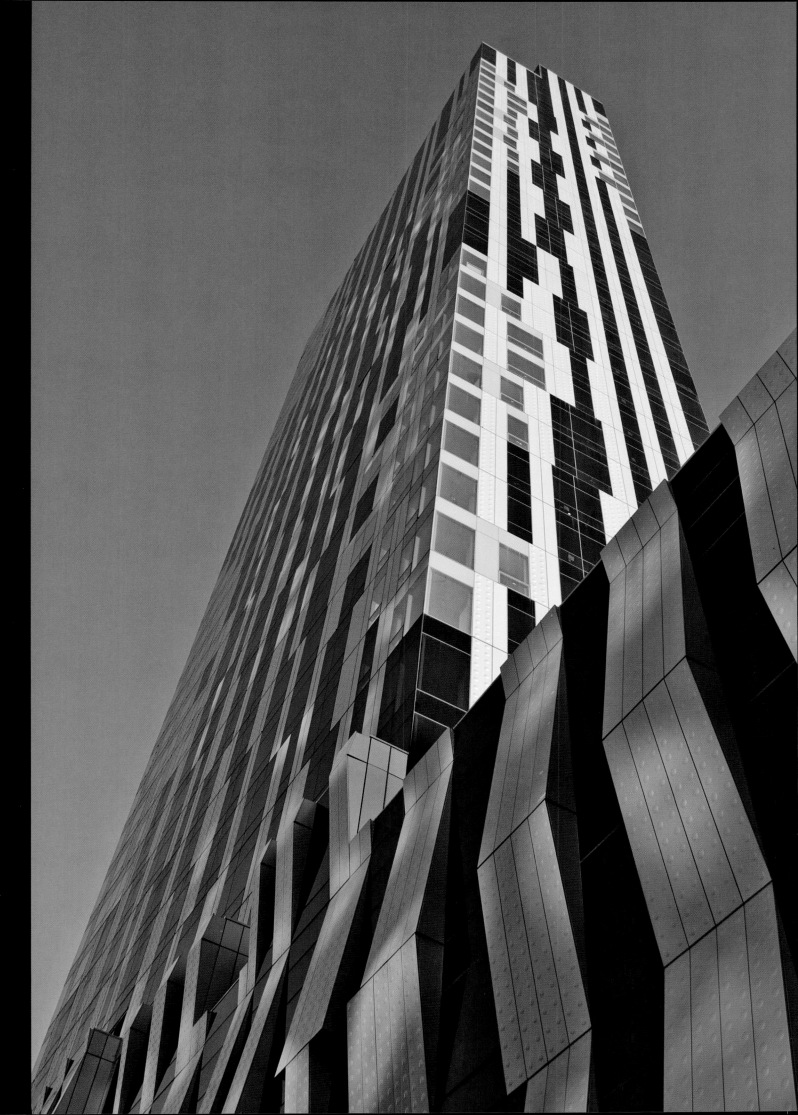

Toren, 150 Myrtle
Avenue, Brooklyn,
Skidmore Owings &
Merrill.

OVERLEAF
Condominium
facade, Hunters
Point, Long Island
City, Queens.

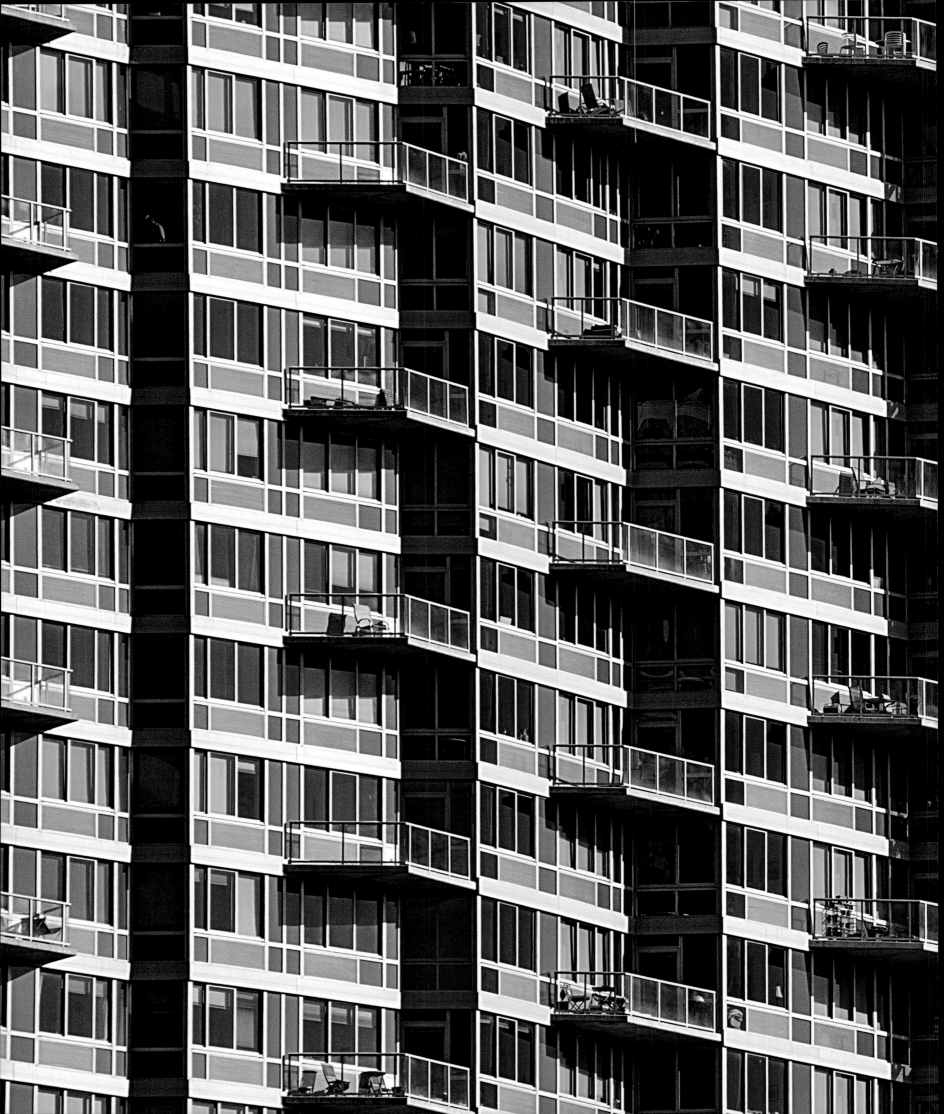

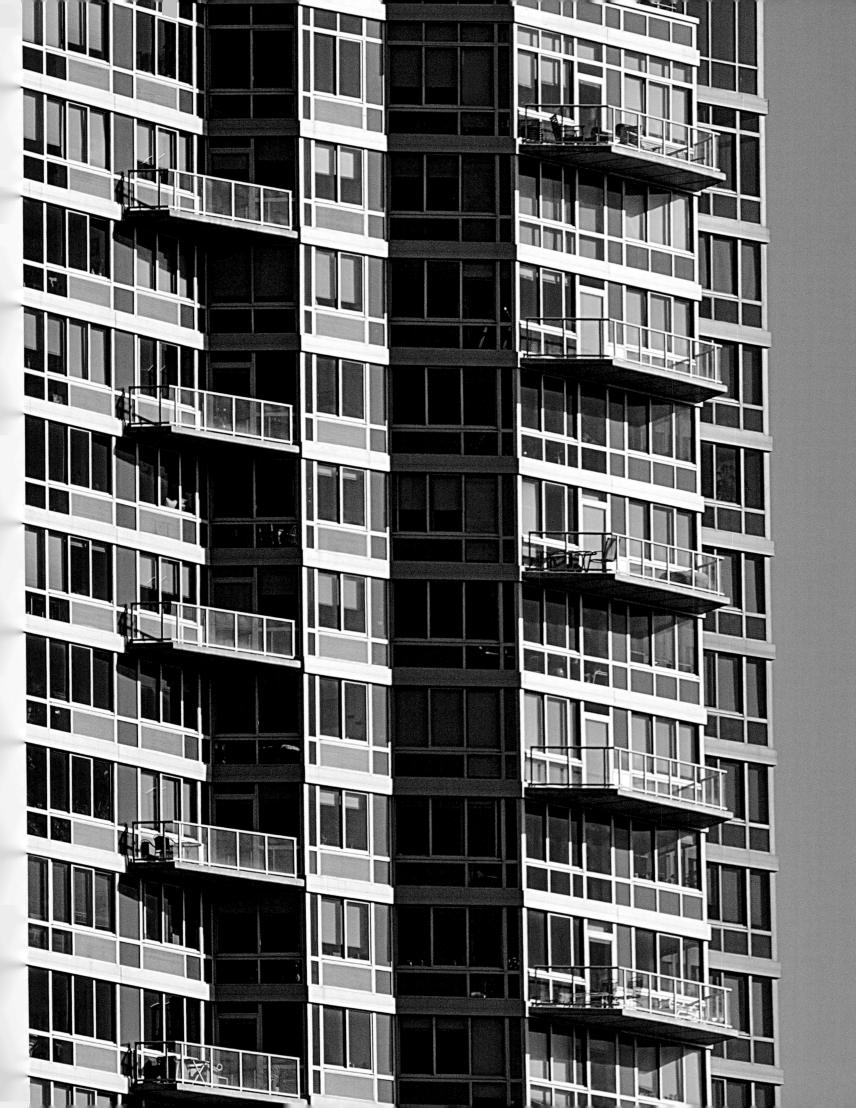

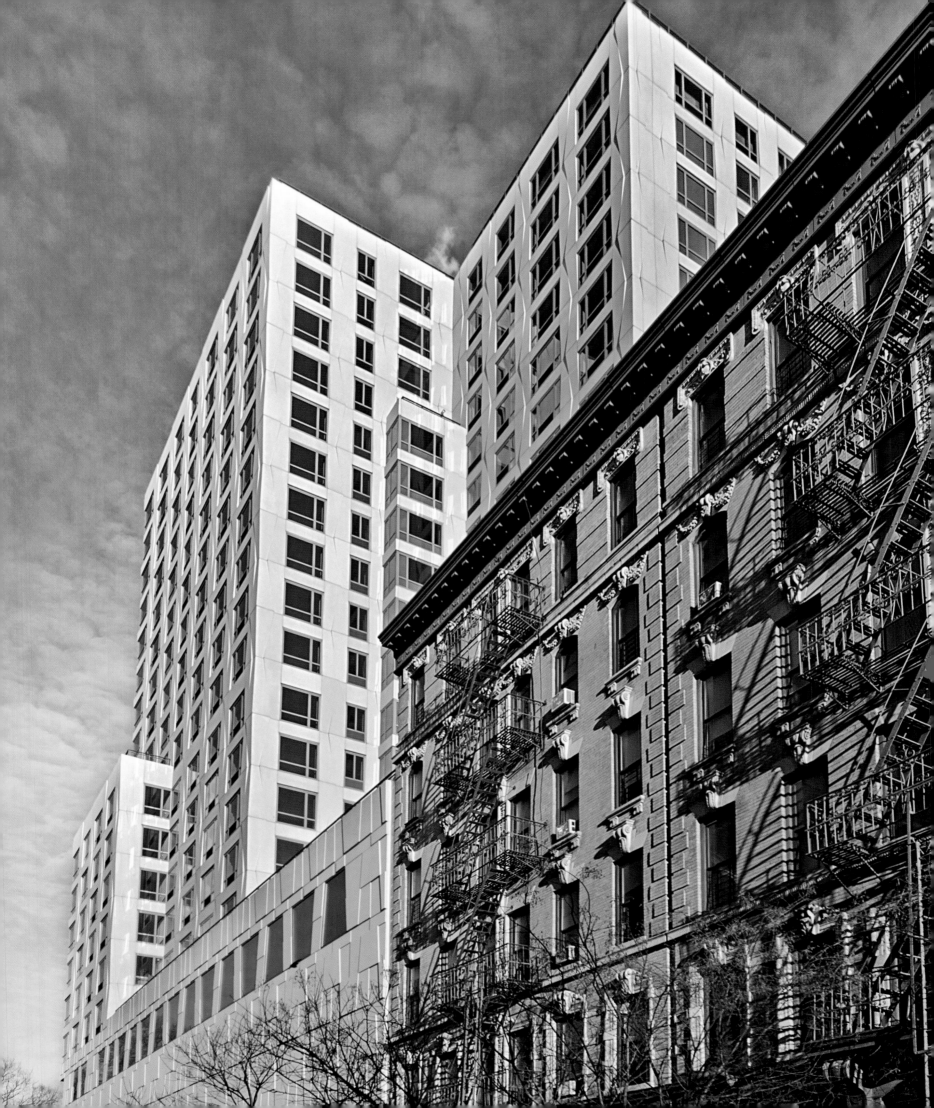

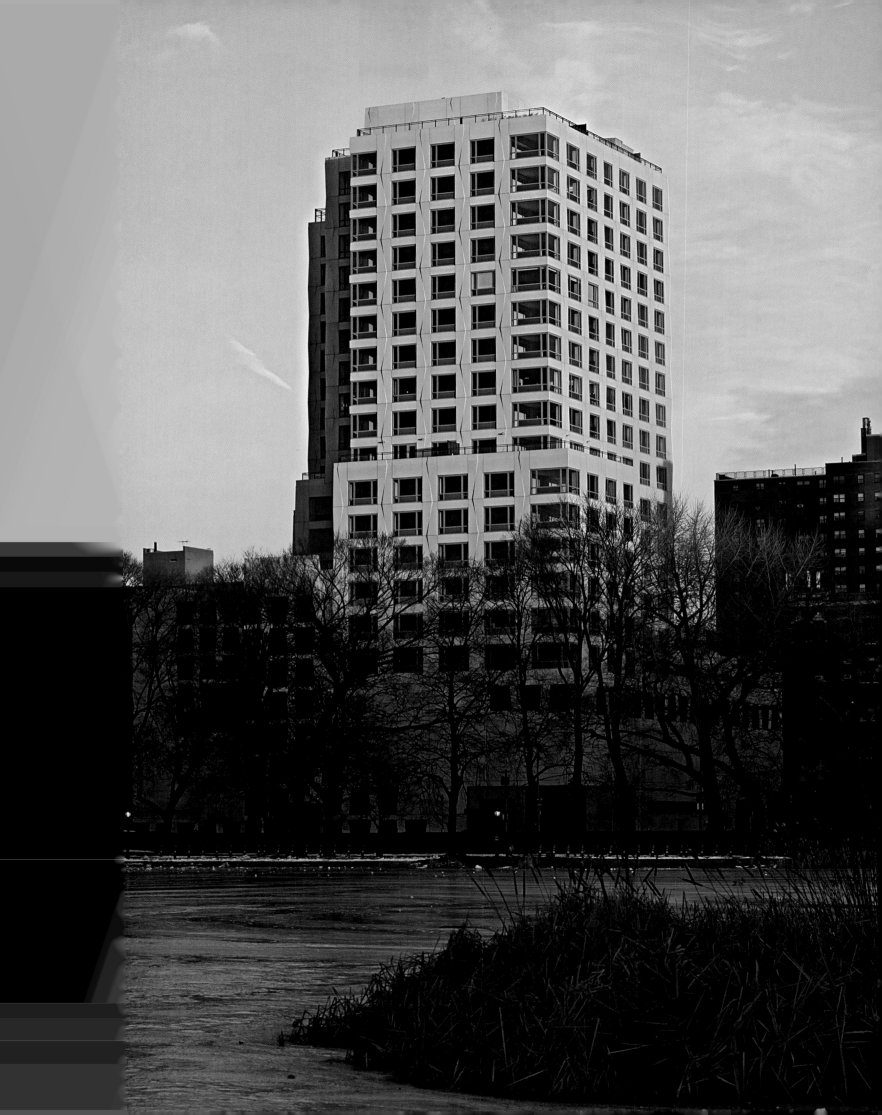

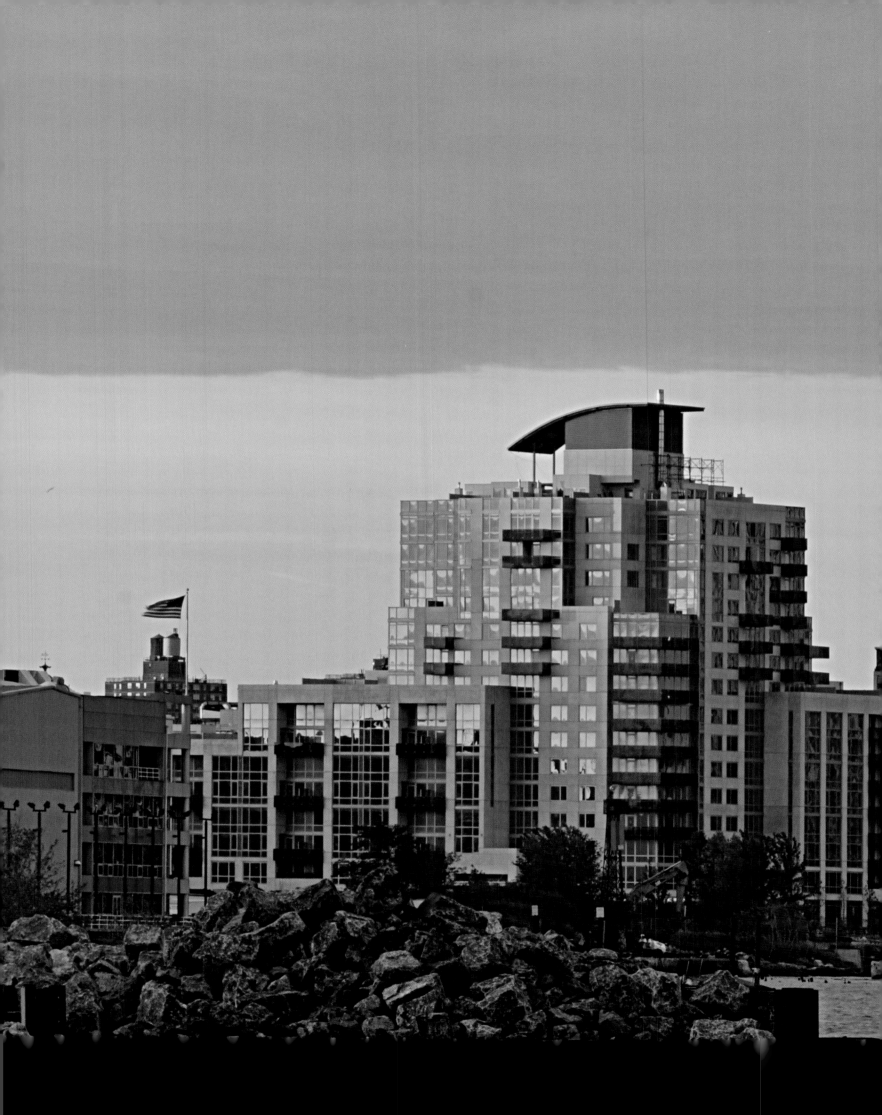

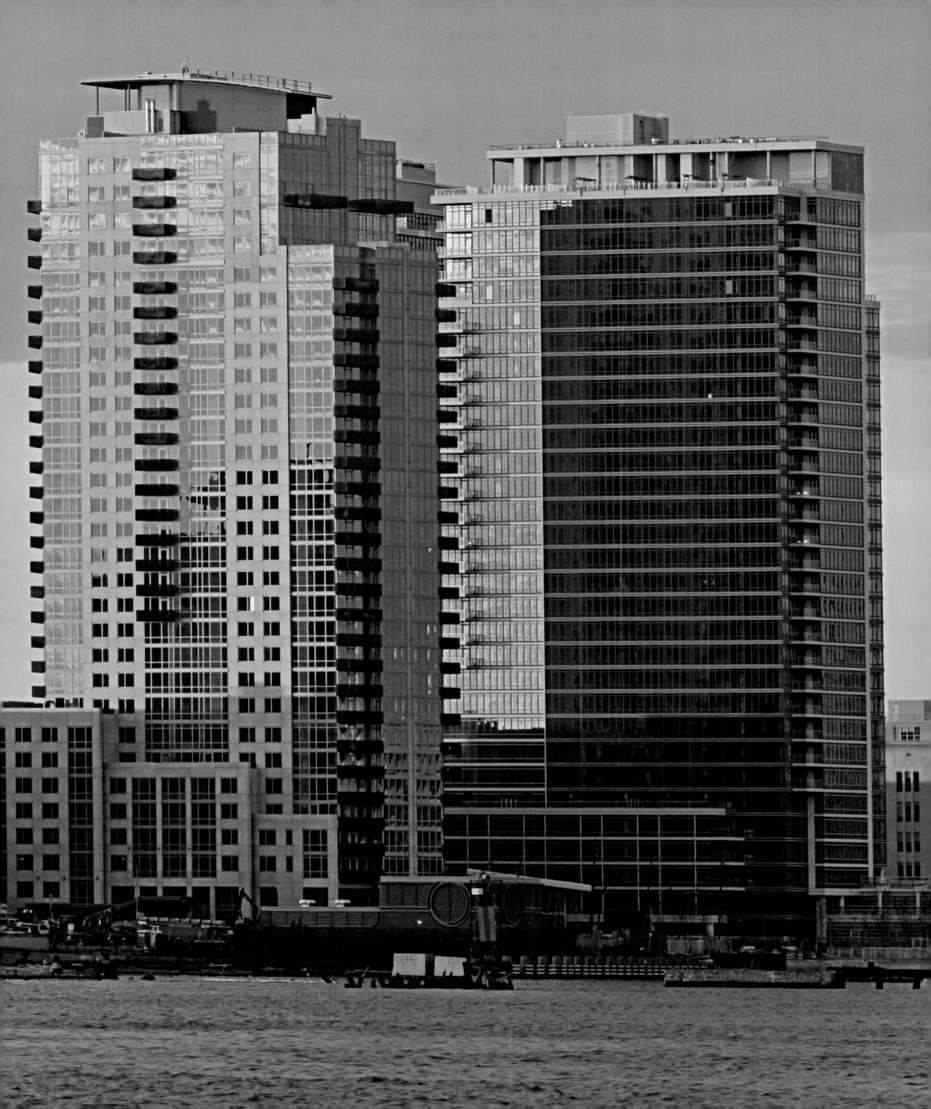

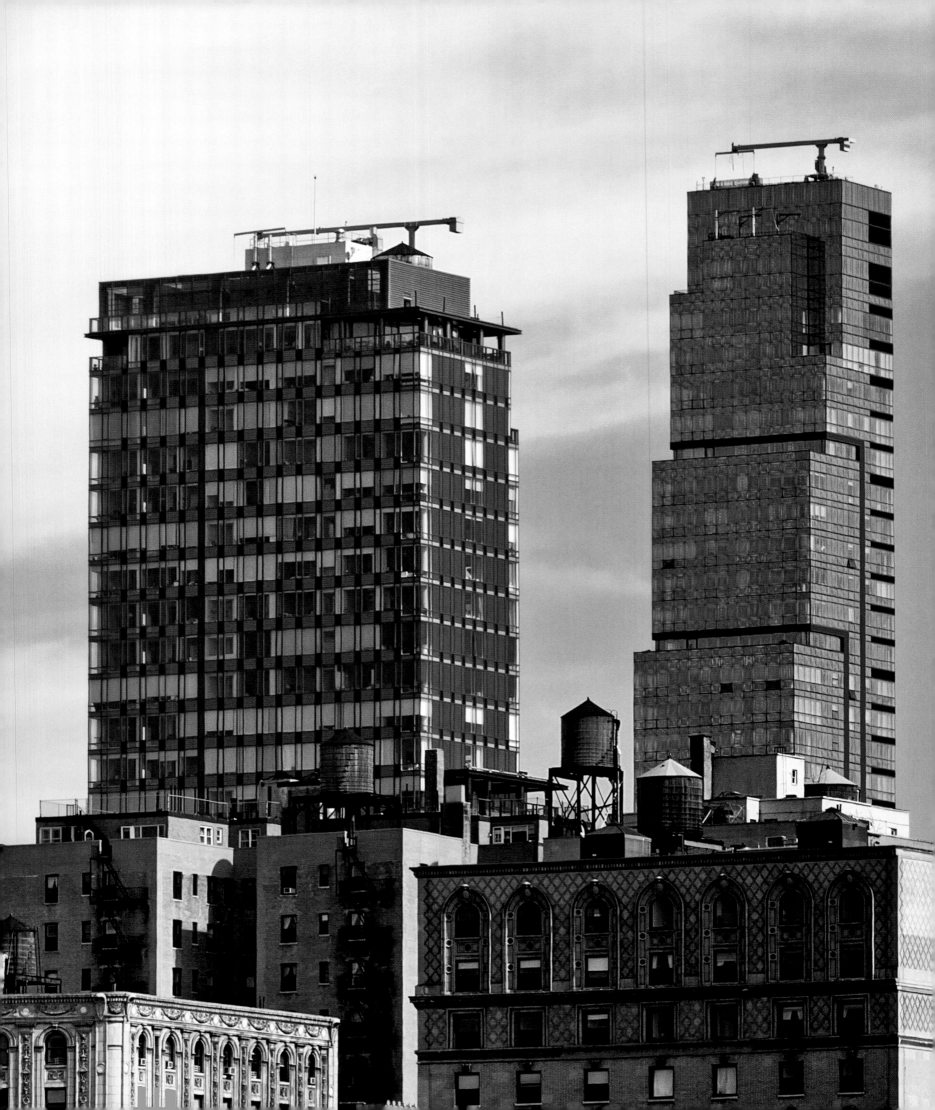

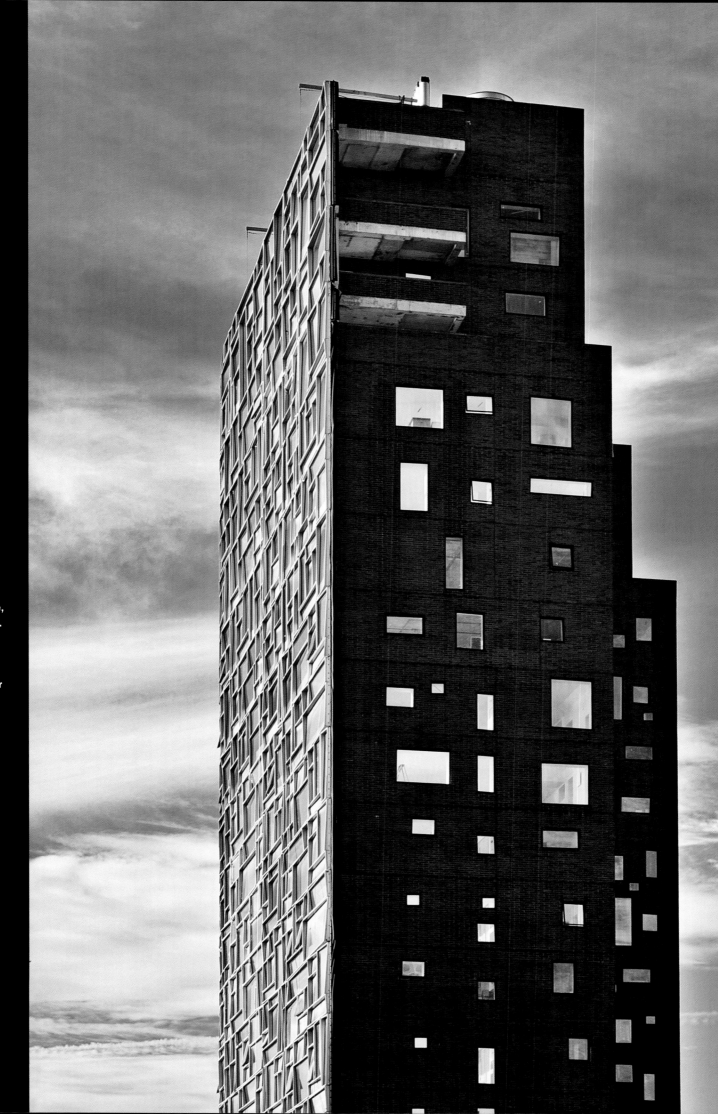

LEFT:
Upper West Side apartment towers.

RIGHT
100 Eleventh Avenue, Ateliers Jean Nouvel.

OVERLEAF
One Grand Army Plaza, Richard Meier & Partners, juxtaposed with a sculptural group by Frederick MacMonnies on the Soldiers and Sailors Memorial Arch, Brooklyn.

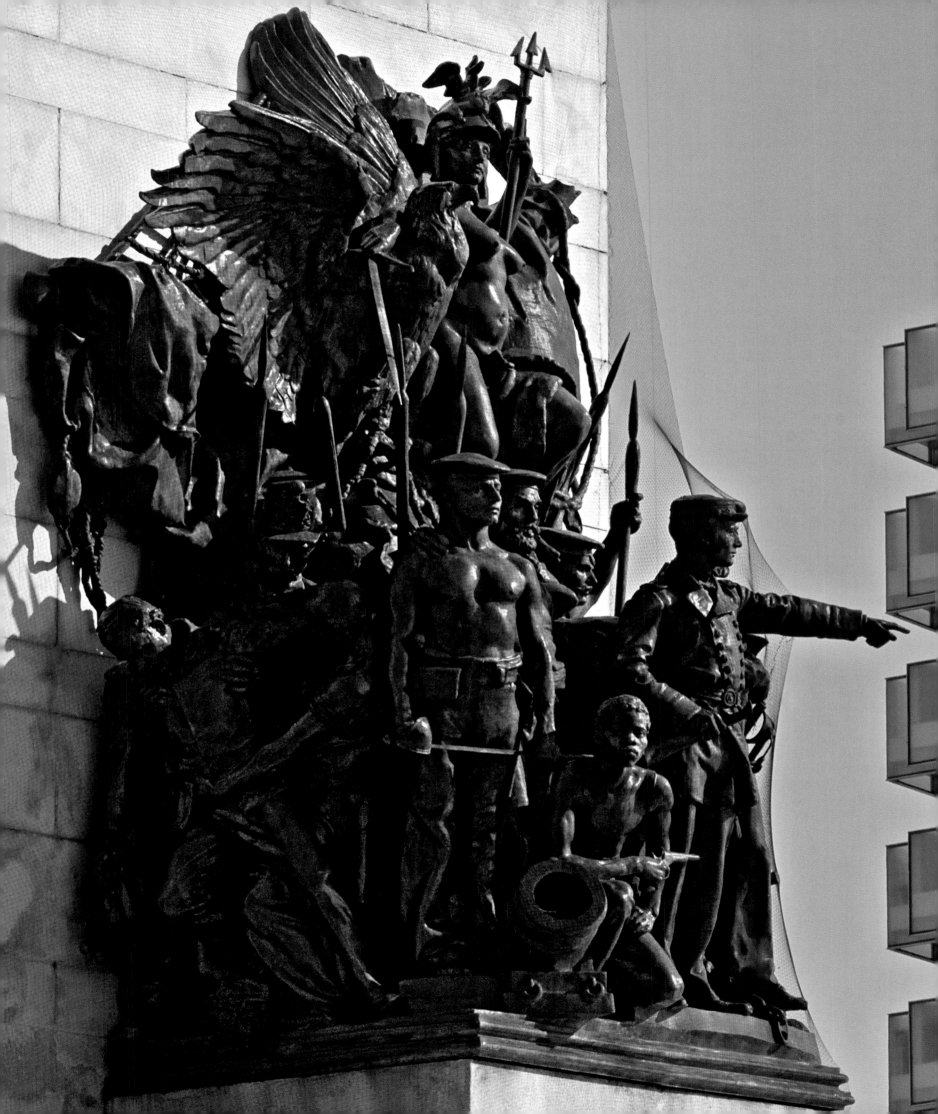

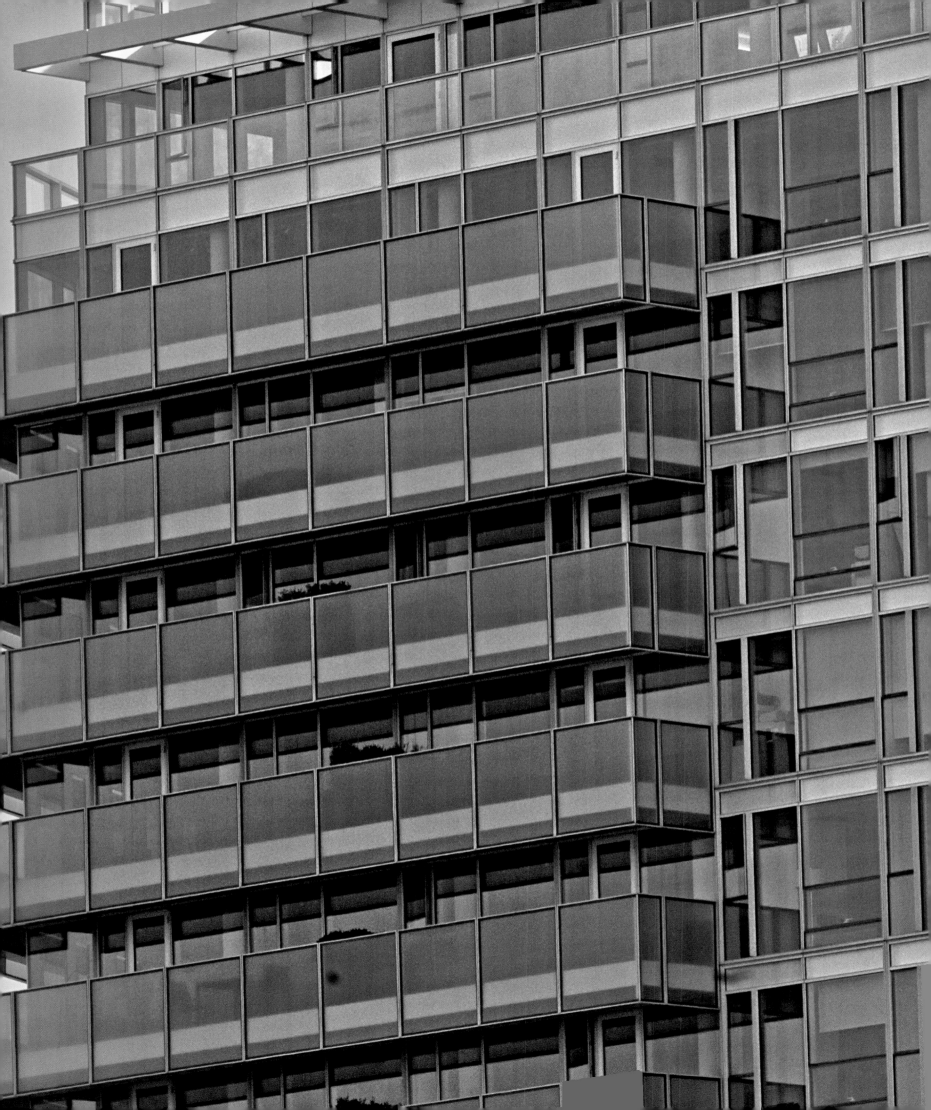

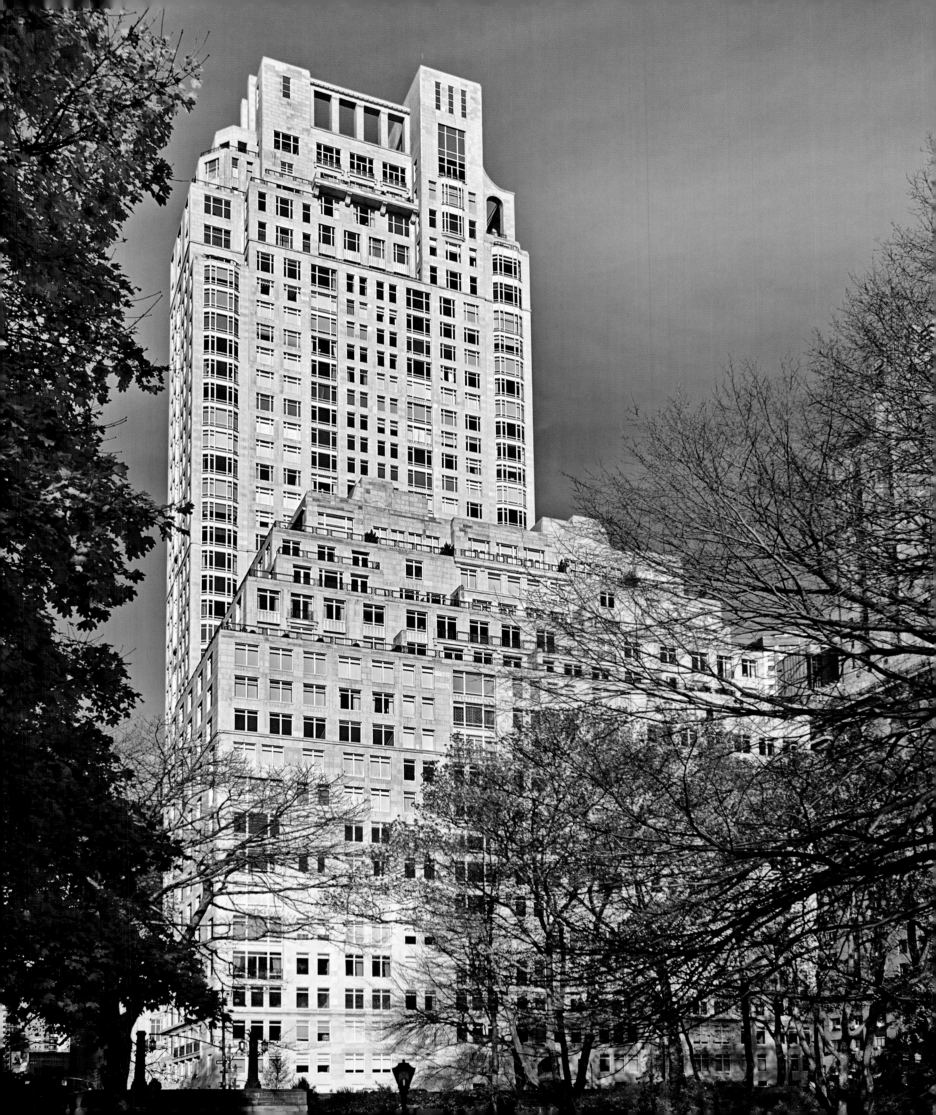

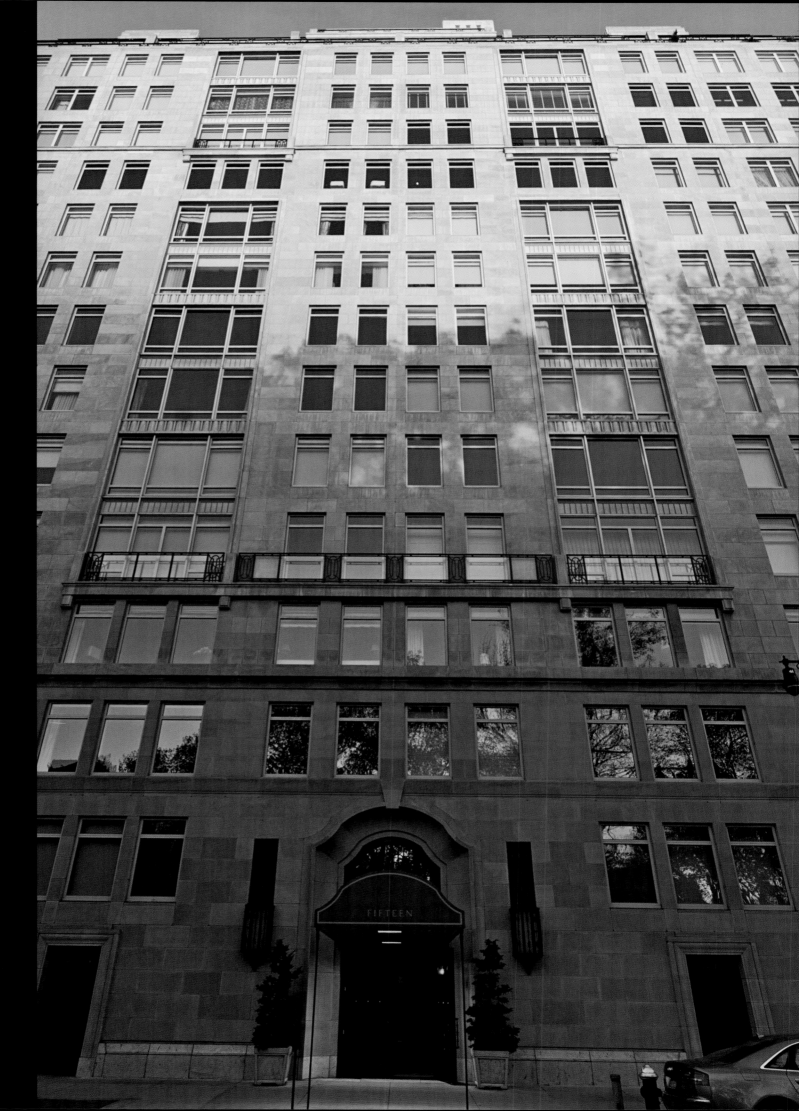

15 Central Park
West, Robert A. M.
Stern Architects.

OVERLEAF
459 West 18th
Street, Della Valle
Bernheimer.

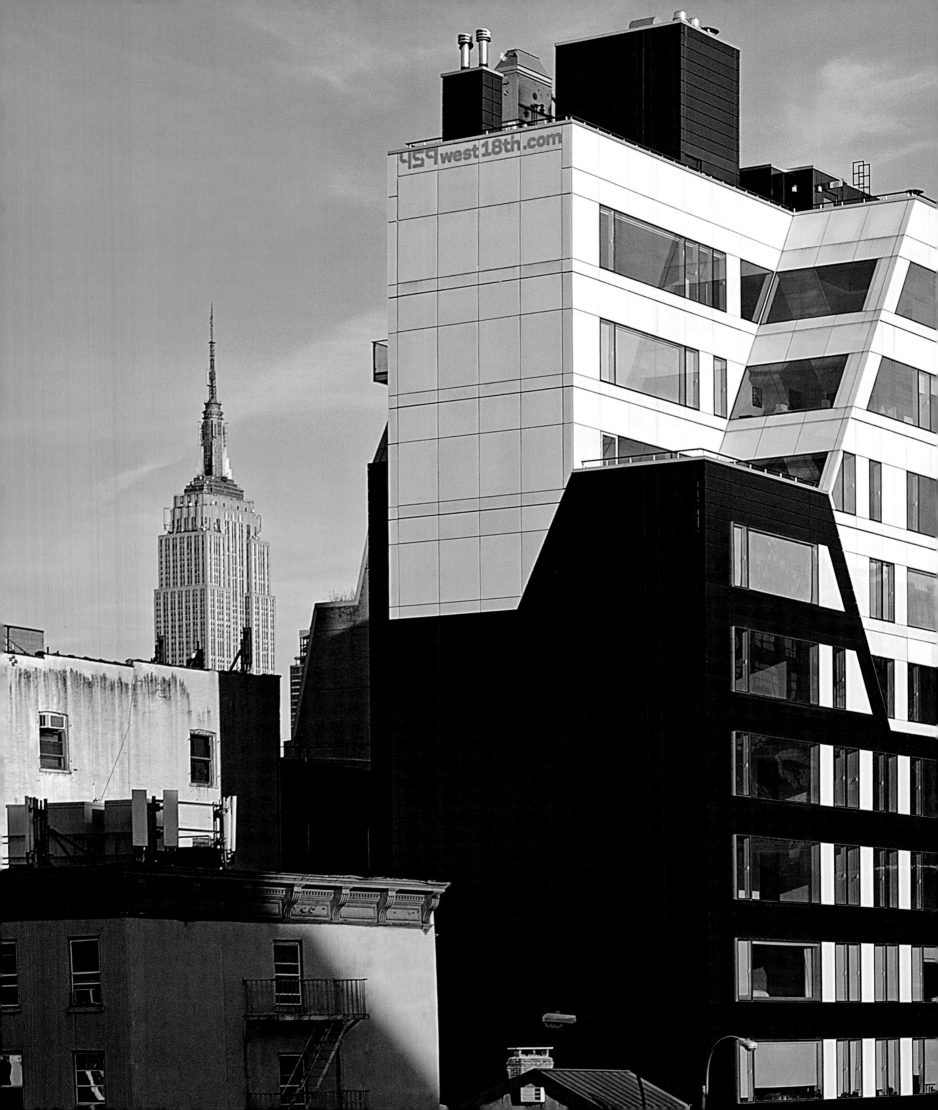

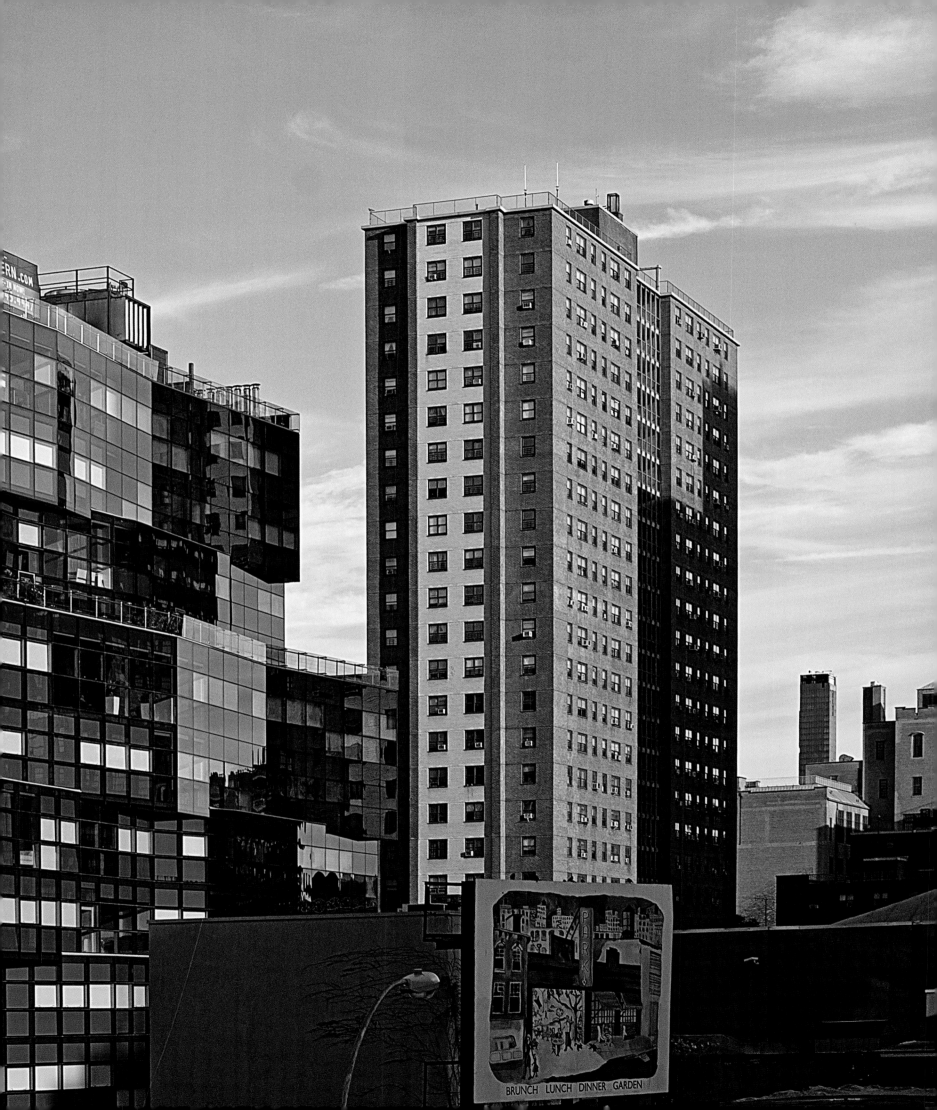

BRUNCH LUNCH DINNER GARDEN

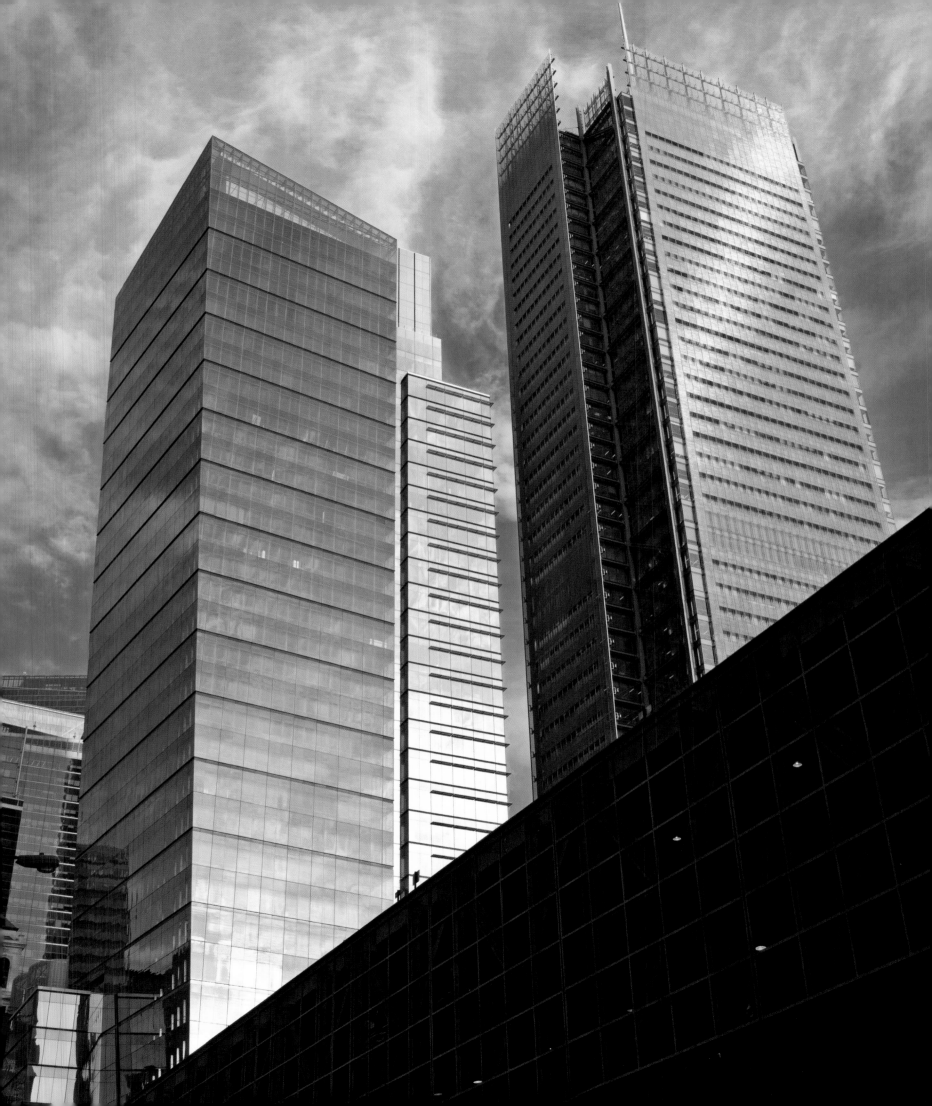

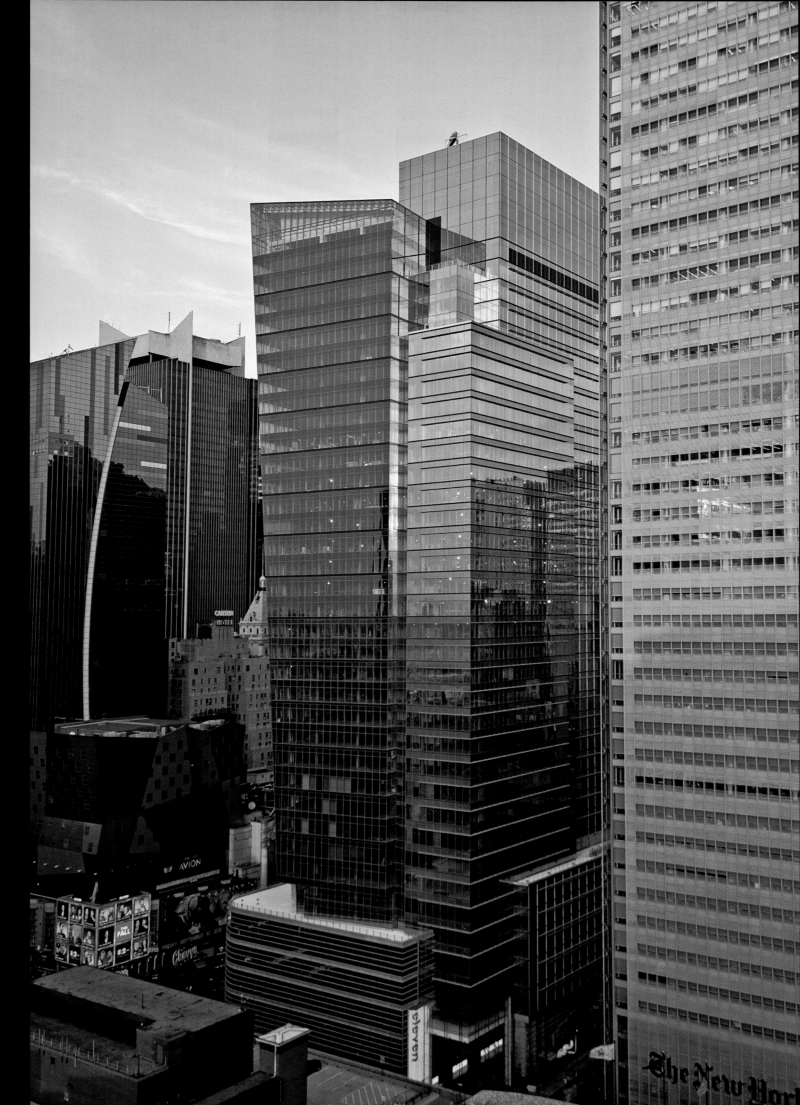

11 Times Square, FXFowle (left), and New York Times Building, Renzo Piano Building Workshop.

OVERLEAF AND SECOND OVERLEAF **New York Times Building entrance and lobby.**

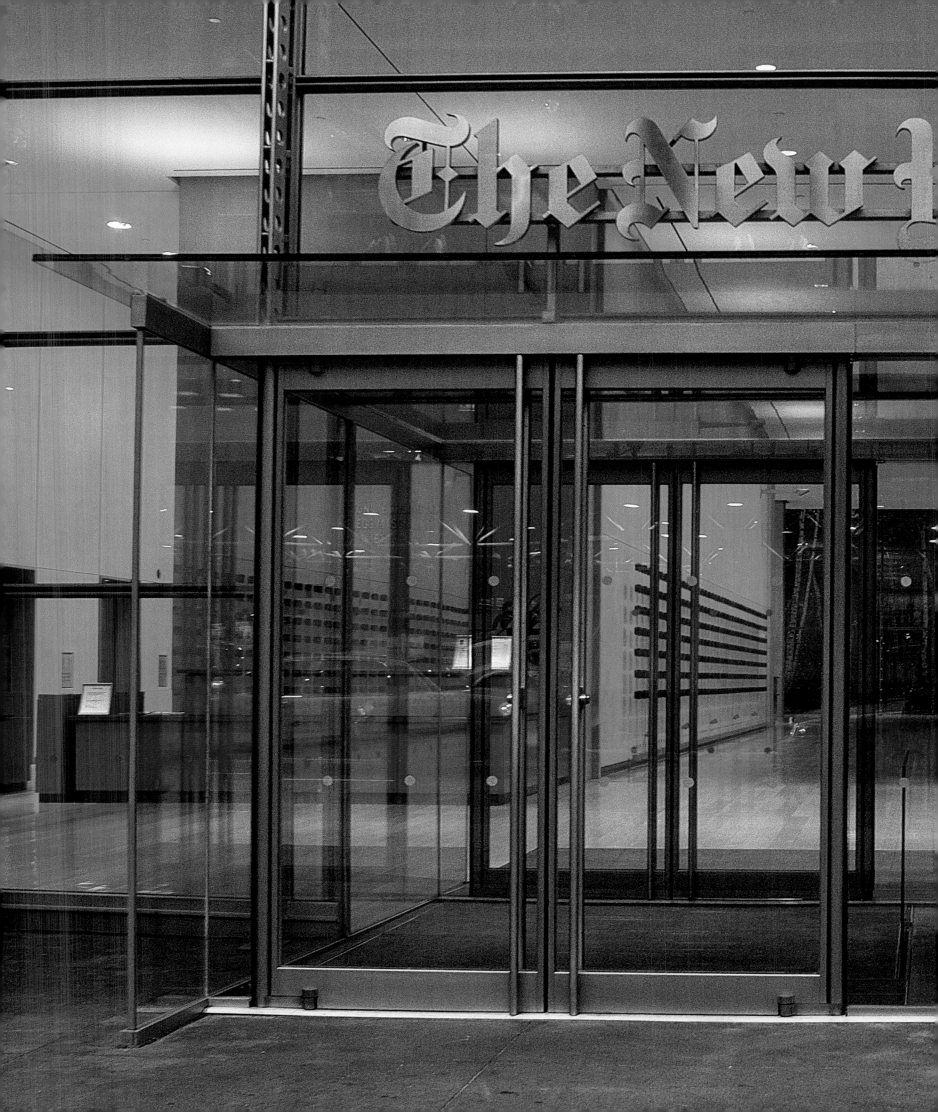

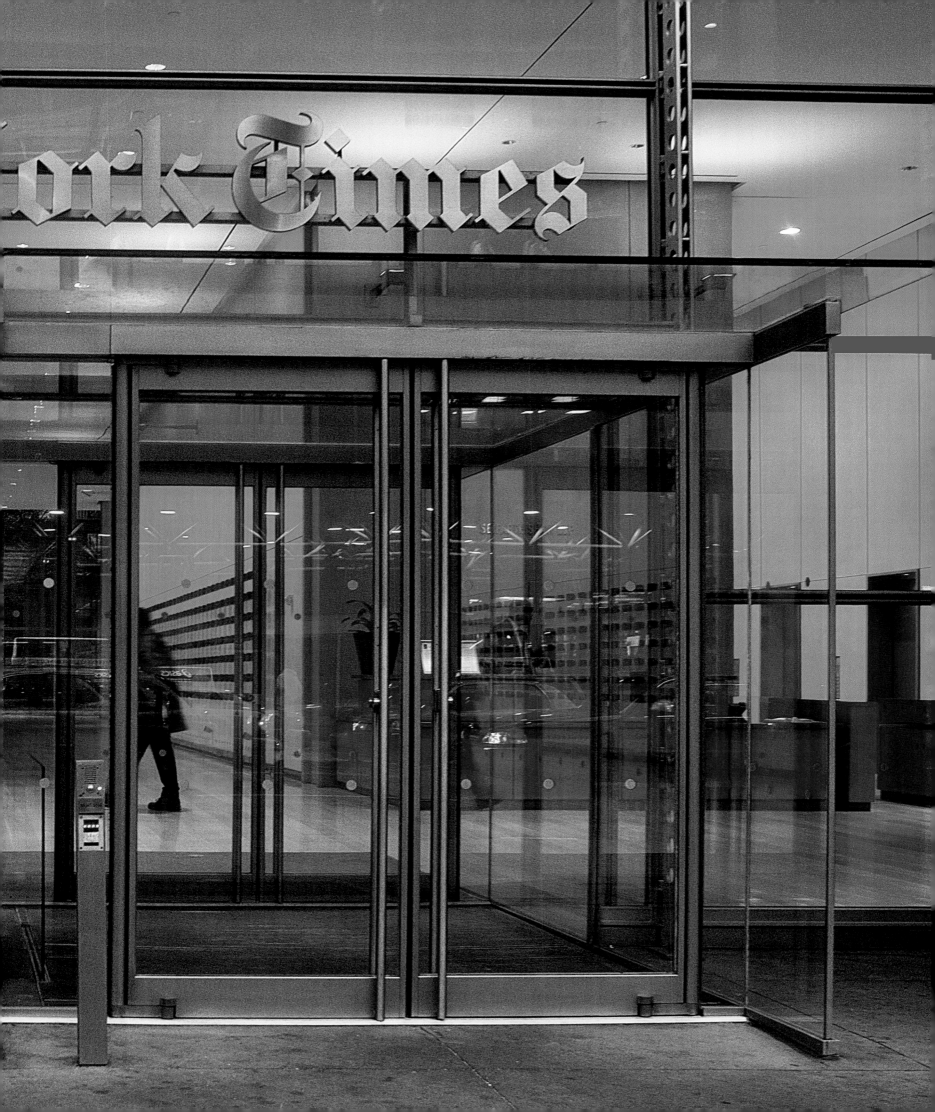

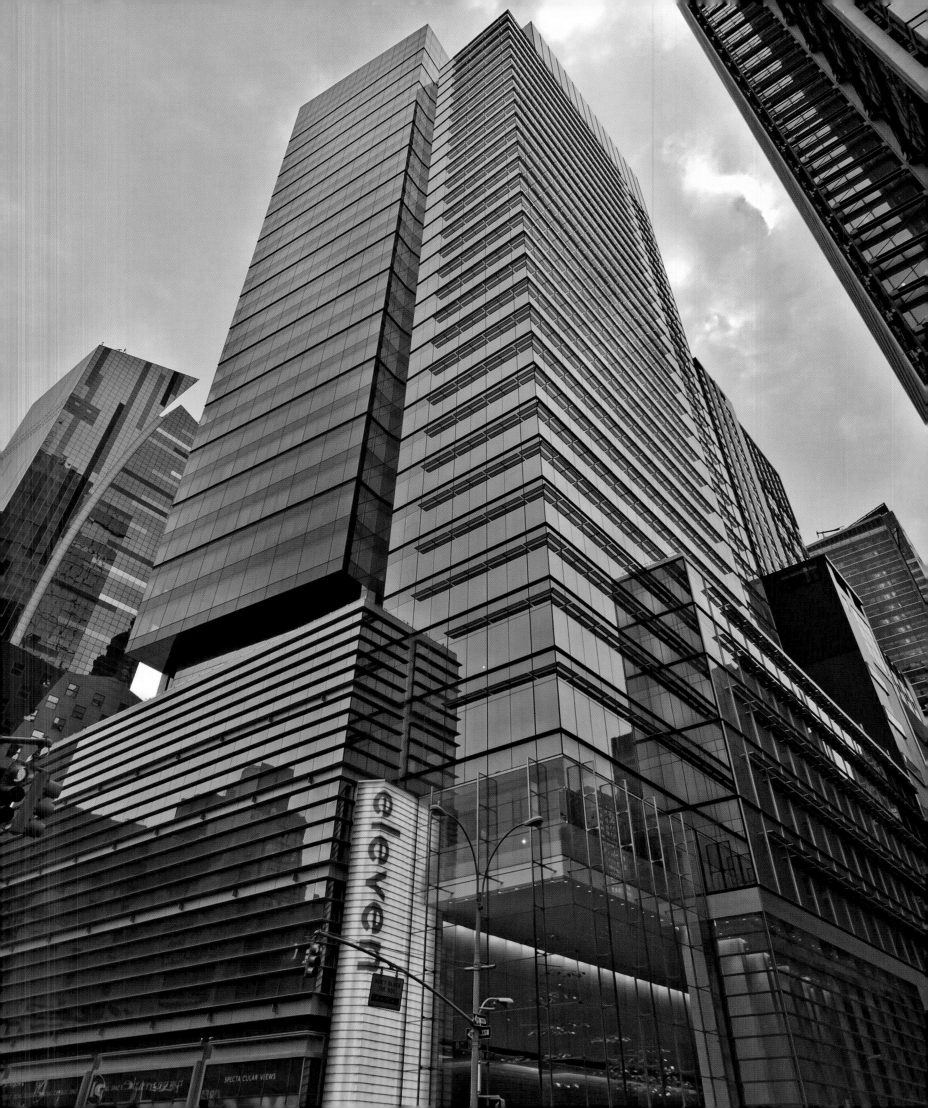

LEFT
11 Times Square,
FXFowle.

RIGHT
Chelsea Arts Tower,
Kossar + Garry
Architects.

OVERLEAF
Goldman Sachs
Headquarters, 200
West Street, Pei
Cobb Freed &
Partners.

CHELSEAARTSTOWER

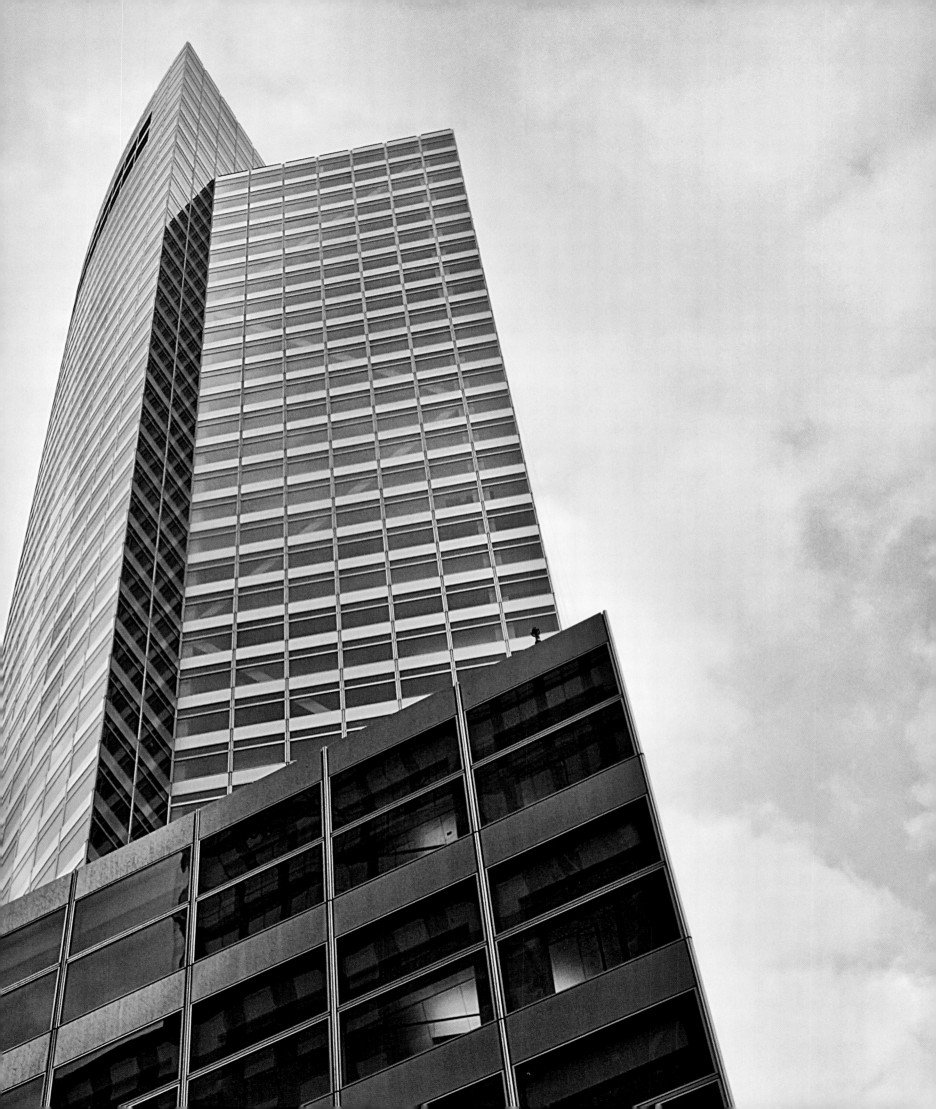

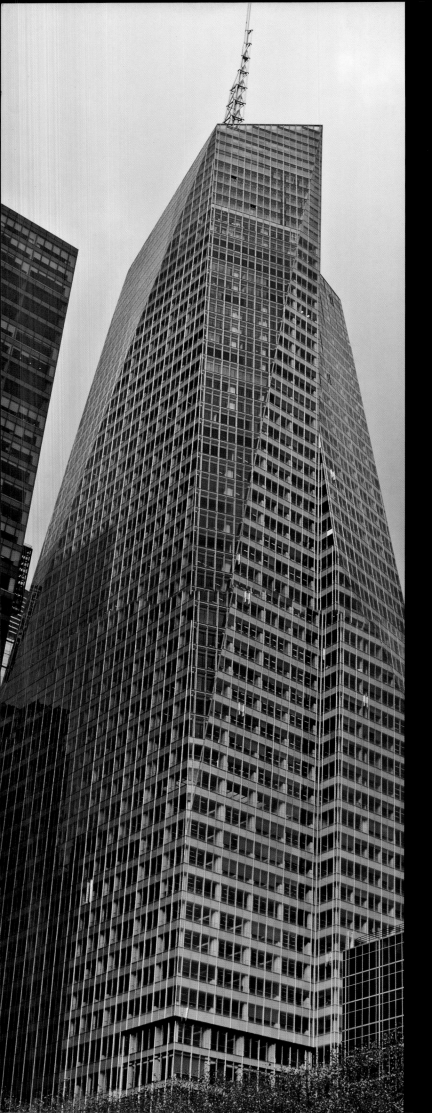

Bank of America,
1 Bryant Park, Cook
+ Fox Architects.

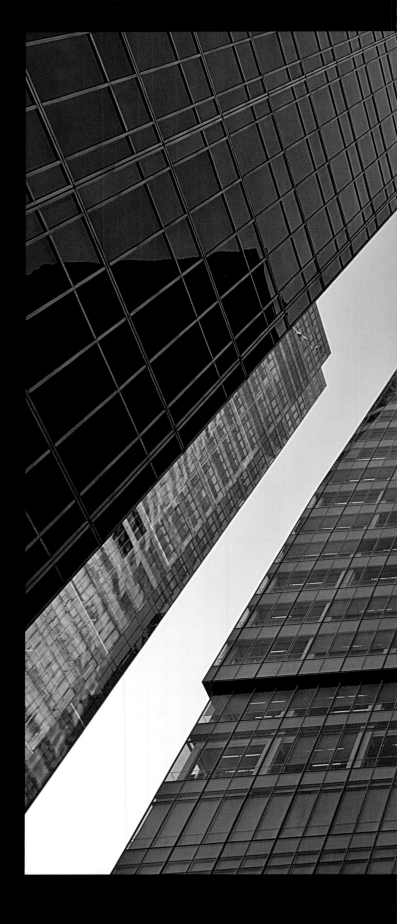

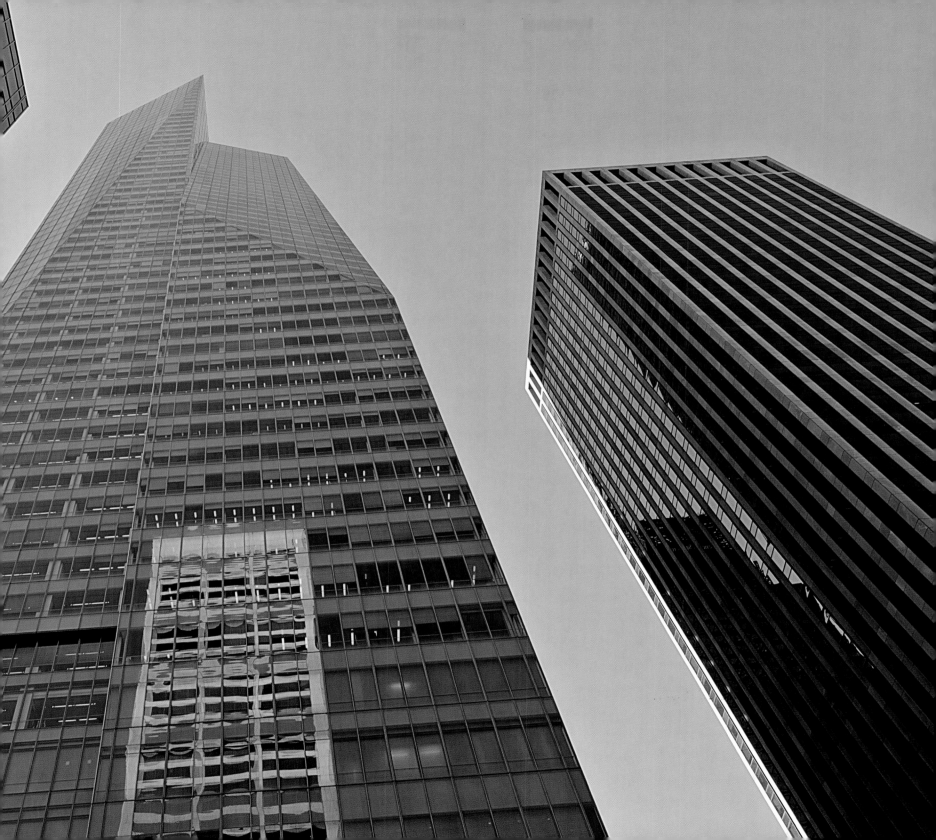

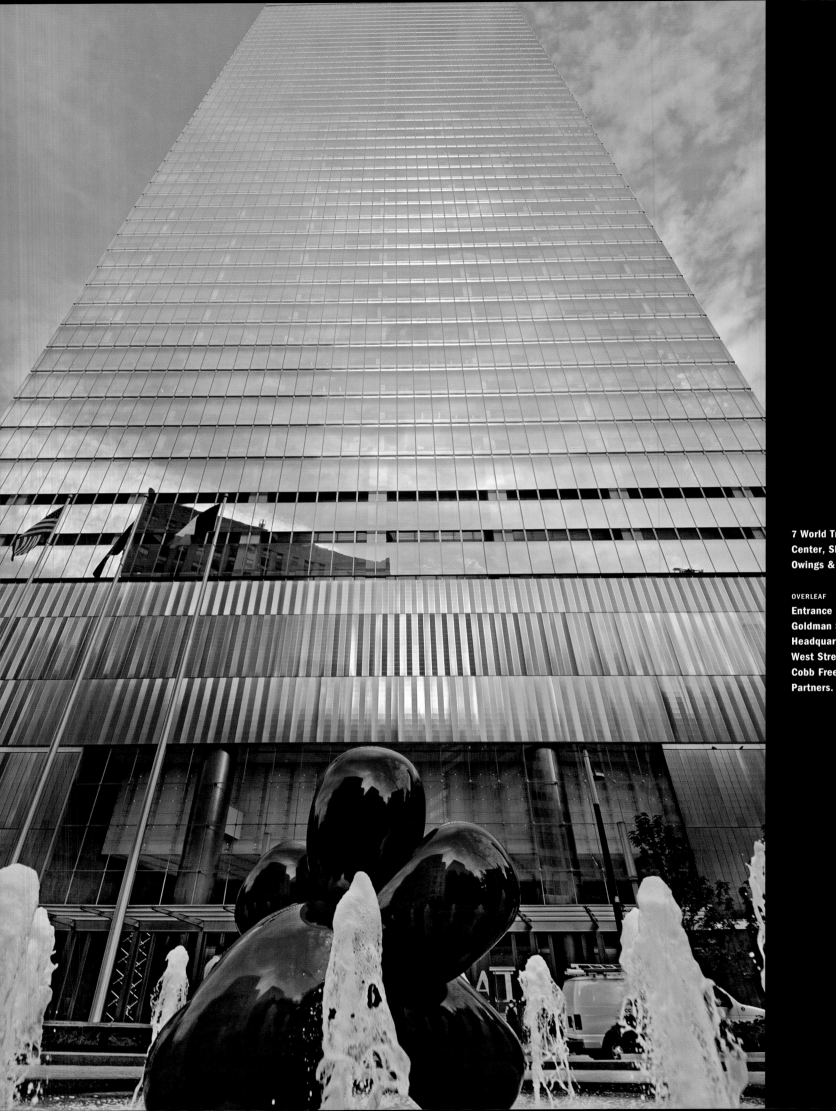

7 World Trade
Center, Skidmore,
Owings & Merrill.

OVERLEAF
Entrance to
Goldman Sachs
Headquarters, 200
West Street, Pei
Cobb Freed &
Partners.

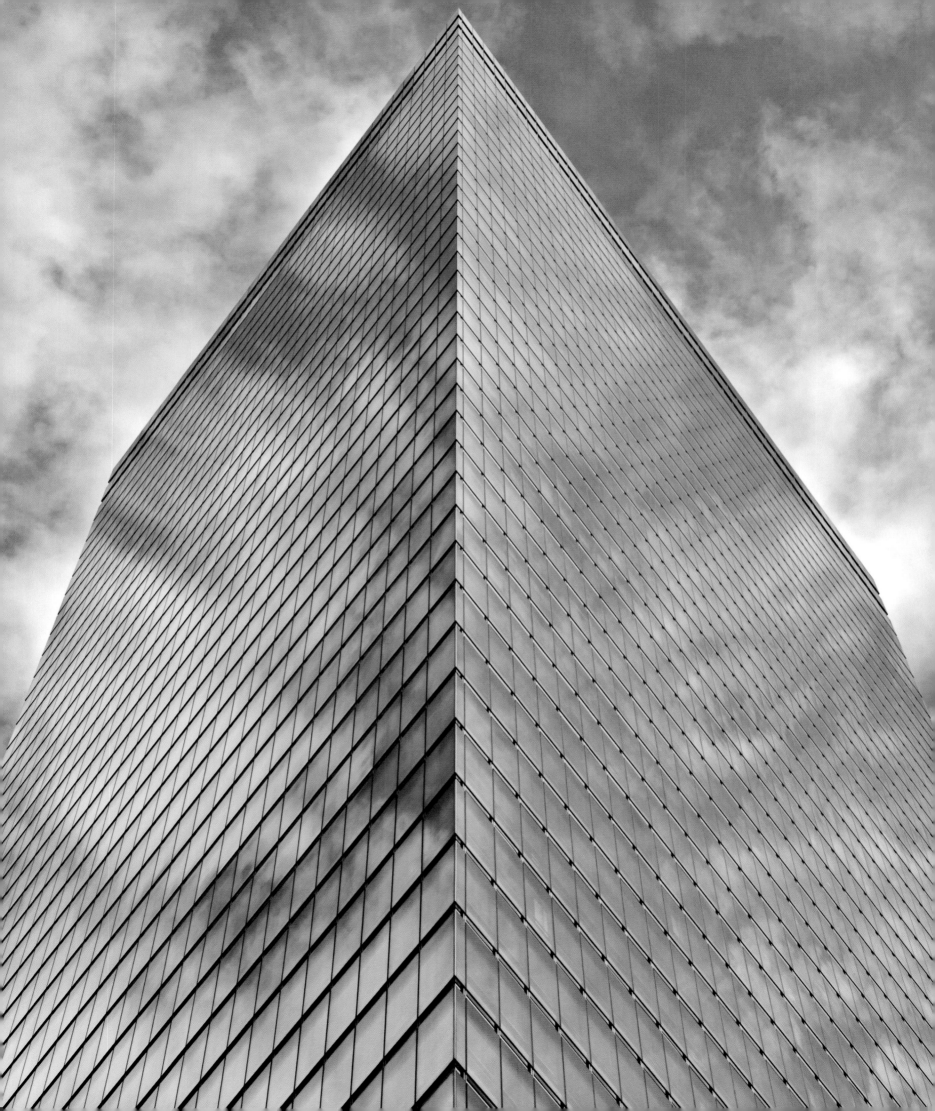

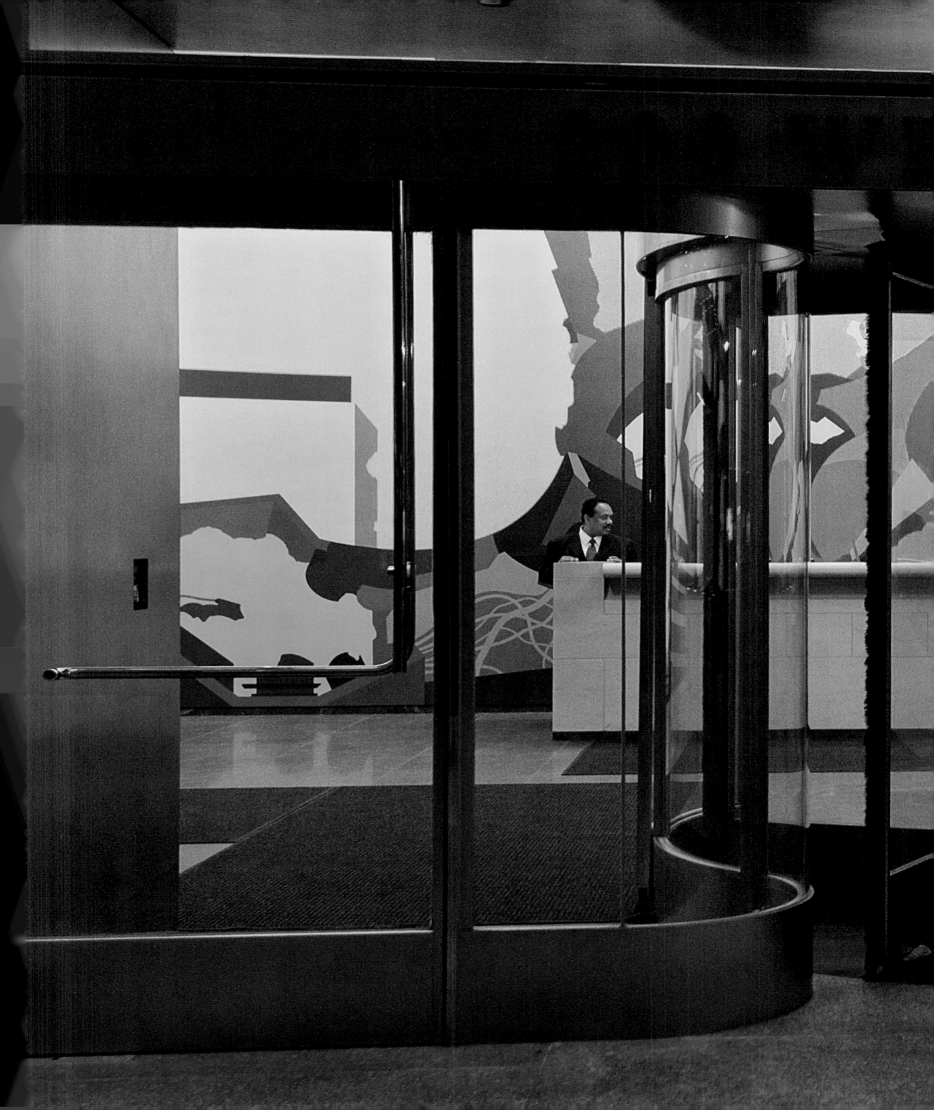

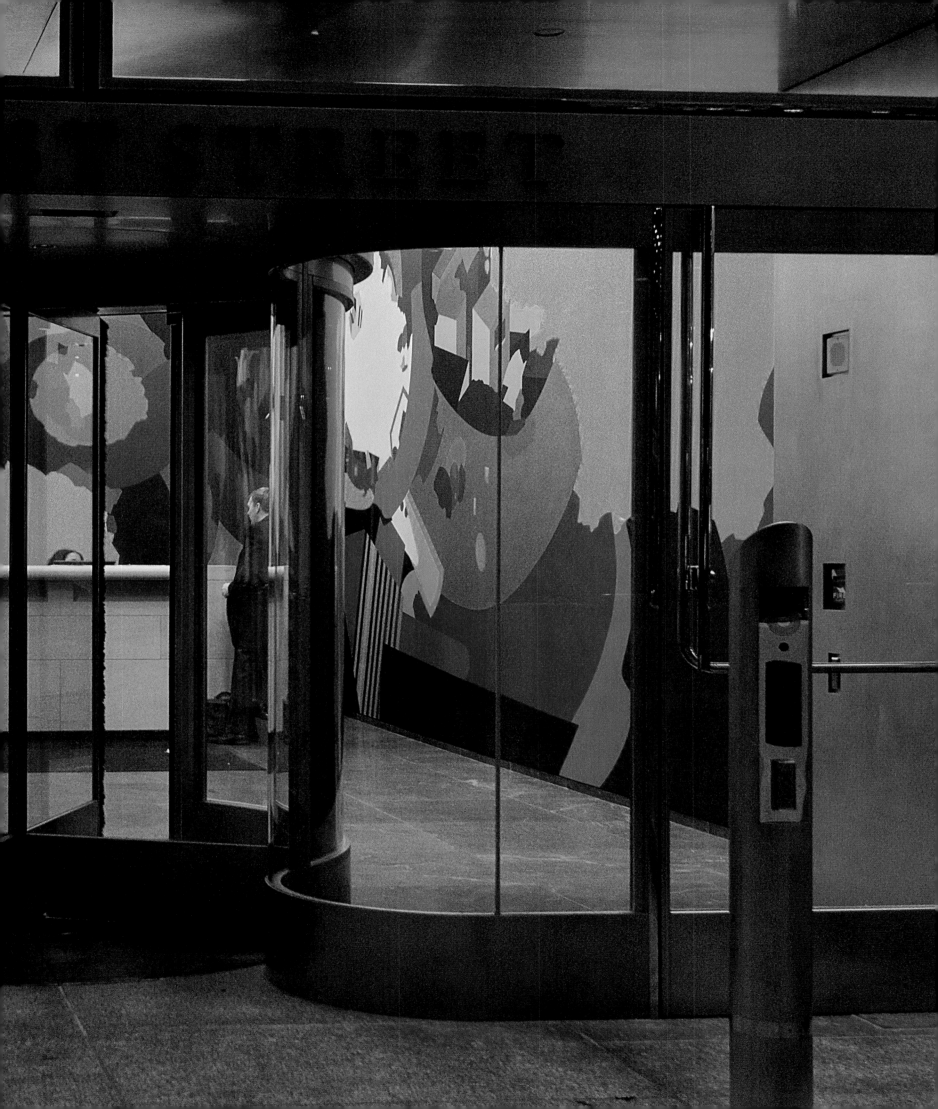

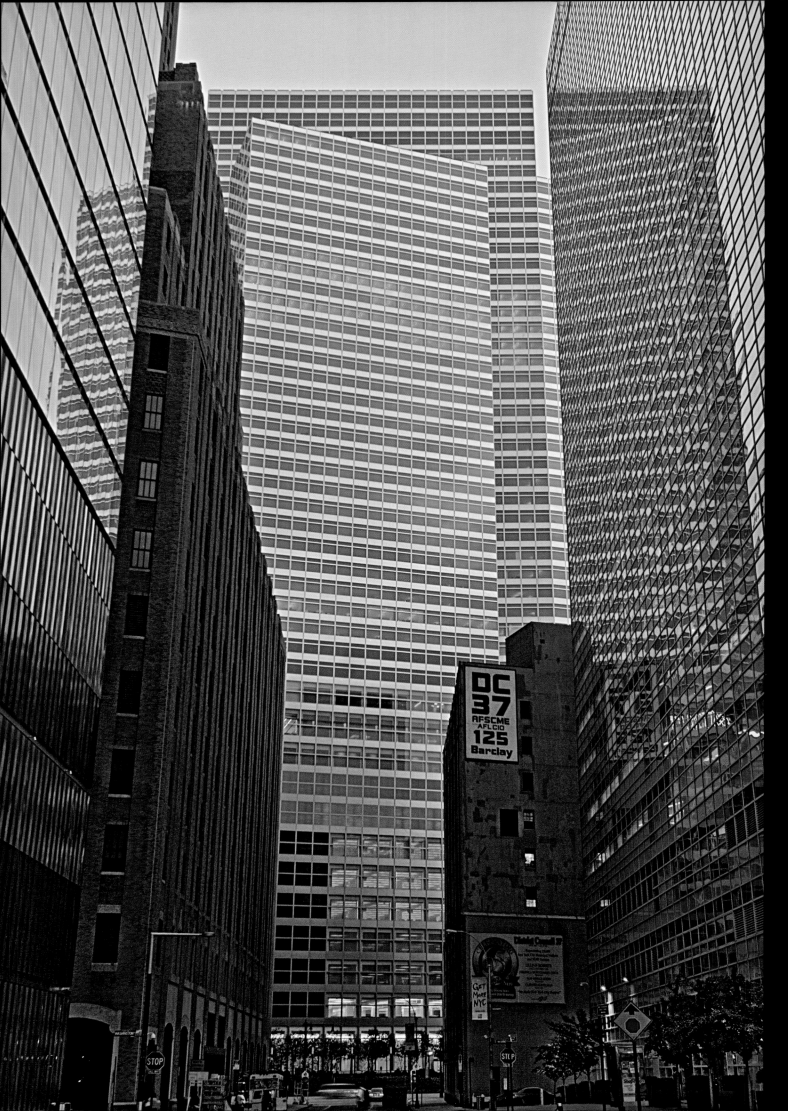

Goldman Sachs
Headquarters,
200 West Street,
Pei Cobb Freed and
Partners.

OVERLEAF
Battery Park City
Ferry Terminal.

112

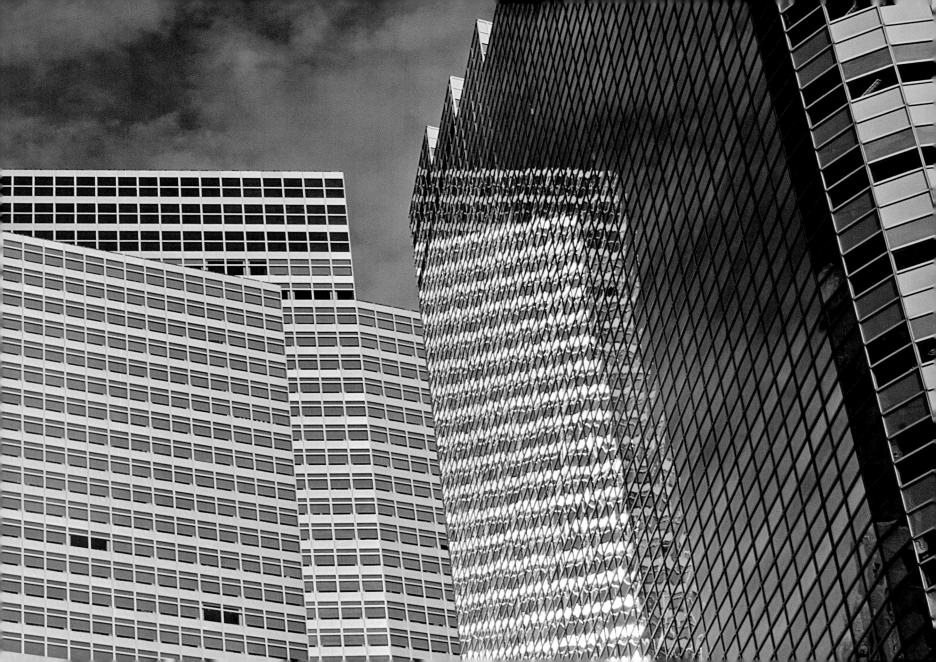

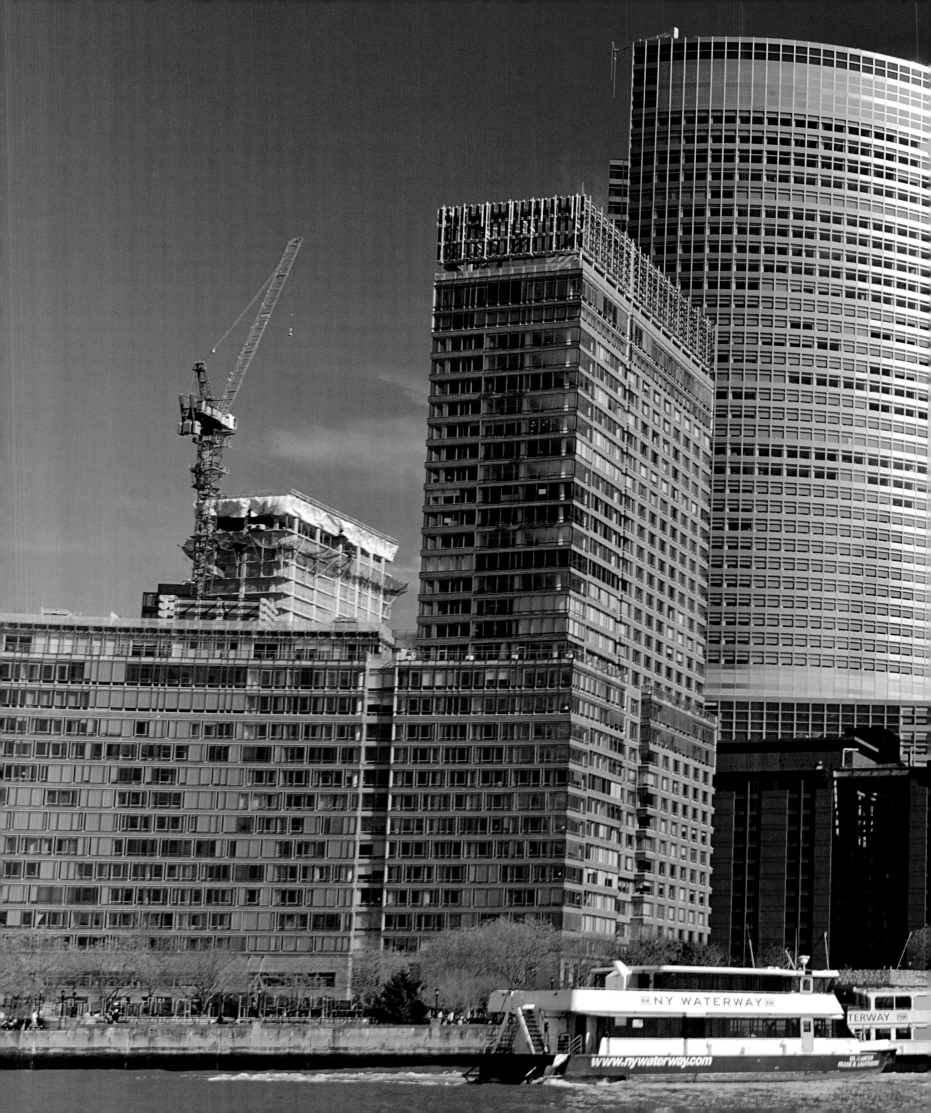

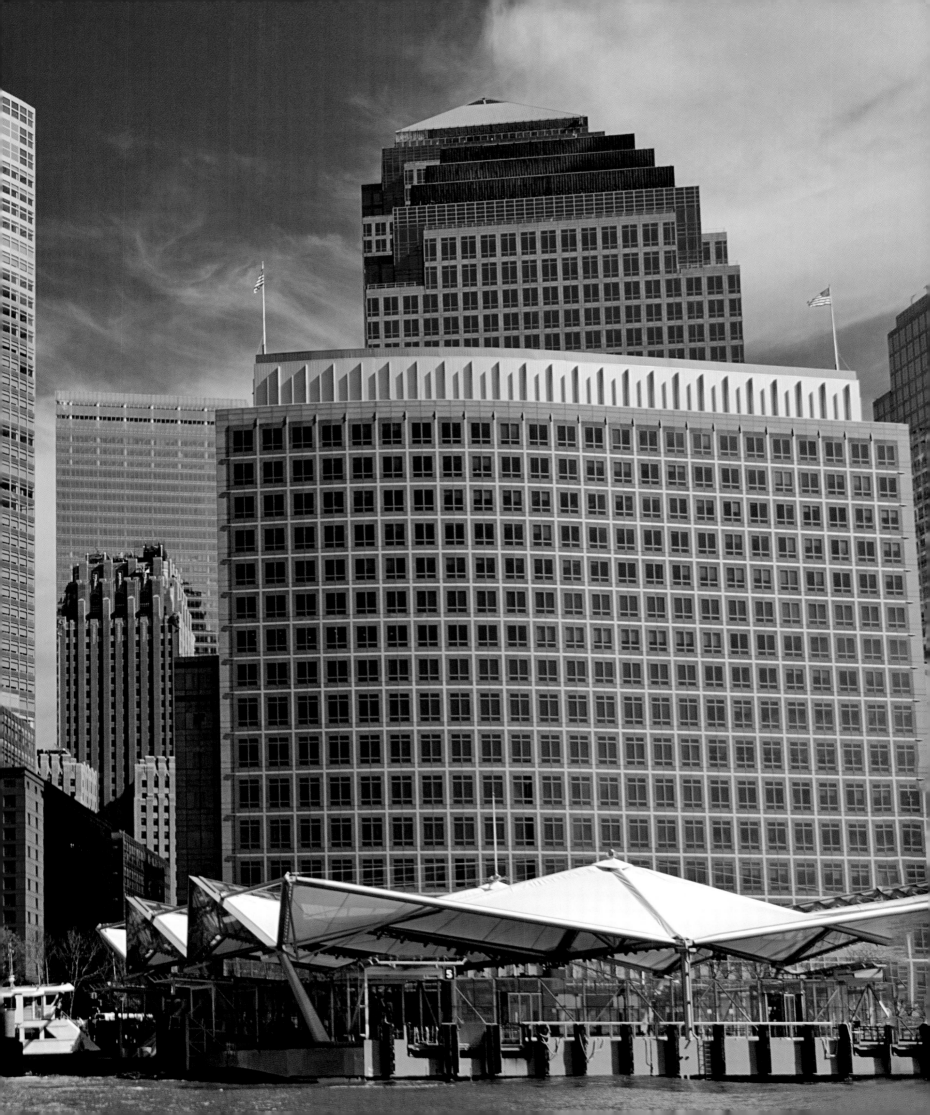

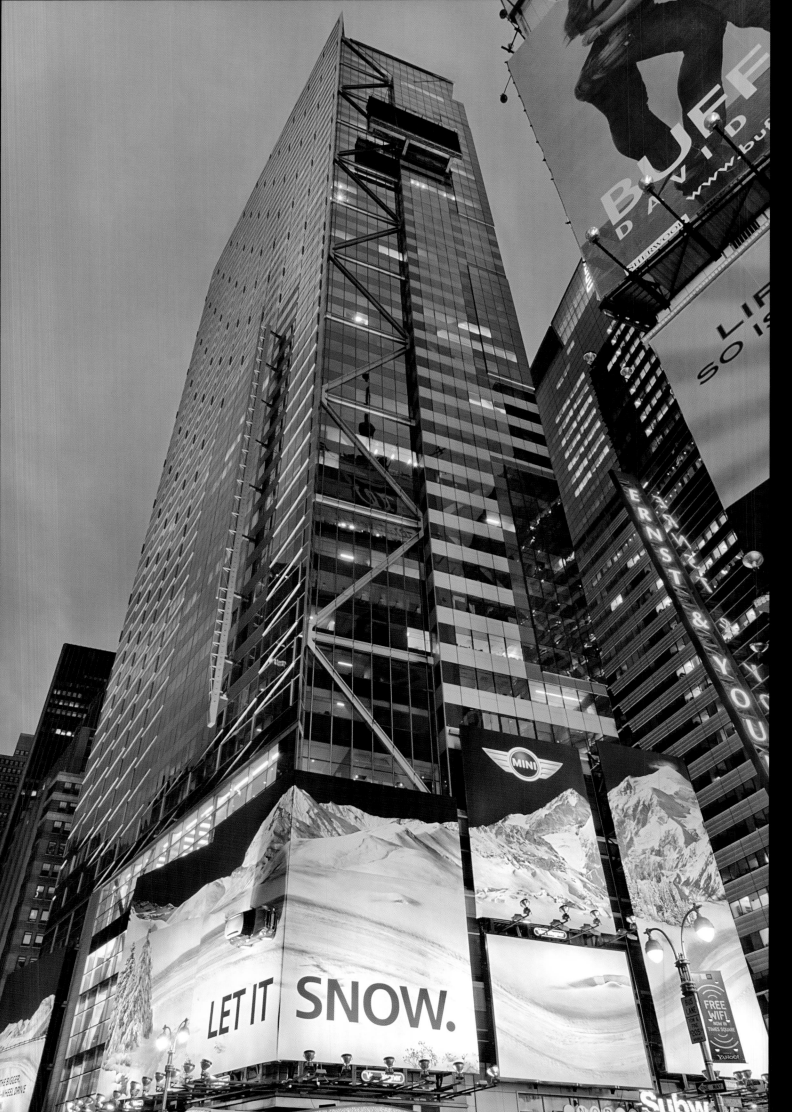

116

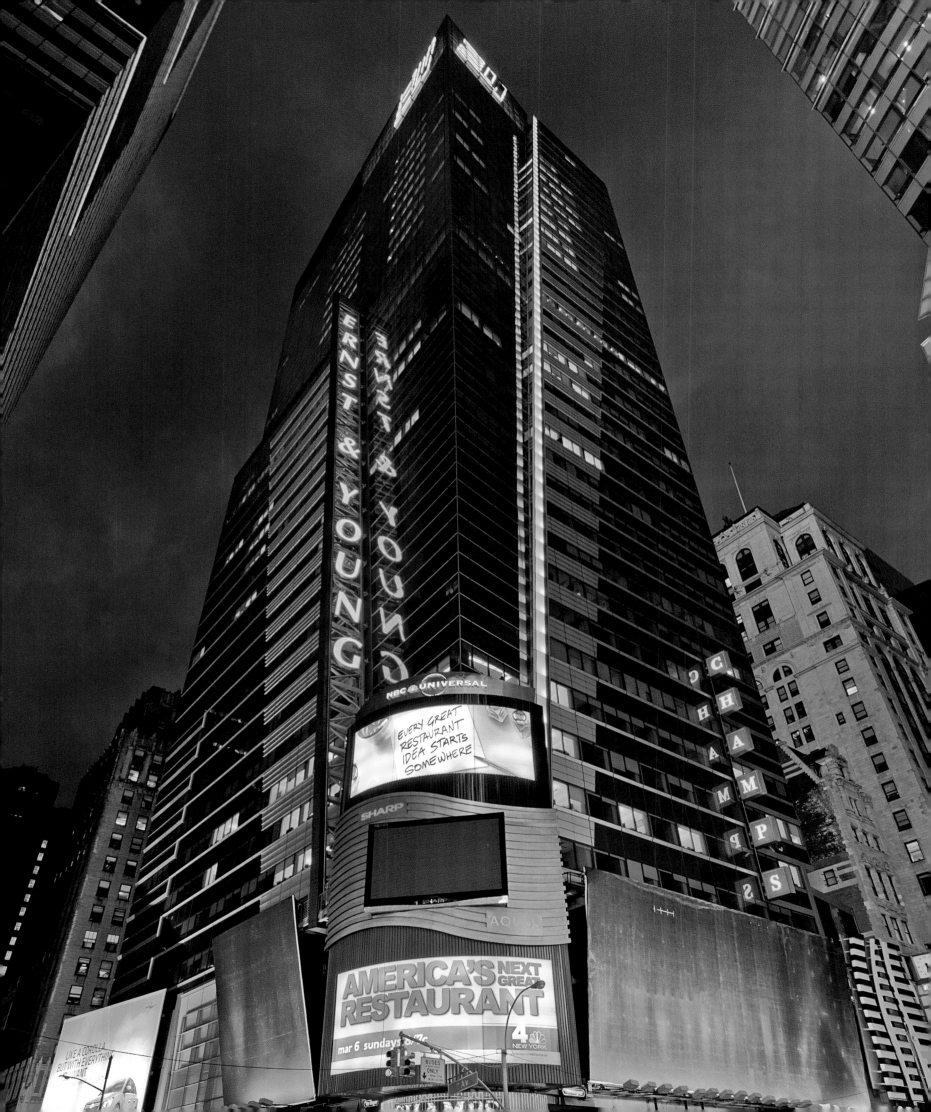

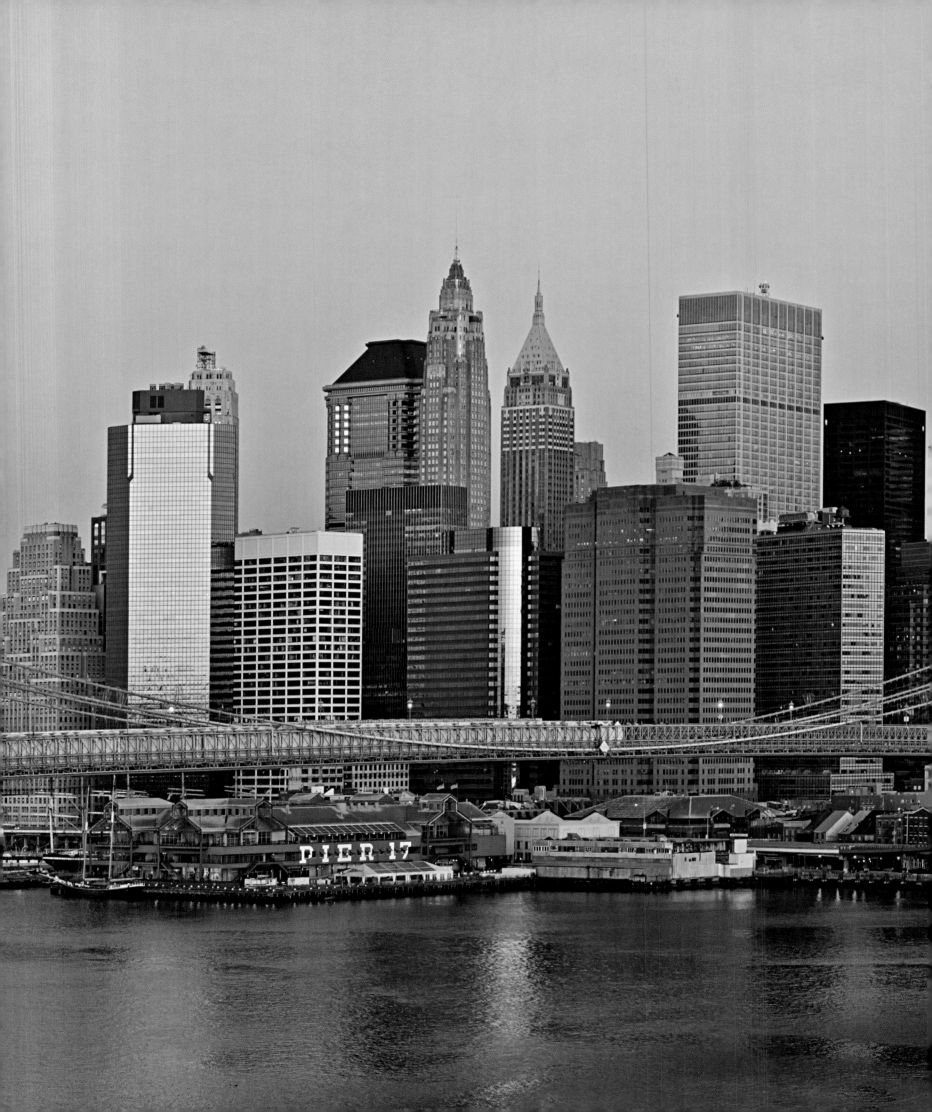

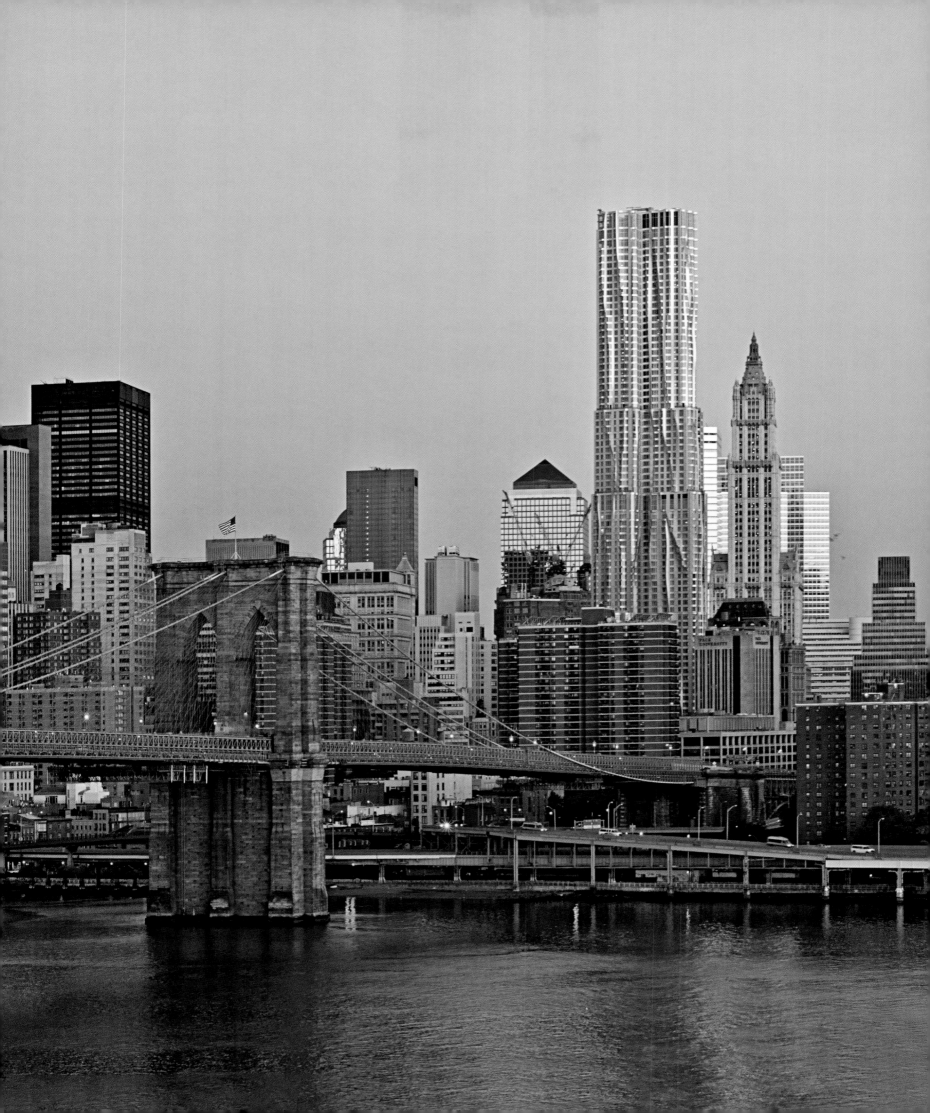

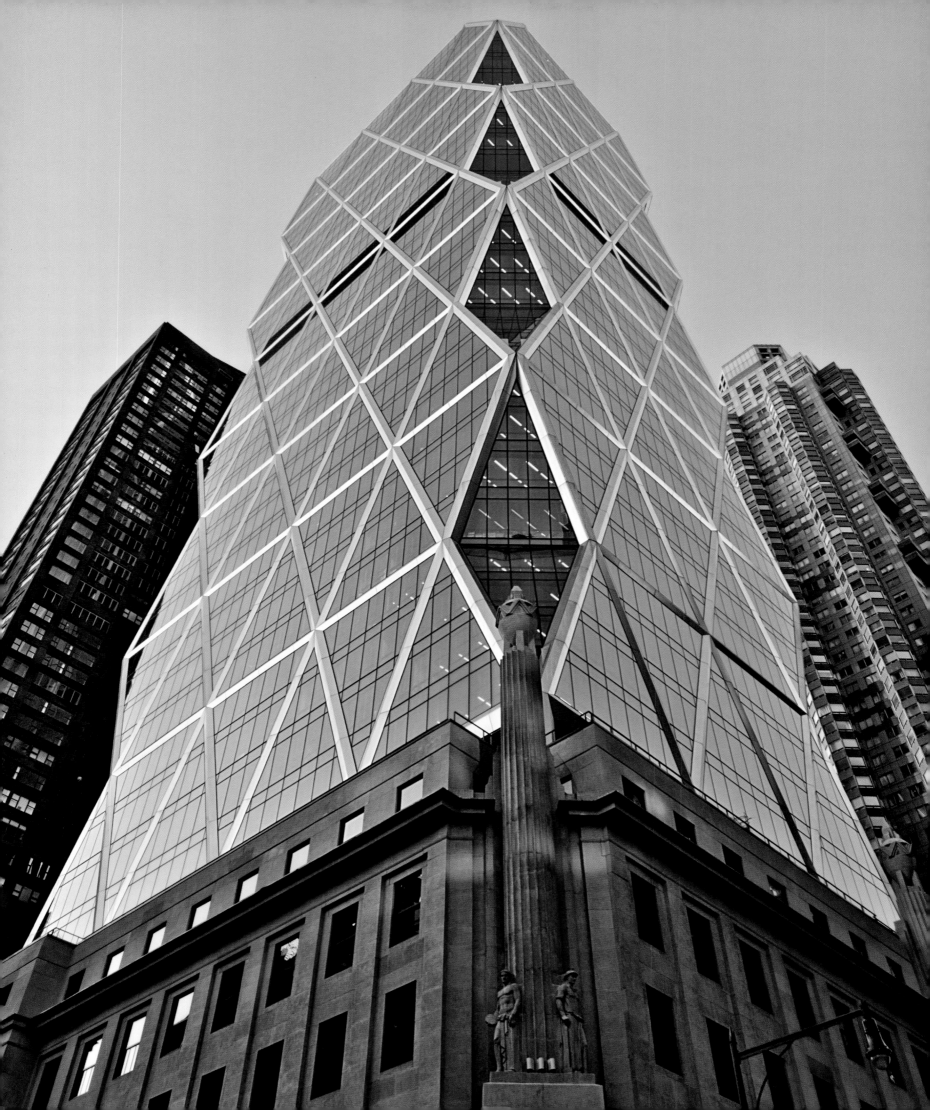

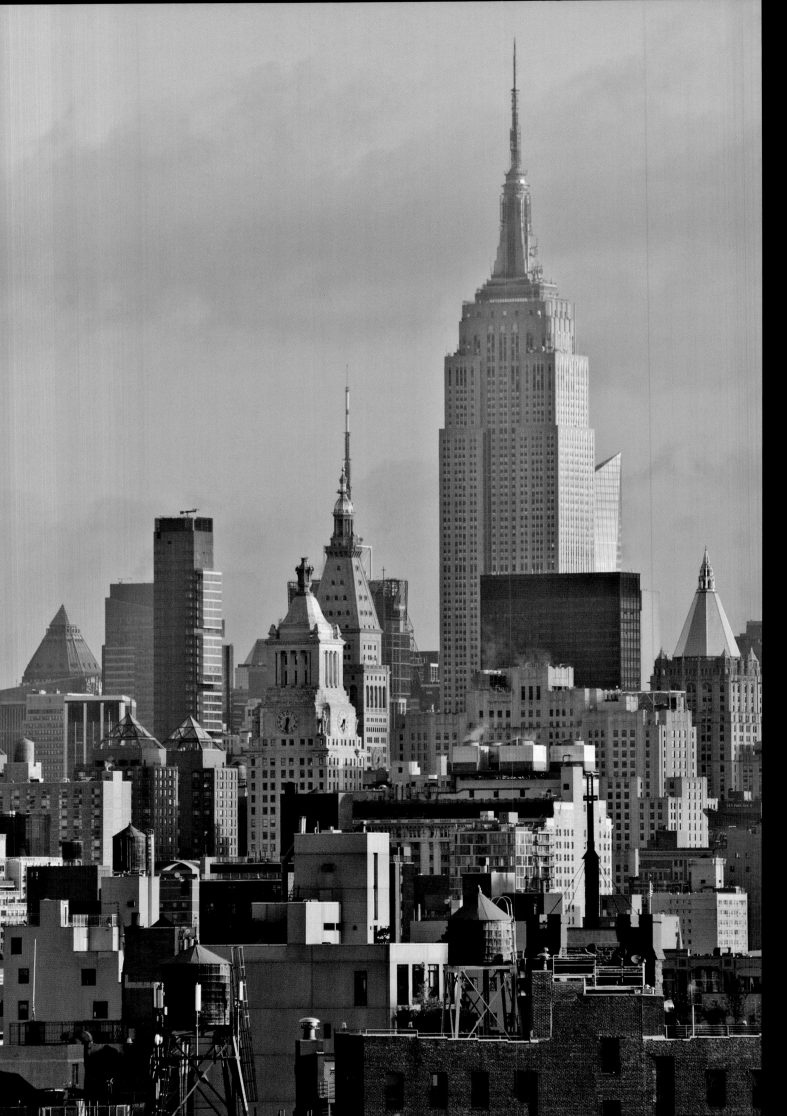

LEFT
**View north to the
Empire State
Building.**

RIGHT
**Midtown Manhattan
from the Hudson
River.**

124

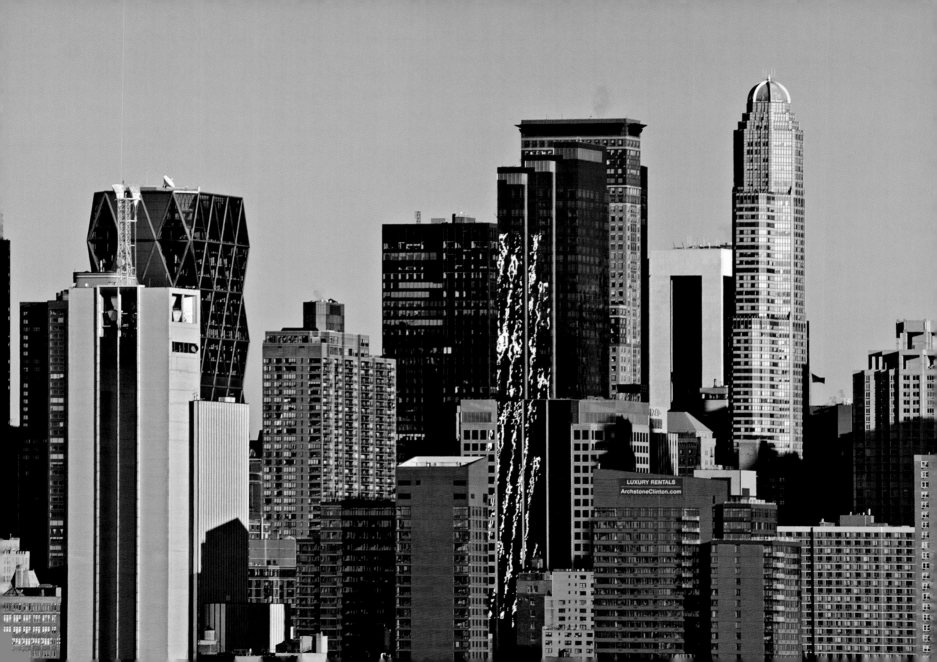

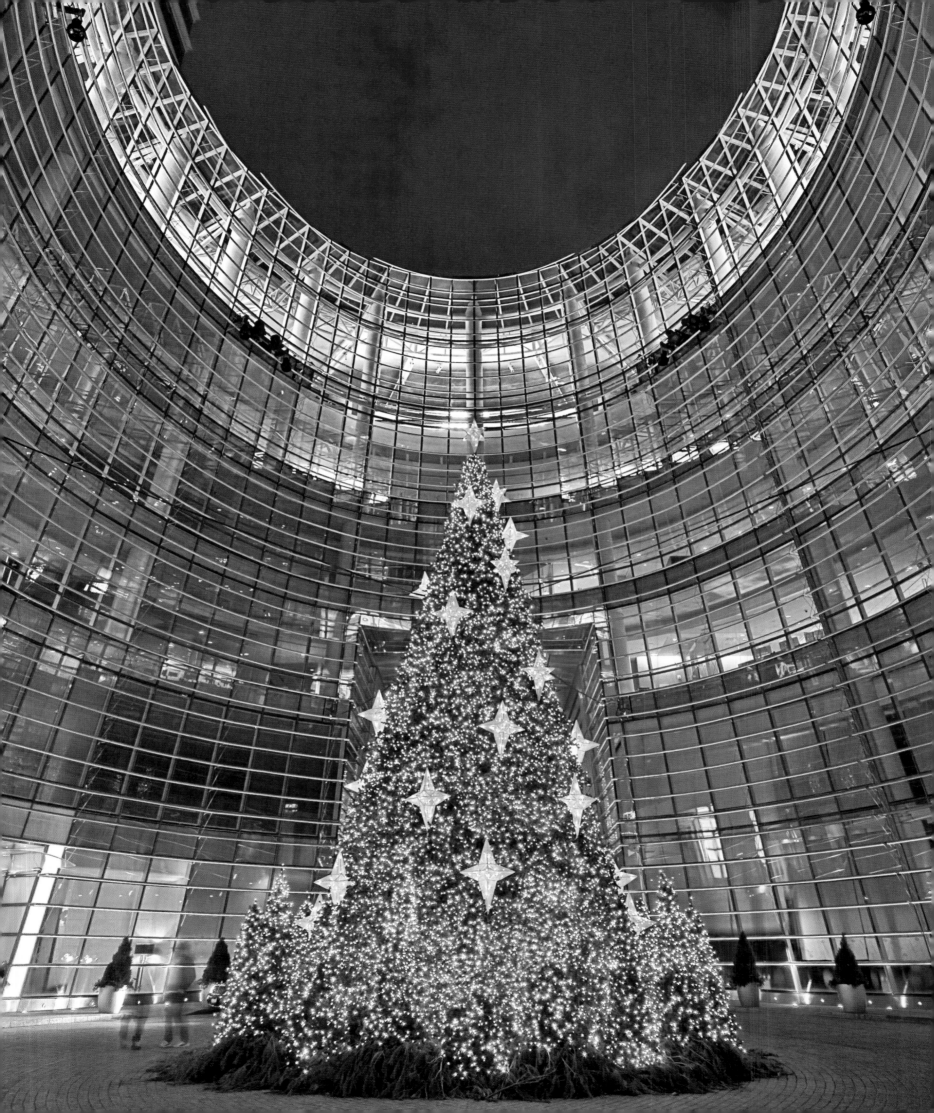

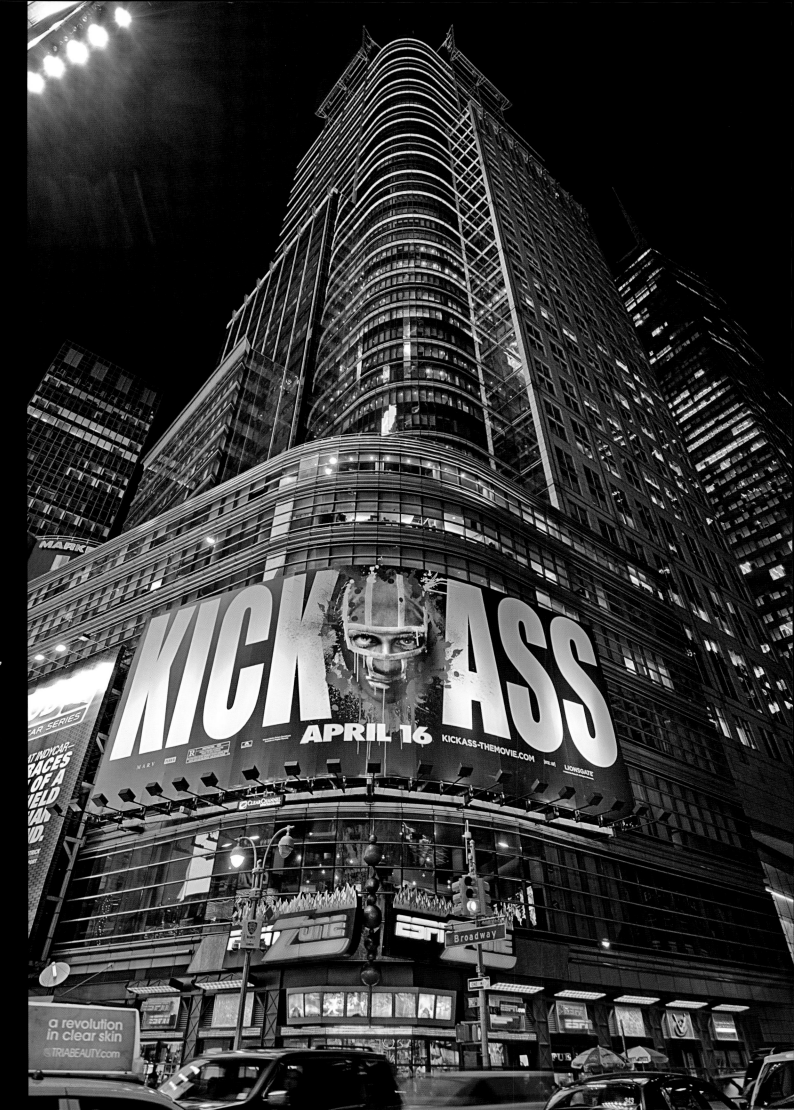

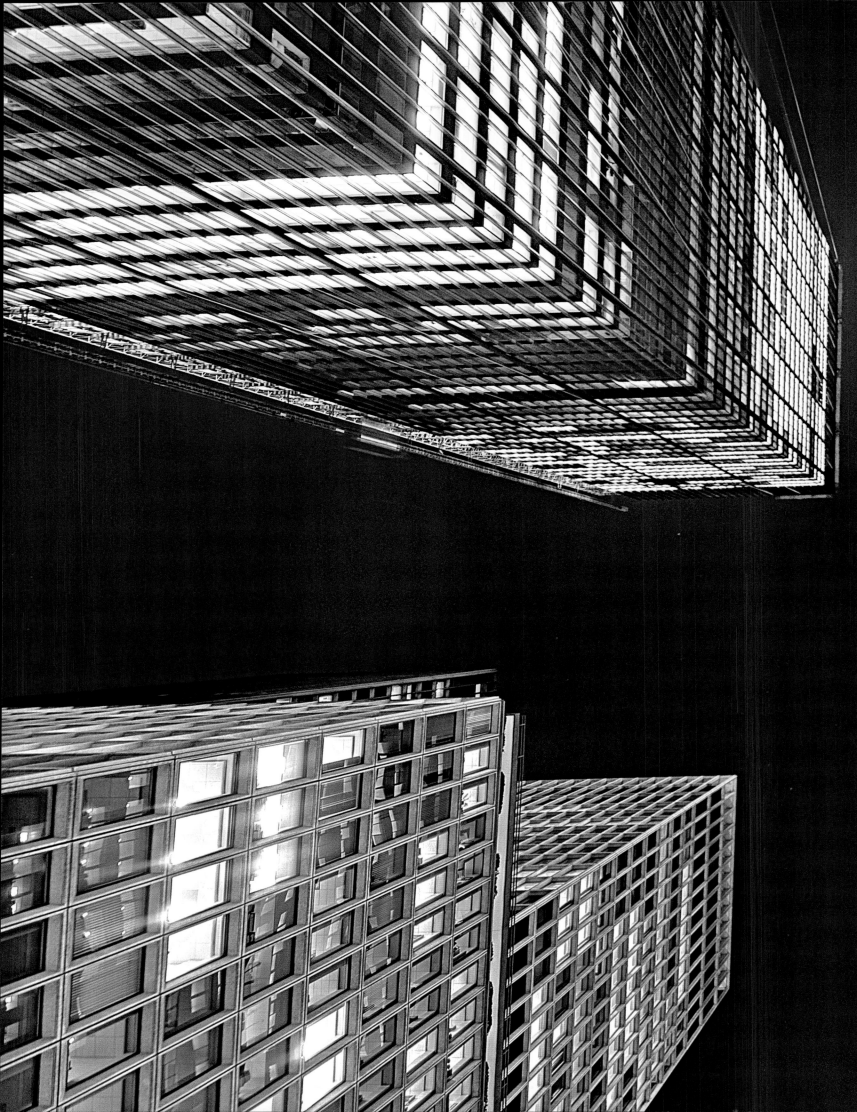

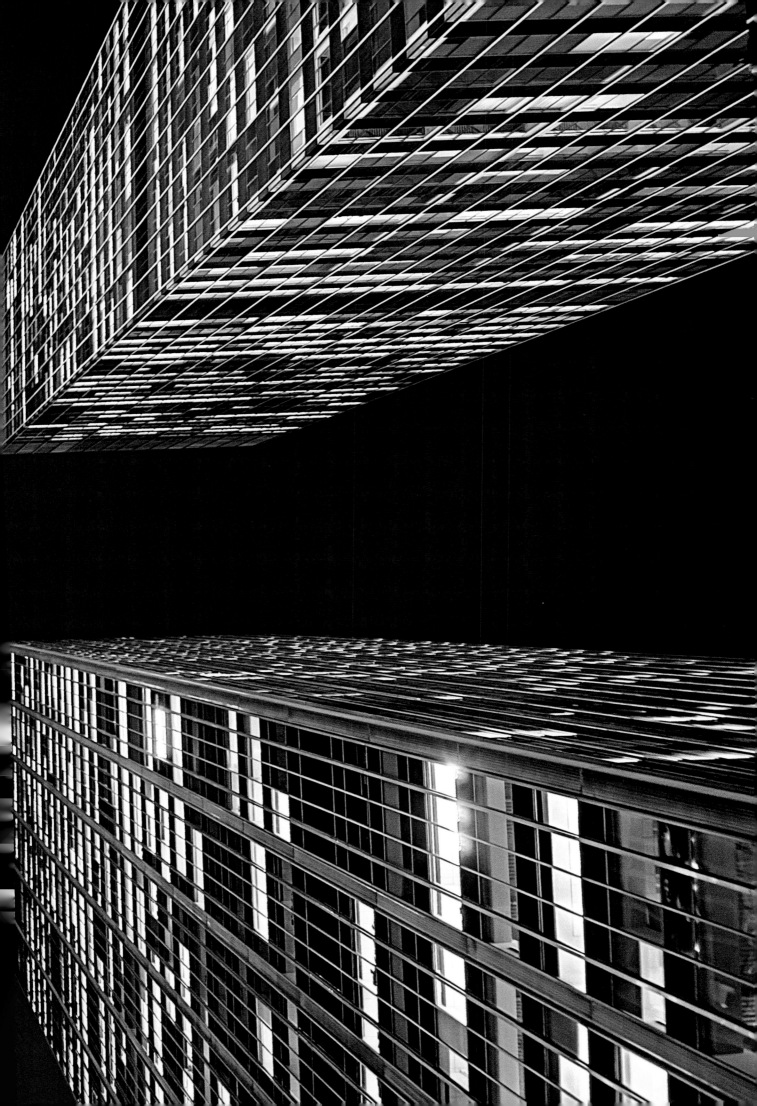

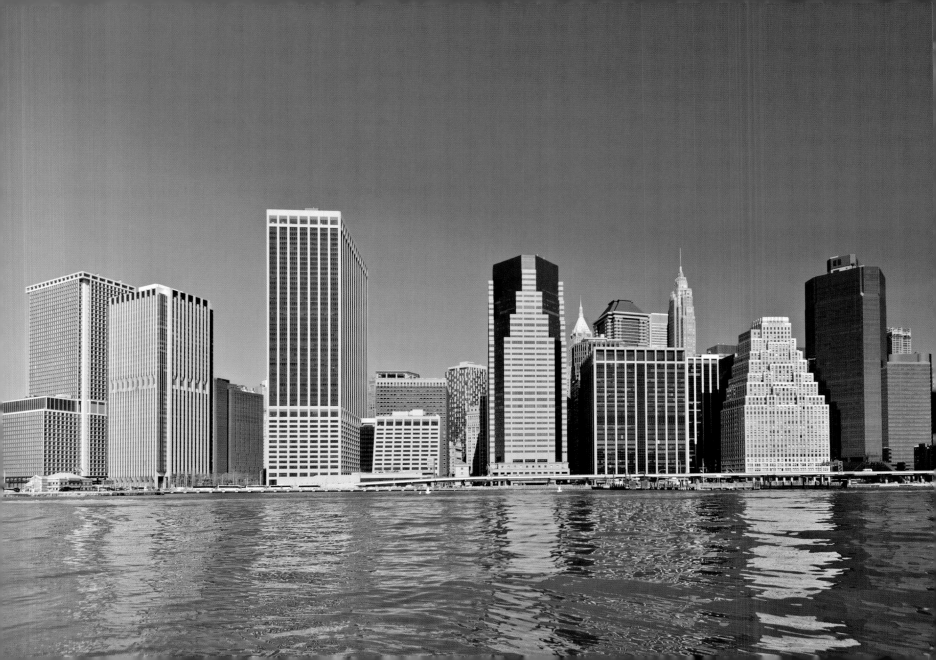

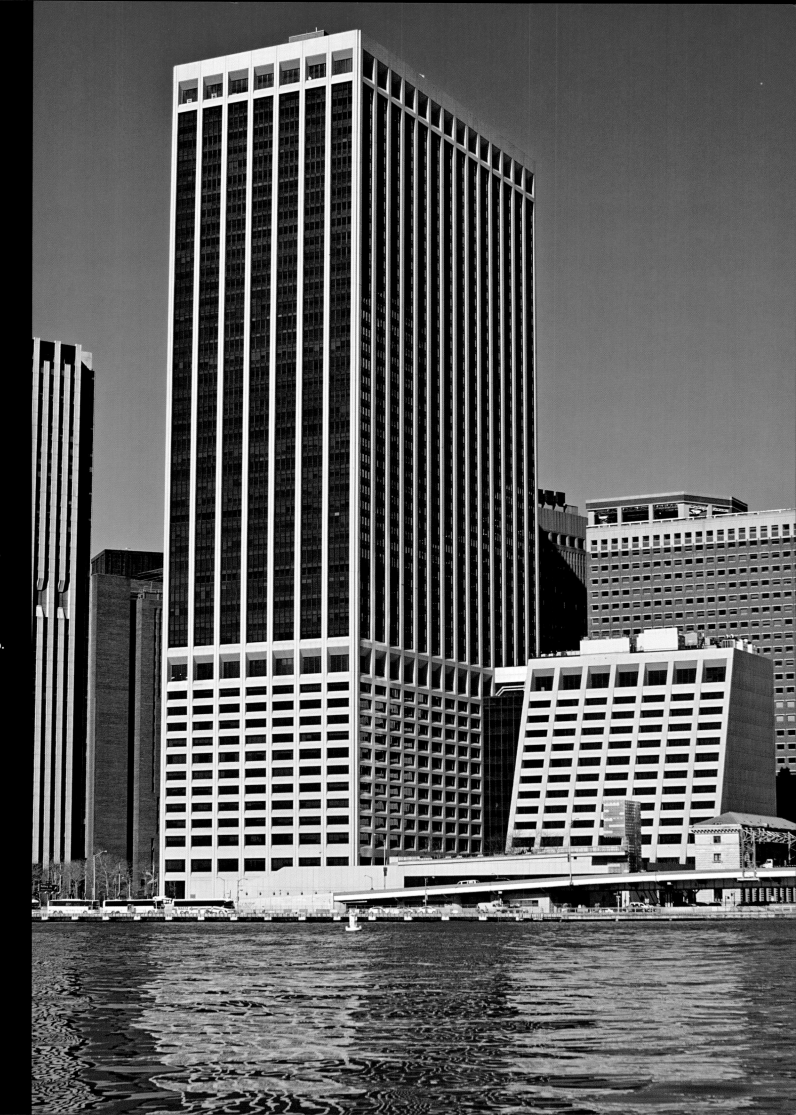

Lower Manhattan
from the East River.

OVERLEAF
Newtown Creek
Sewage Treatment
Plant, Brooklyn,
Polshek Partnership.

131

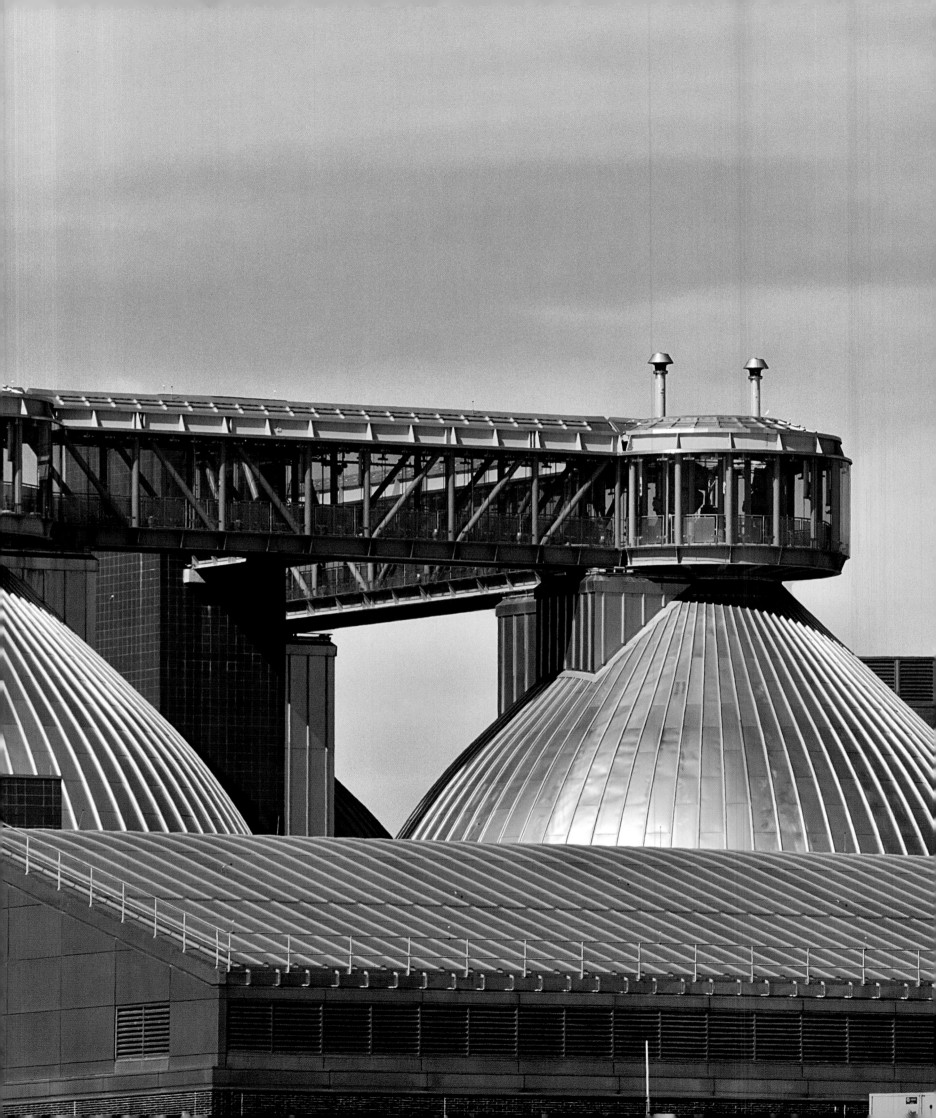

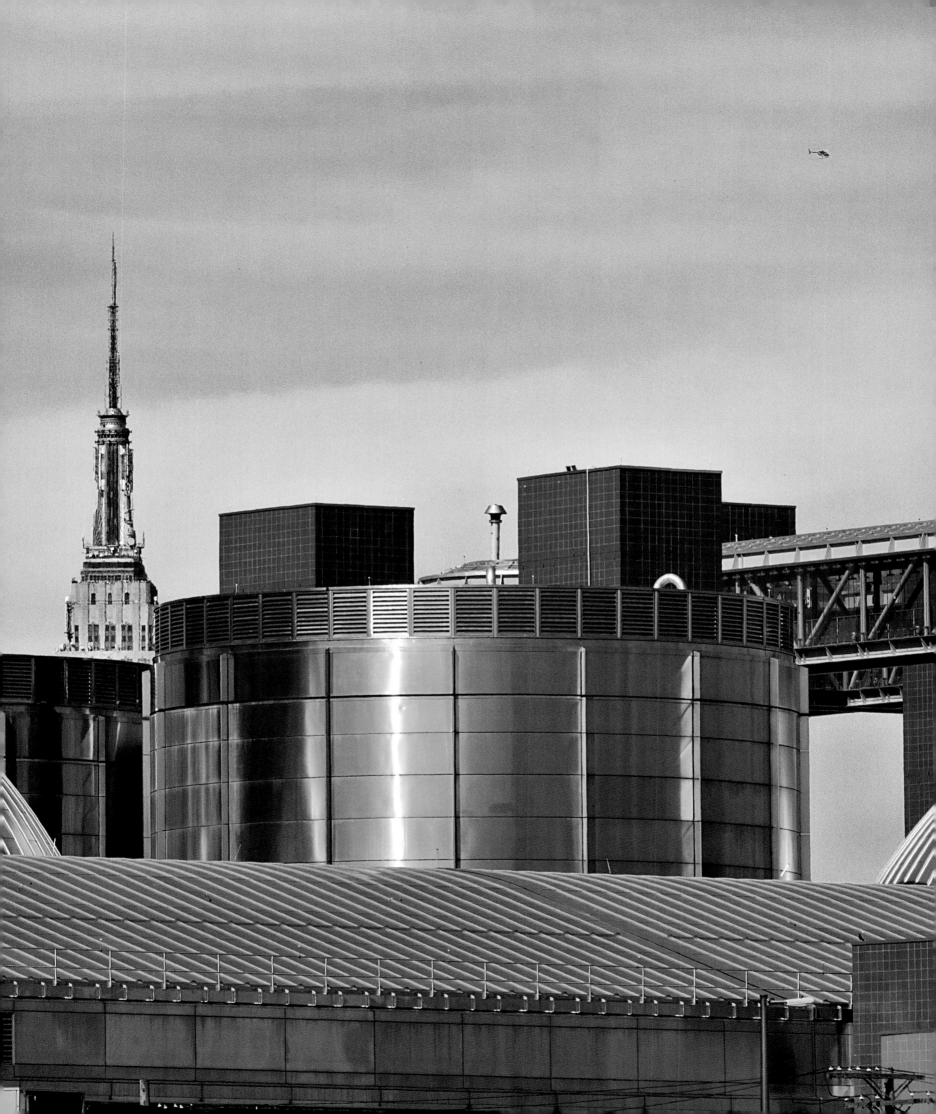

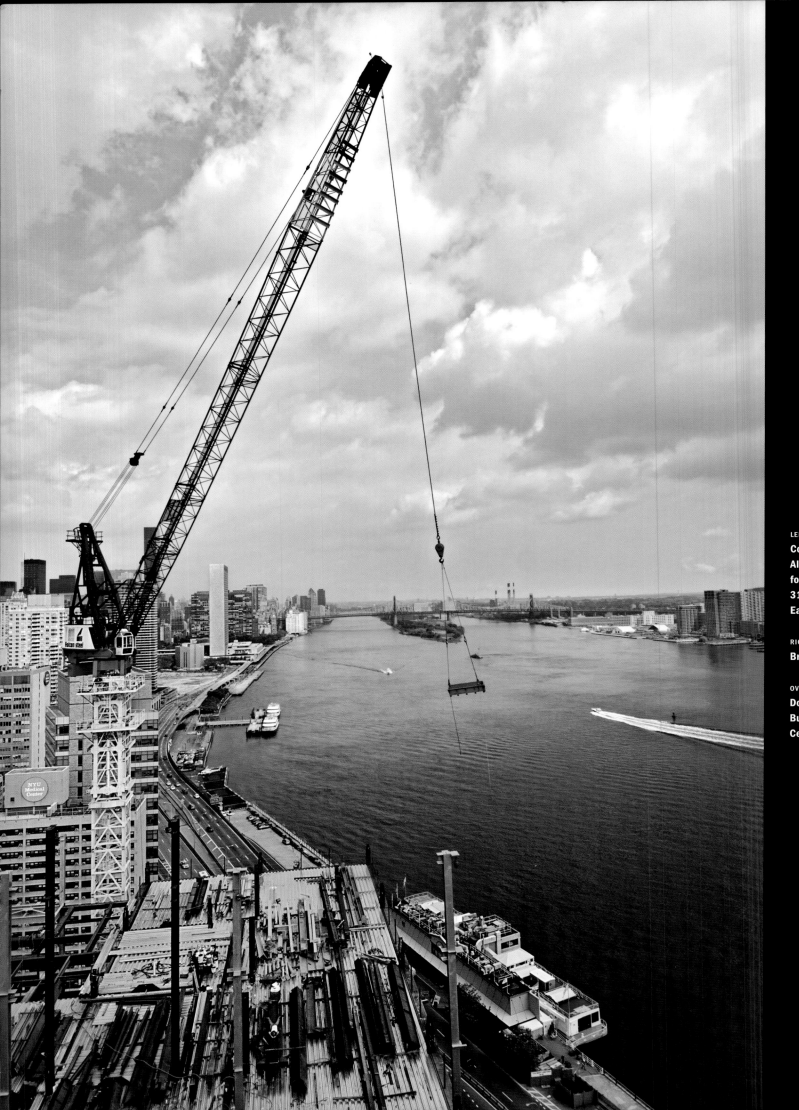

134

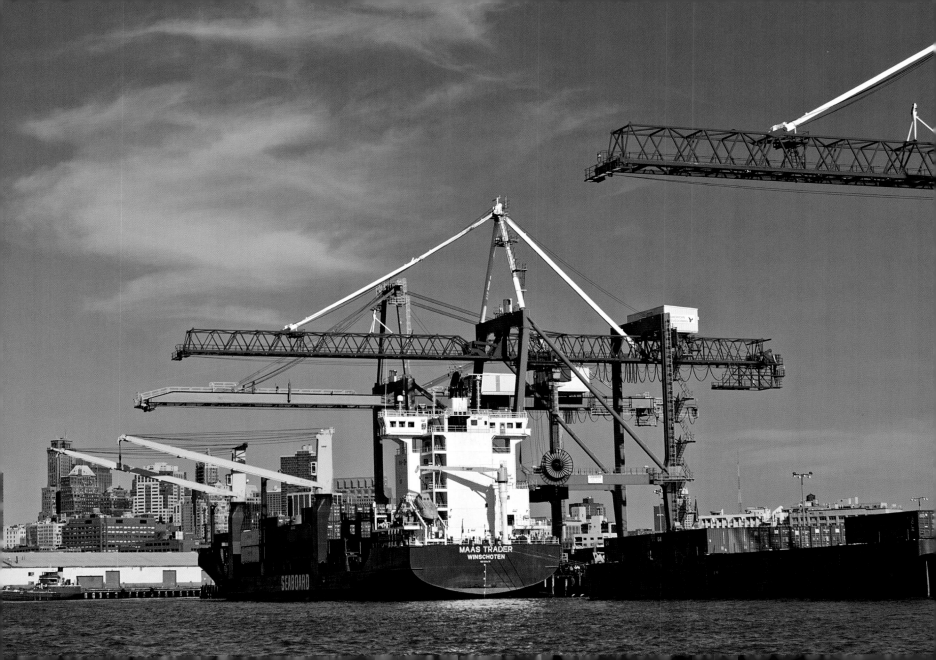

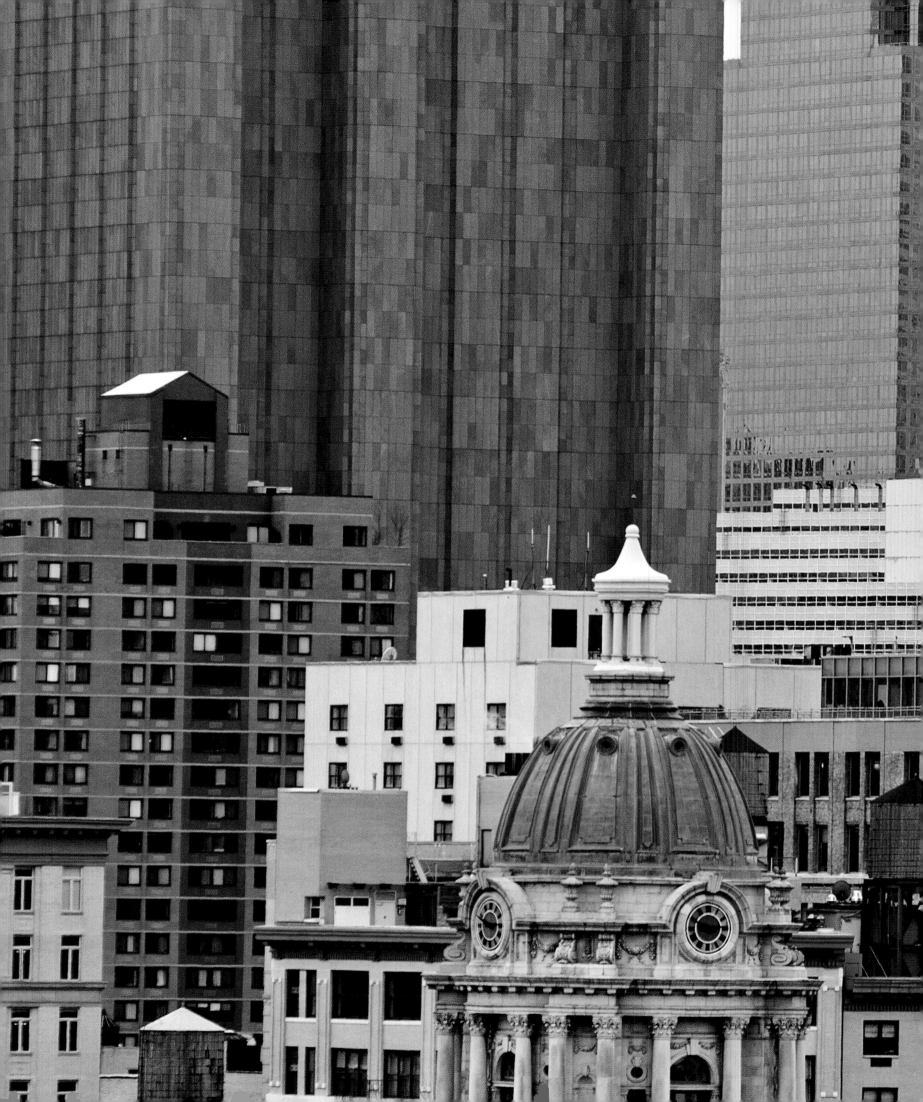

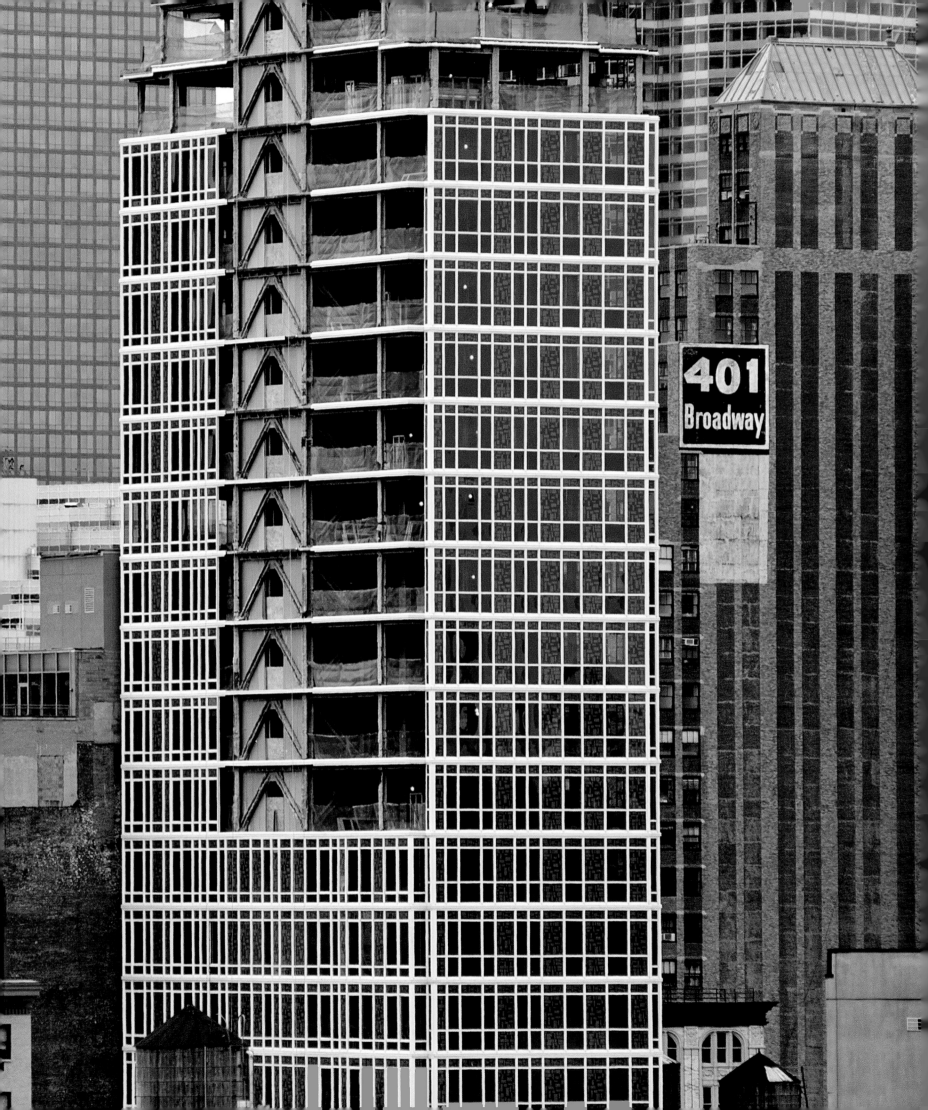

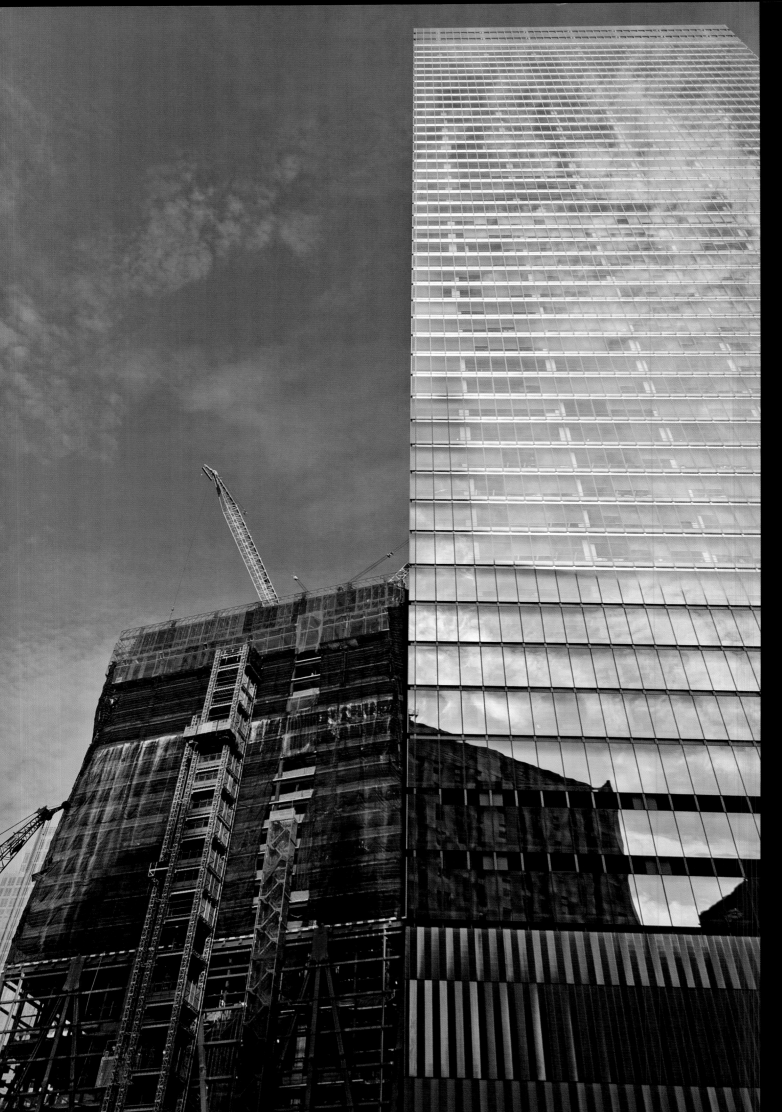

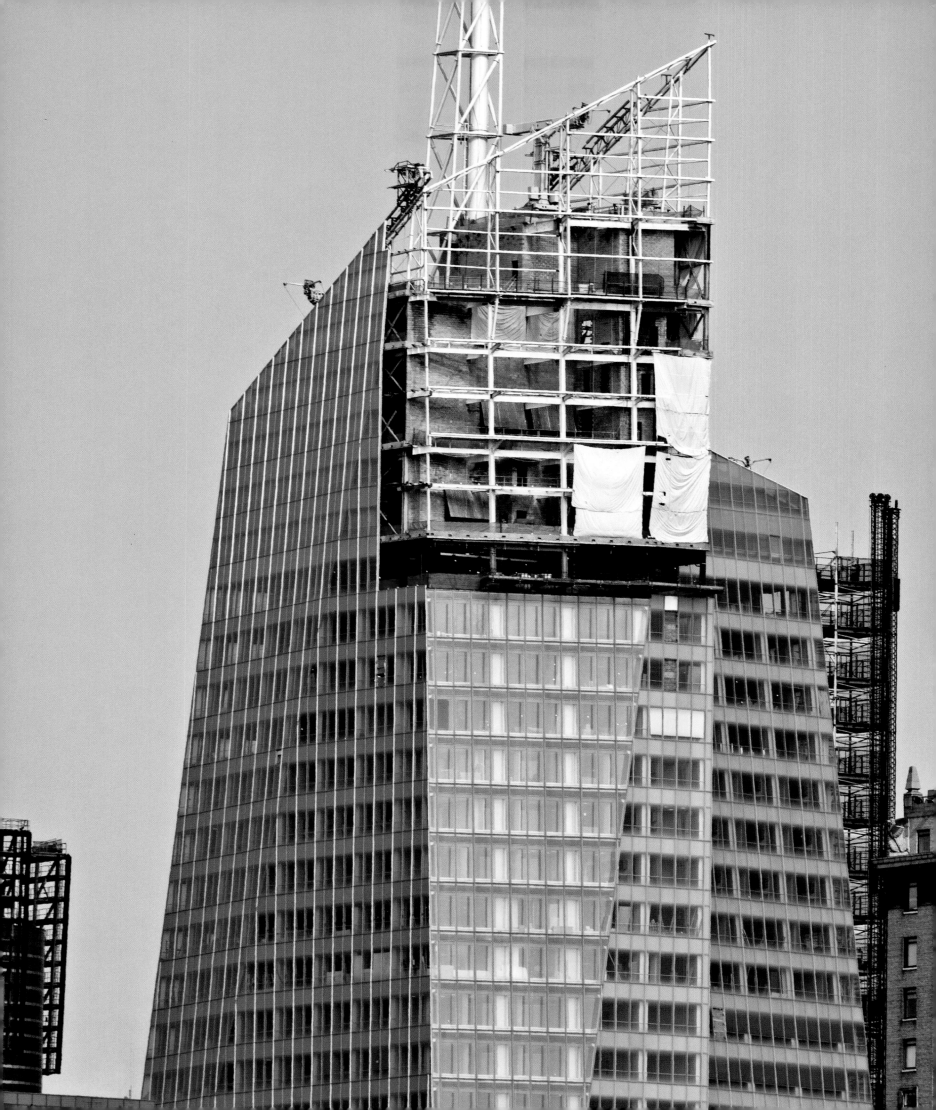

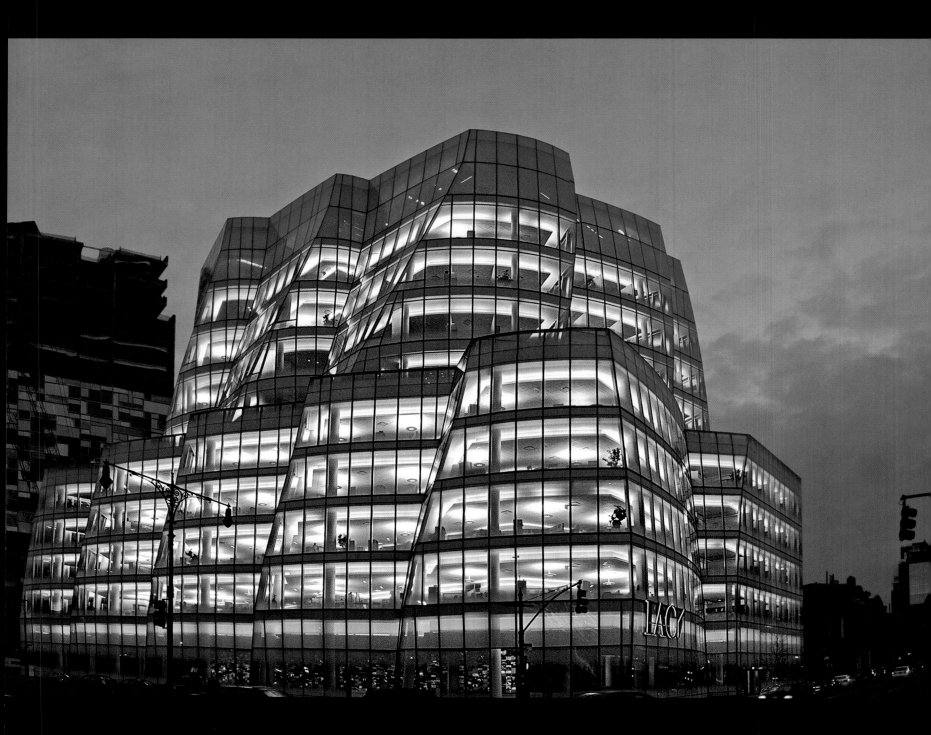

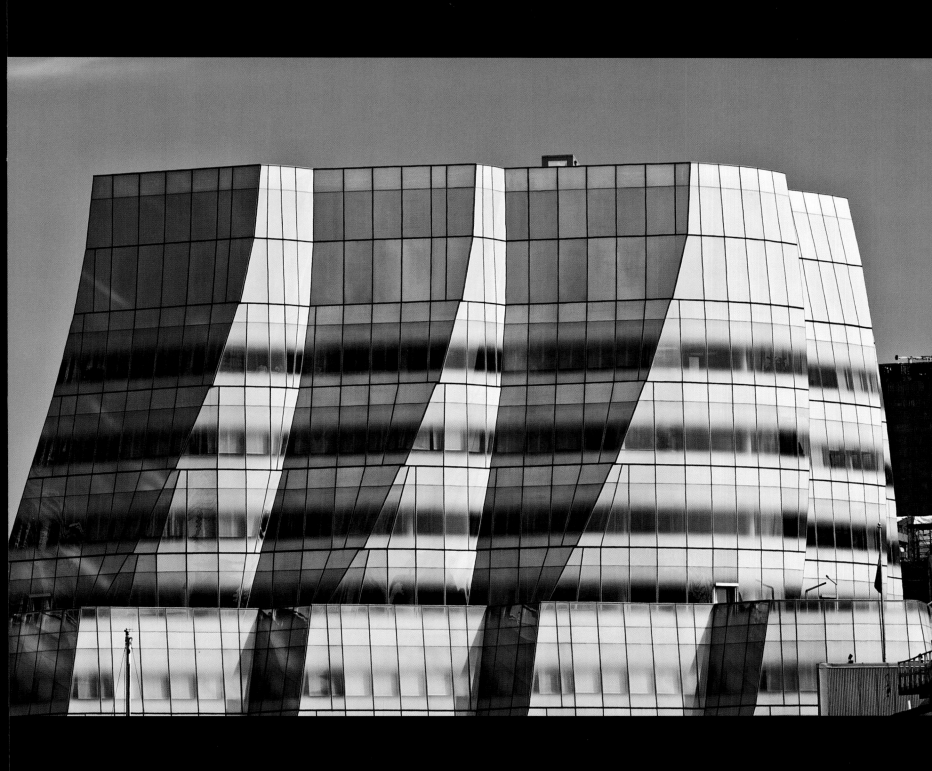

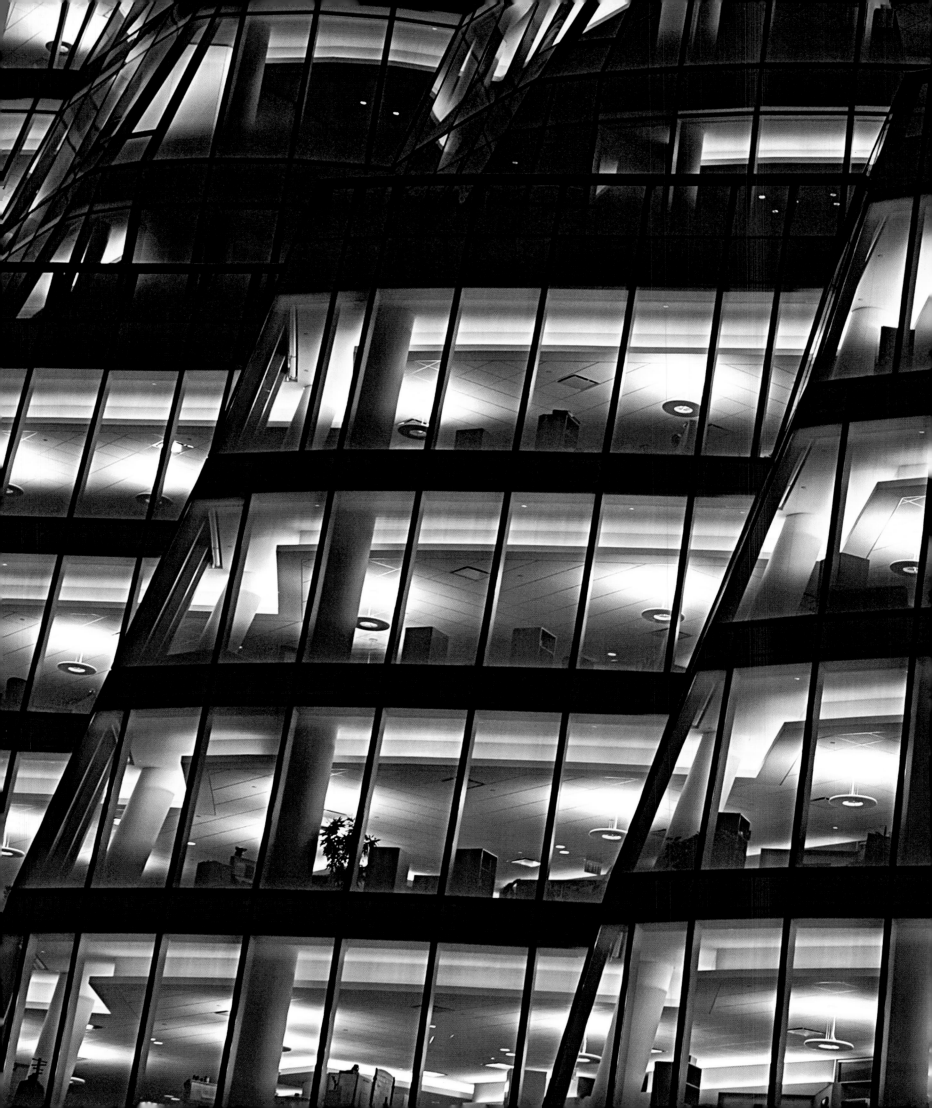

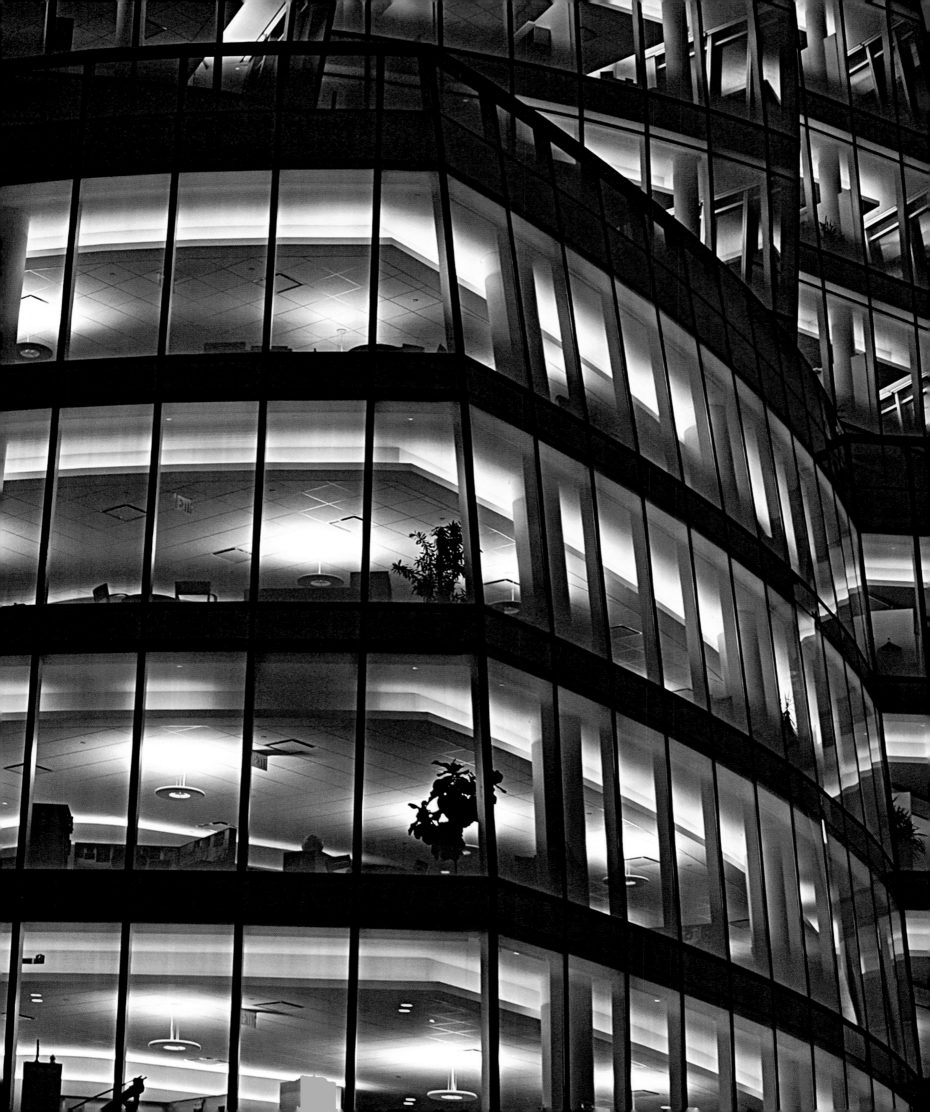

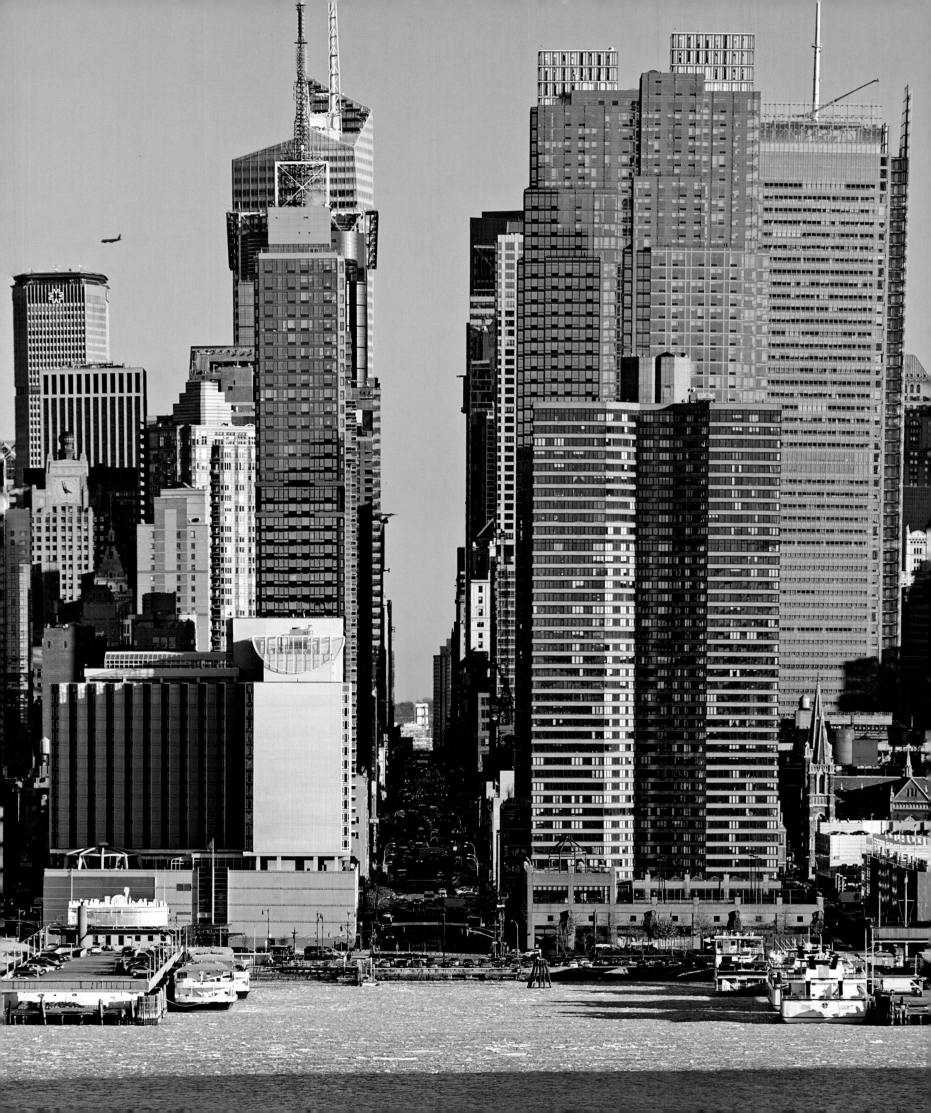

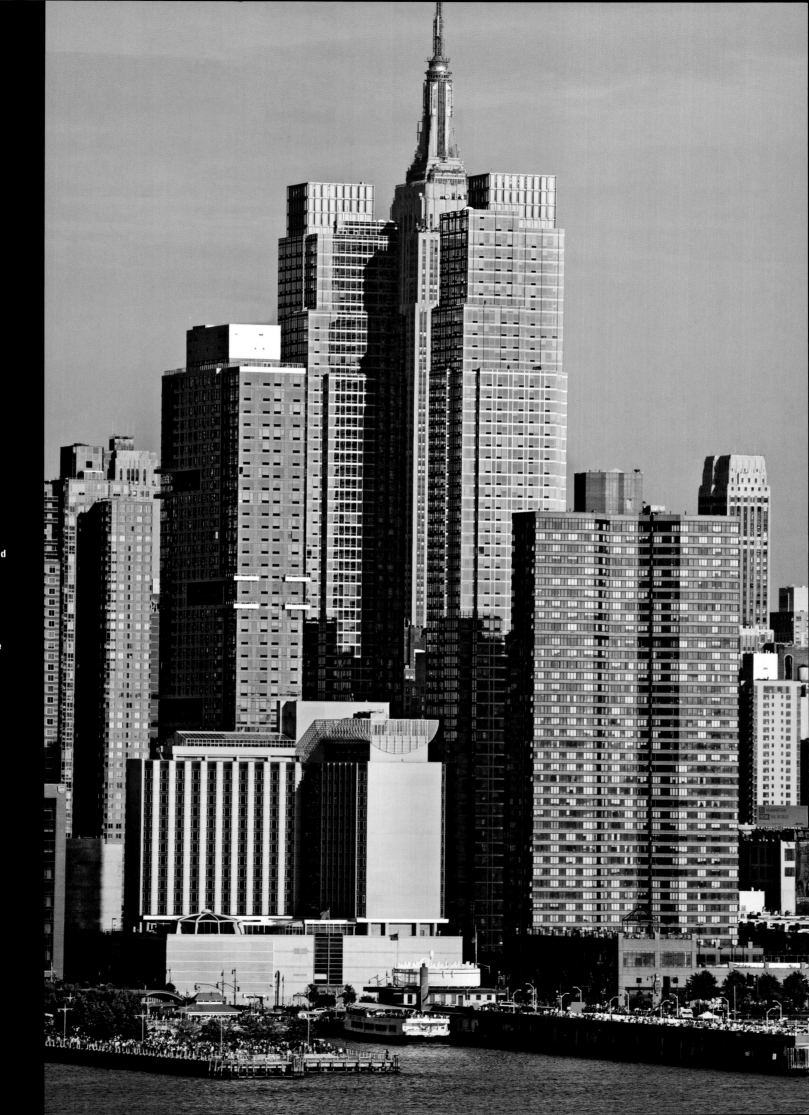

LEFT
View east on 42nd Street from the Hudson River.

RIGHT
Empire State Building from the Hudson River.

OVERLEAF
One Court Square, Citigroup Building, Long Island City, Queens. Skidmore, Owings & Merrill

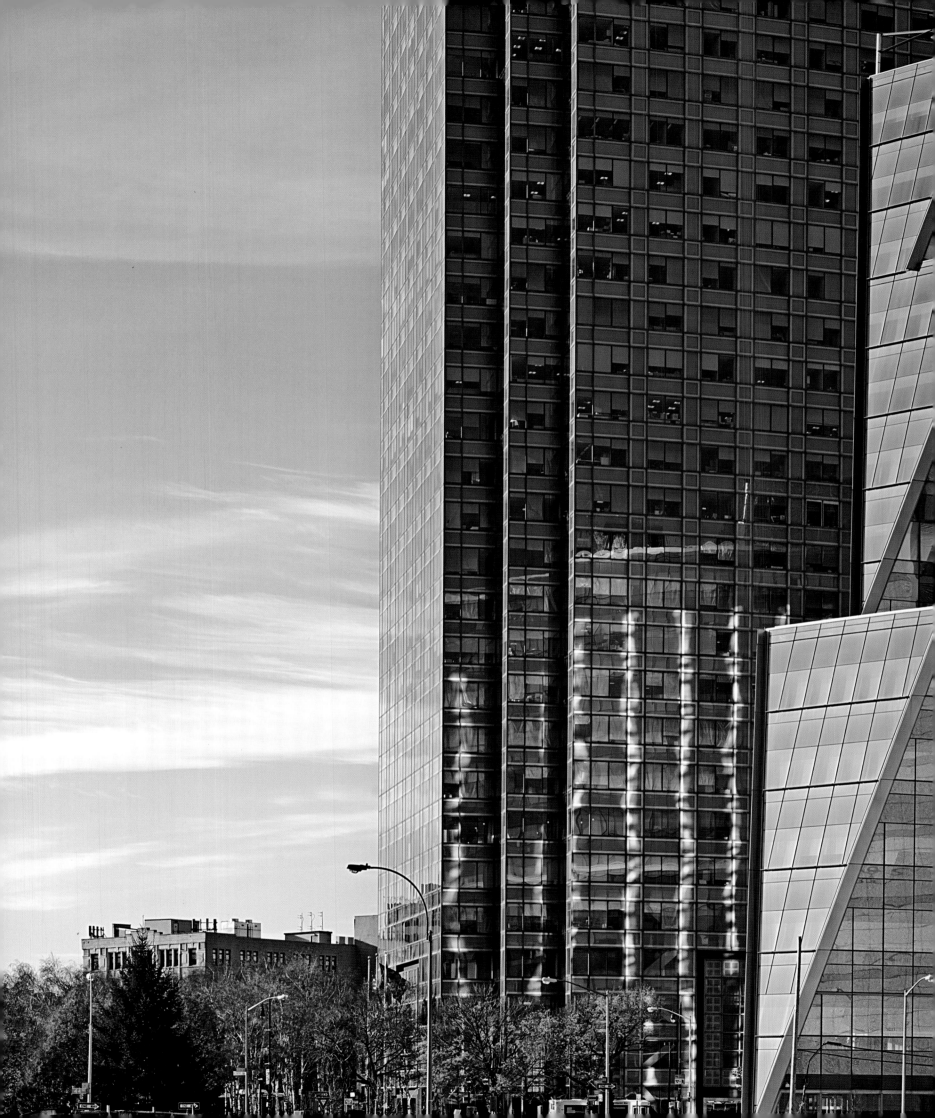

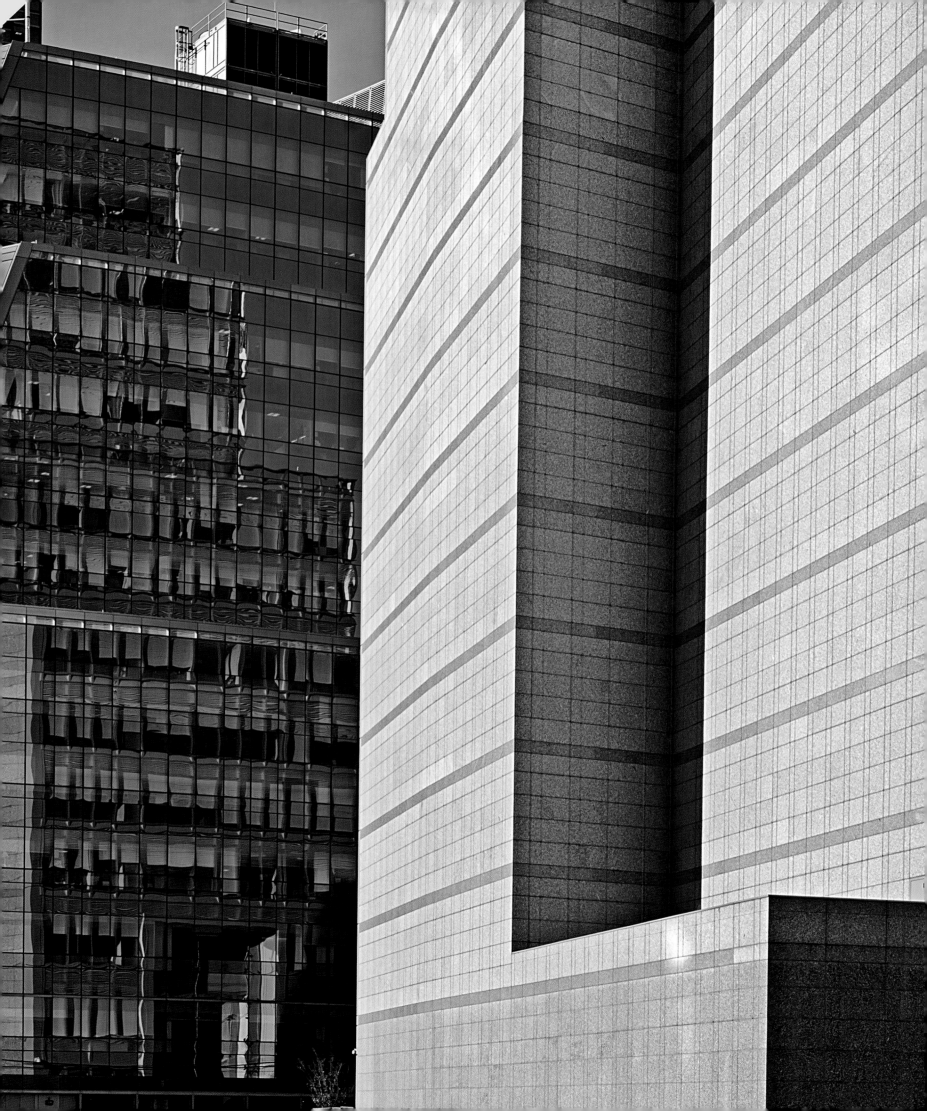

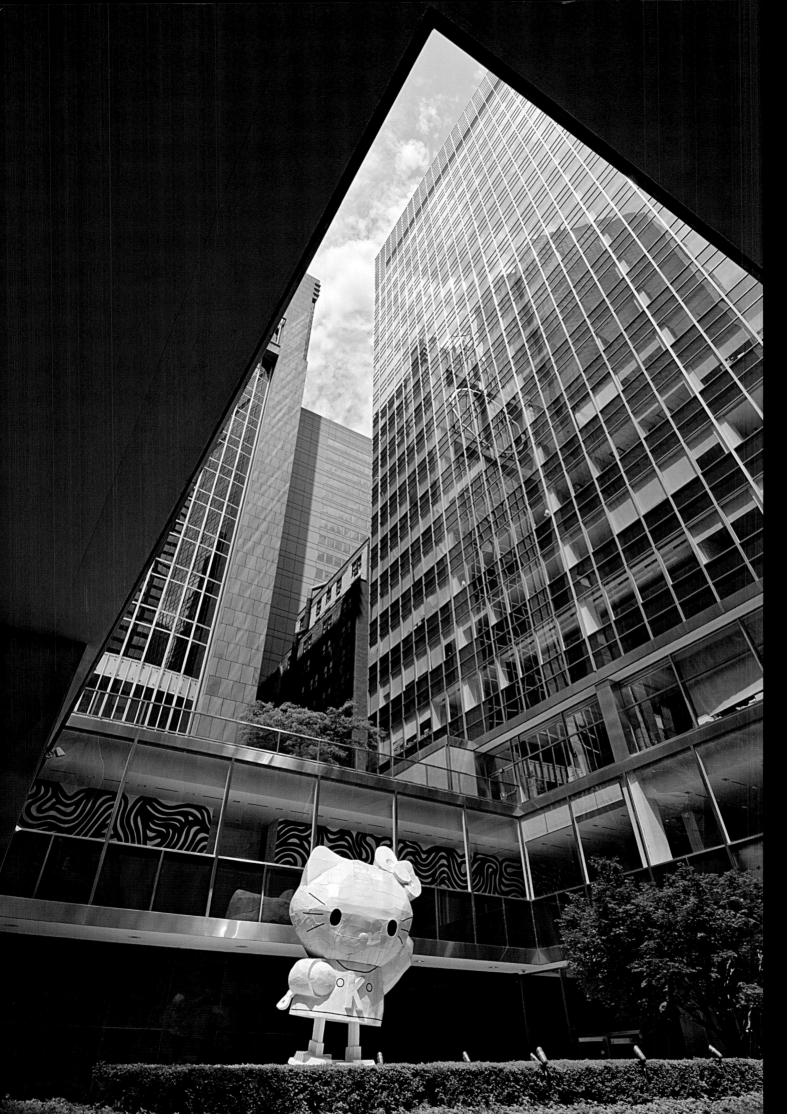

152

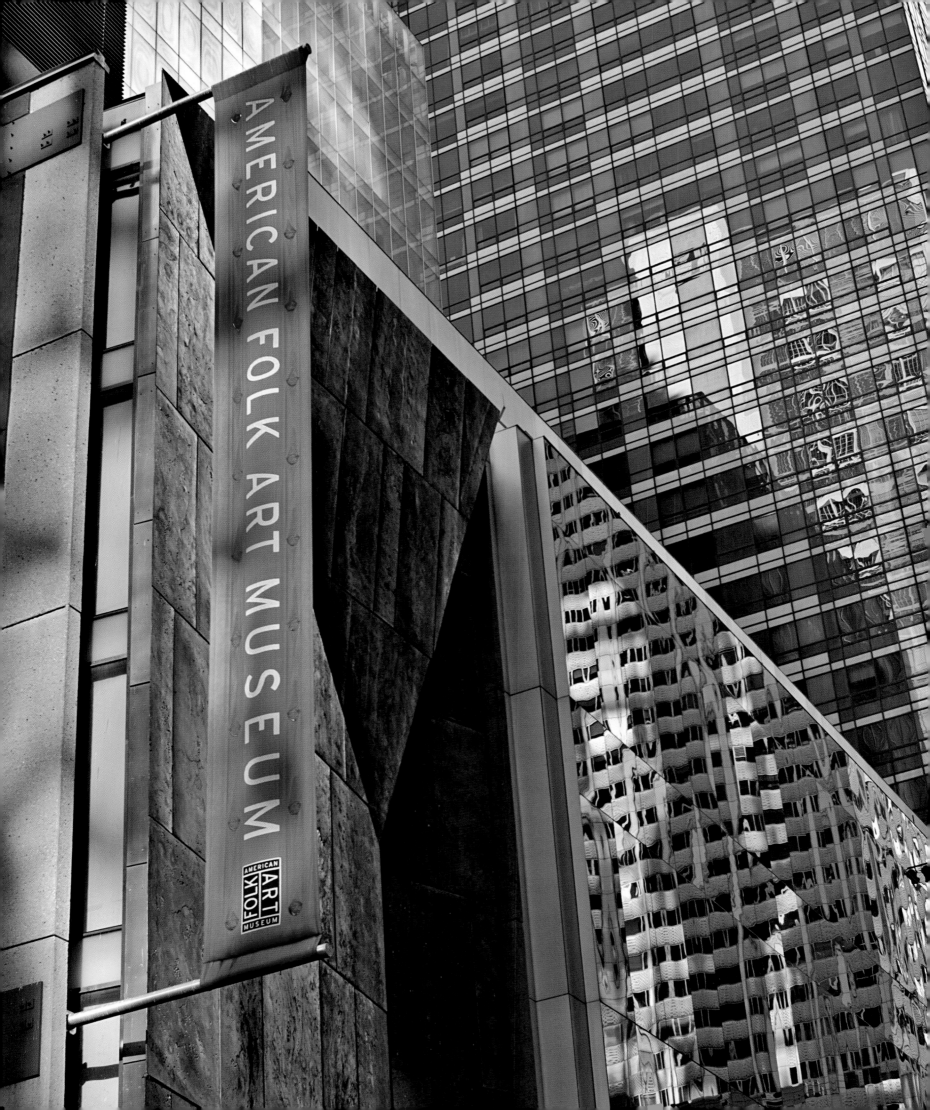

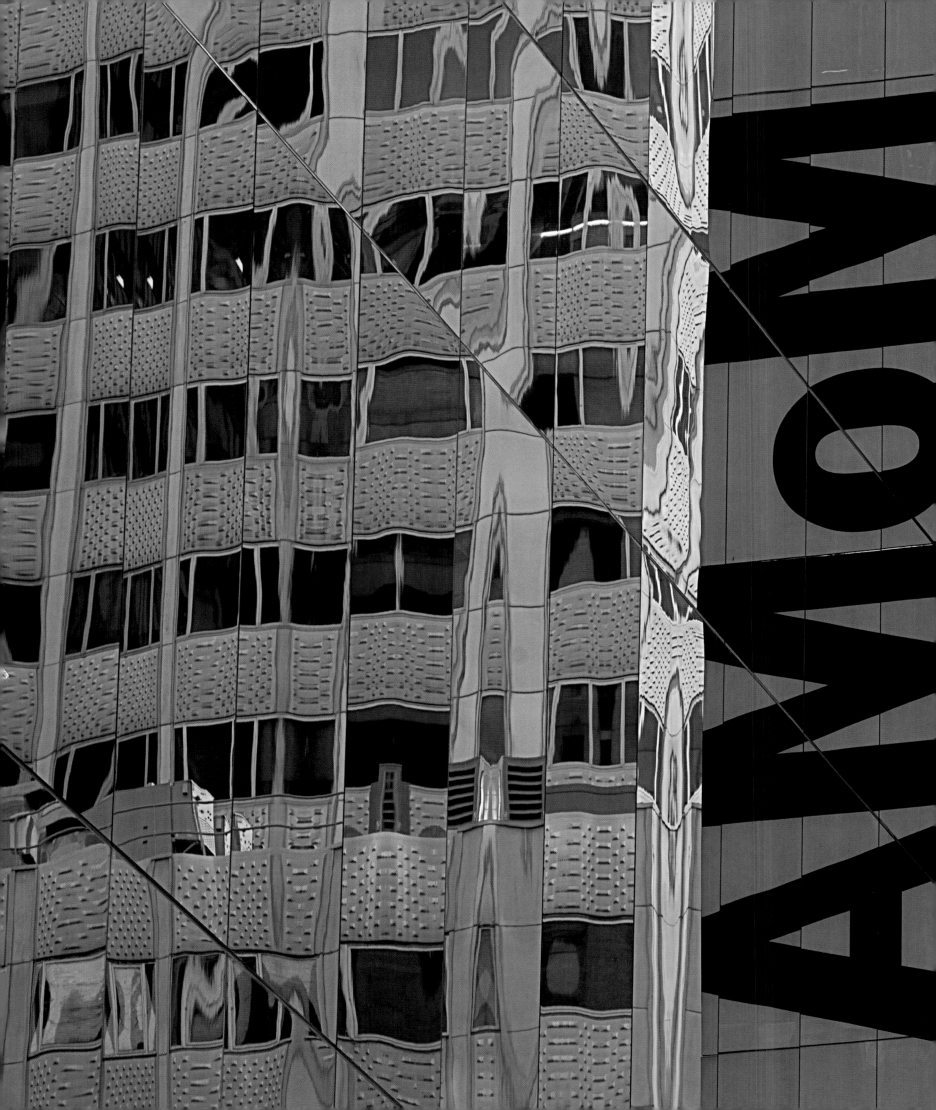

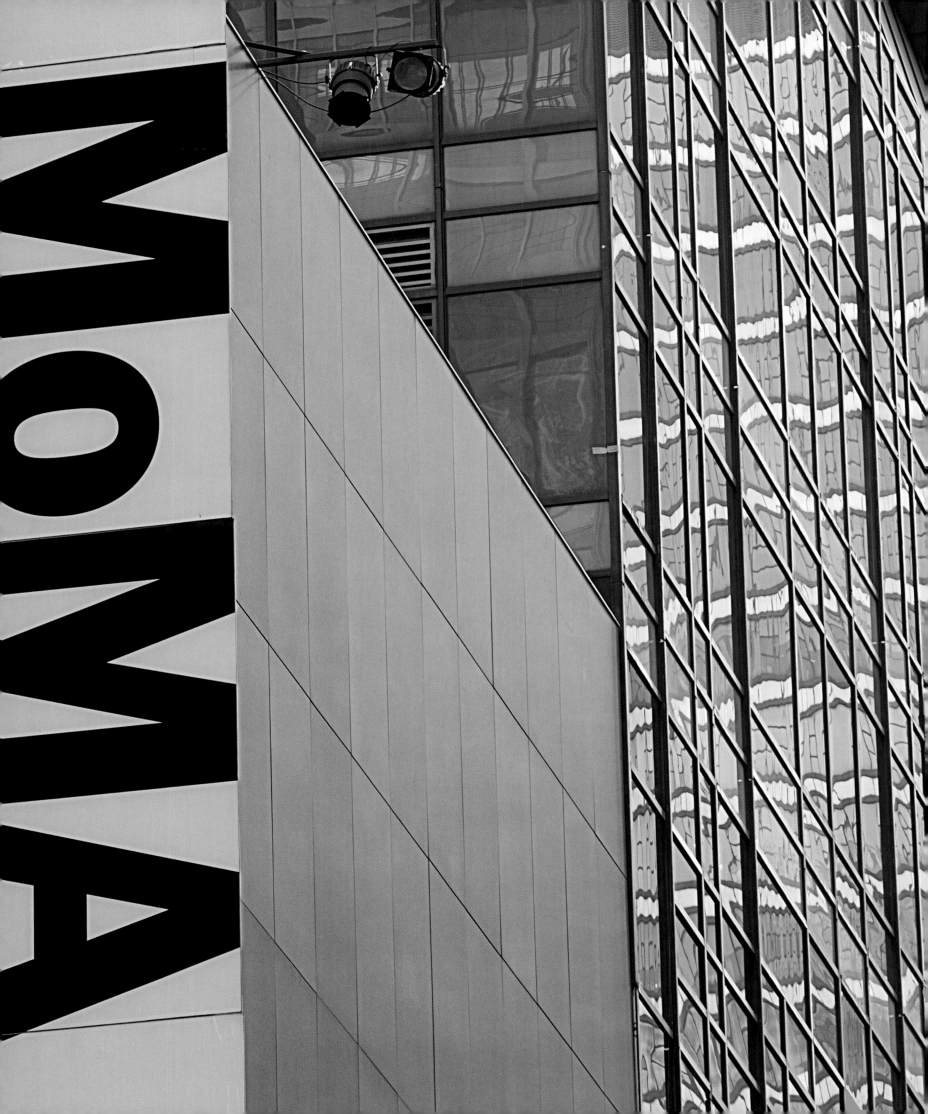

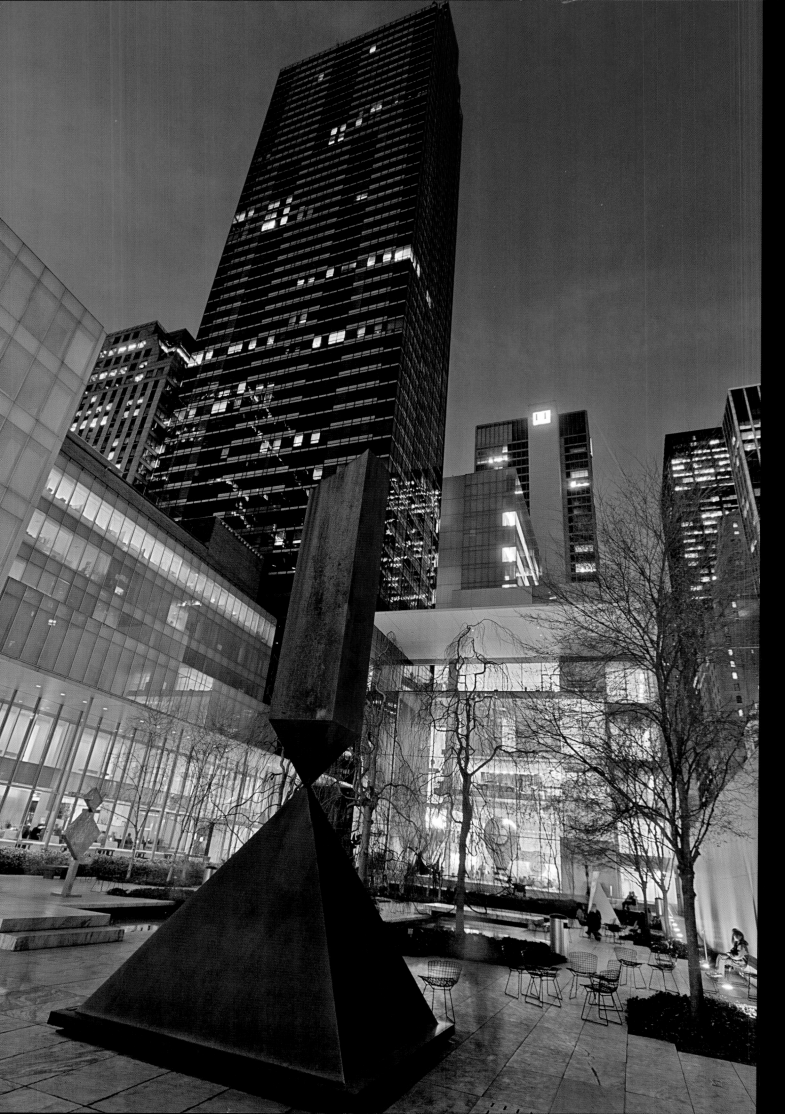

156

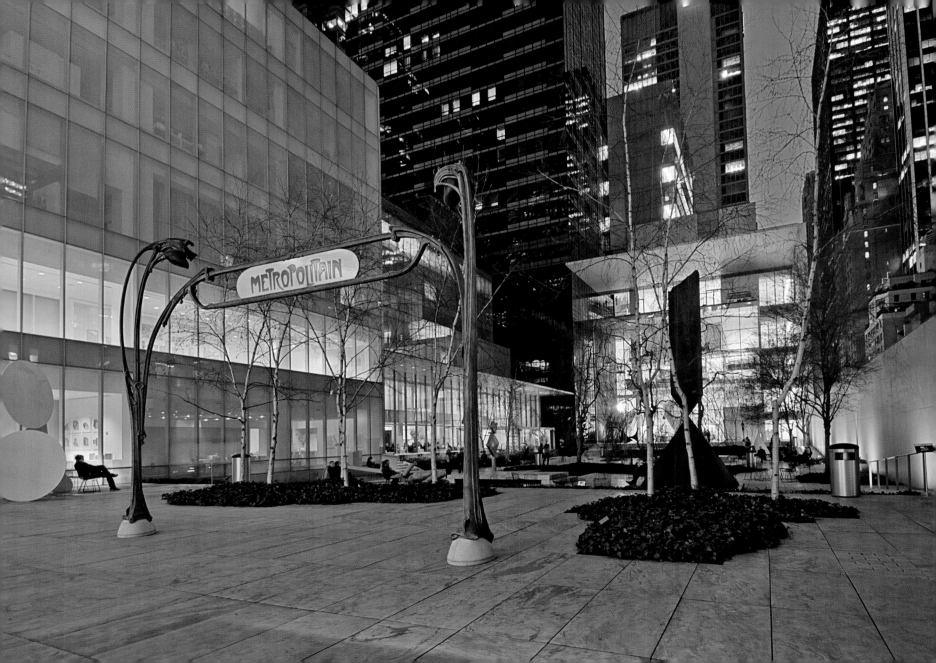

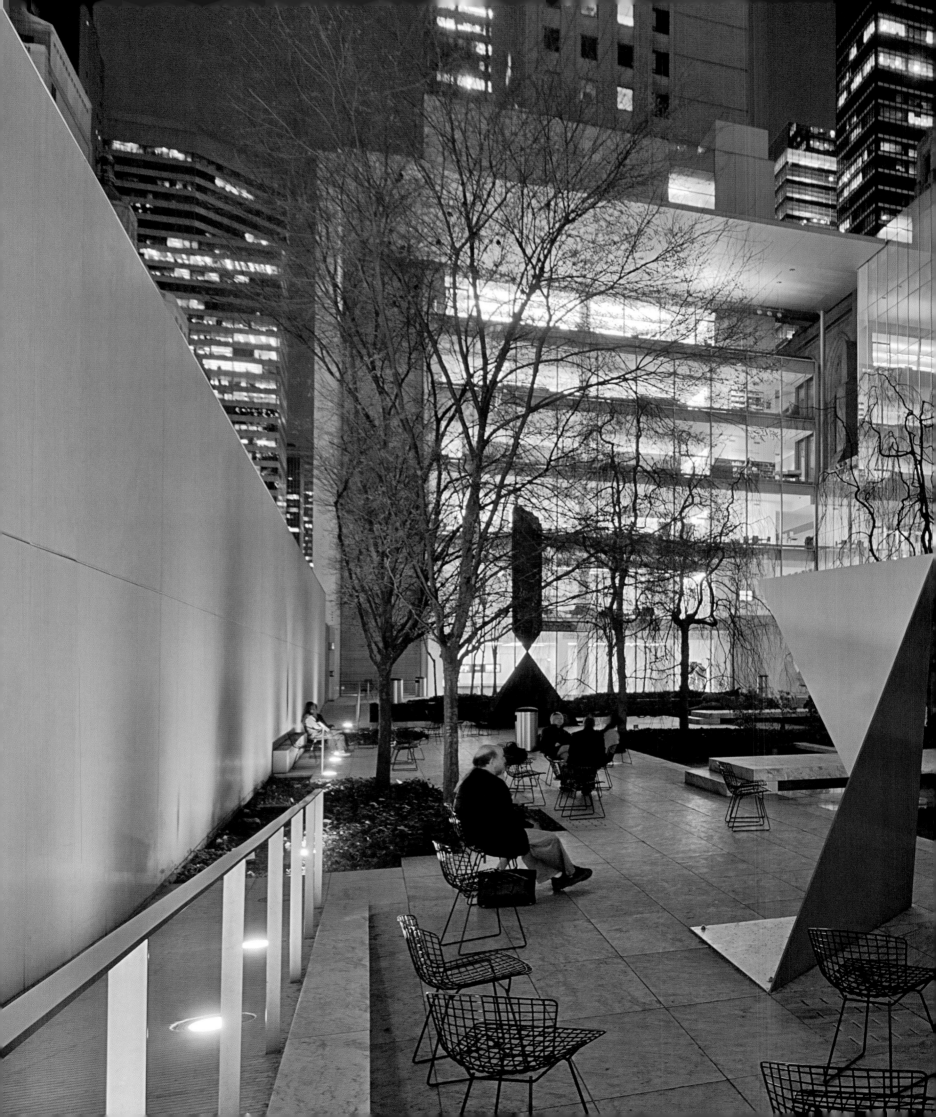

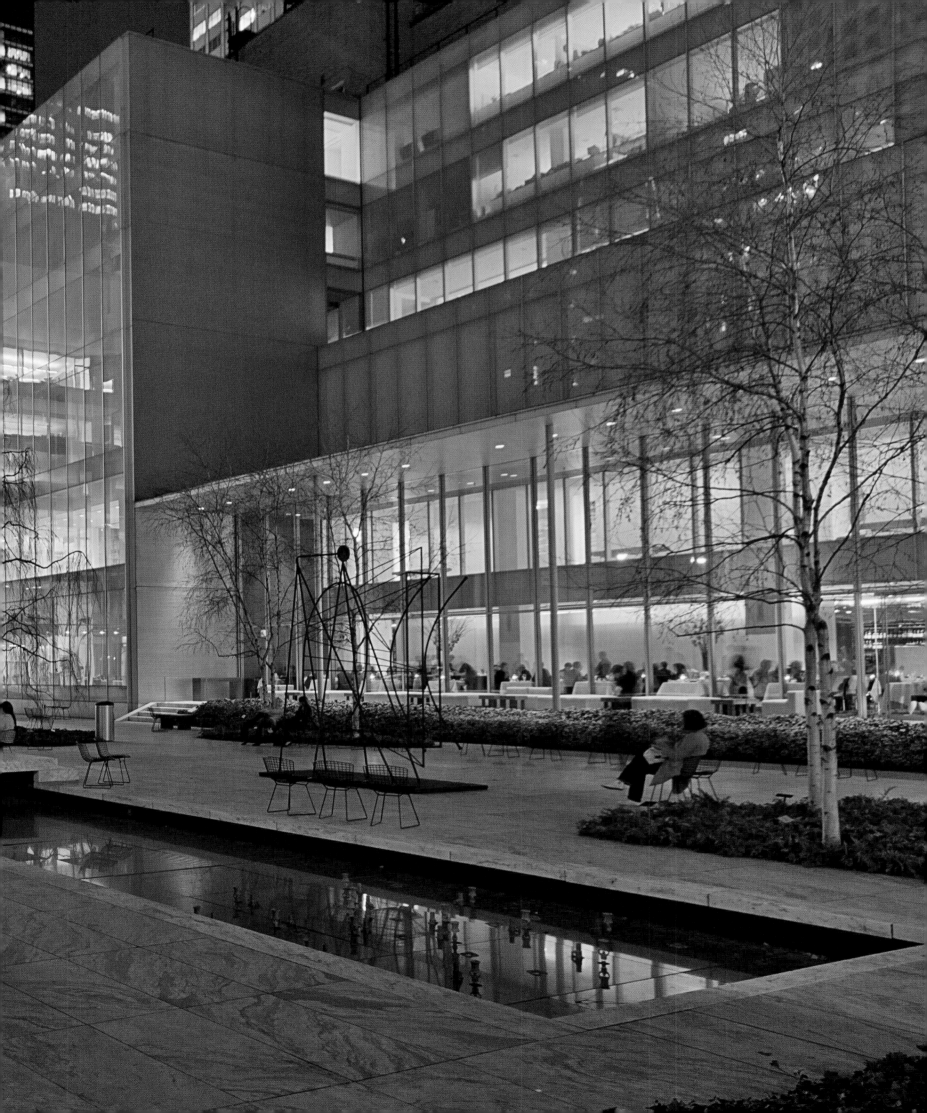

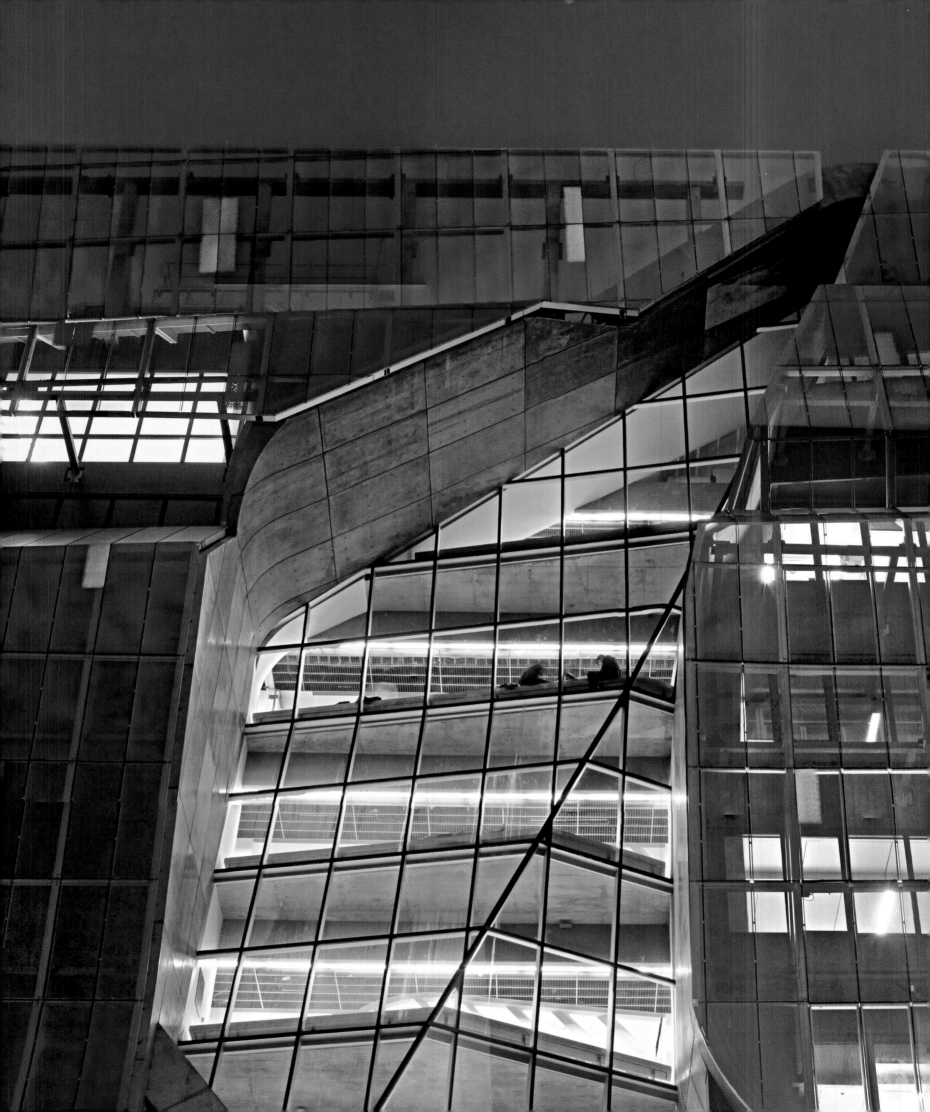

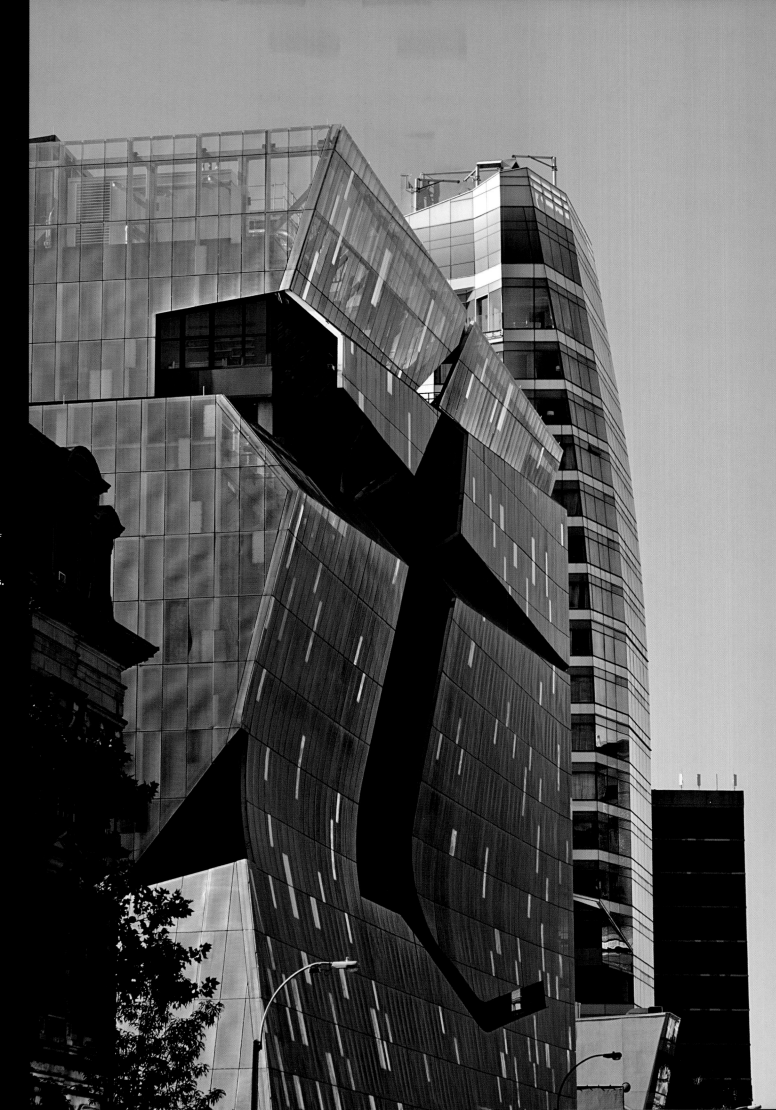

LEFT, RIGHT AND OVERLEAF
41 Cooper Square,
The Cooper Union,
Morphosis Architects.

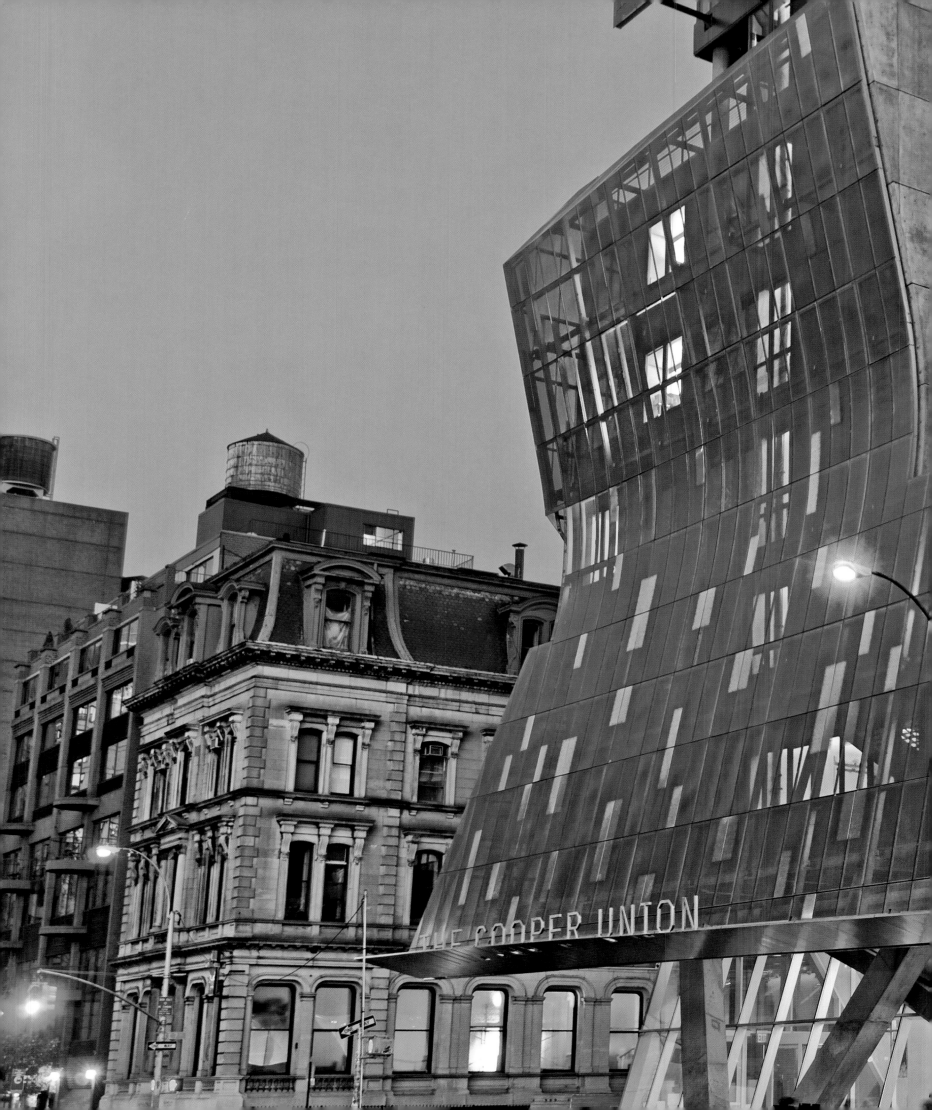

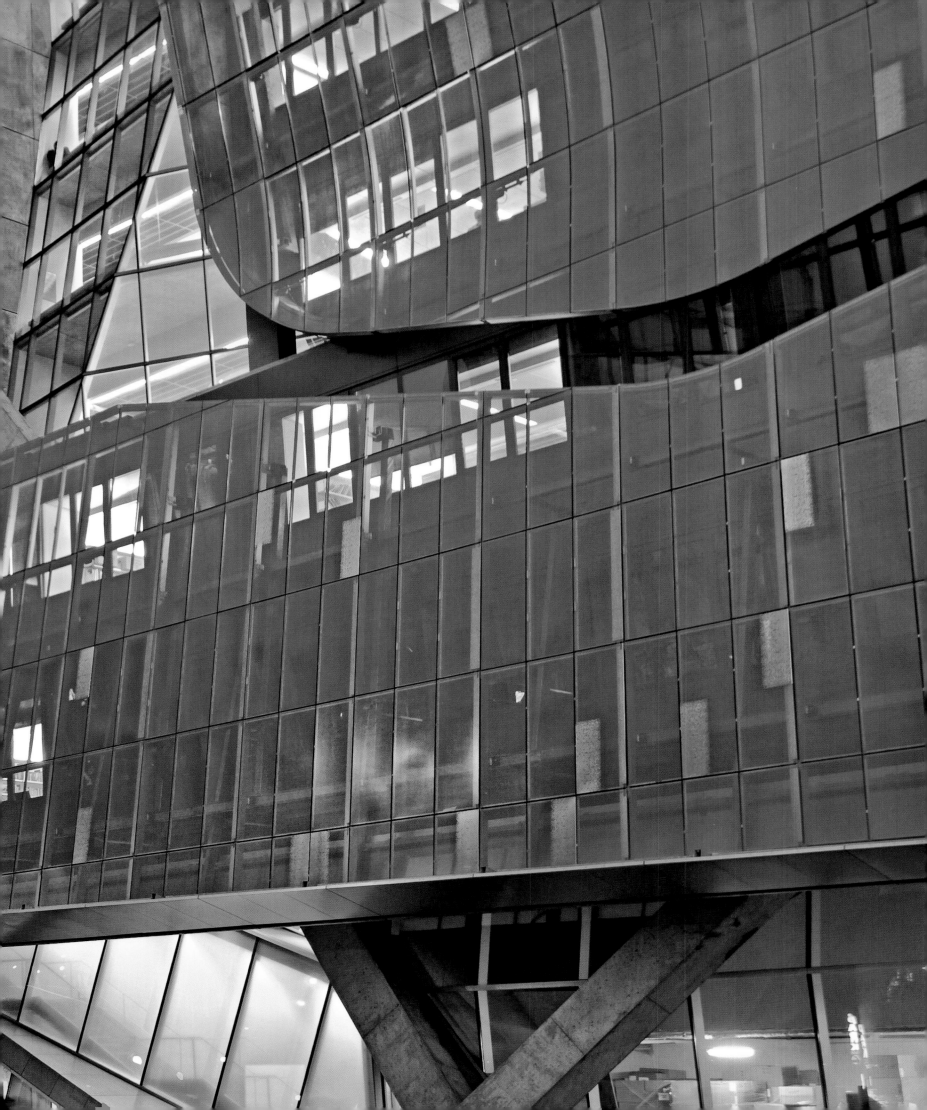

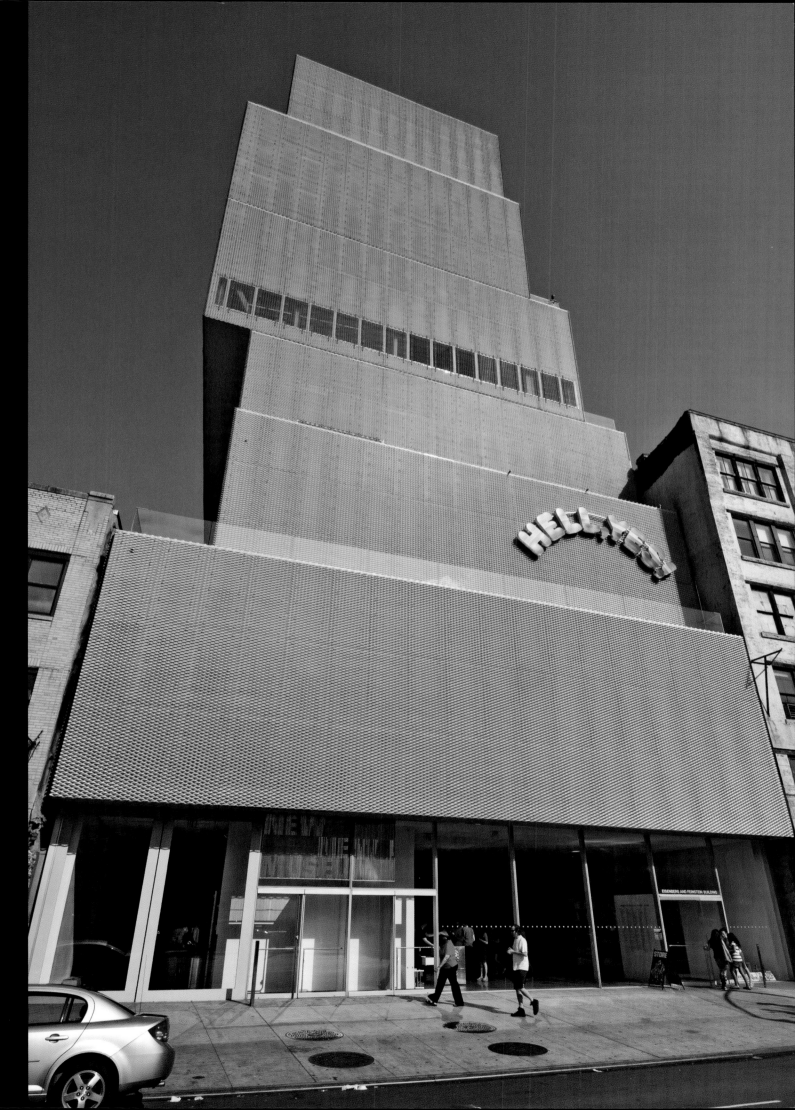

New Museum,
235 Bowery, Kazuyo
Sejima + Ryue
Nishizawa / S A N A A

OVERLEAF
5 Pointz, Long
Island City, Queens.

165

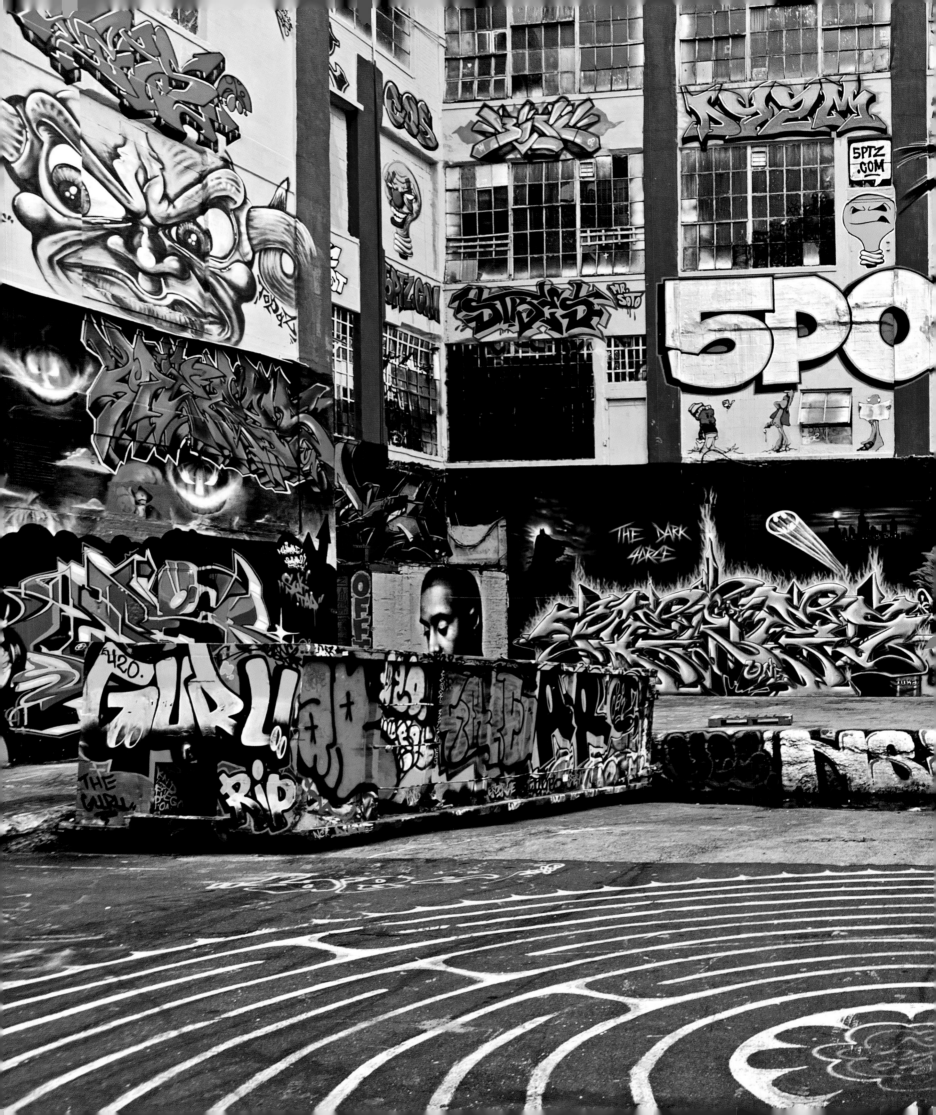

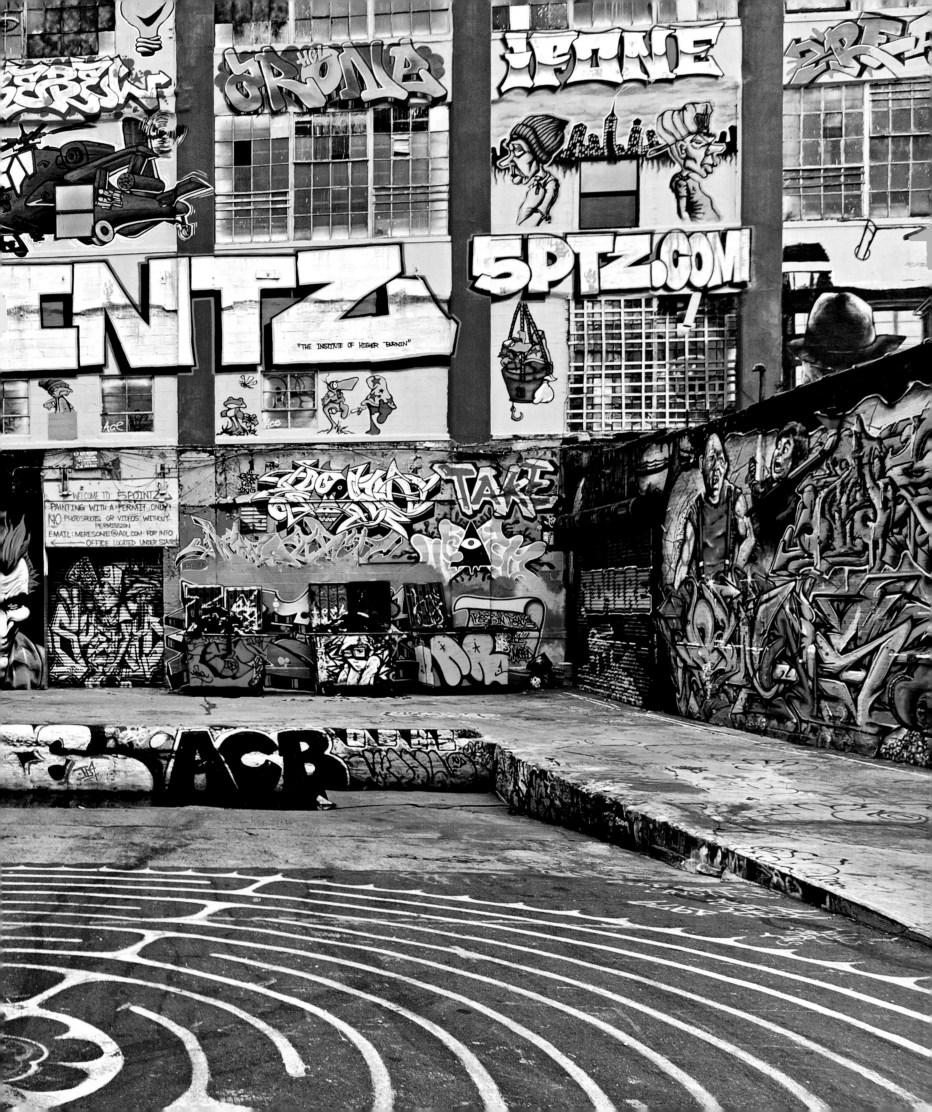

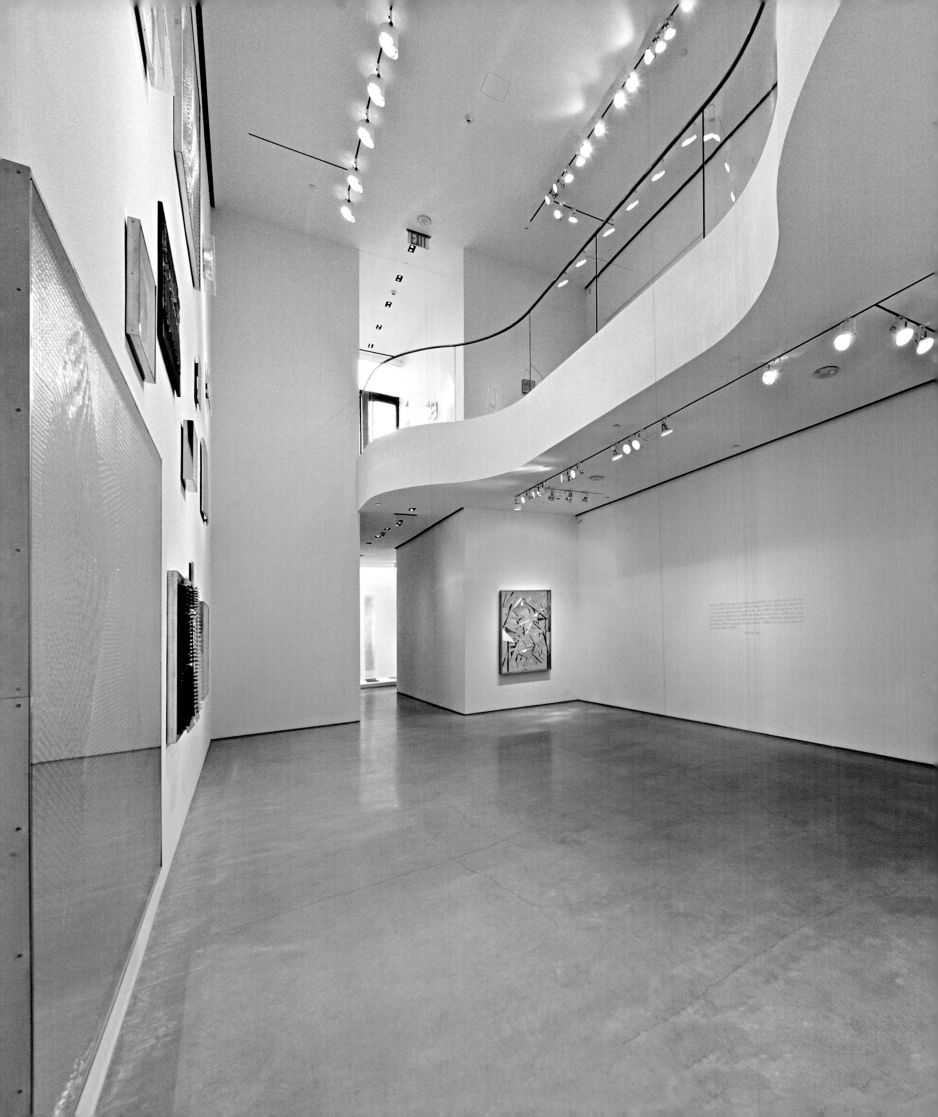

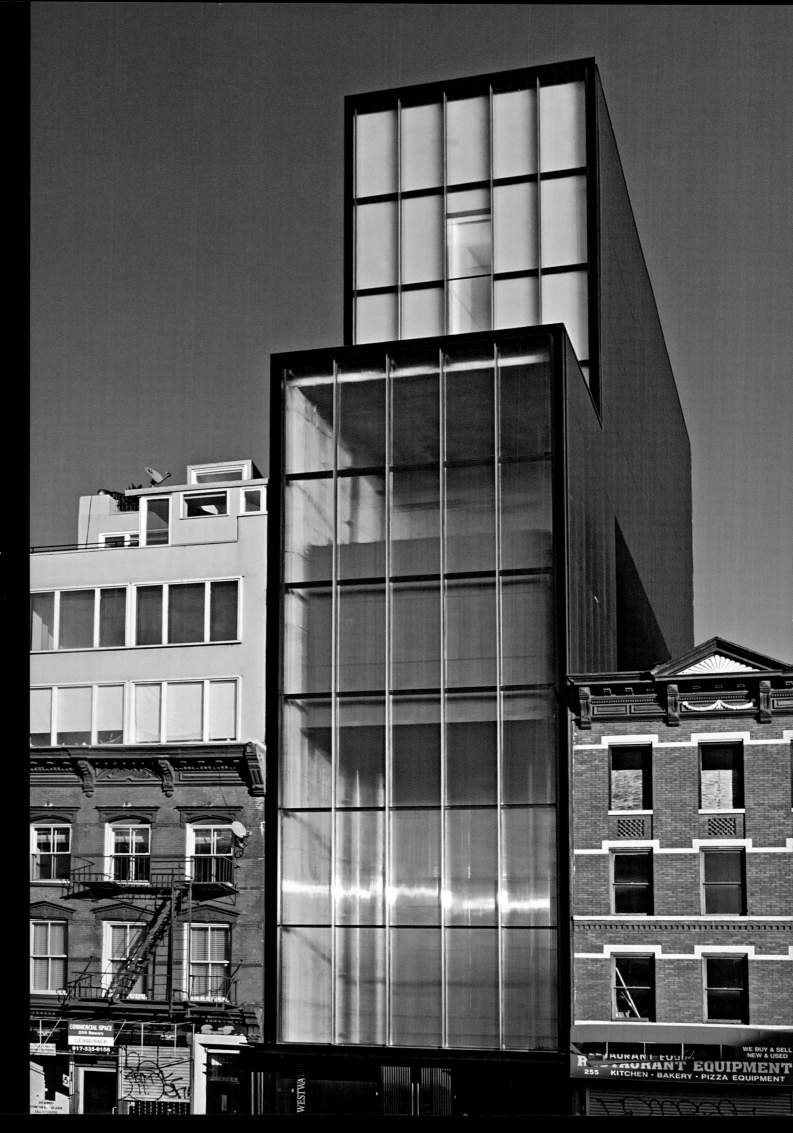

Sperone Westwater
Gallery, 257 Bowery,
Foster + Partners.

OVERLEAF
New Museum,
235 Bowery, Kazuyo
Sejima + Ryue
Nishizawa / S A N A A

169

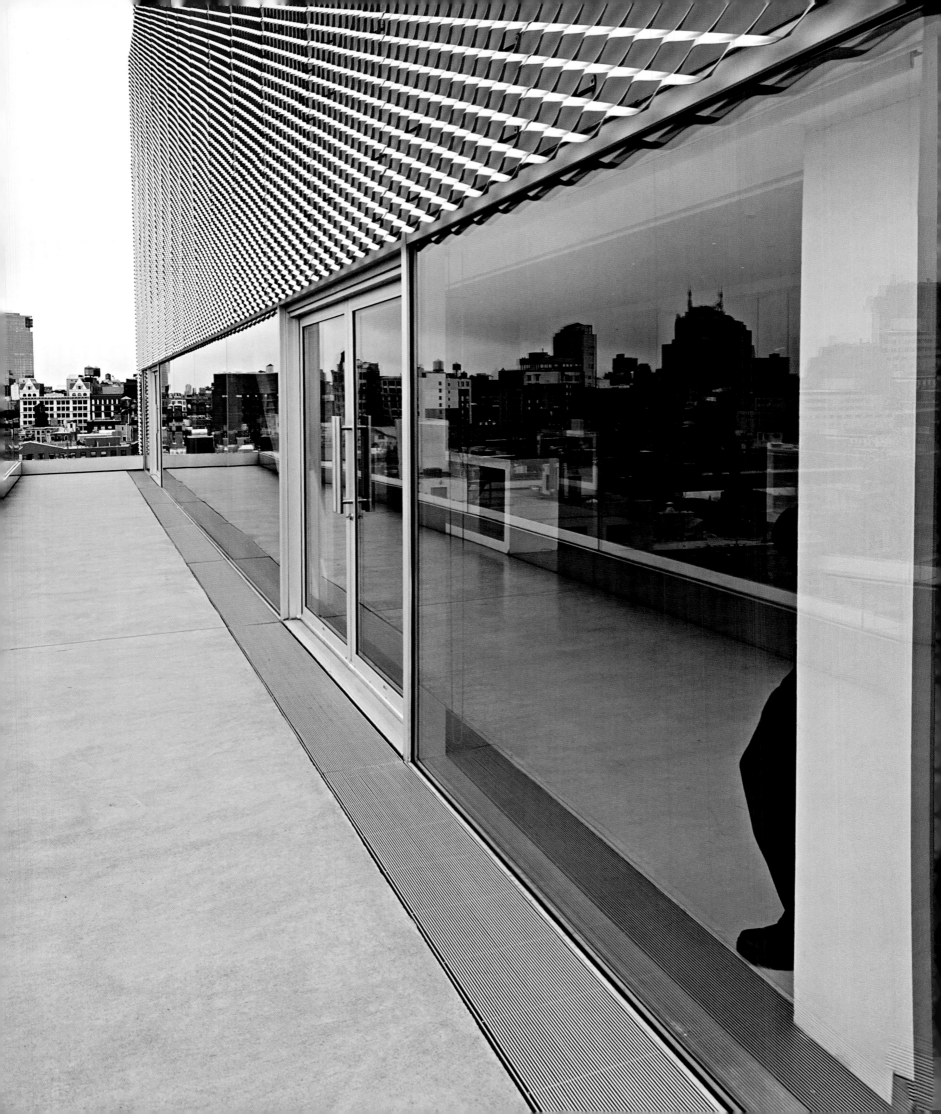

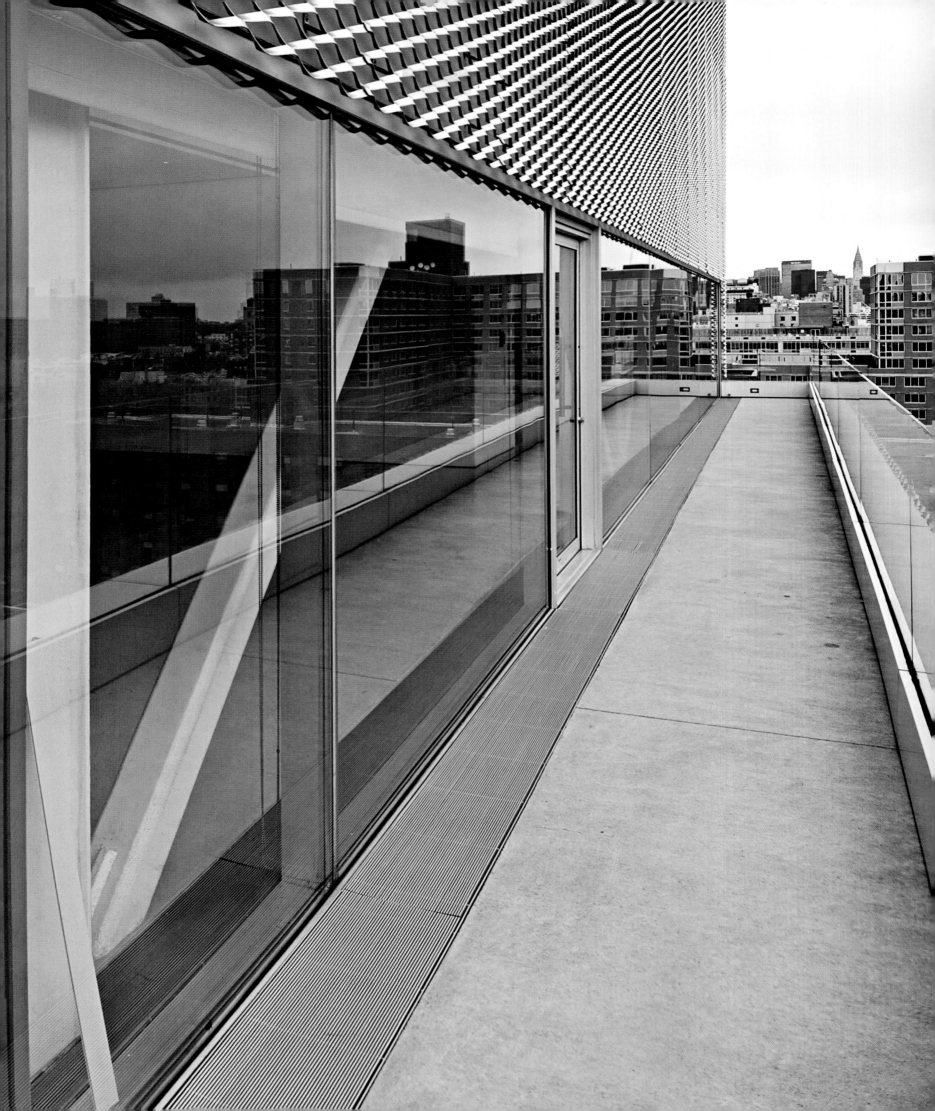

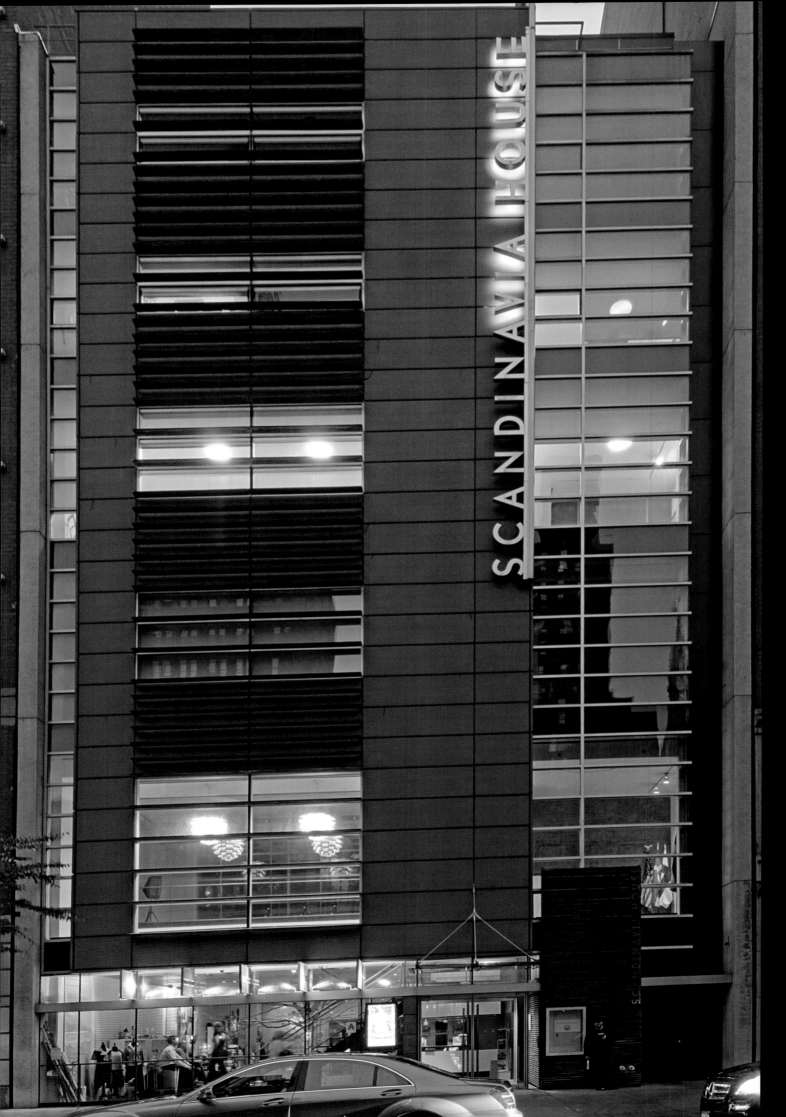

Scandinavia House,
58 Park Avenue,
Polshek Partnership.

OVERLEAF
Andy Goldsworthy,
Garden of Stones,
at the Museum of
Jewish Heritage,
Kevin Roche John
Dinkeloo Associates.

172

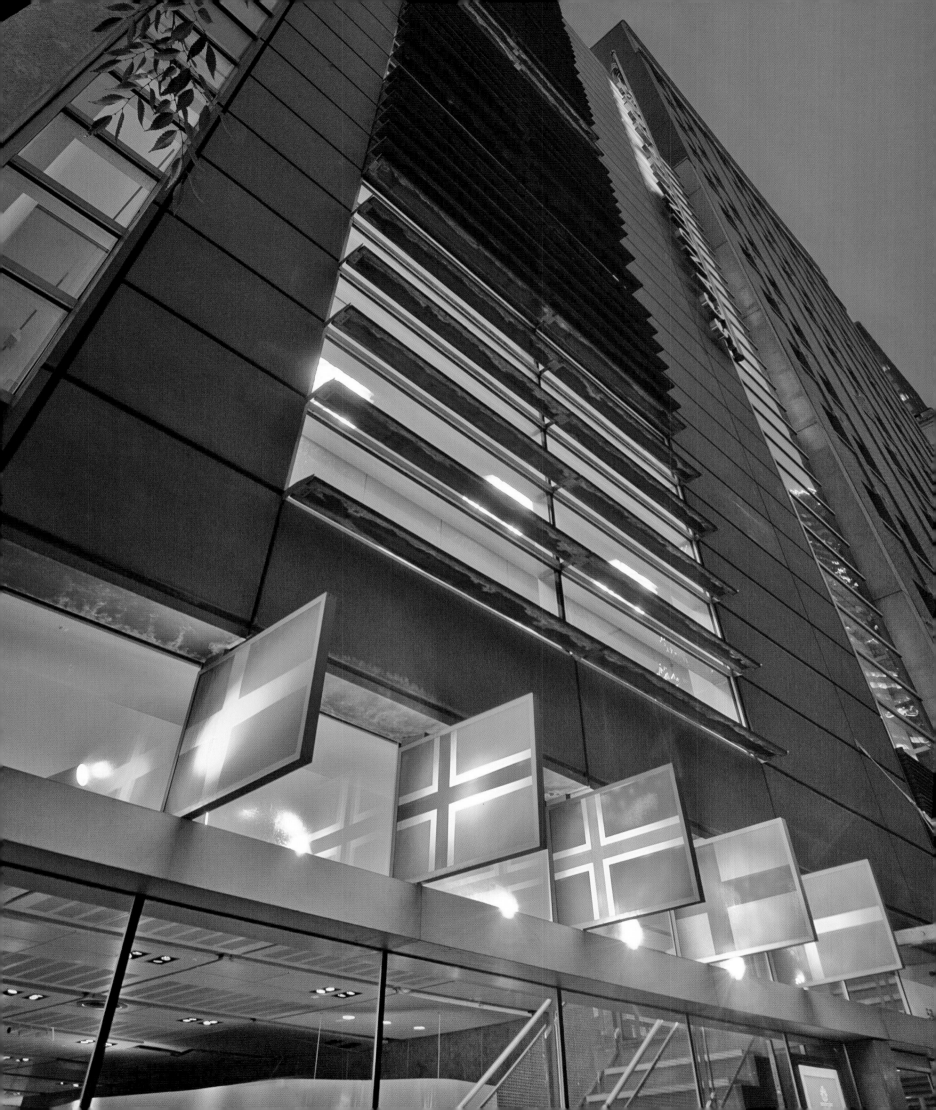

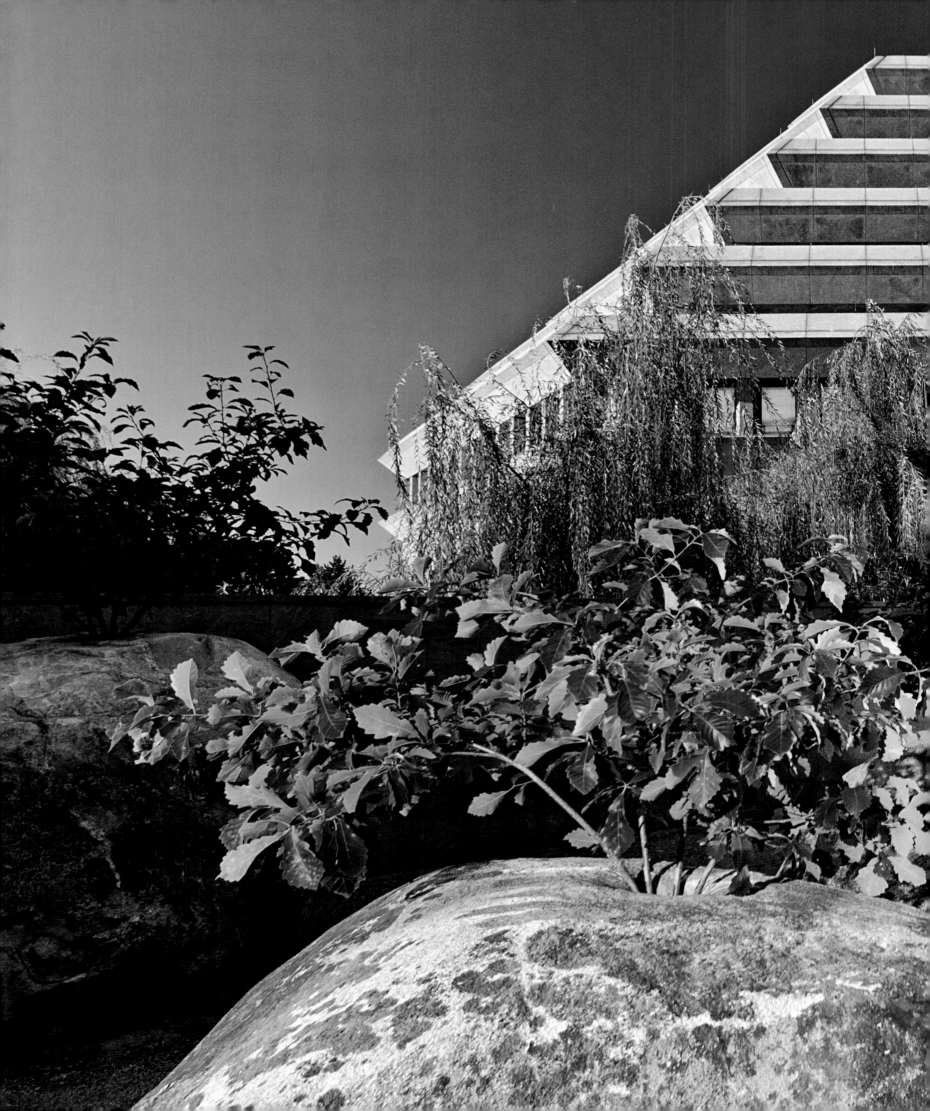

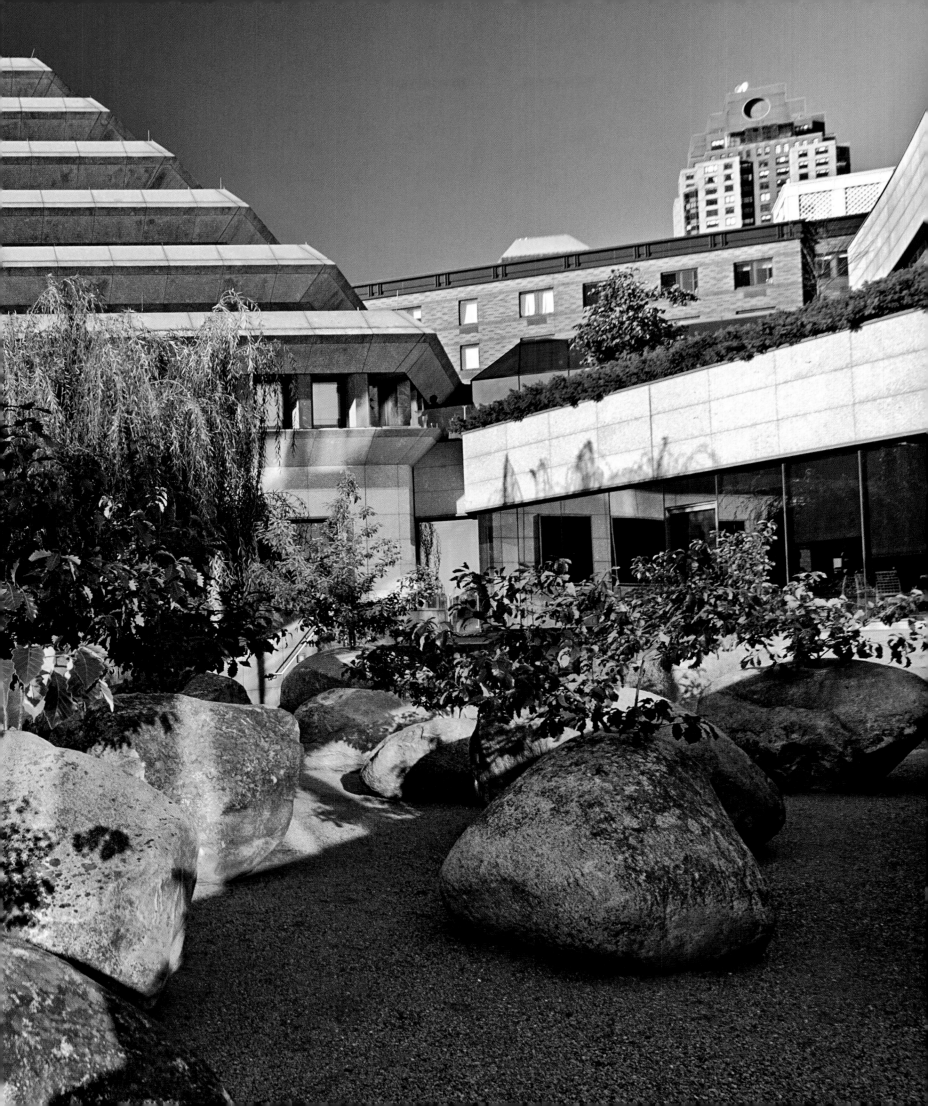

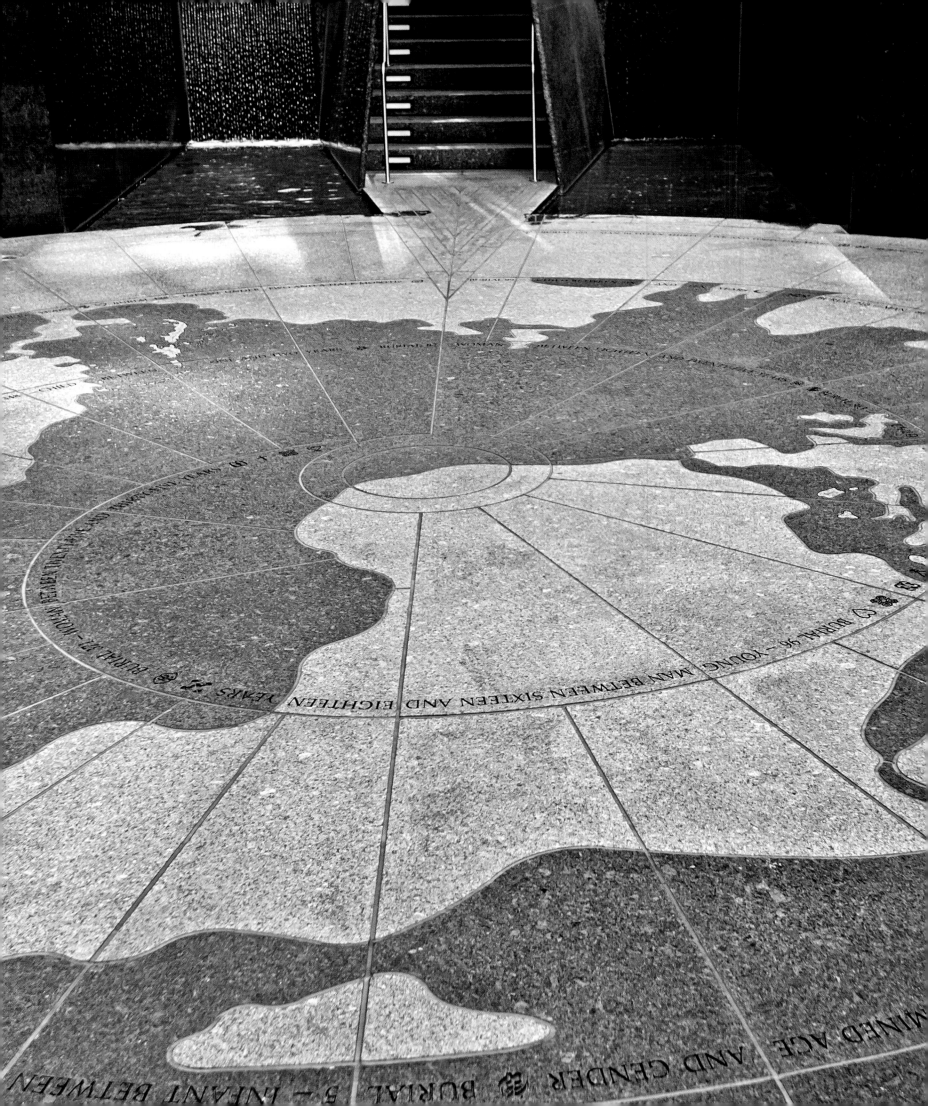

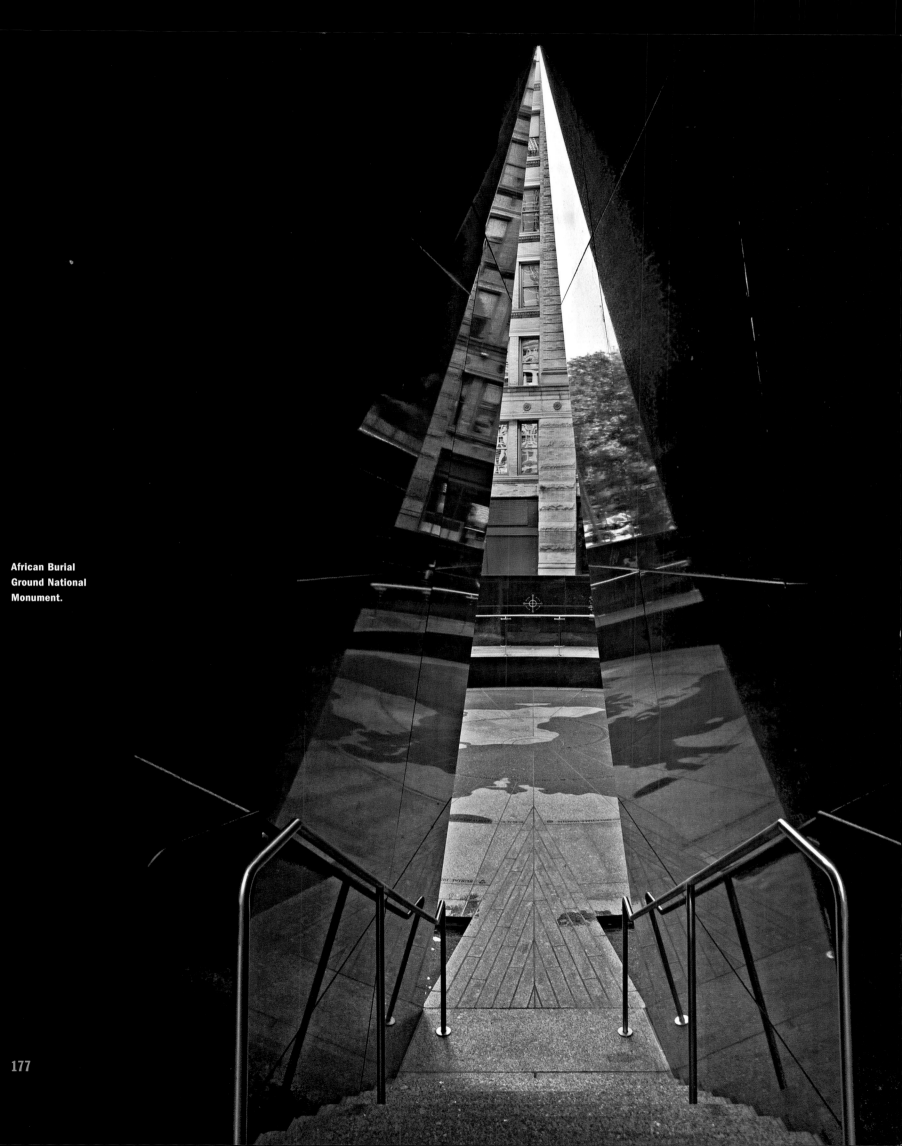

African Burial
Ground National
Monument.

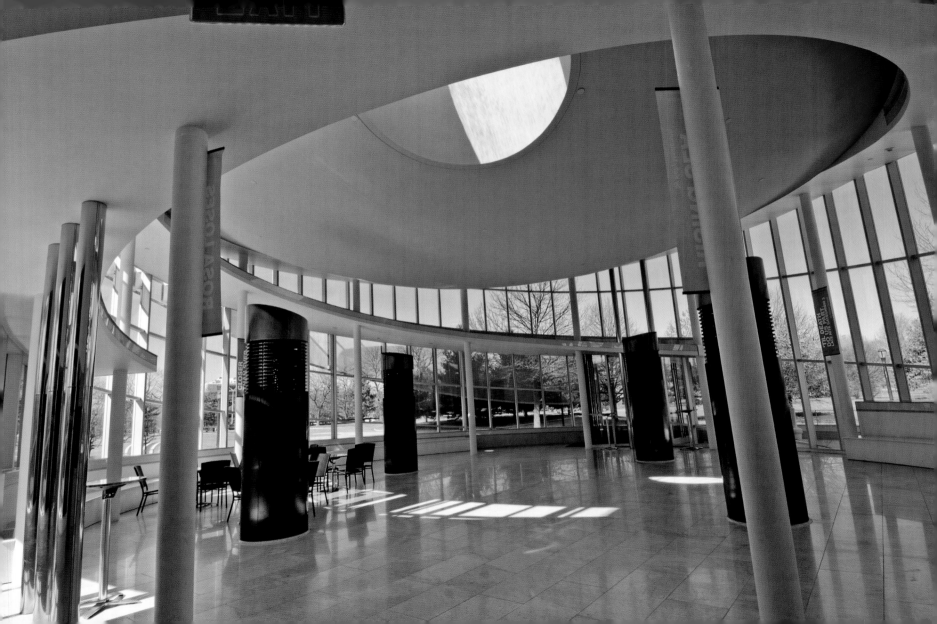

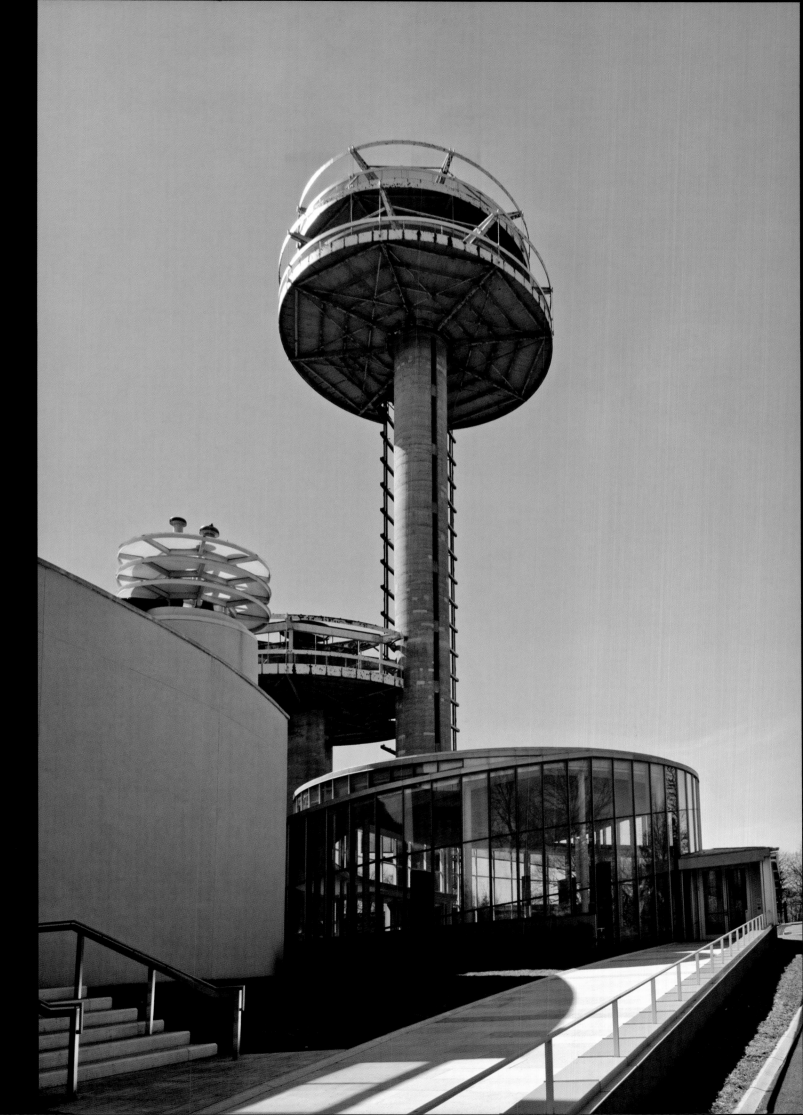

Queens Theater in the Park, Flushing Meadows-Corona Park, Queens, Caples Jefferson Architects.

OVERLEAF
Alice Tully Hall, Lincoln Center, renovation Diller Scofidio + Renfro.

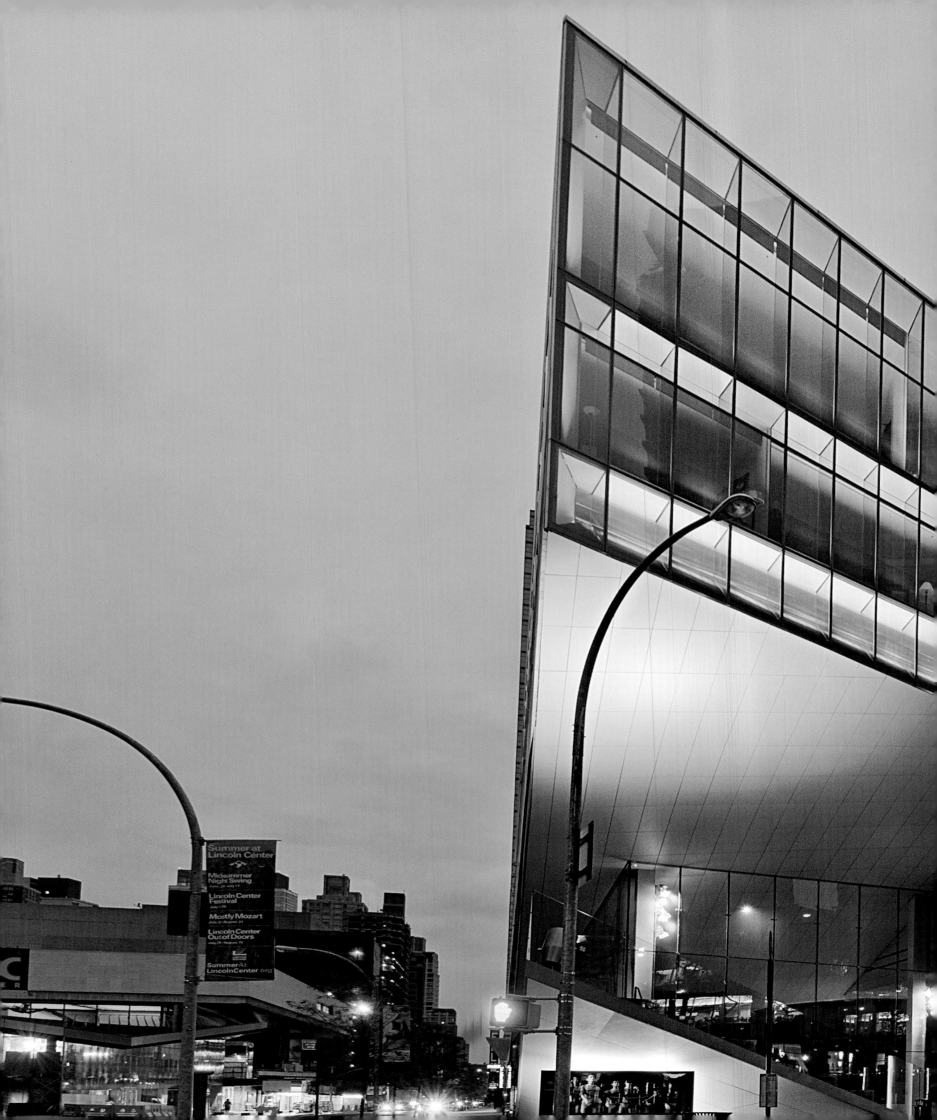

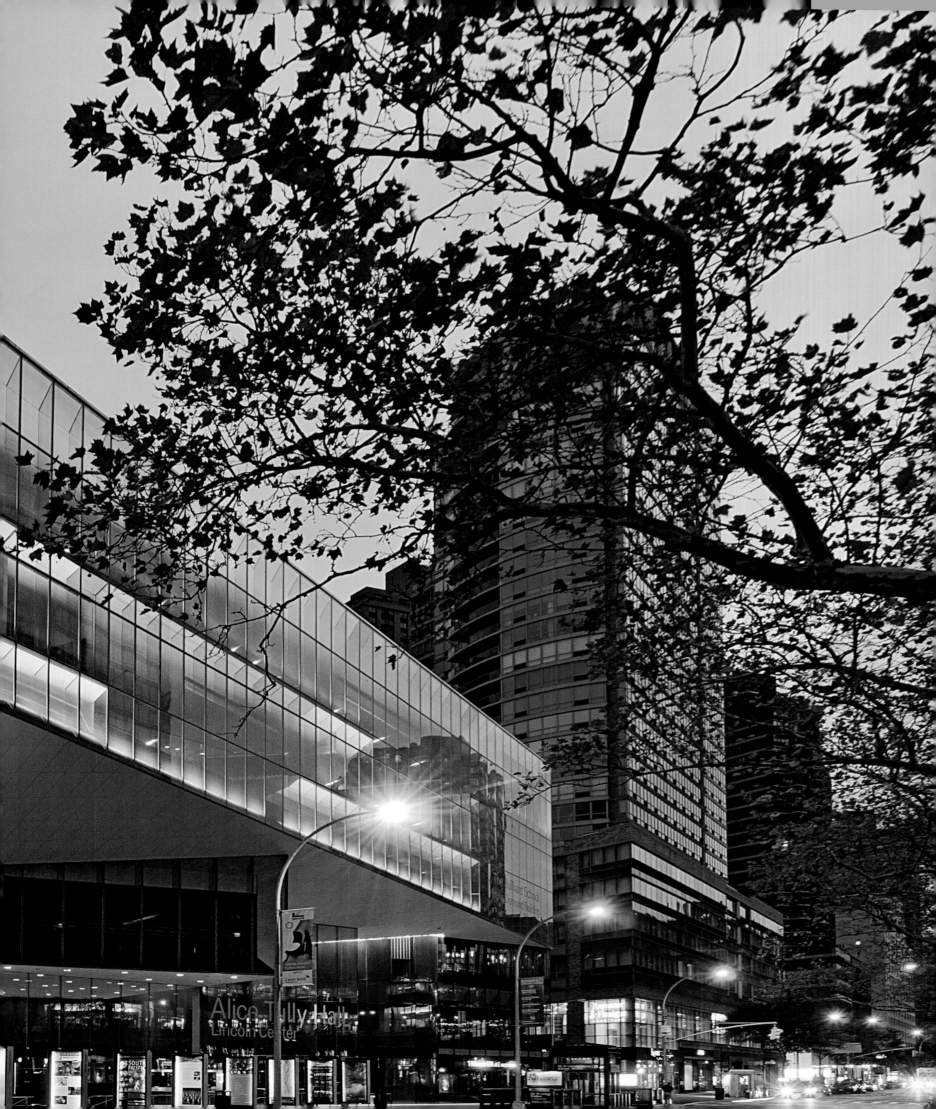

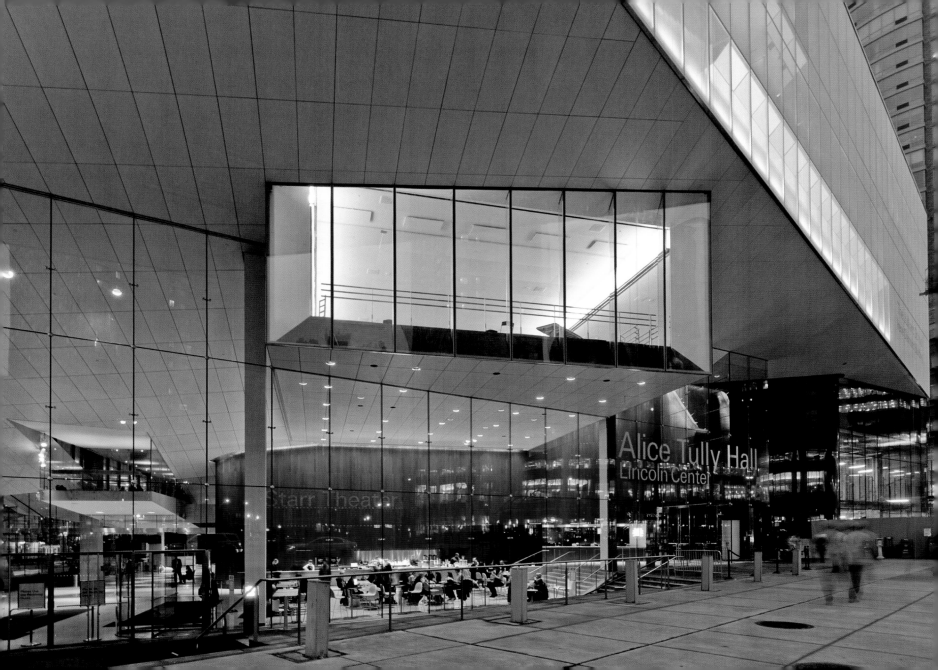

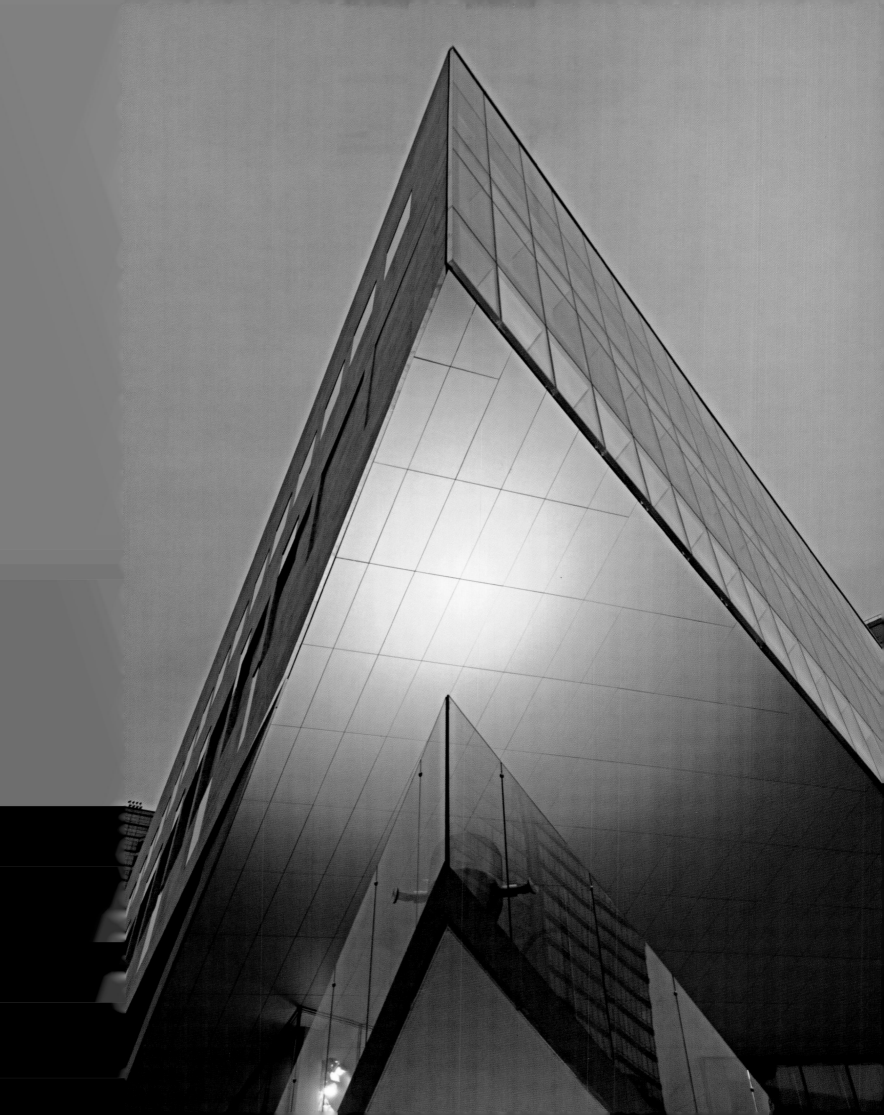

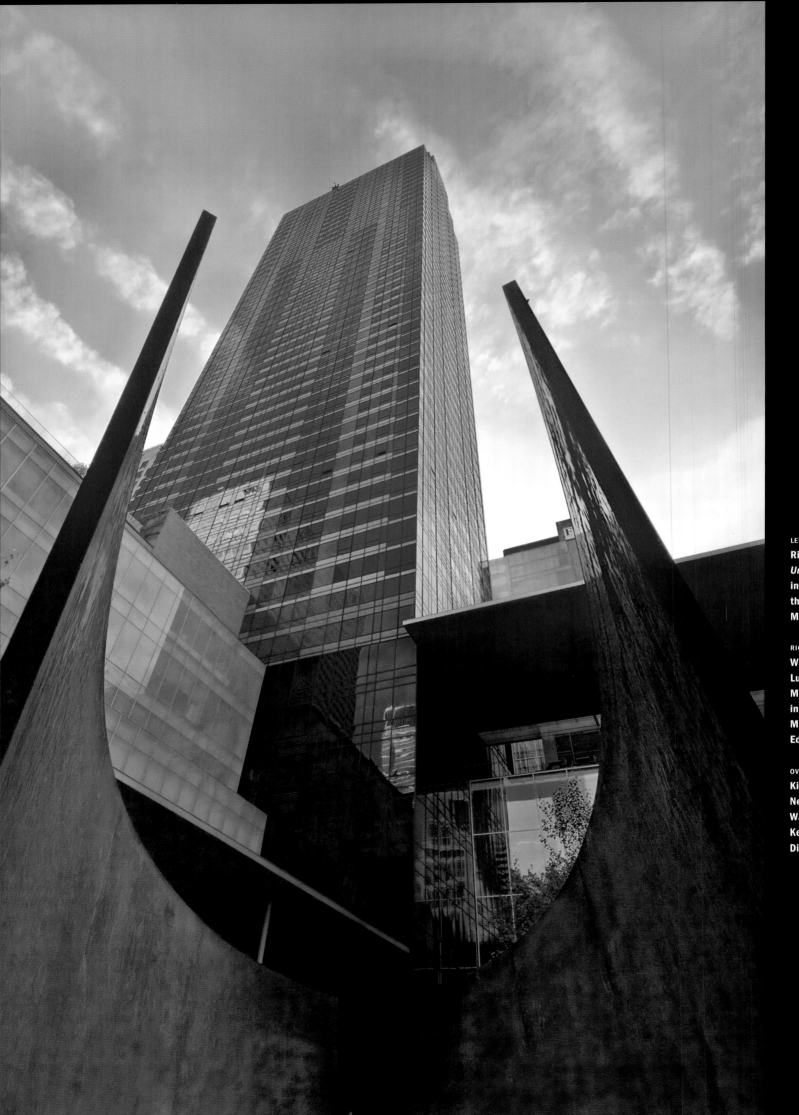

184

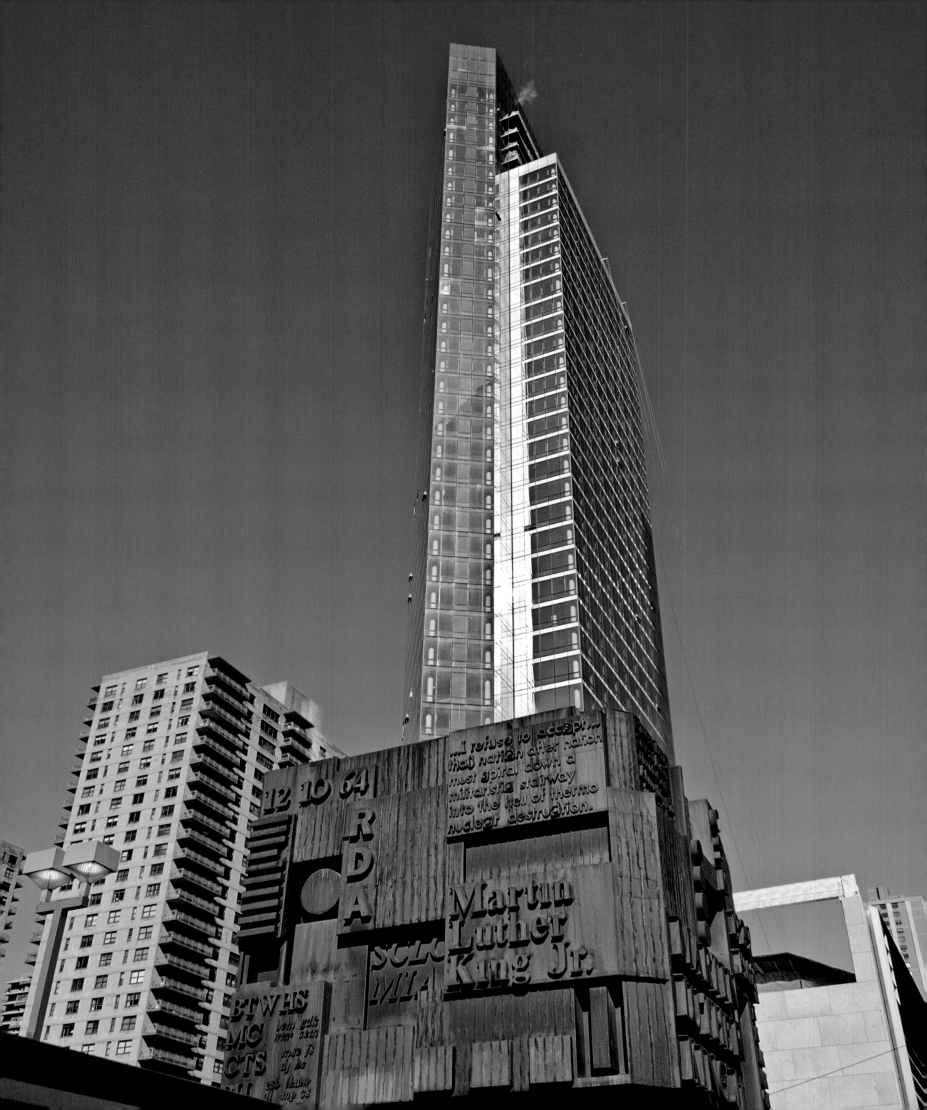

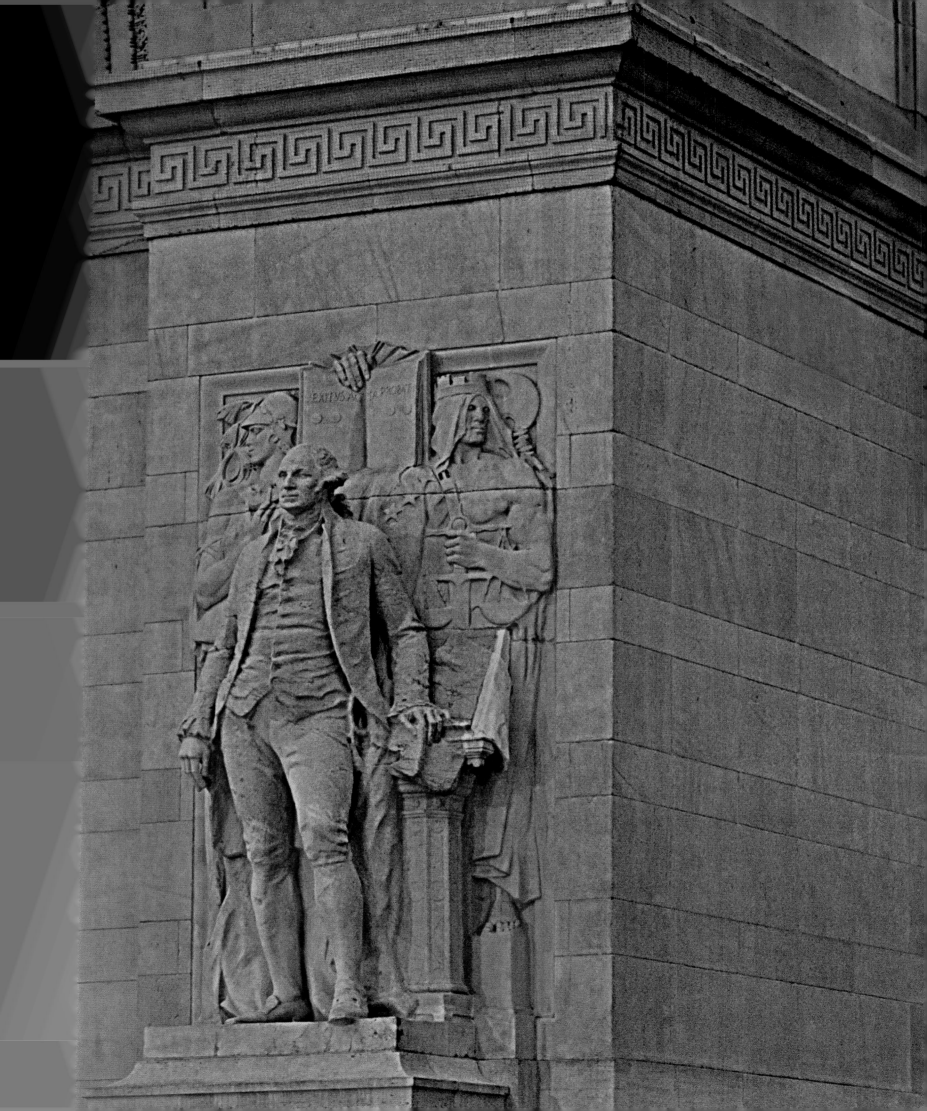

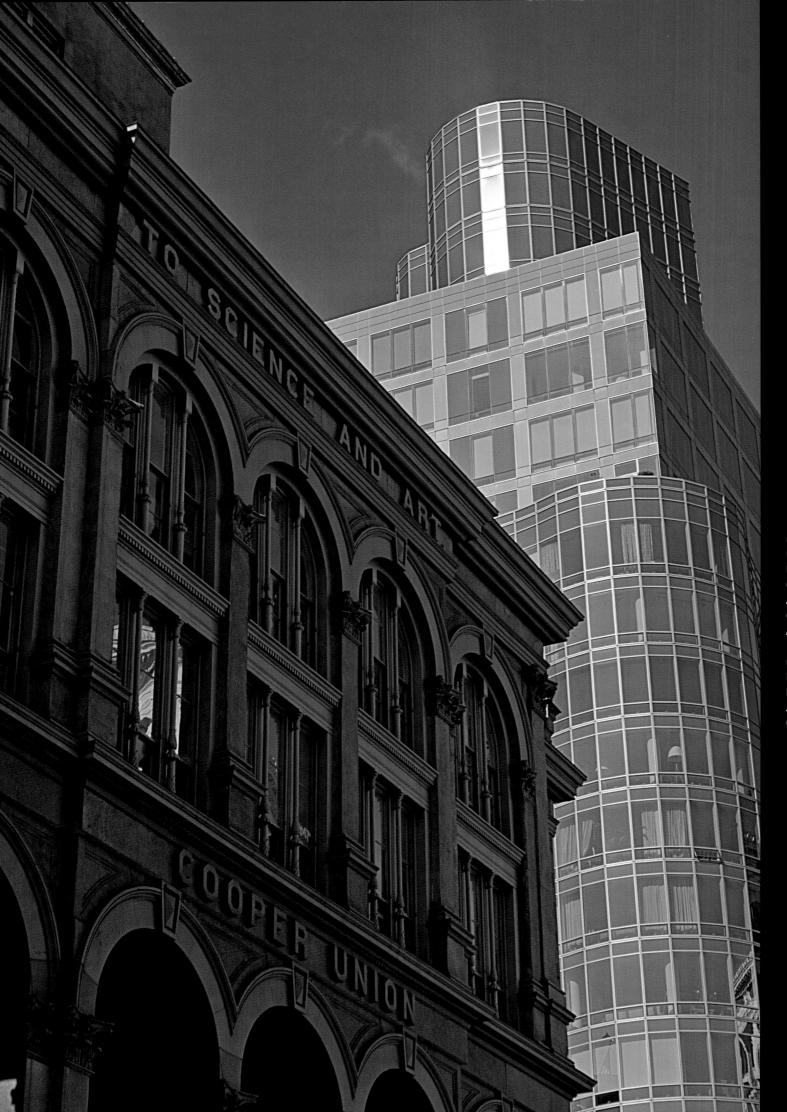

188

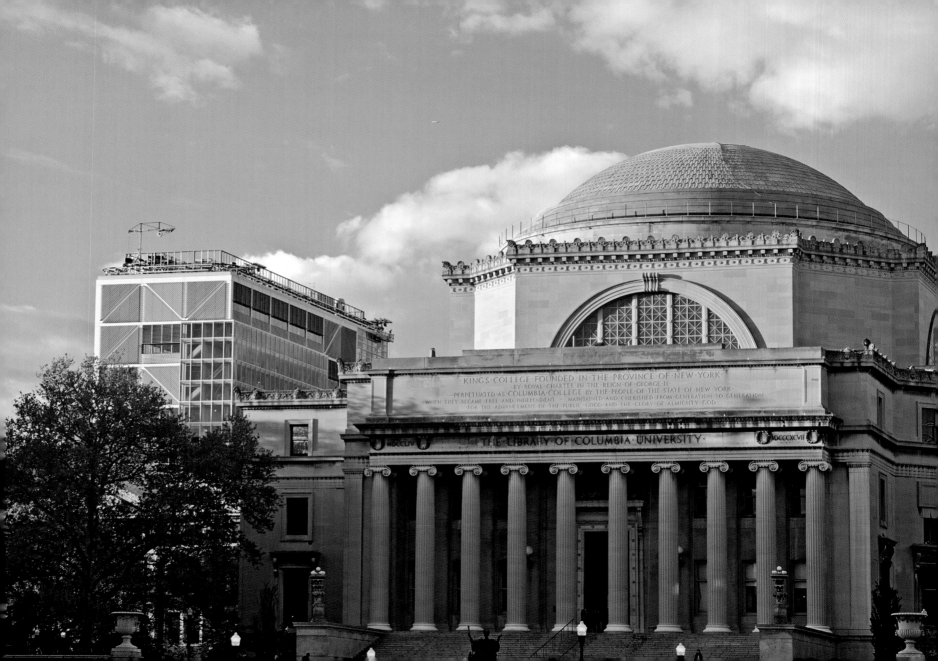

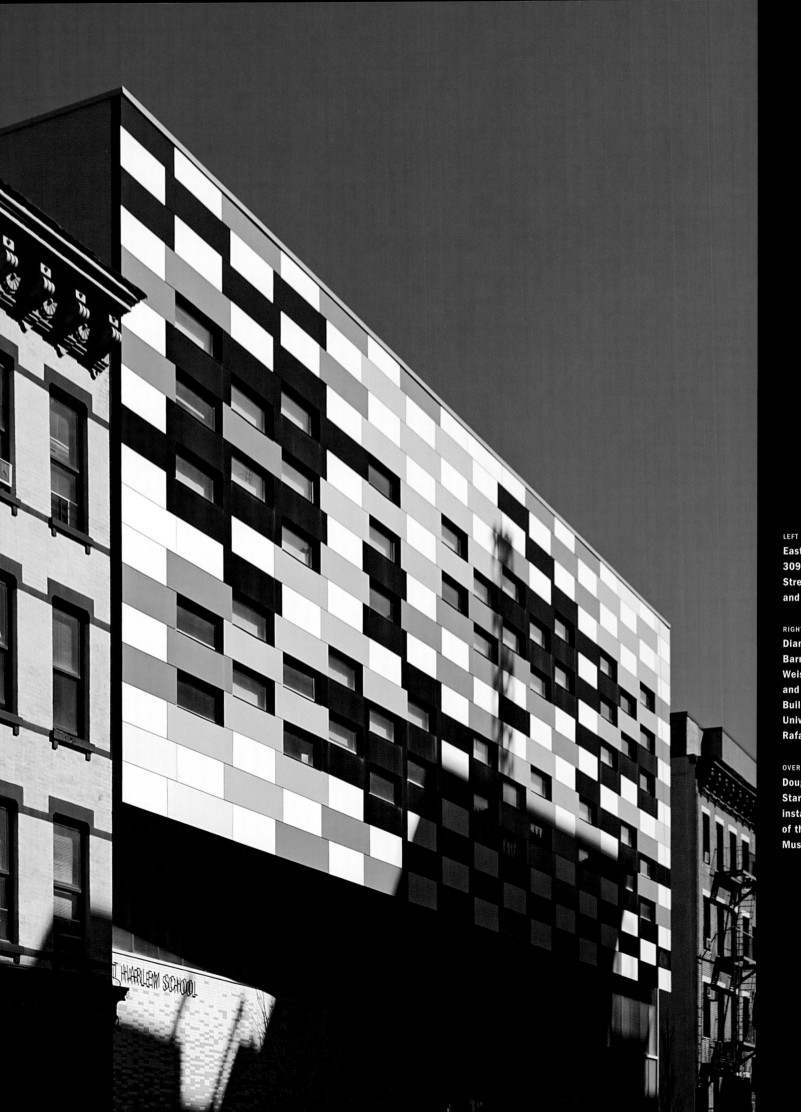

LEFT
East Harlem School, 309 East 103rd Street, Peter Gluck and Partners.

RIGHT
Diana Center, Barnard College, Weiss/Manfredi, and Northwest Building, Columbia University, José Rafael Moneo.

OVERLEAF
Doug and Mike Starn, *Big Bambu*, installed on the roof of the Metropolitan Museum of Art.

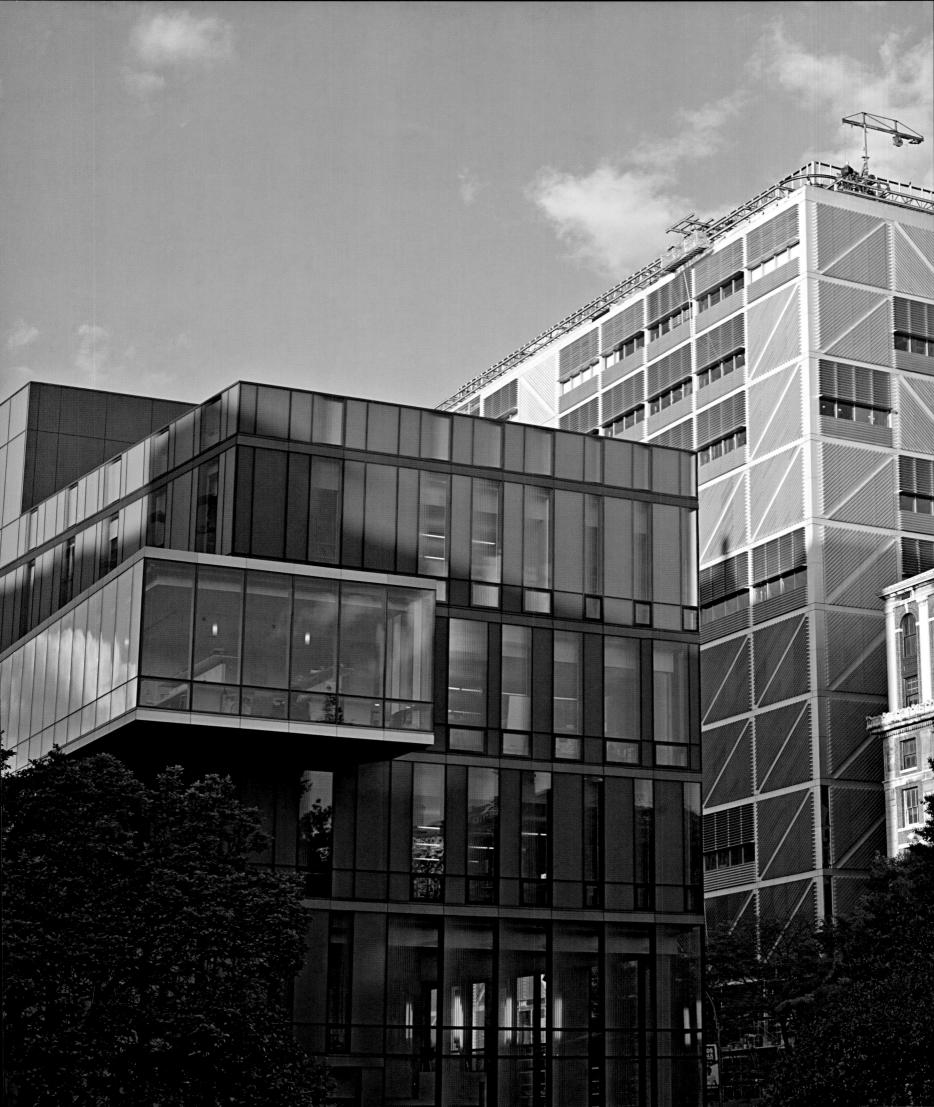

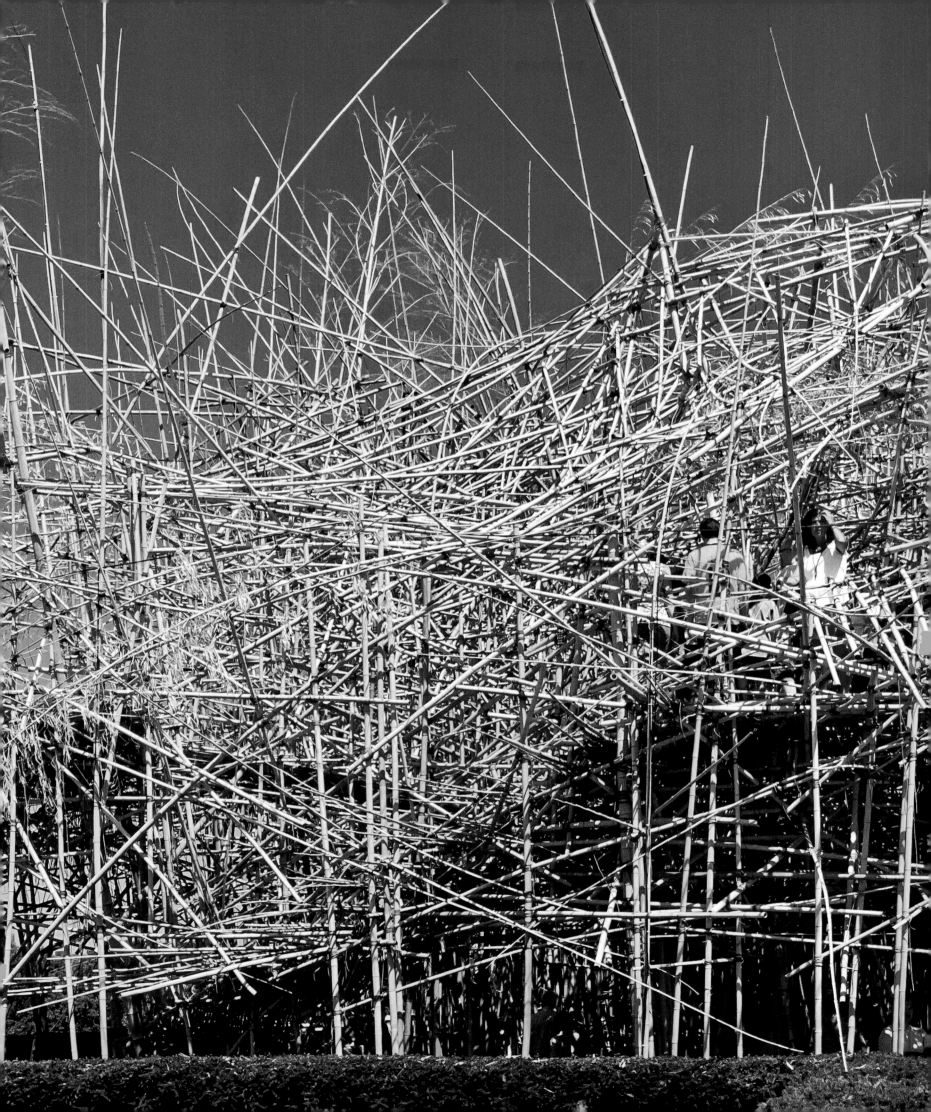

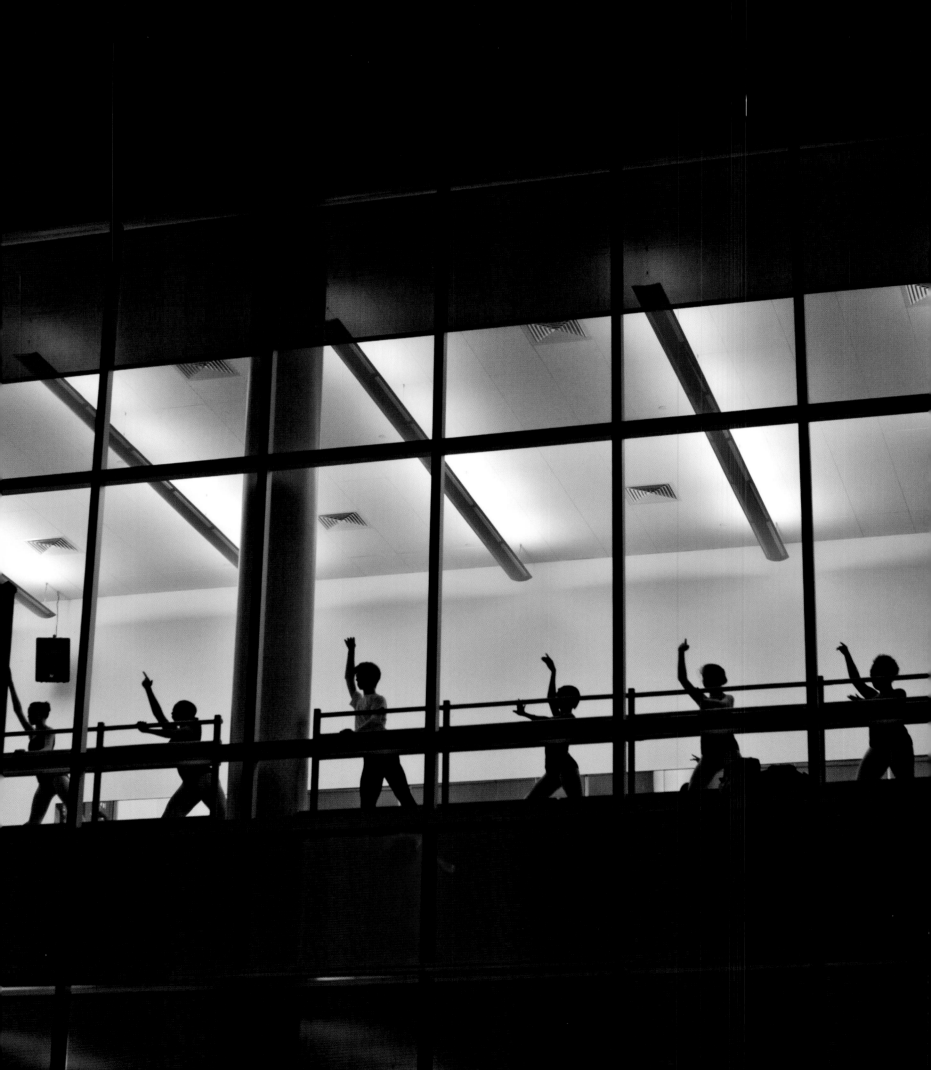

LEFT
Alvin Ailey American Dance Theater, Joan Weill Center for Dance, 405 West 55th Street, Iu + Bibliowicz Architects.

RIGHT
Staircase, Museum of Modern Art.

OVERLEAF
Rose Center for Earth and Space, American Museum of Natural History, Polshek Partnership.

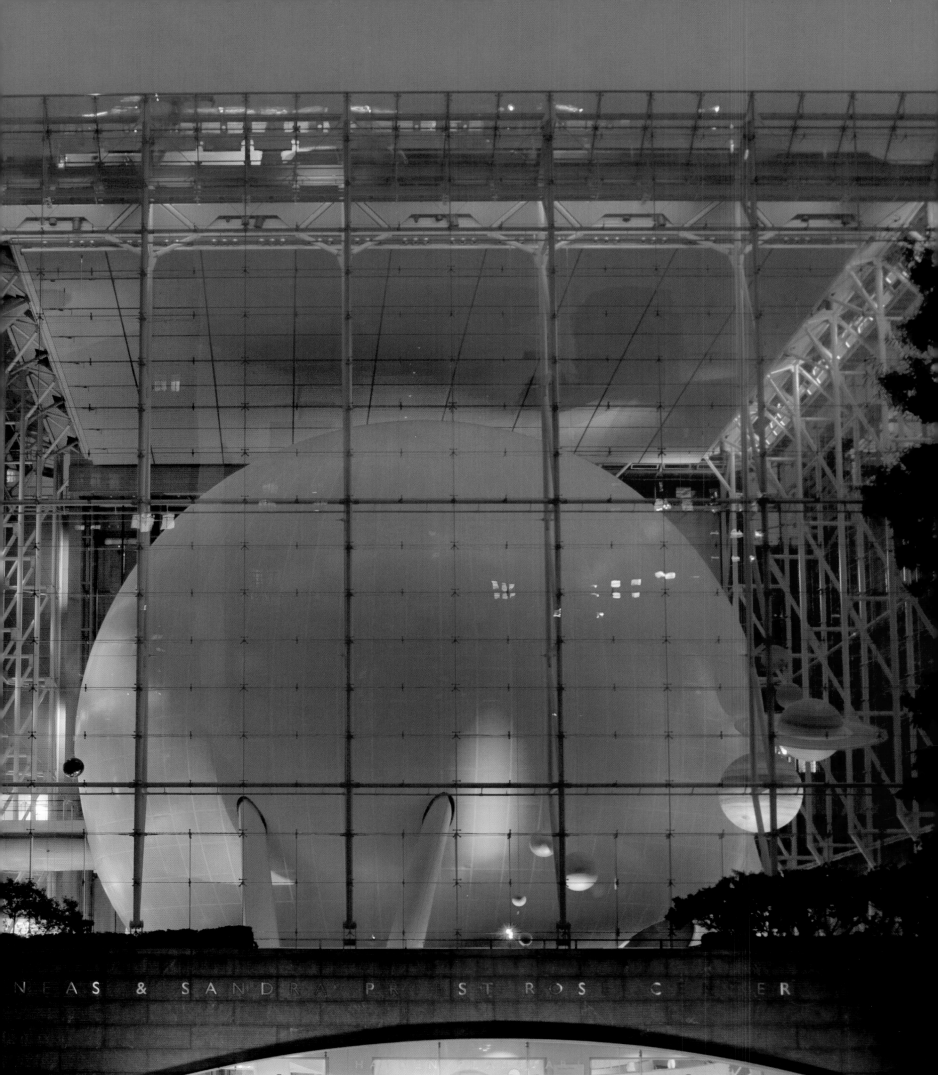

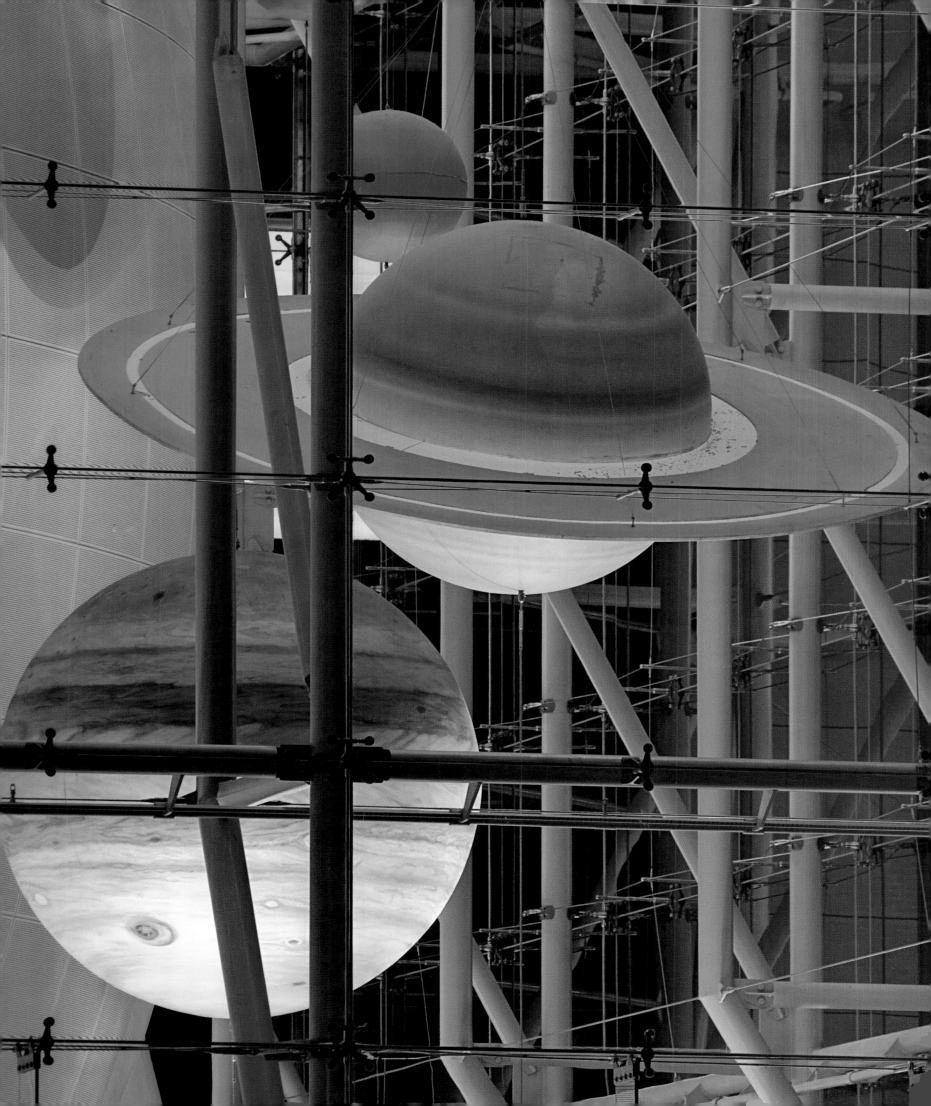

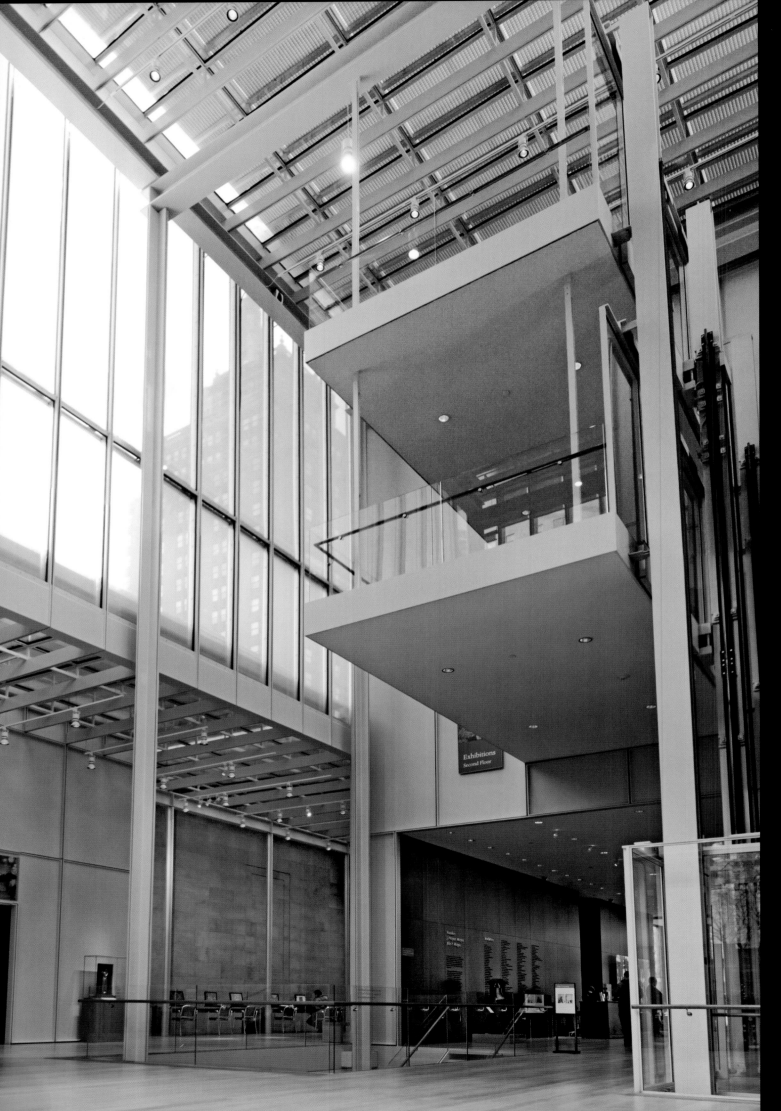

Morgan Library and
Museum, expansion
Renzo Piano Building
Workshop.

OVERLEAF
Museum of Jewish
Heritage, Kevin
Roche John Dinkeloo
Associates.

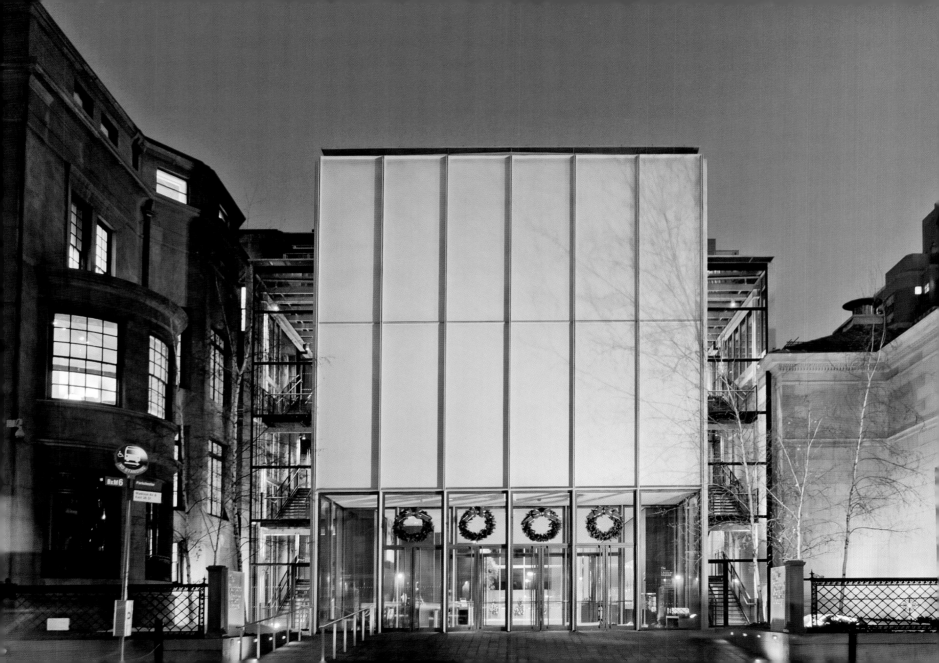

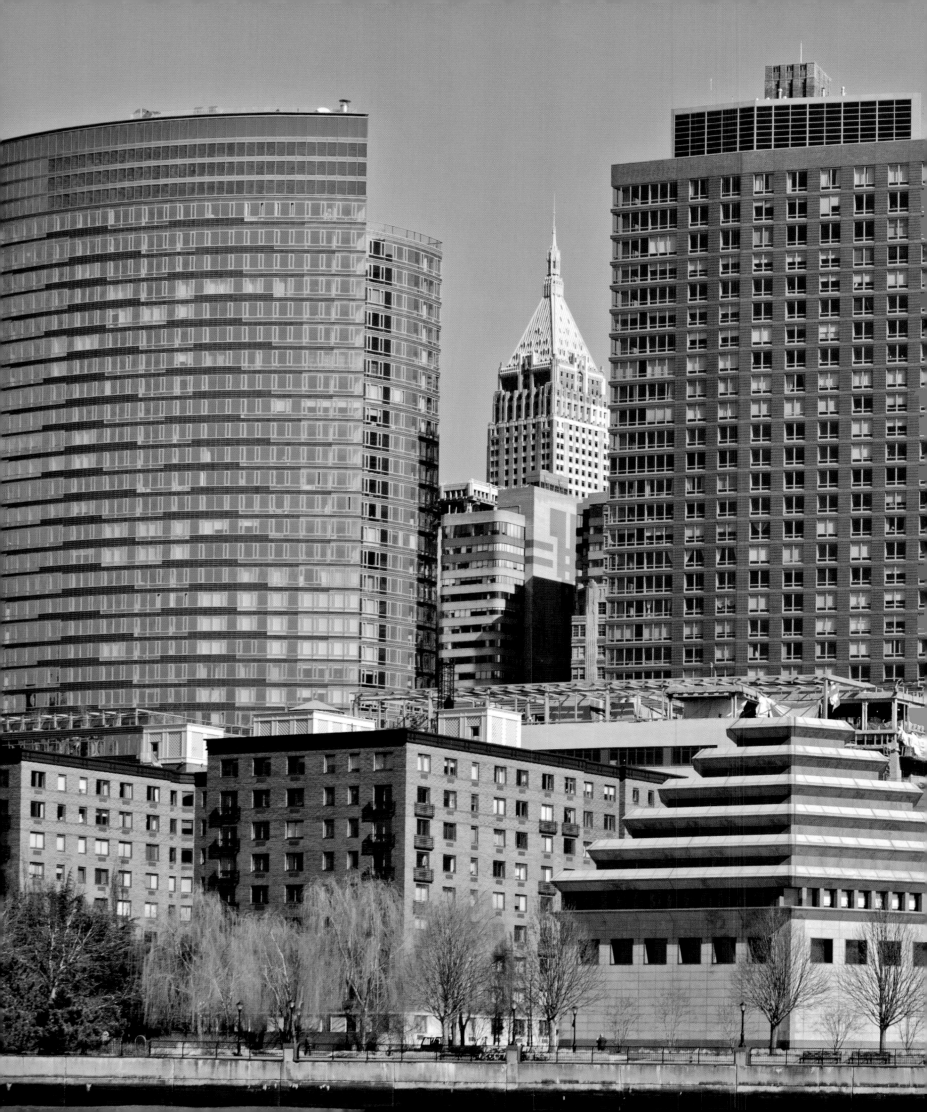

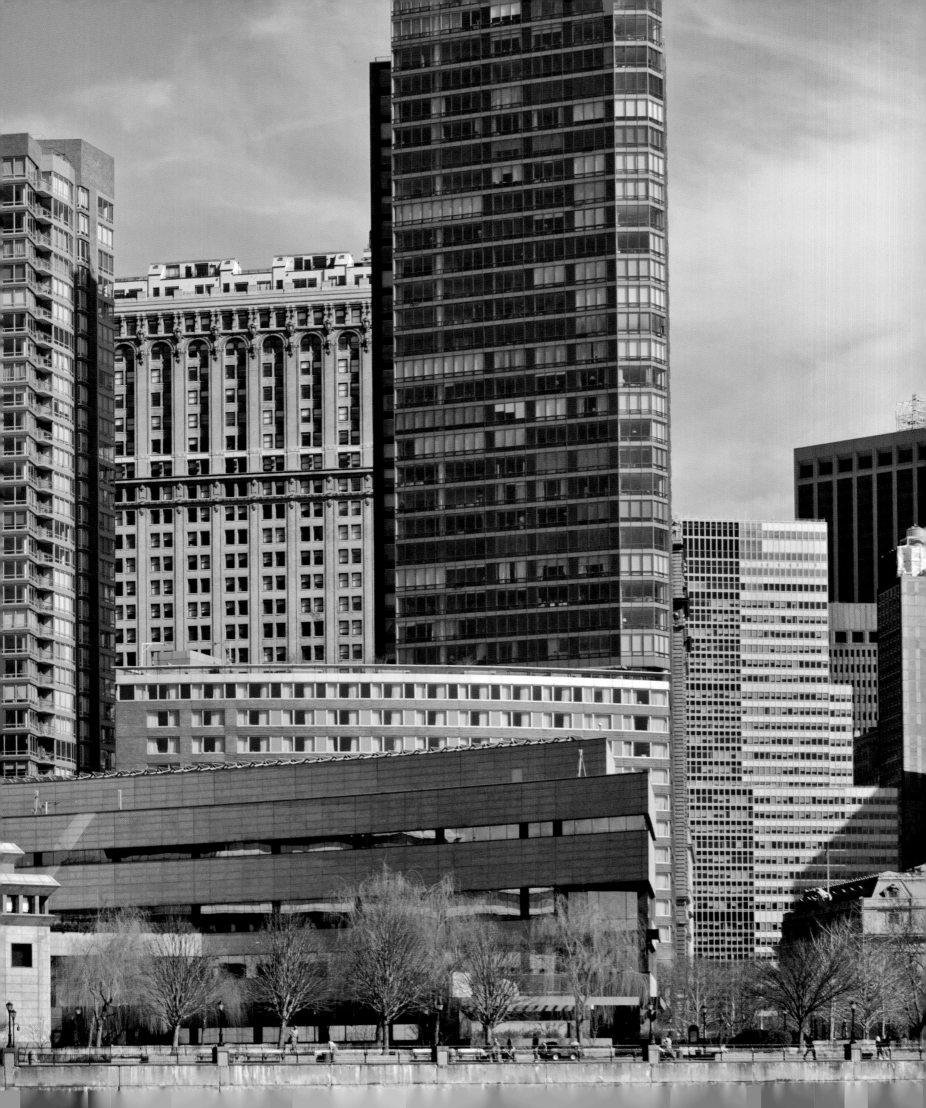

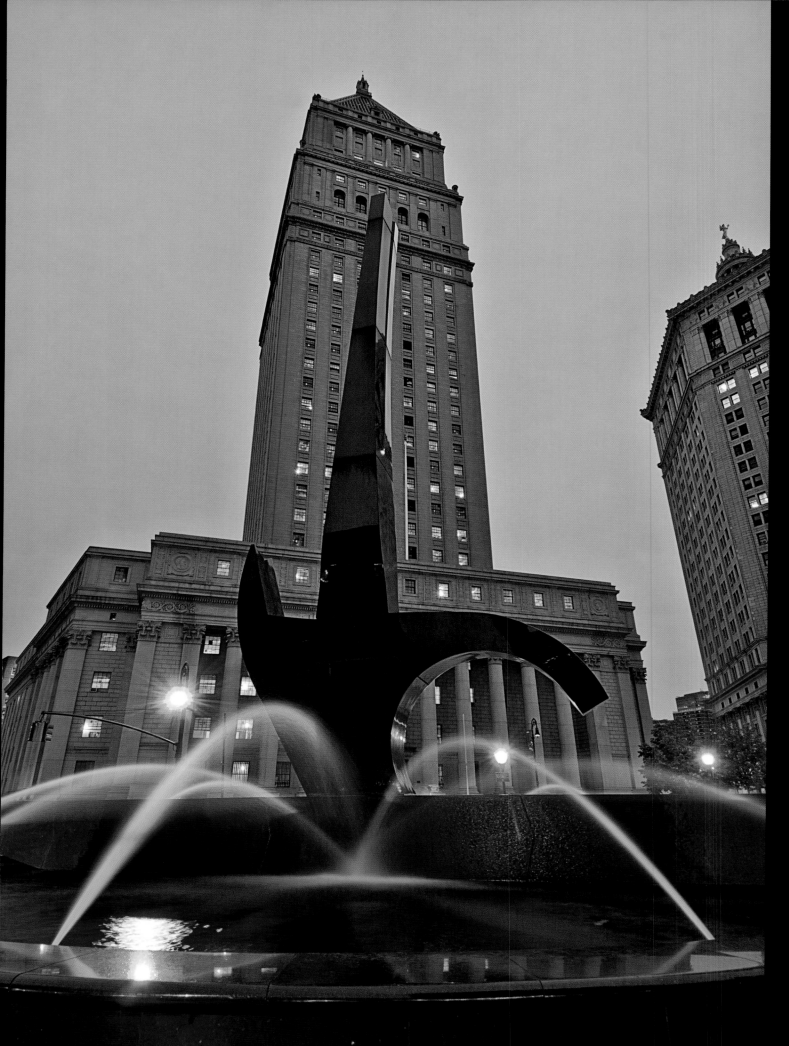

LEFT
Lorenzo Pace, *Triumph of the Human Spirit*, **Foley Square.**

RIGHT
Jeff Koons, *Balloon Flower (Red),* **installed in the fountain at 7 World Trade Center, Ken Smith Landscape Architect.**

OVERLEAF
Lincoln Center.

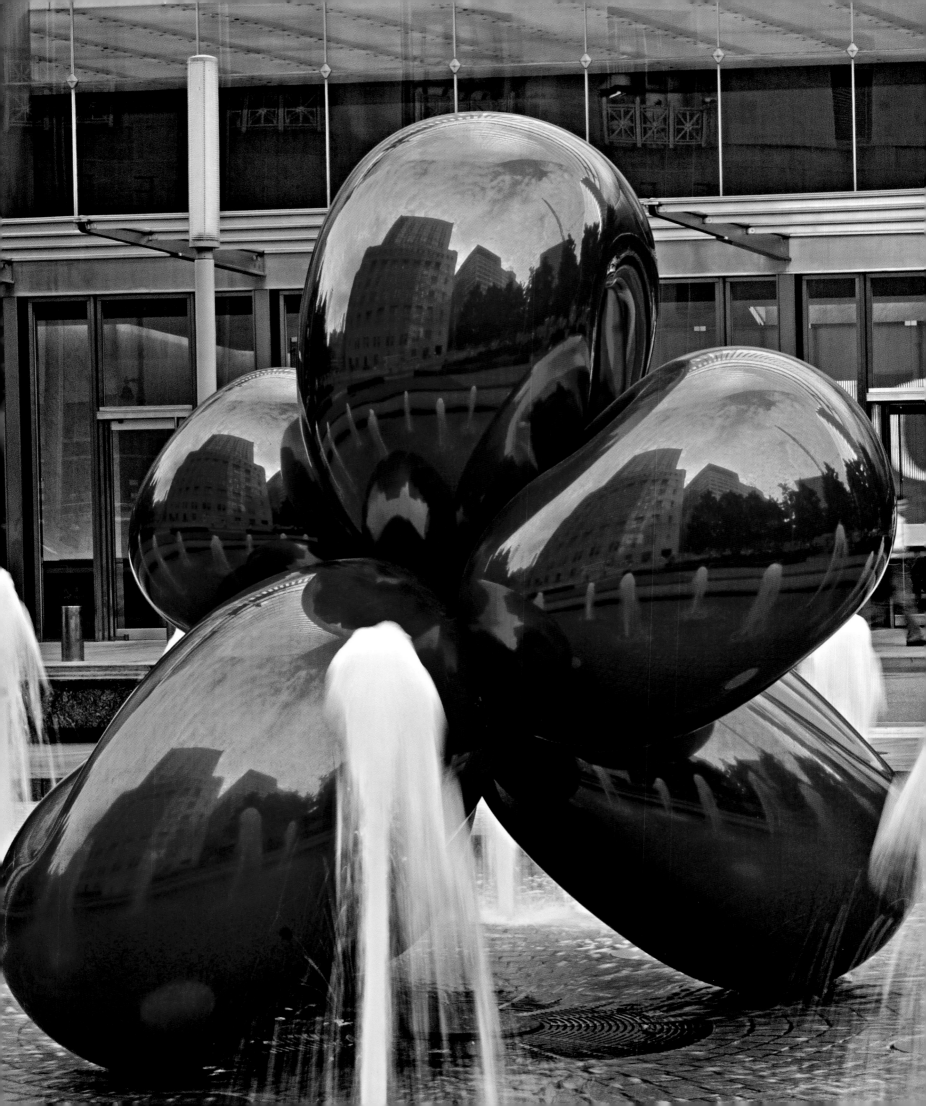

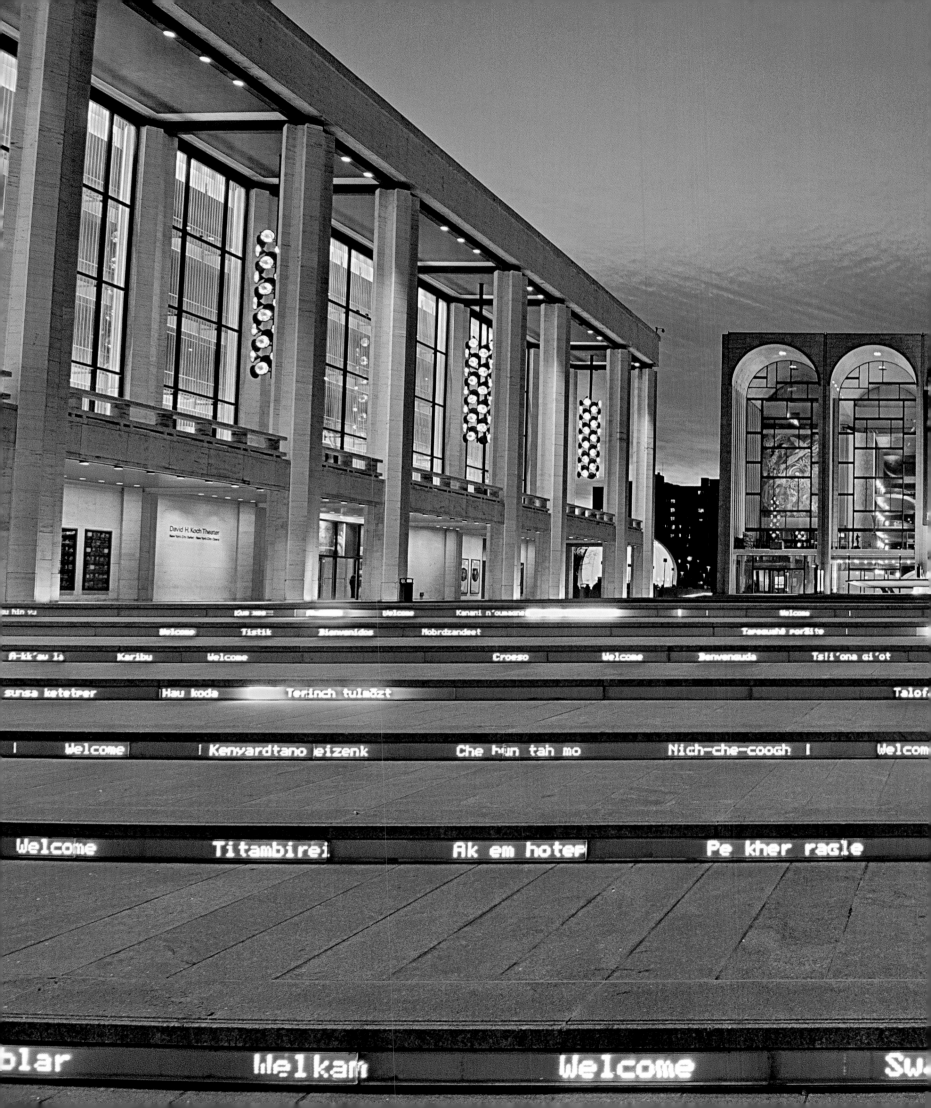

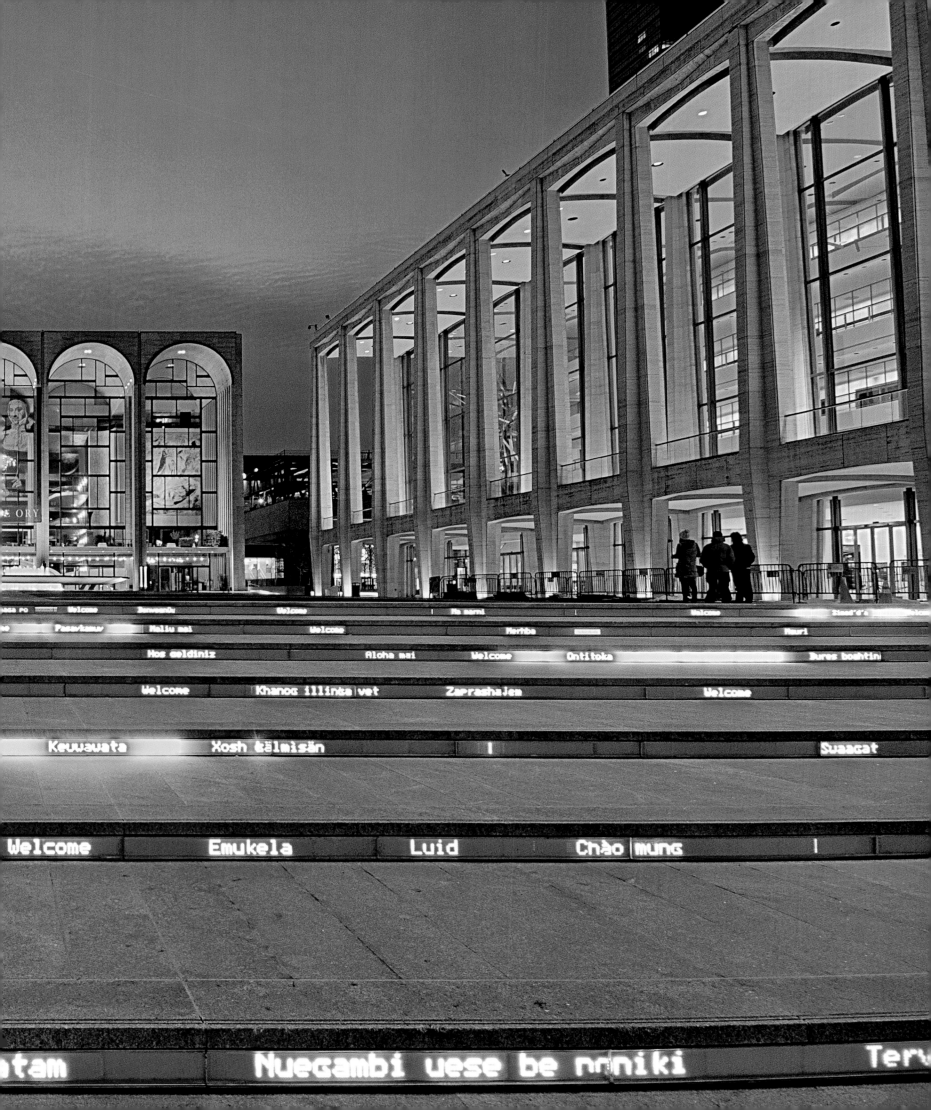

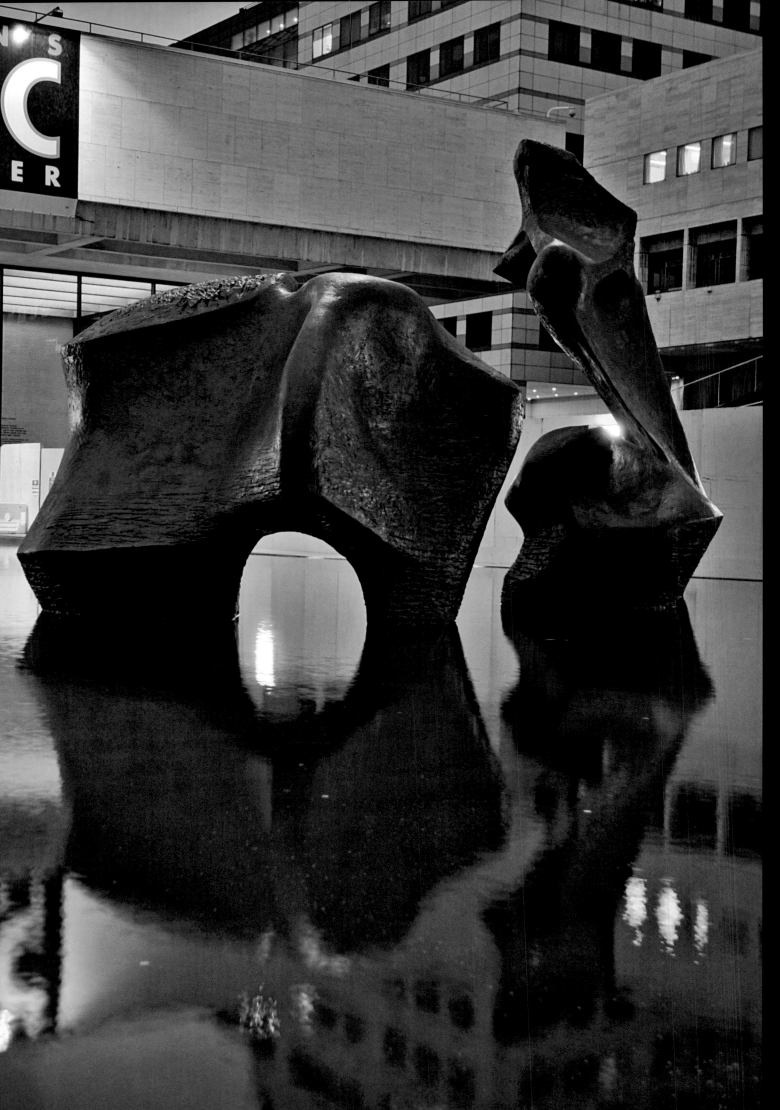

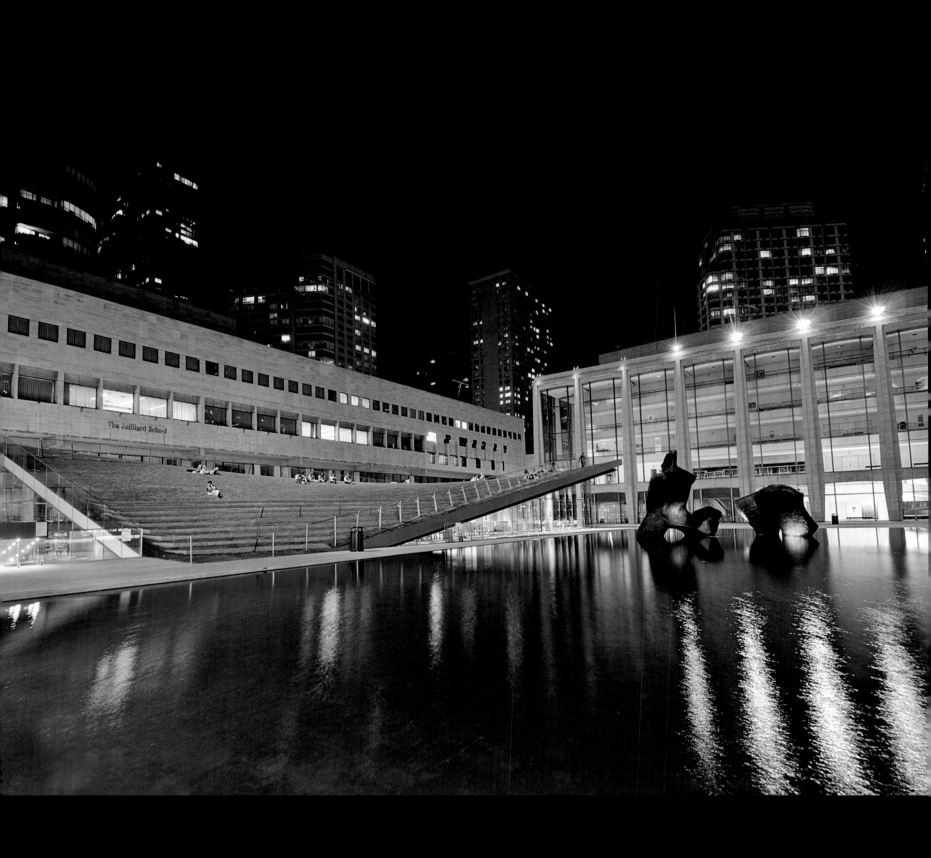

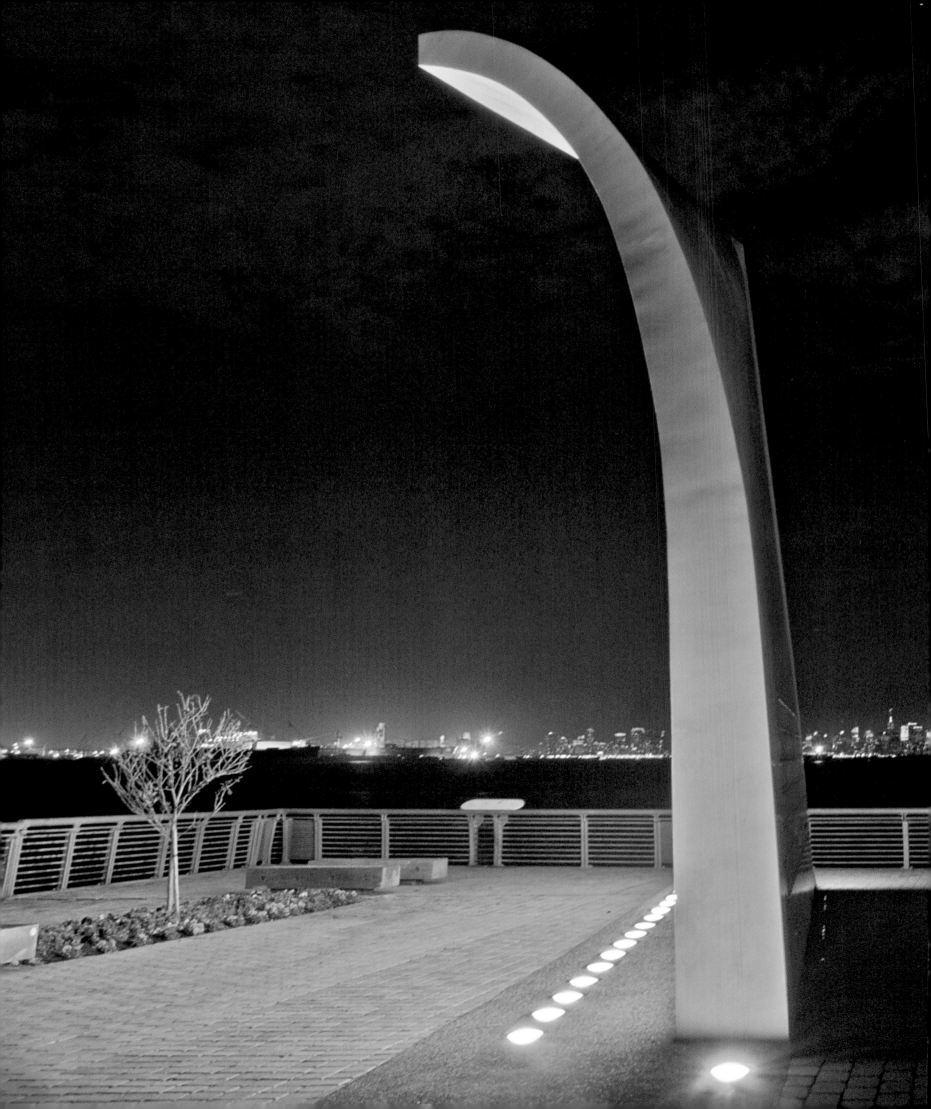

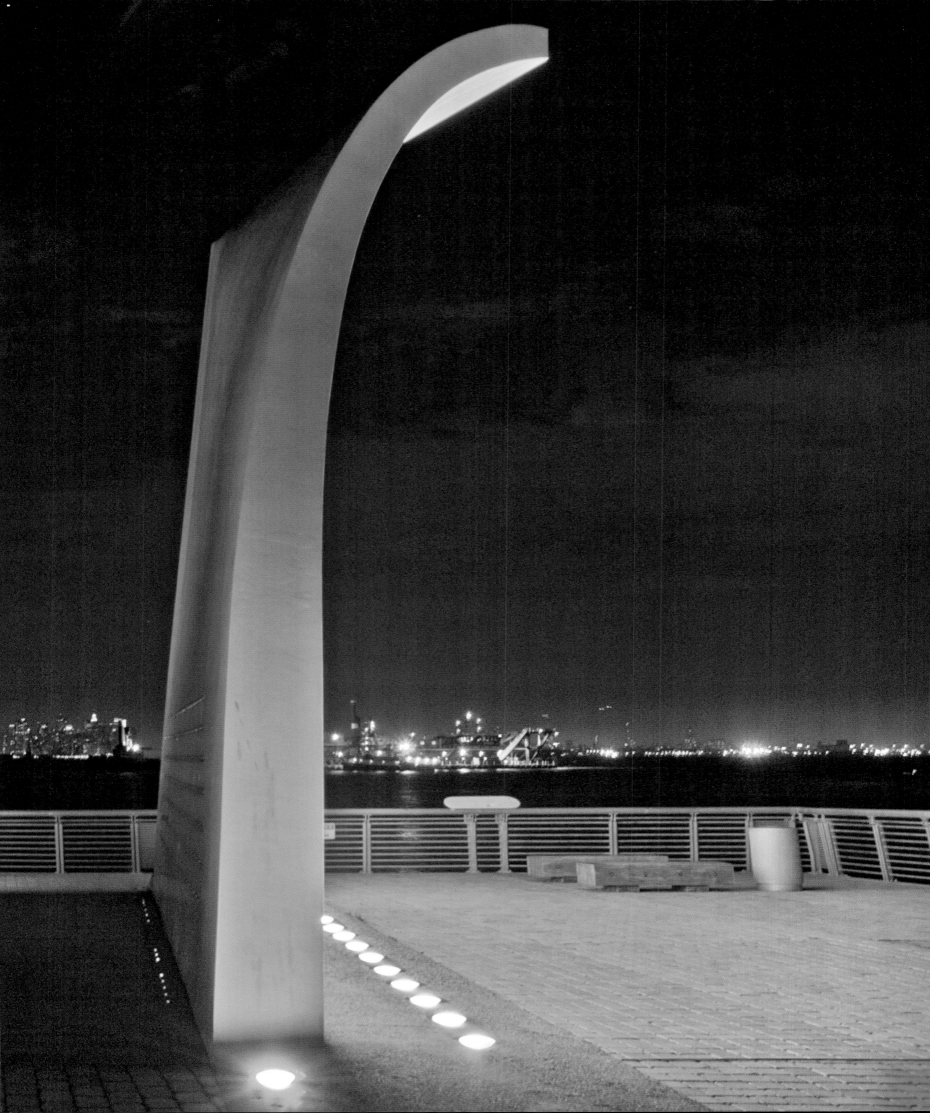

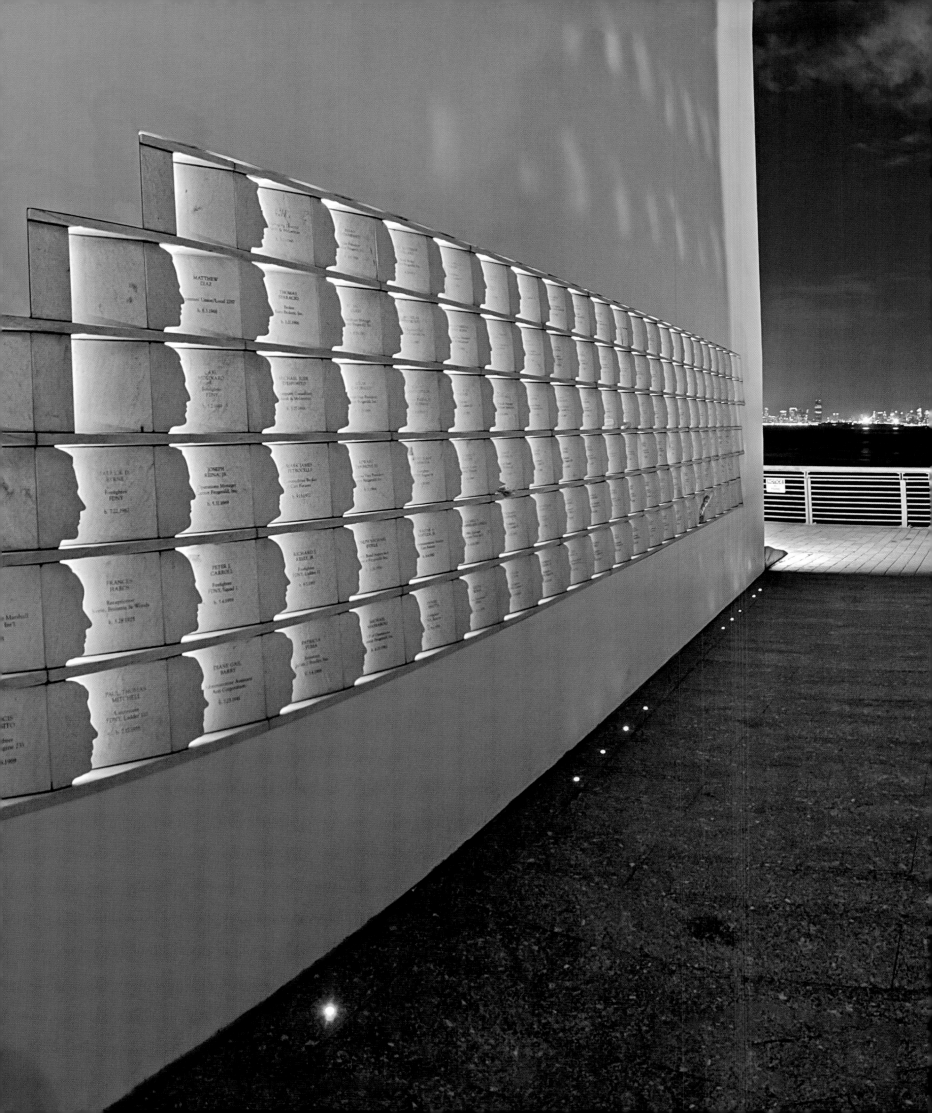

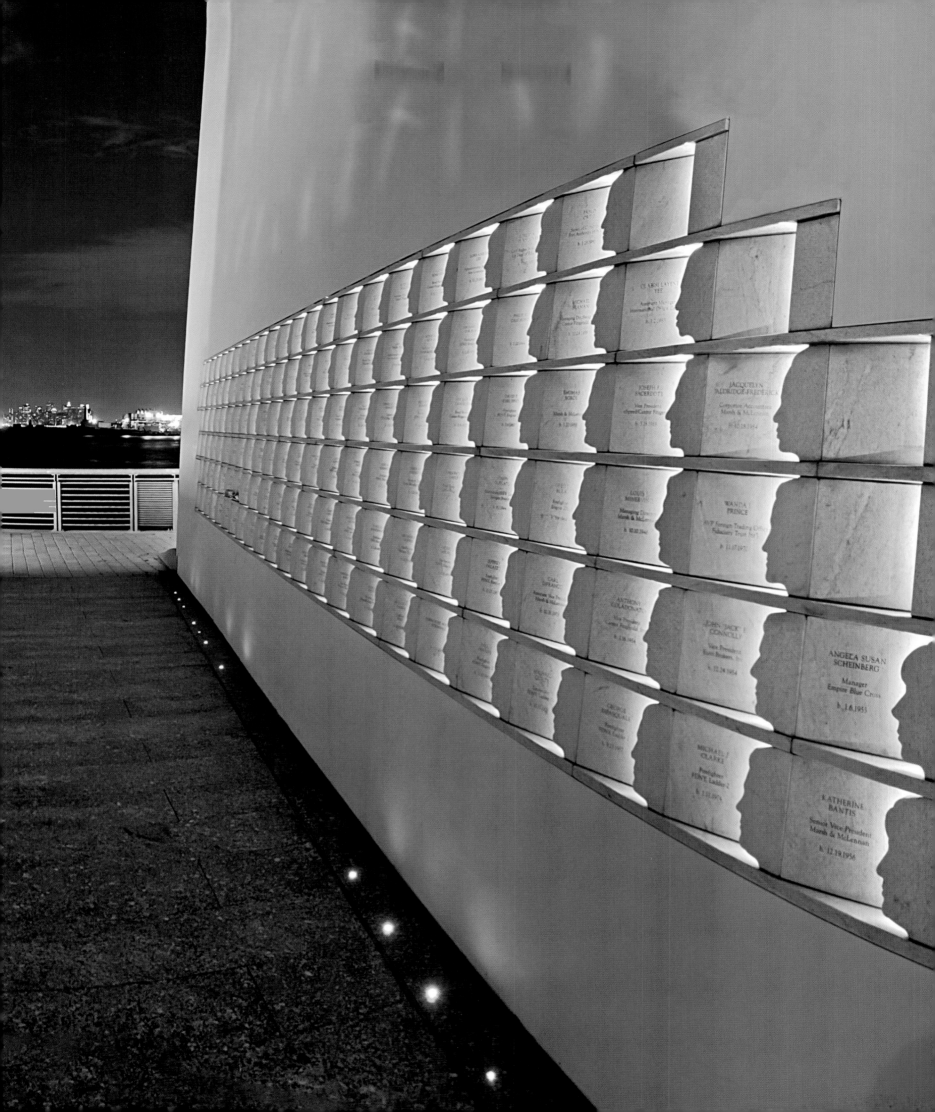

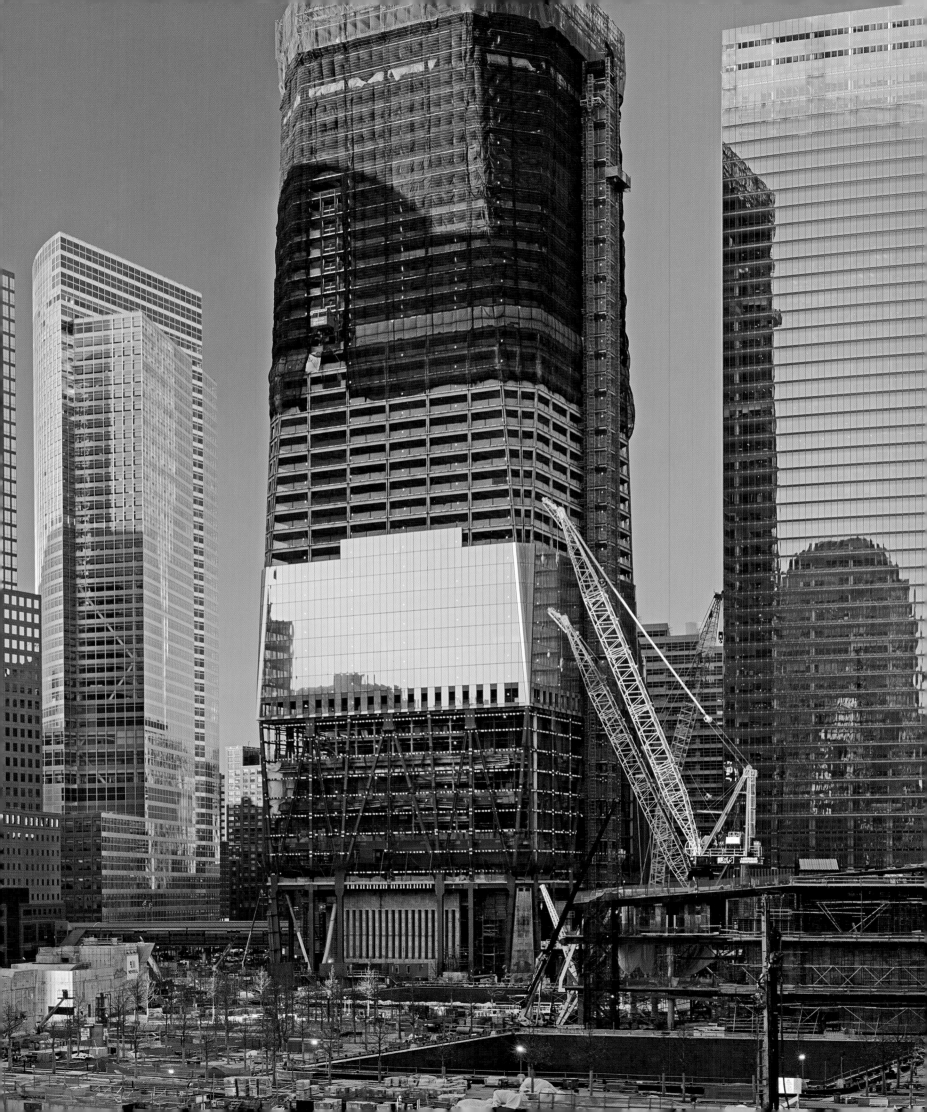

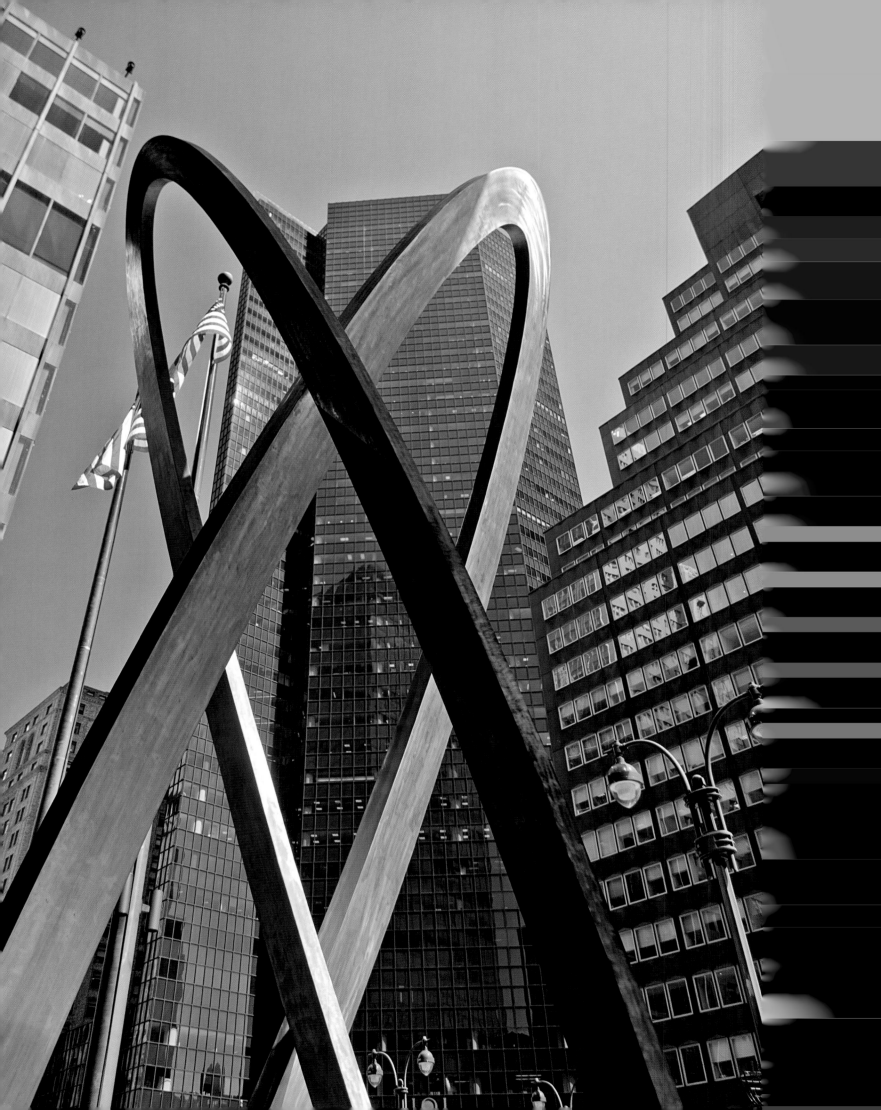

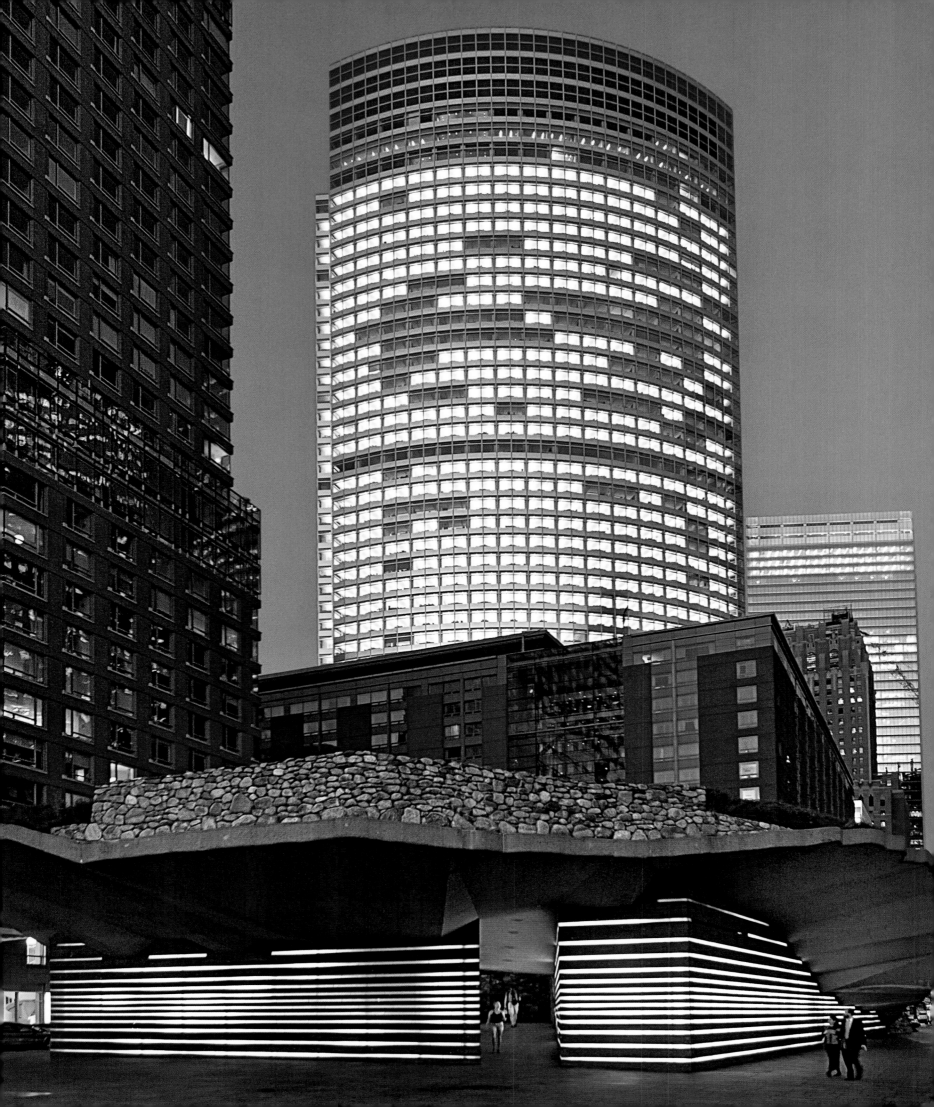

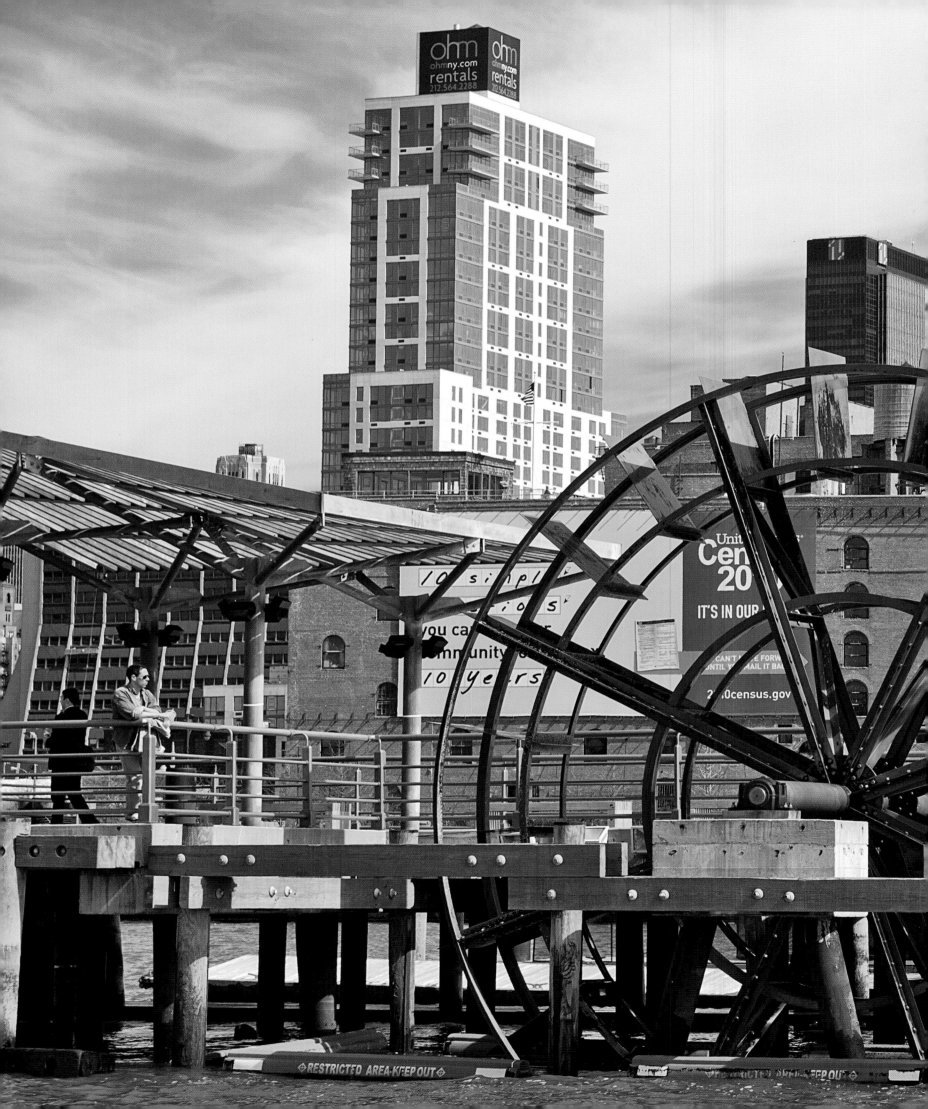

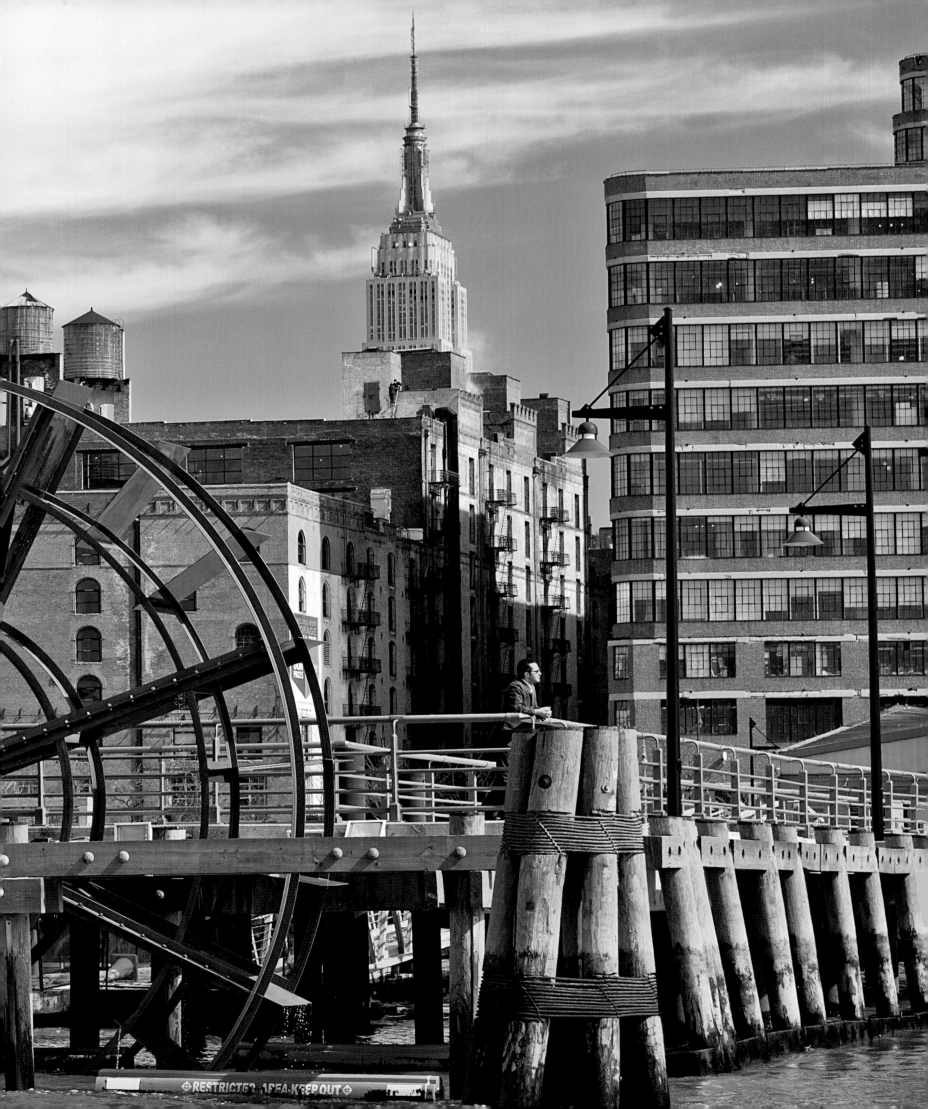

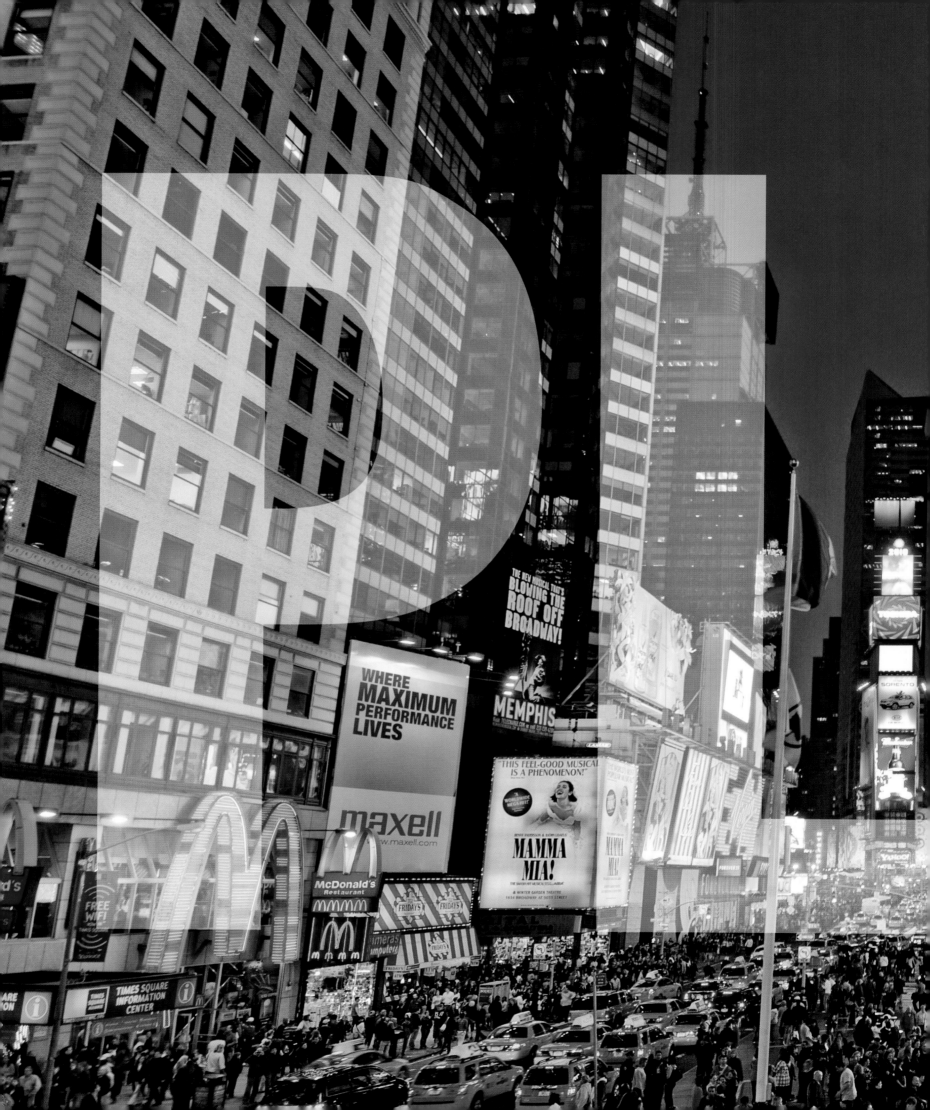

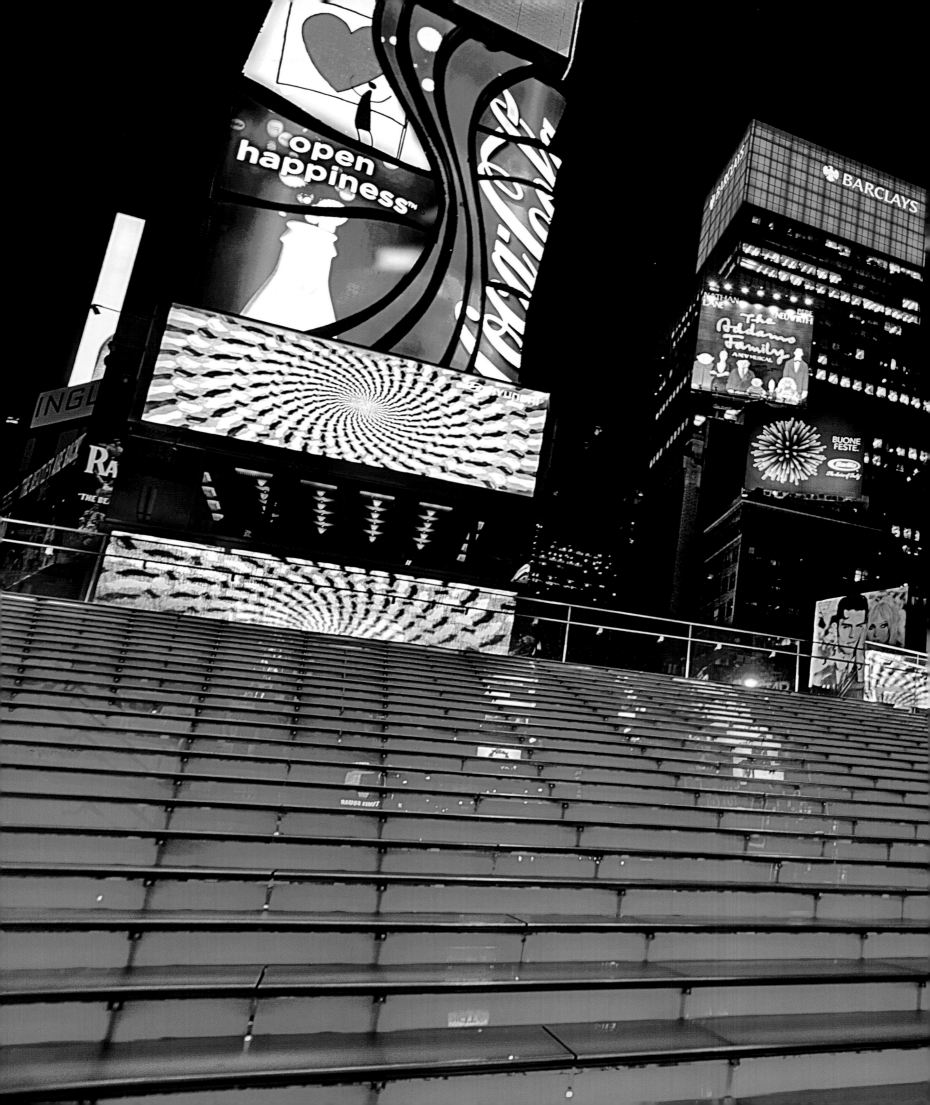

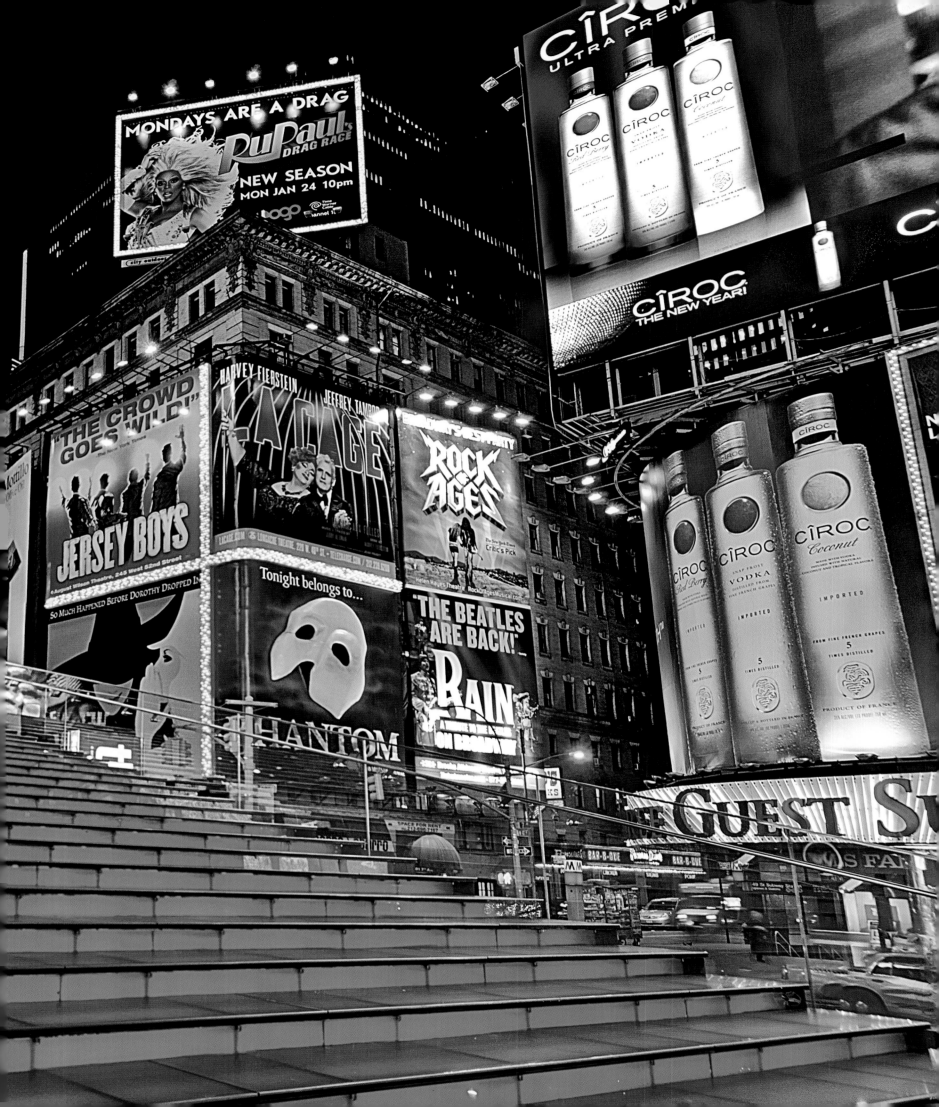

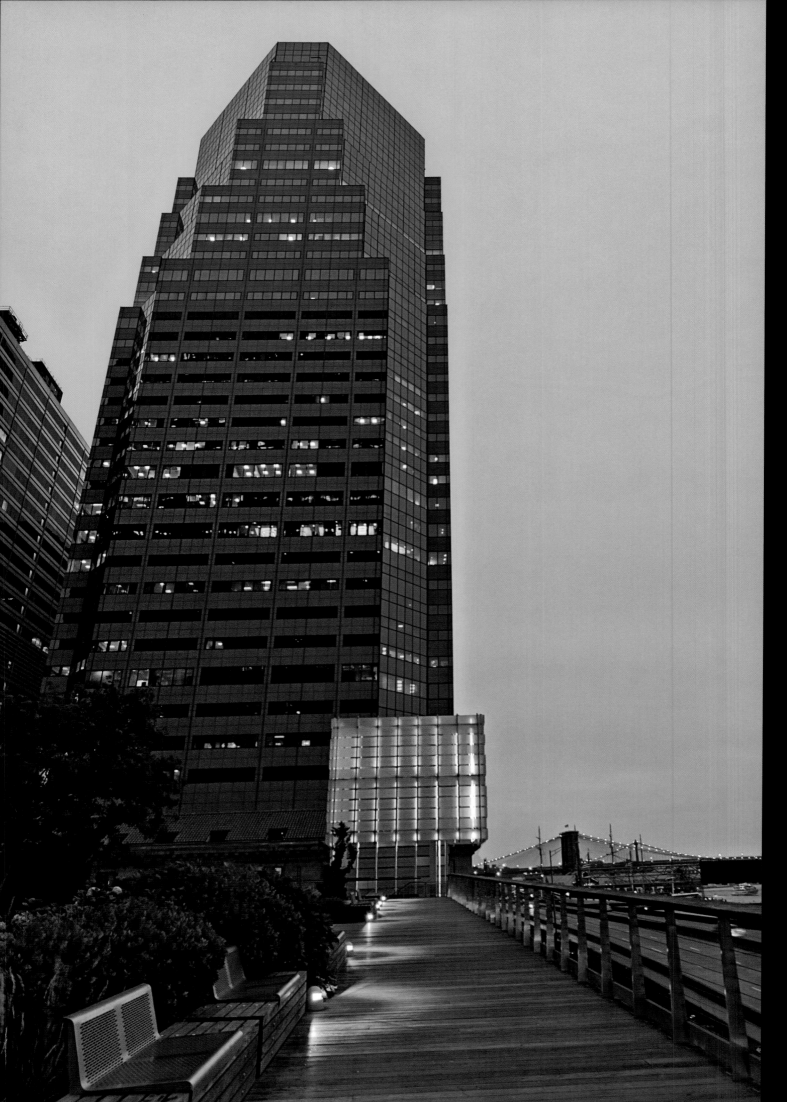

PRECEDING SPREAD
TKTS, Father Duffy
Square, Times
Square, Perkins
Eastman.

Elevated Acre,
Beacon of Progress,
55 Water Street,
Rogers Marvel
Architects and Ken
Smith Landscape
Architect.

OVERLEAF
Norwegian Epic
cruise ship,
Manhattan Cruise
Terminal.

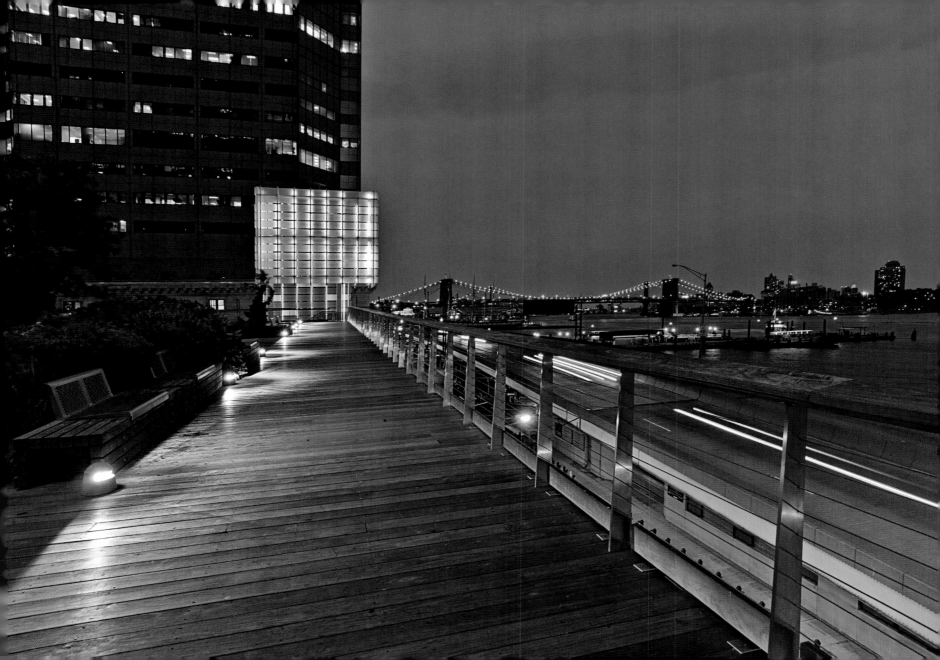

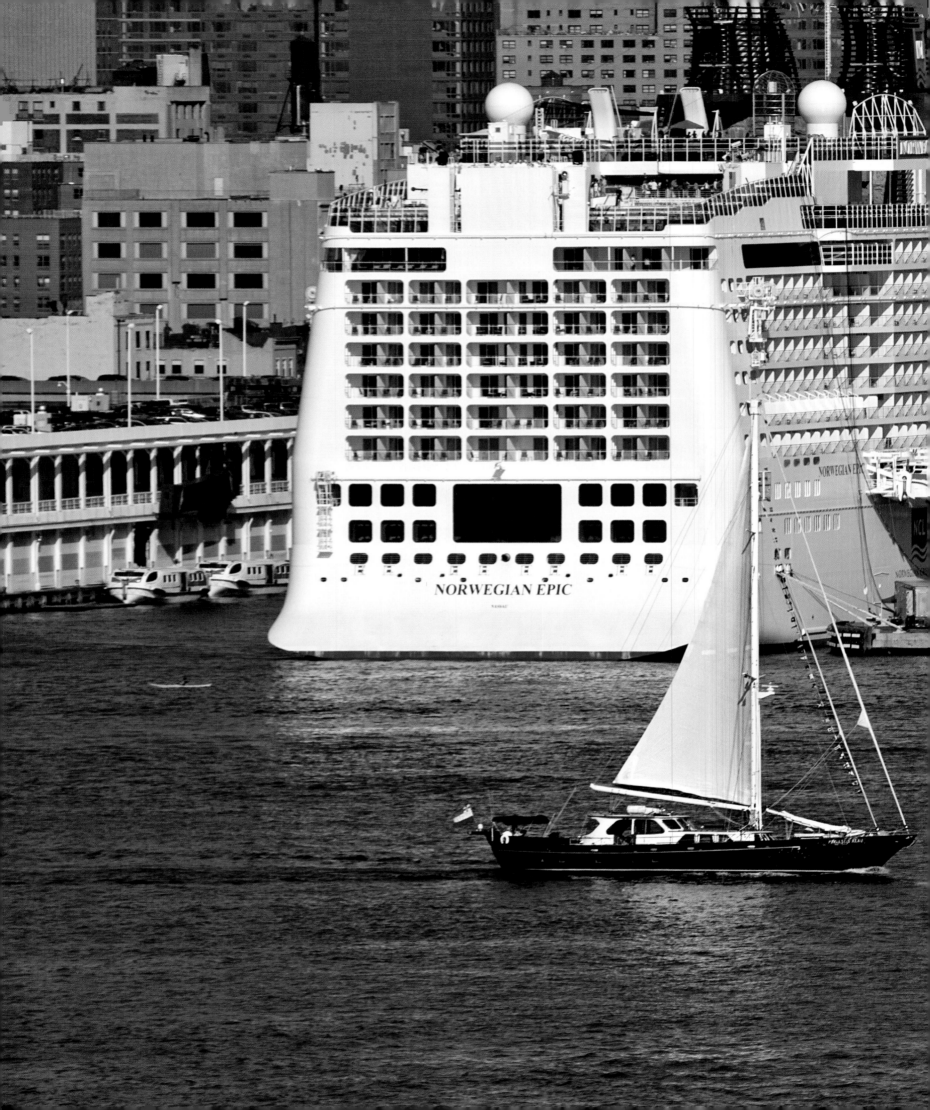

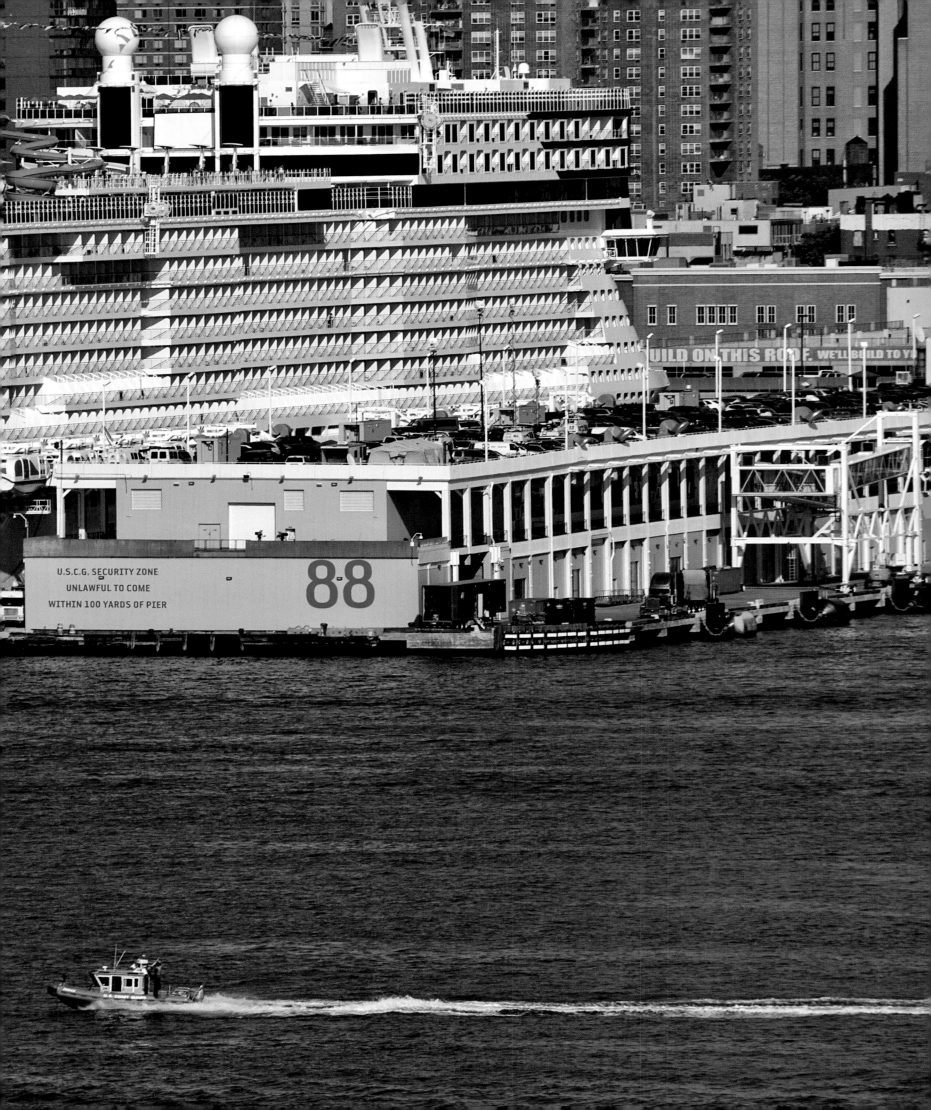

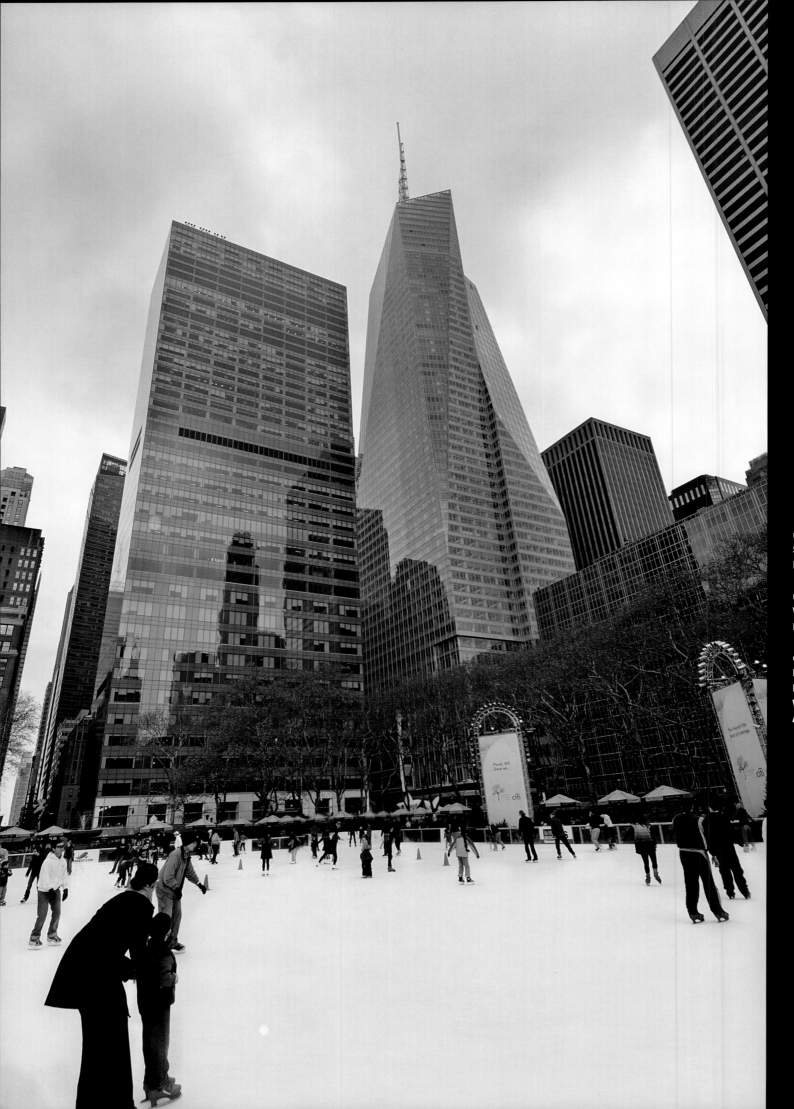

226

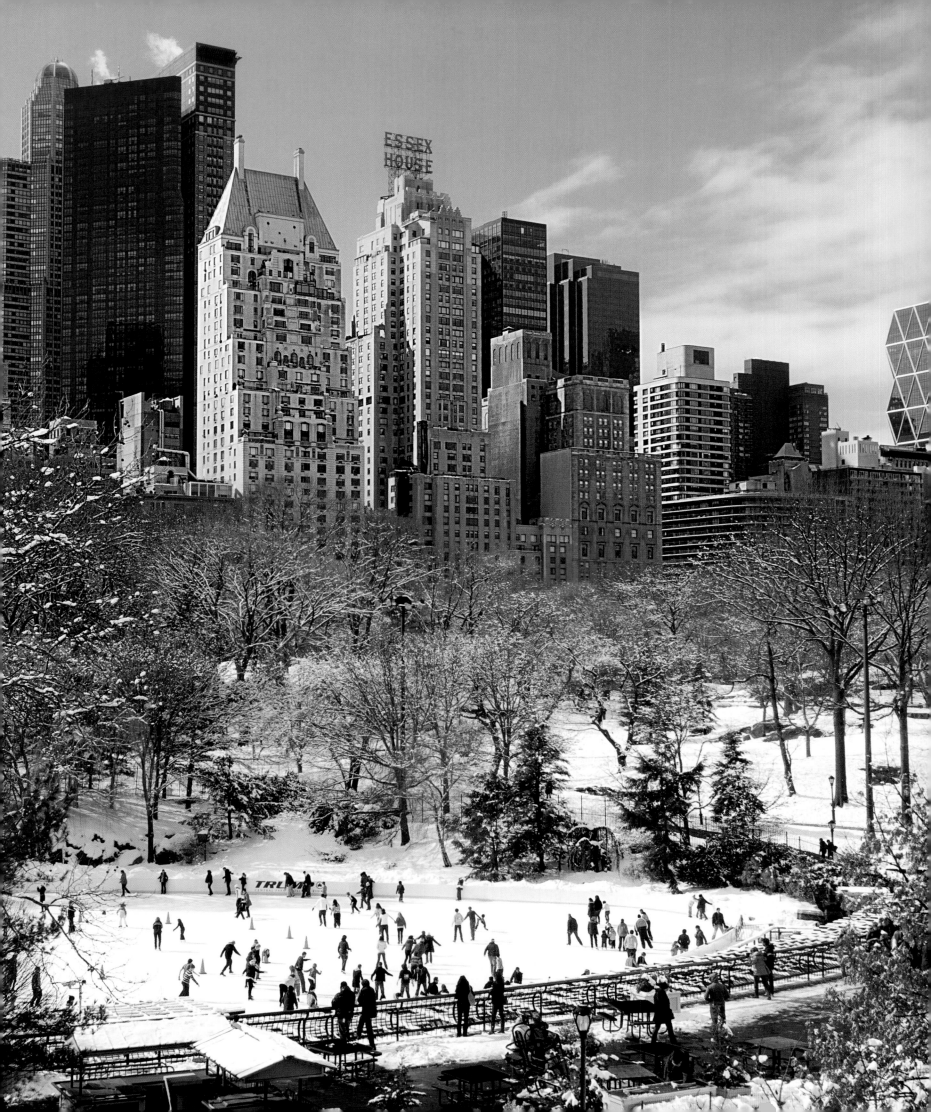

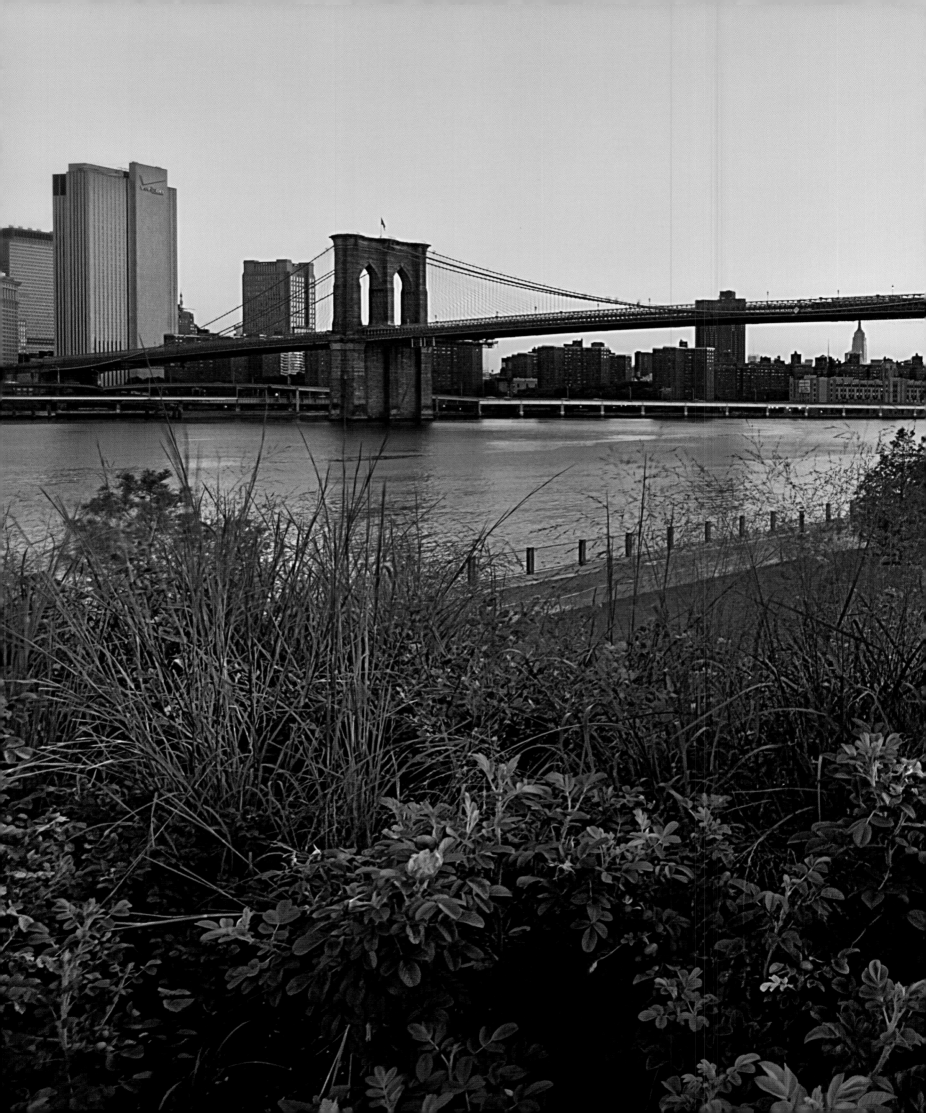

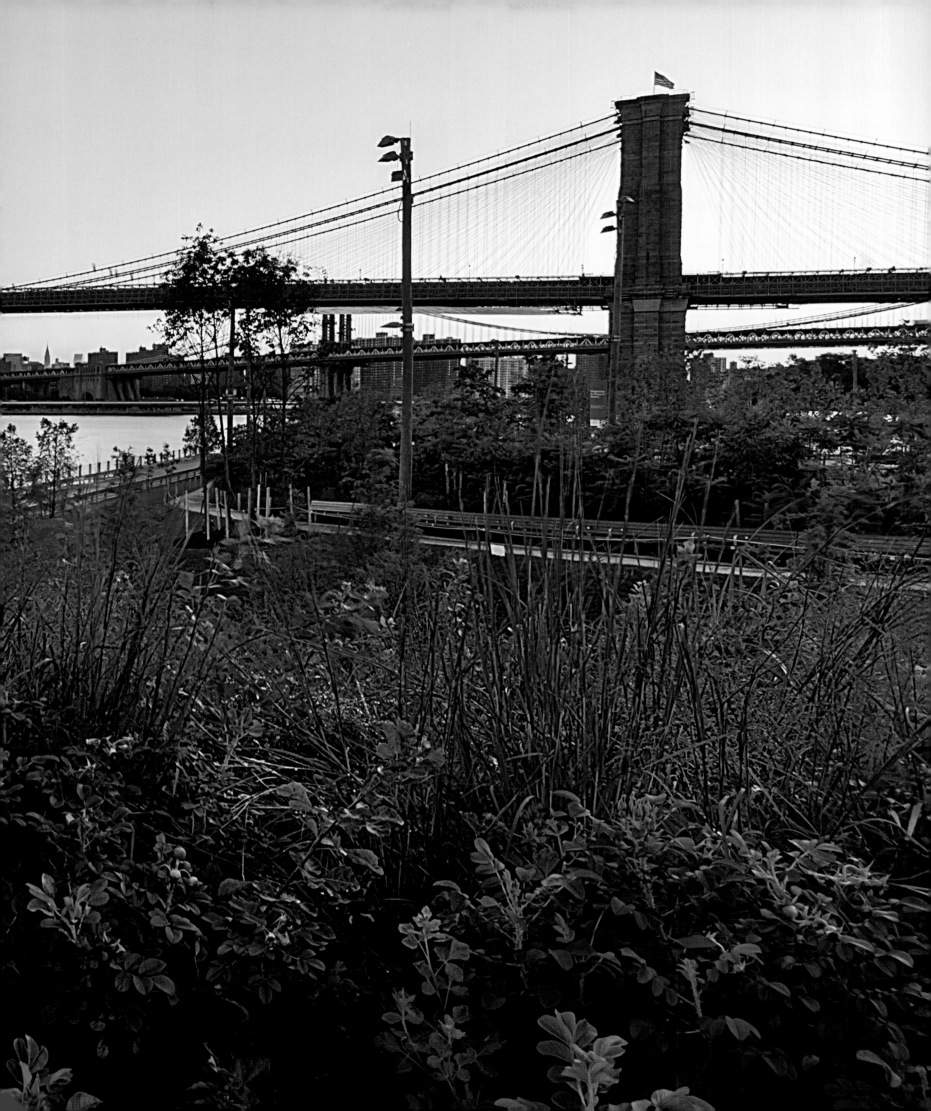

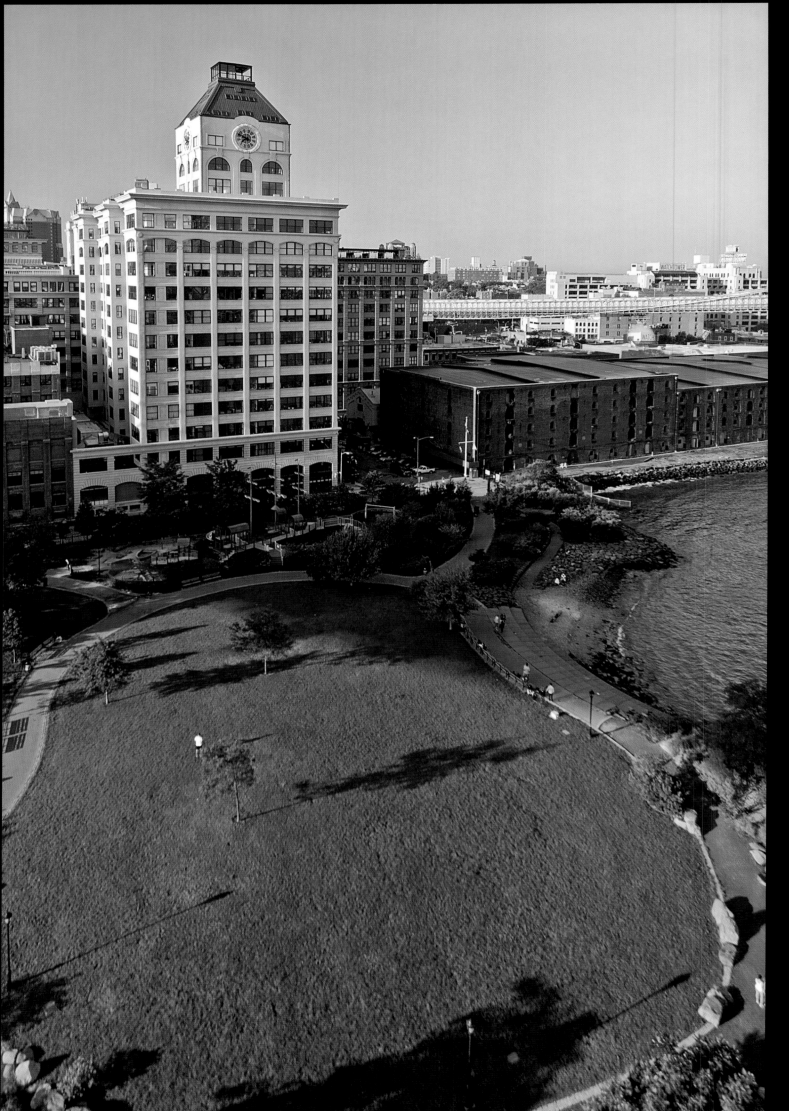

LEFT
Brooklyn Bridge Park, Michael van Valkenburgh Associates.

RIGHT
Reflecting pools, The Battery.

OVERLEAF
Citi Field, New York Mets stadium, Willets Point, Queens.

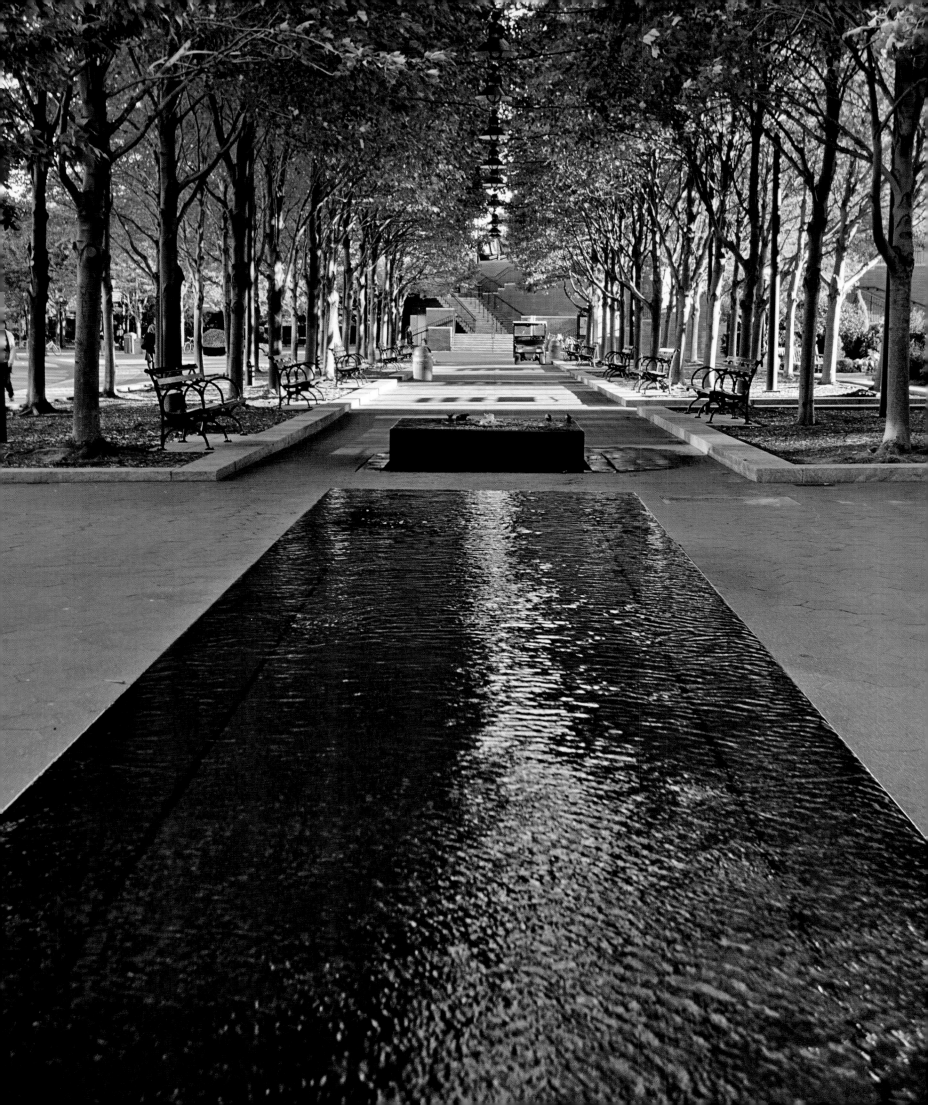

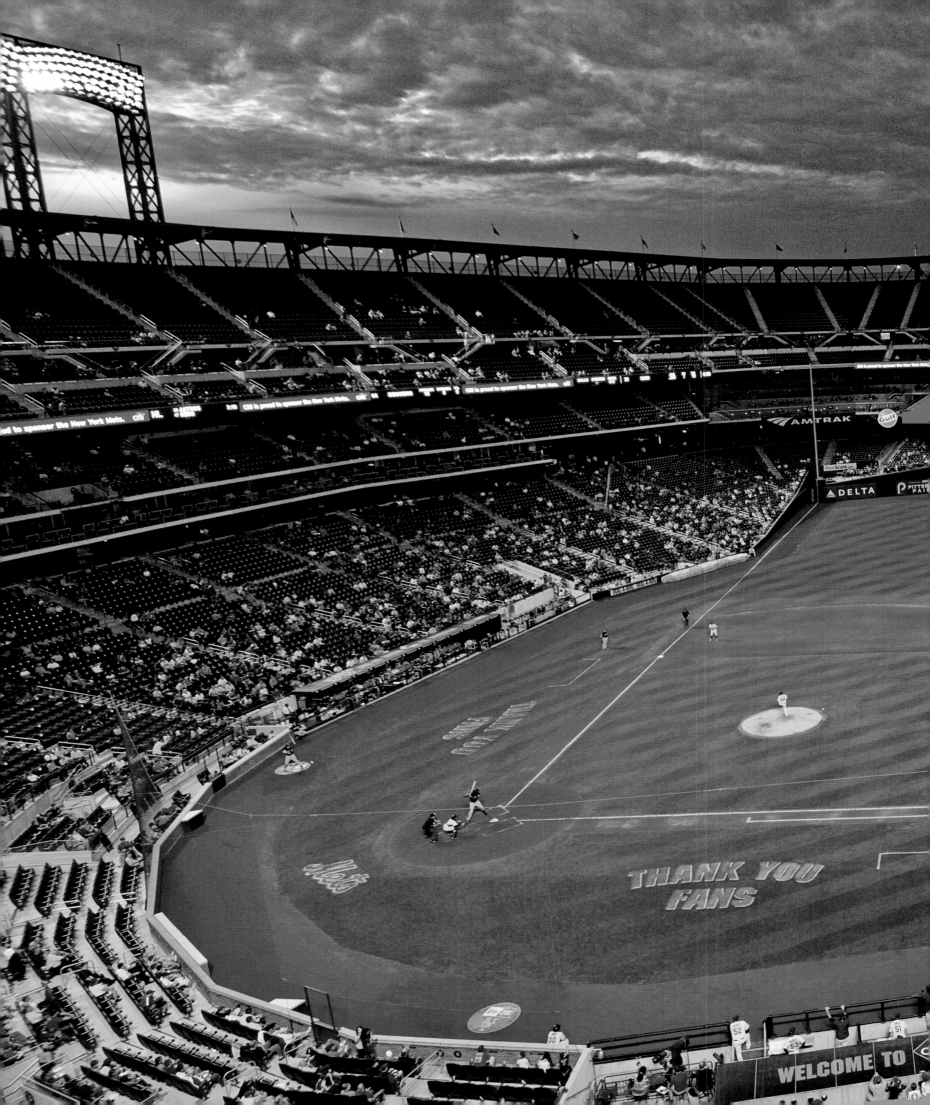

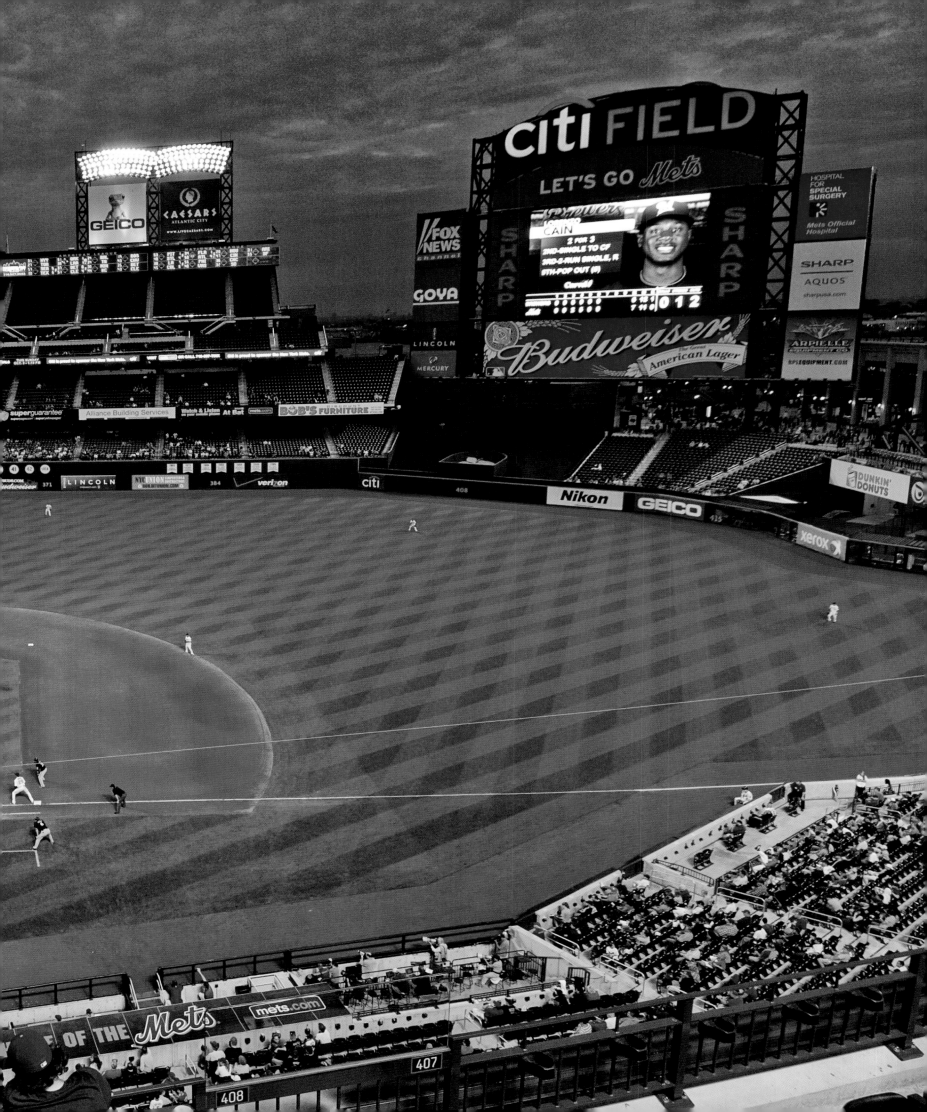

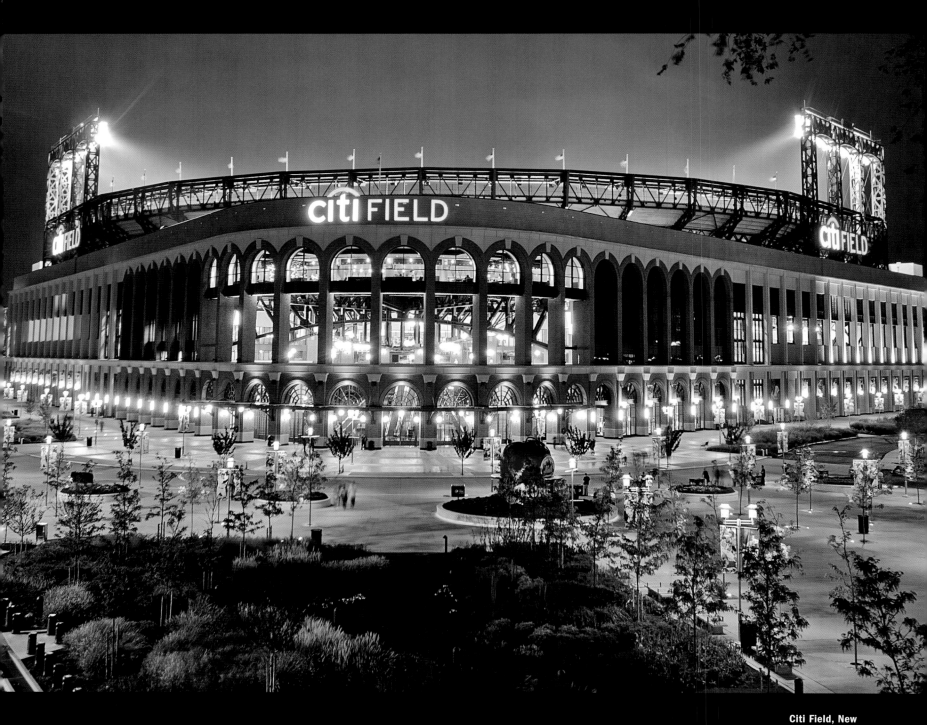

Citi Field, New
York Mets stadium,
Willets Point,
Queens.

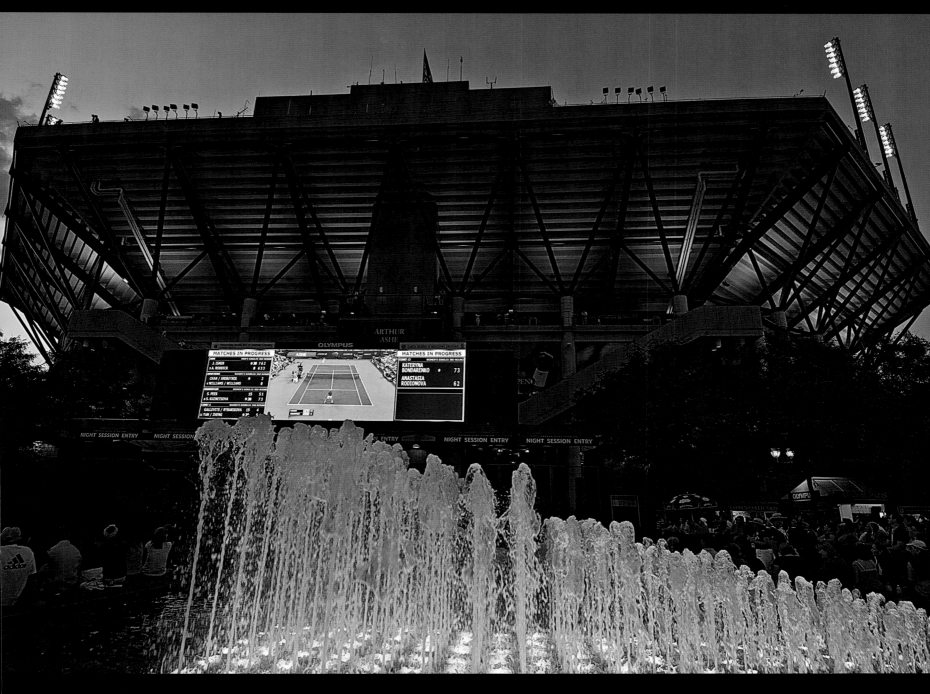

**Arthur Ashe Stadium,
USTA Billie Jean
King National Tennis
Center, Flushing
Meadows, Queens.**

OVERLEAF
**Center court, Arthur
Ashe Stadium.**

235

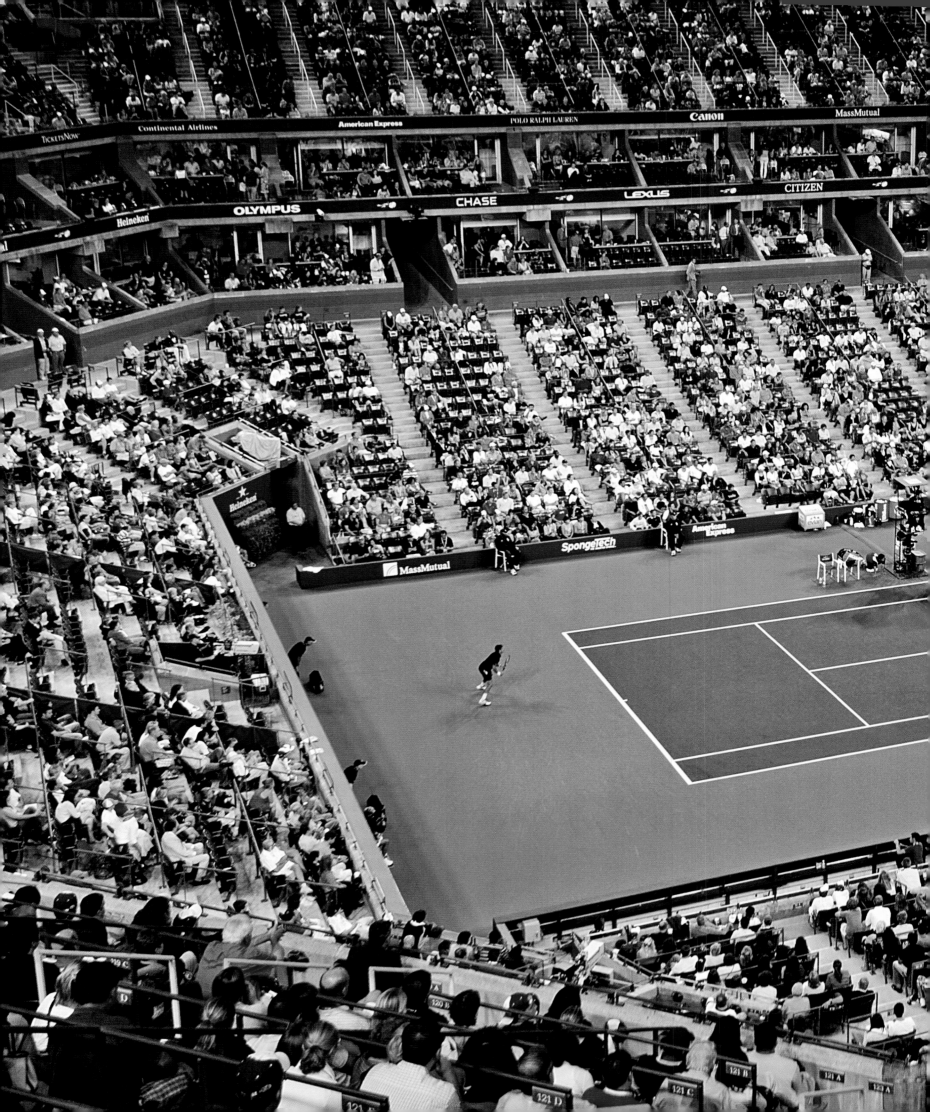

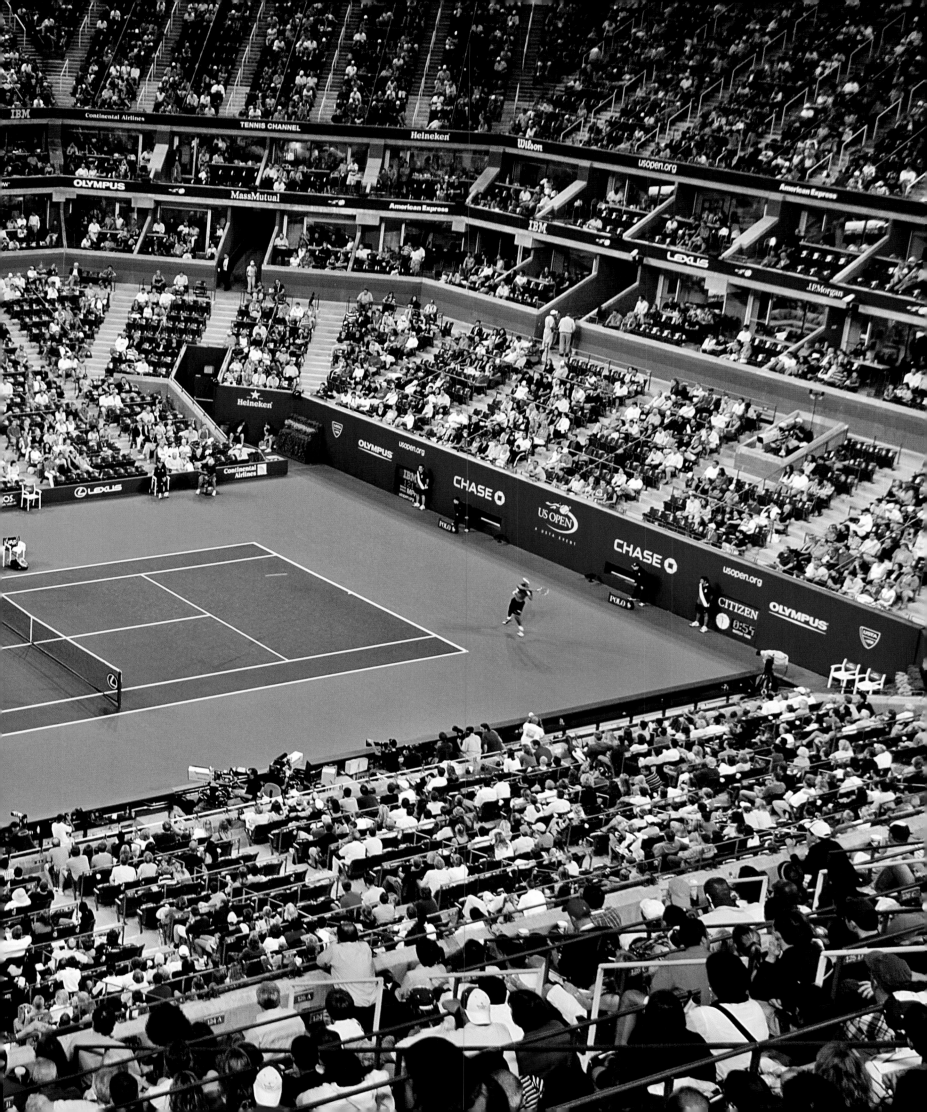

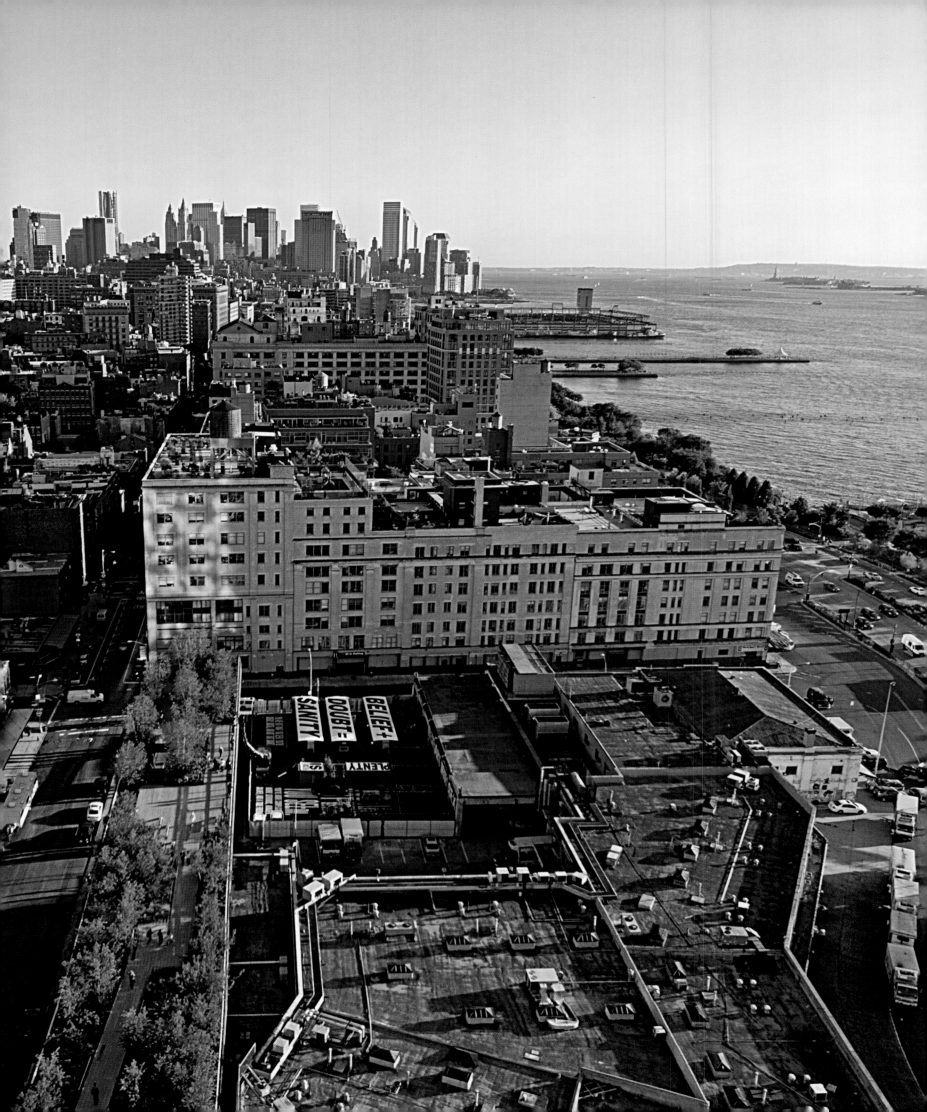

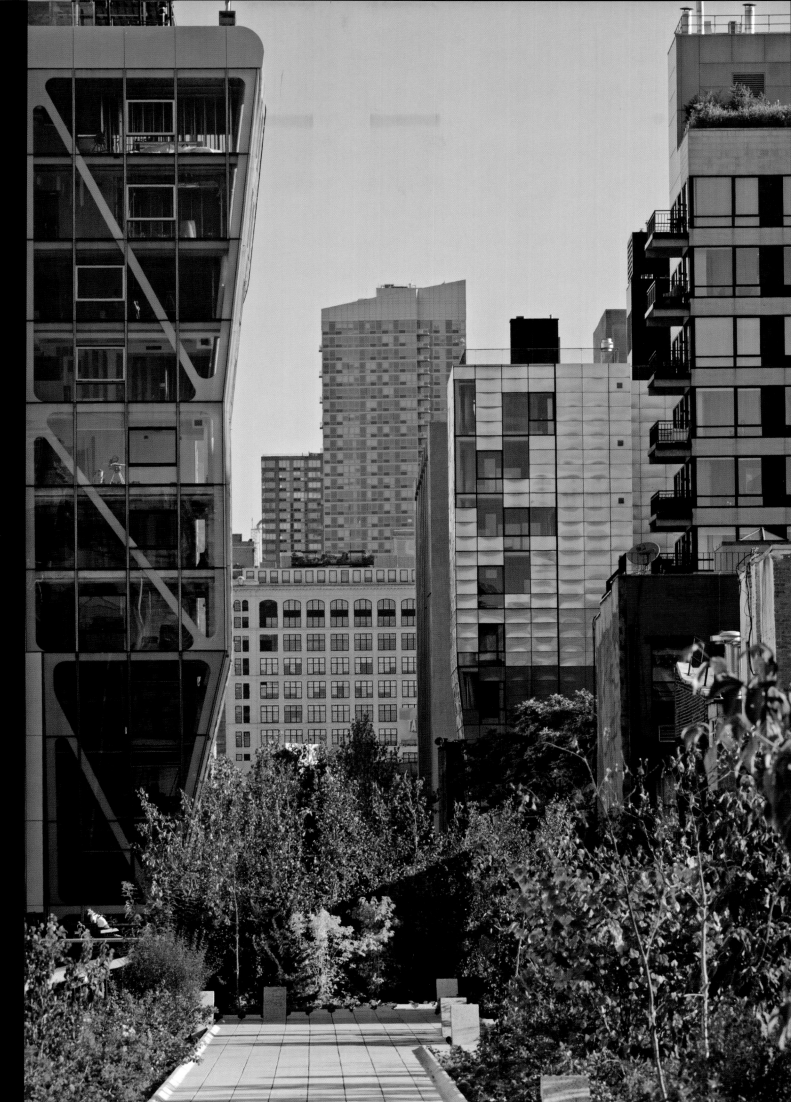

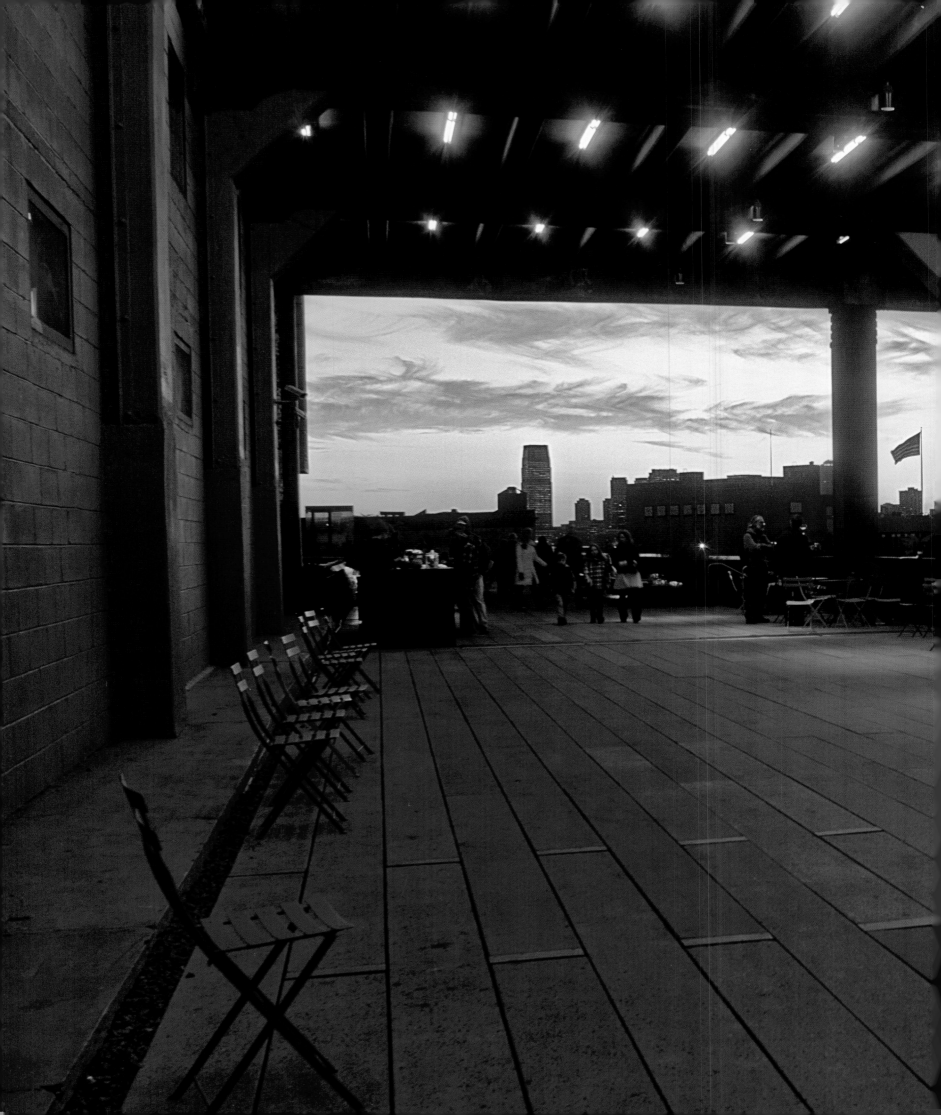

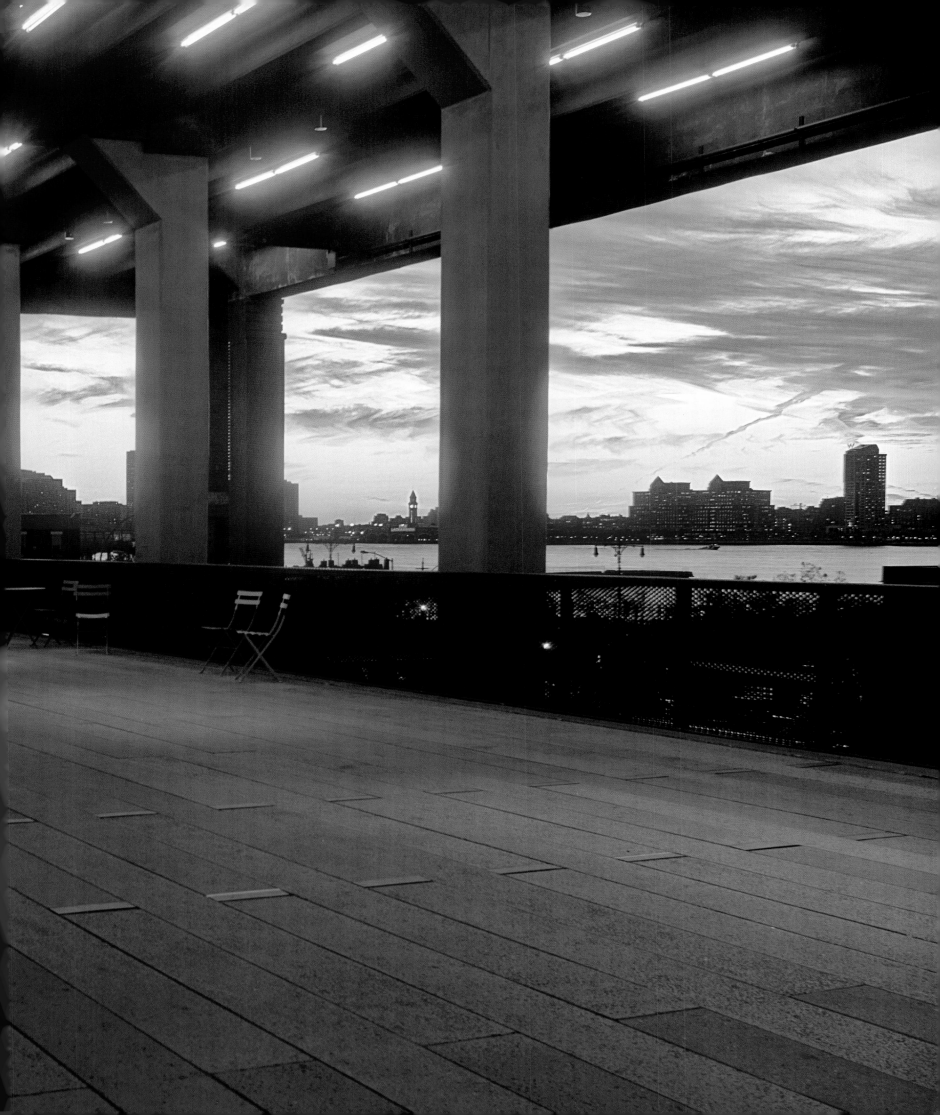

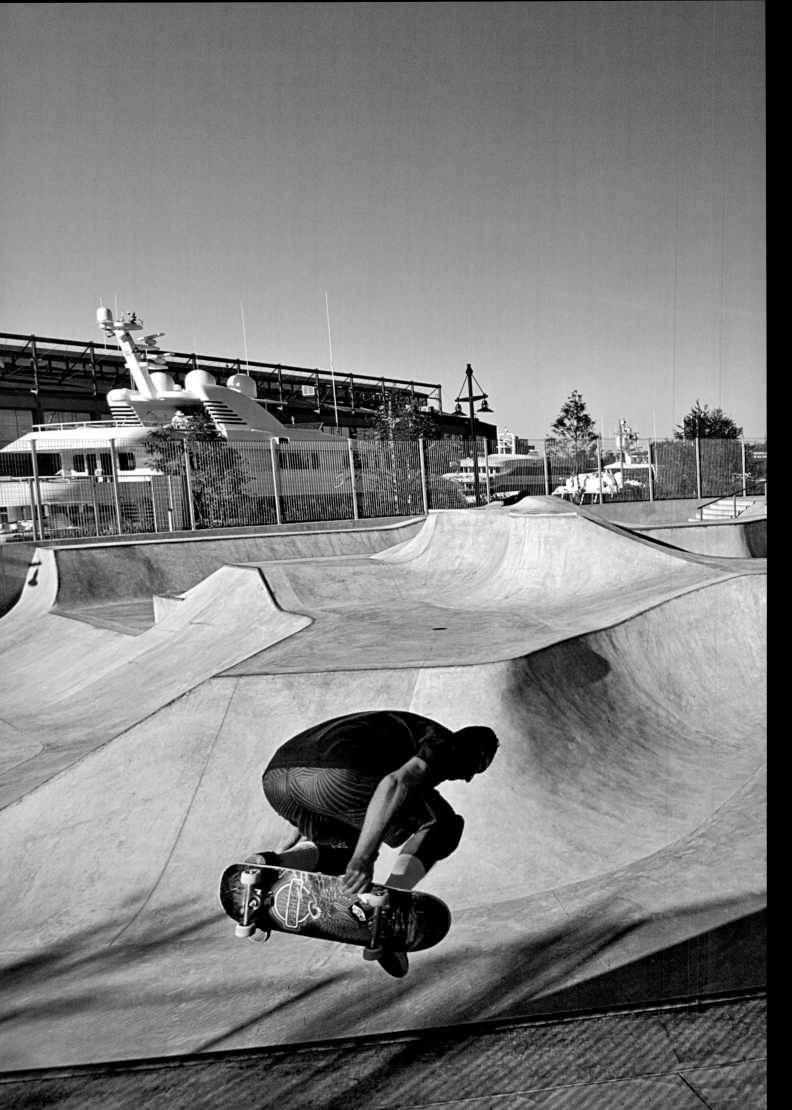

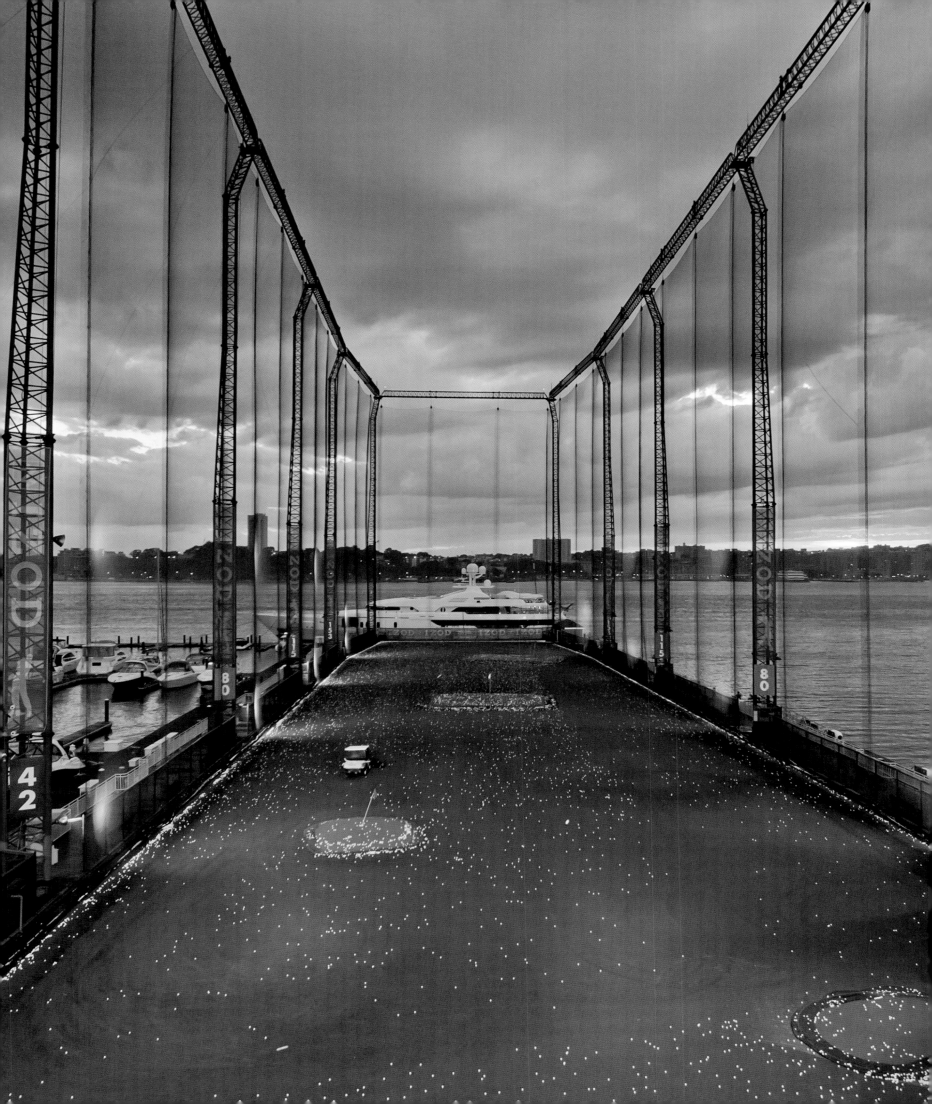

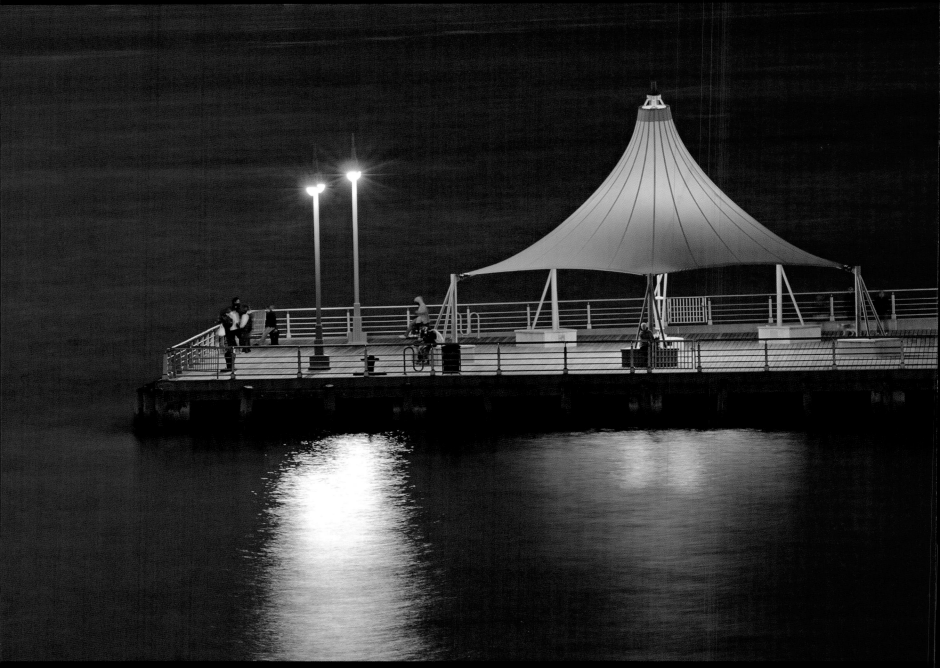

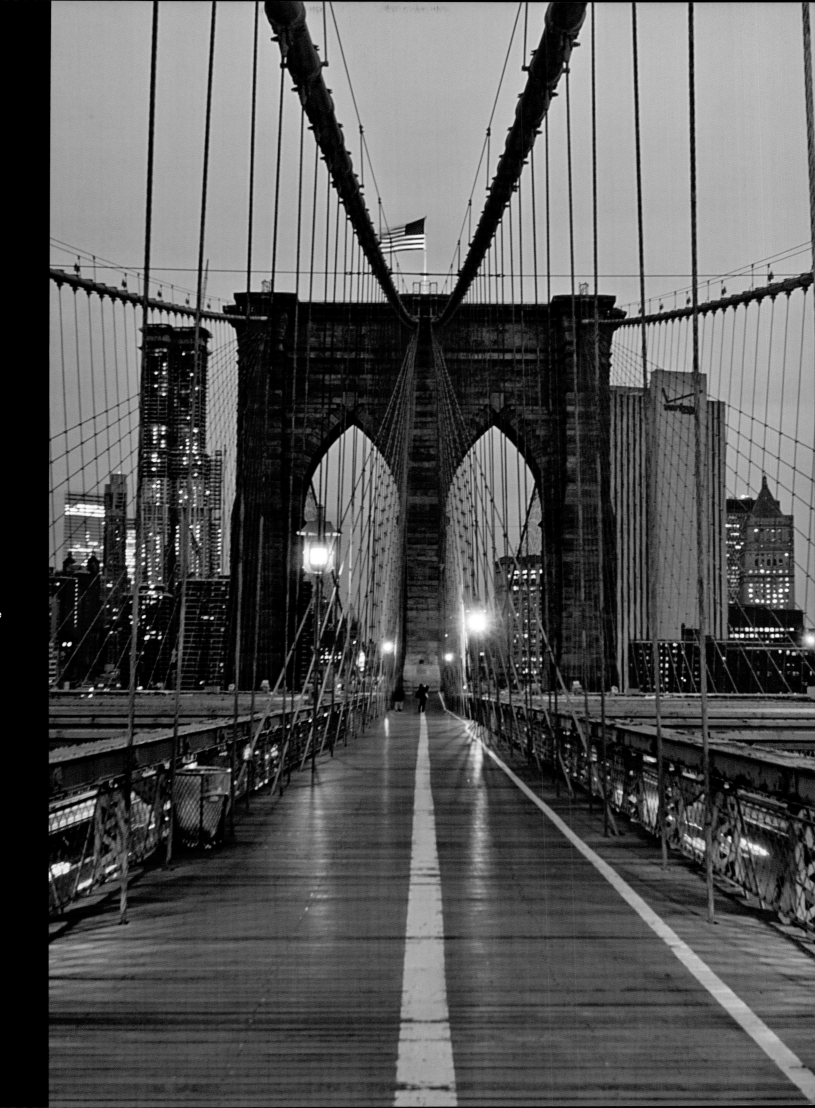

245

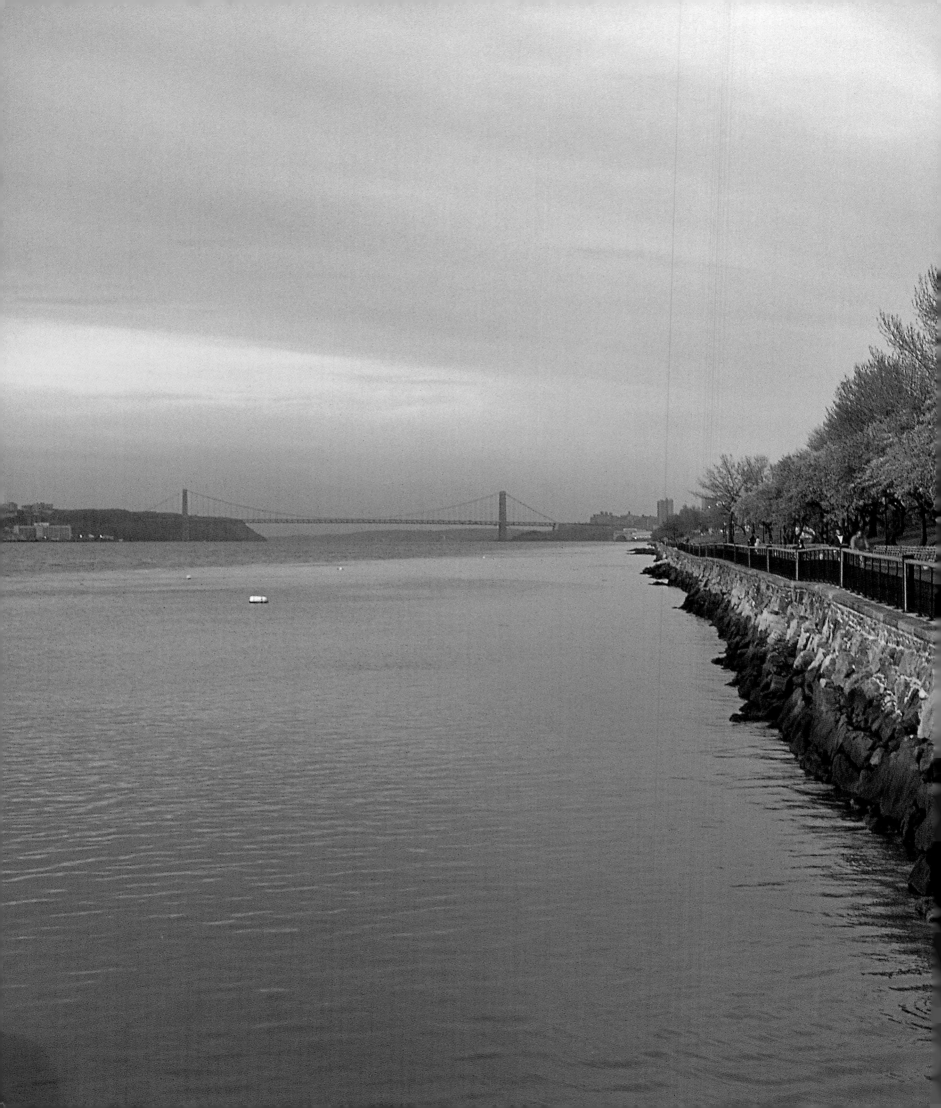

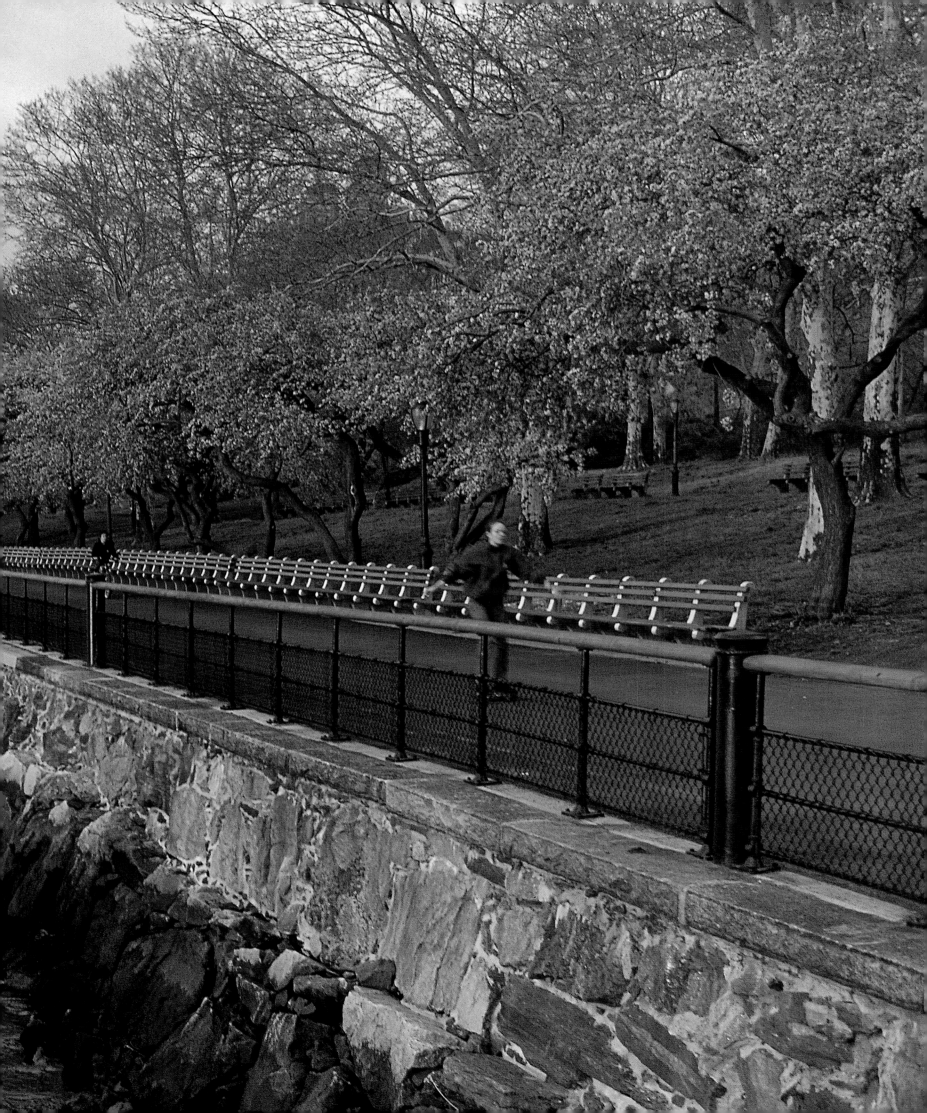

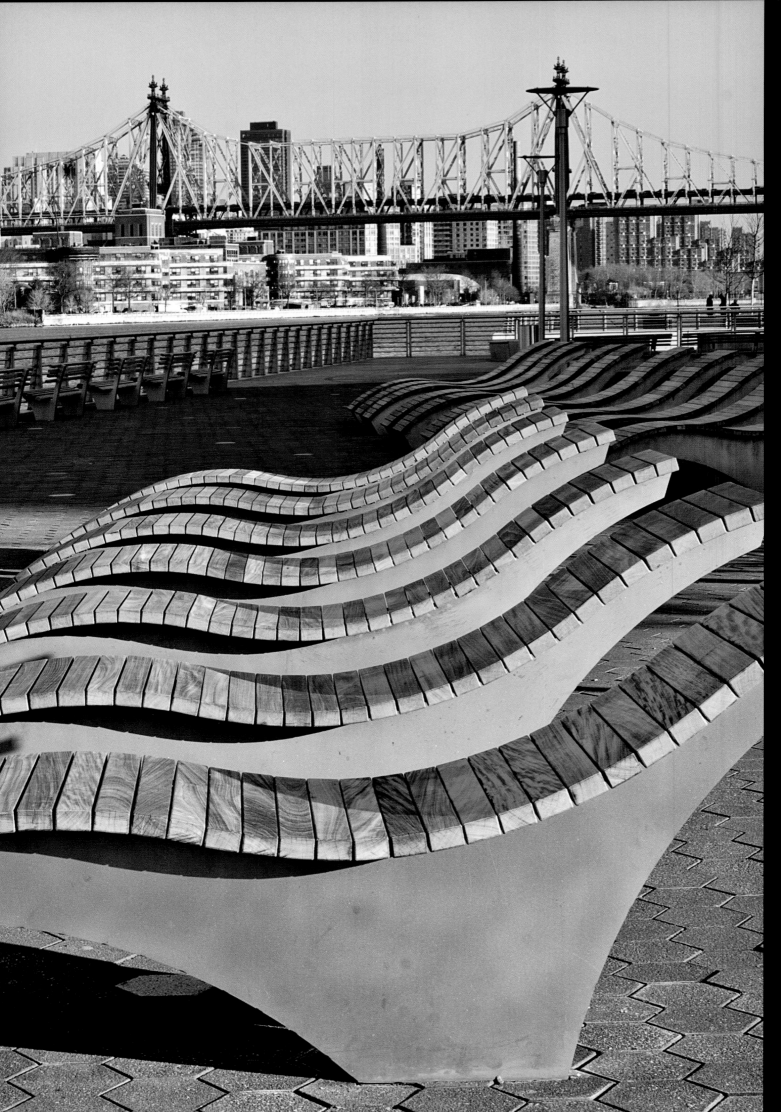

Gantry Plaza State
Park, Long Island
City, Queens.

OVERLEAF
Marina, Chelsea
Piers, Hudson River
Park.

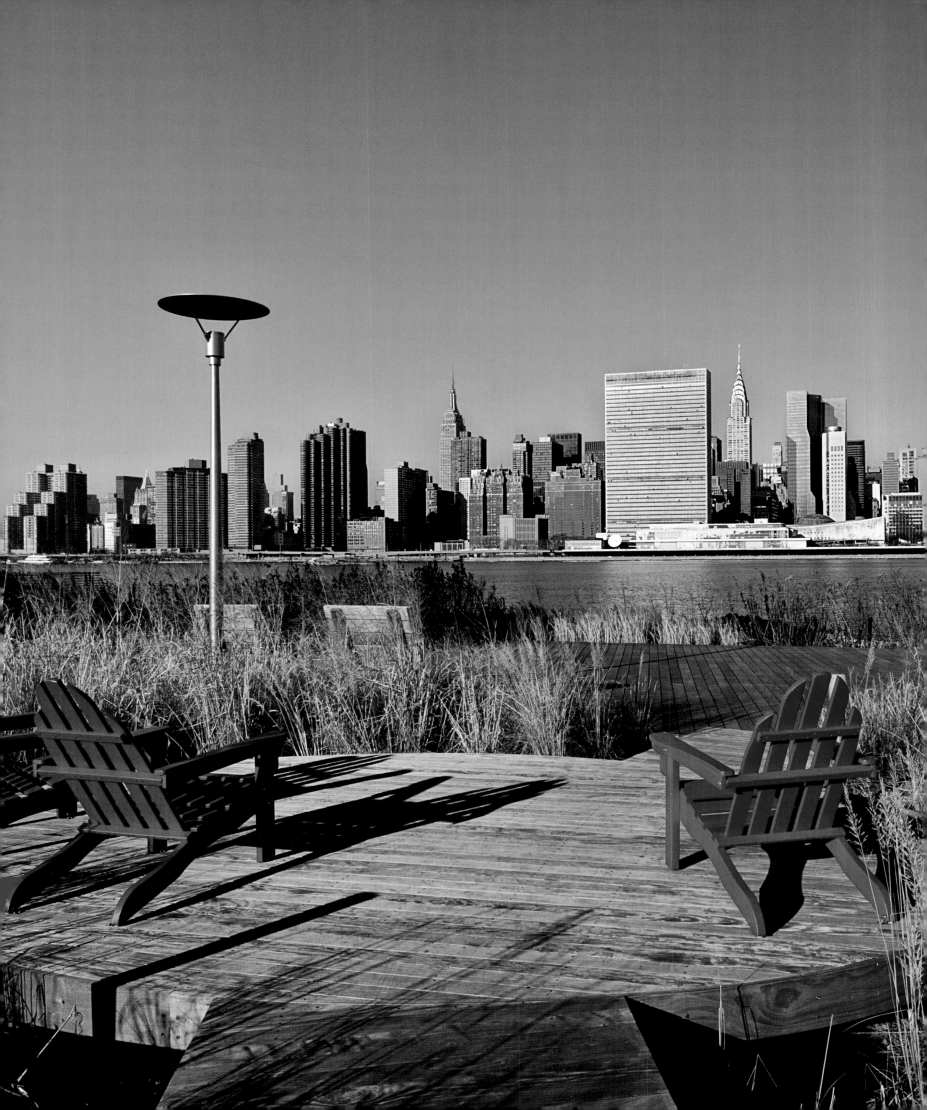

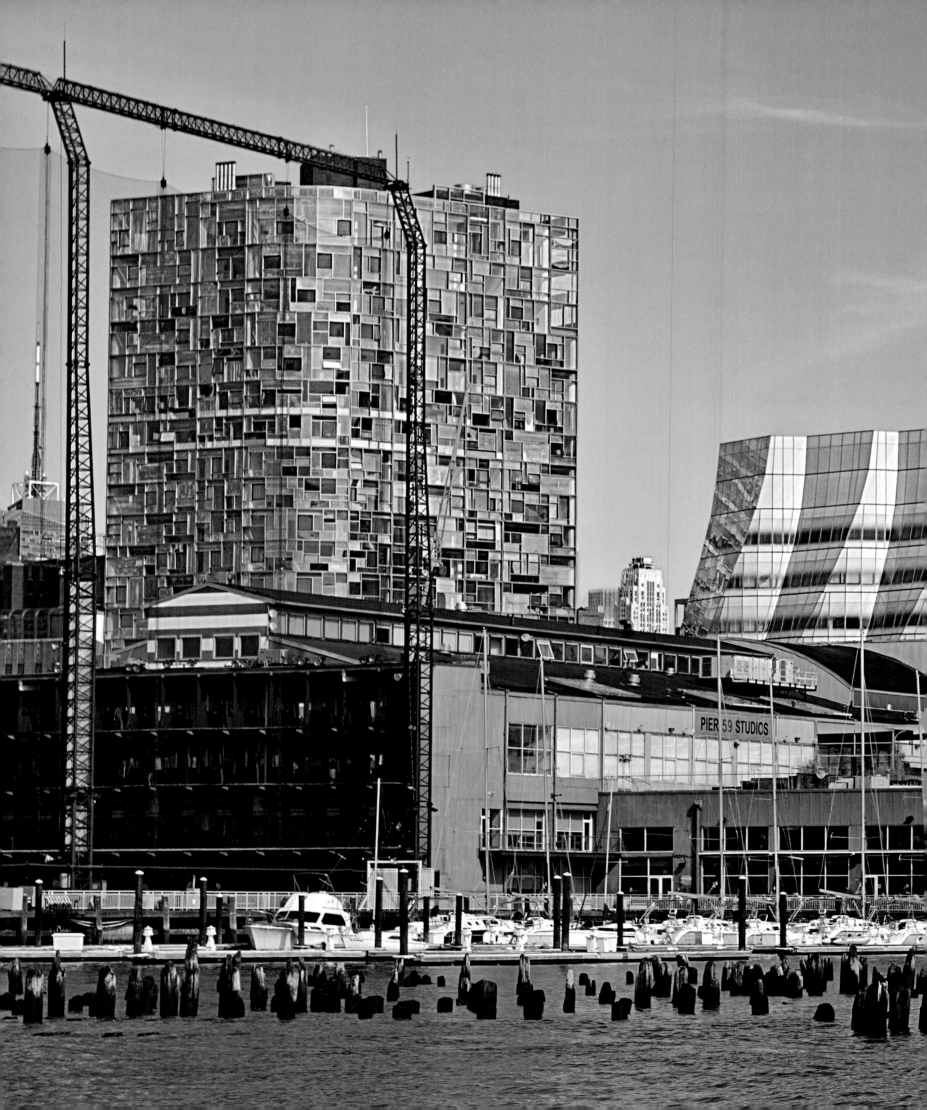

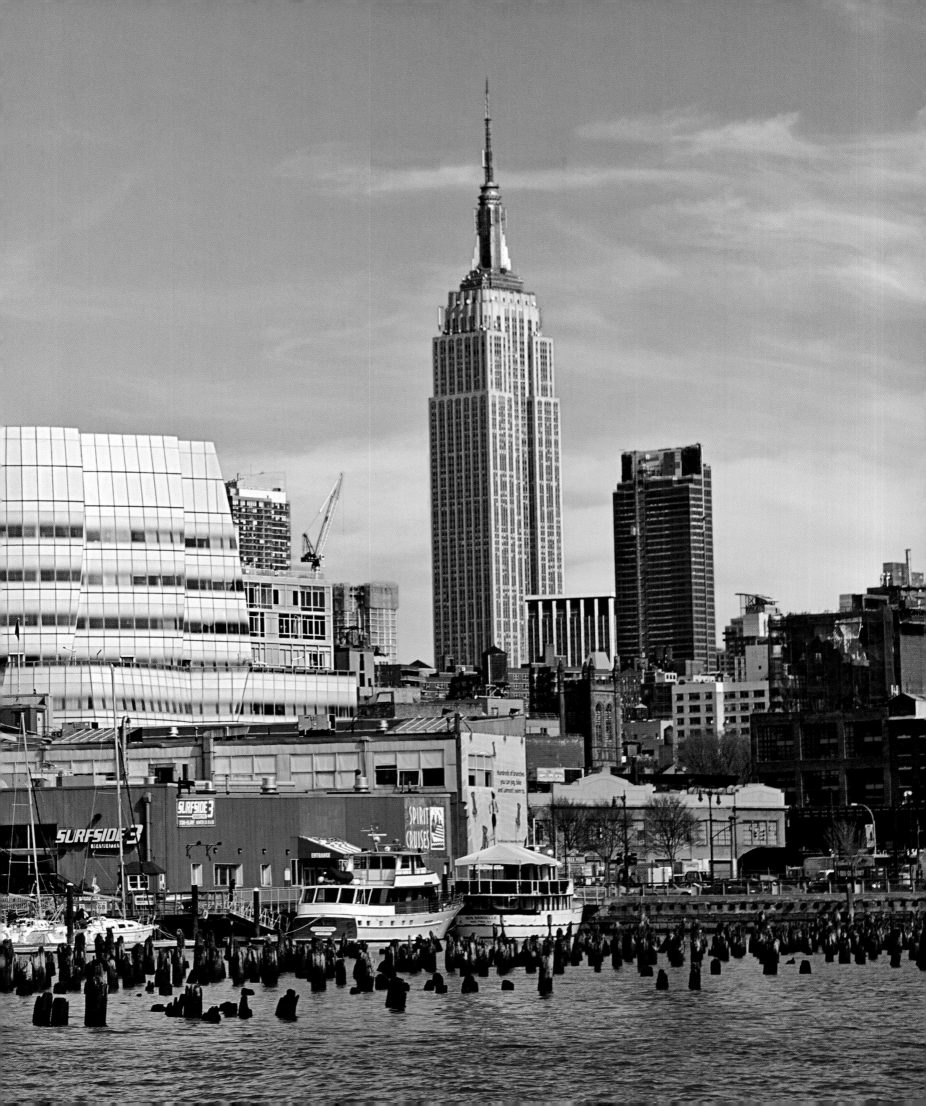

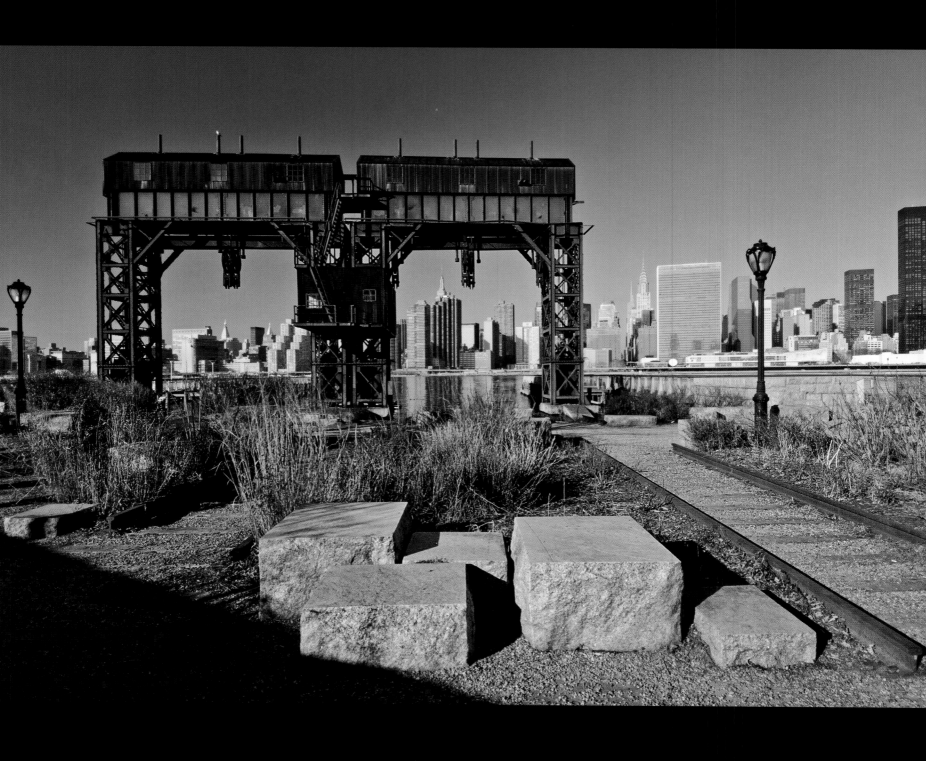

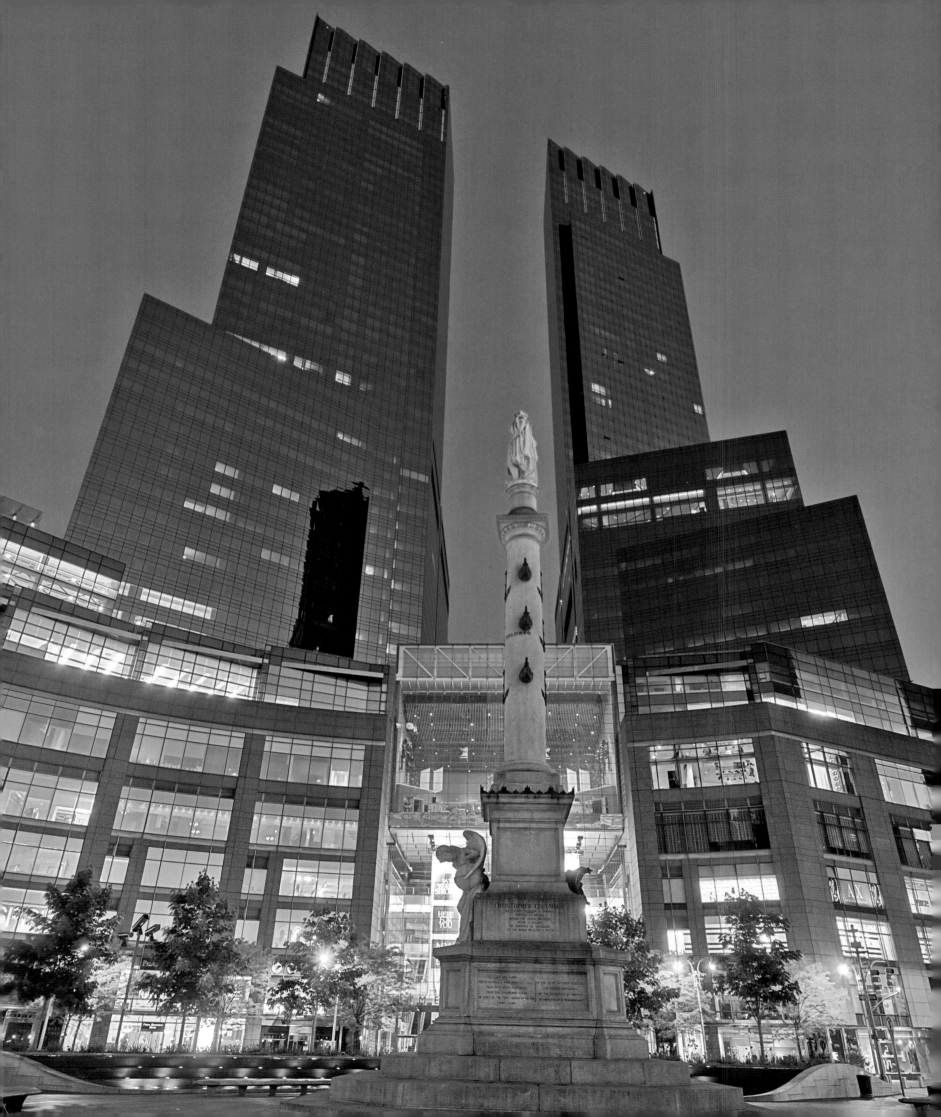

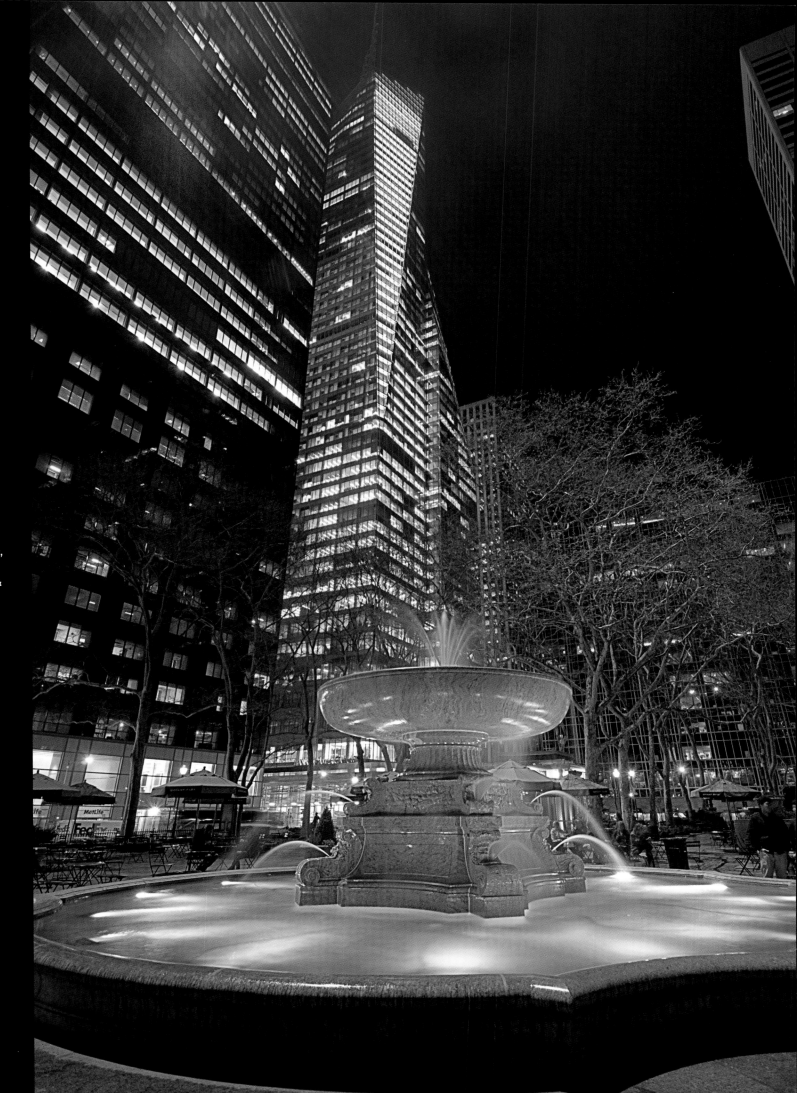

255

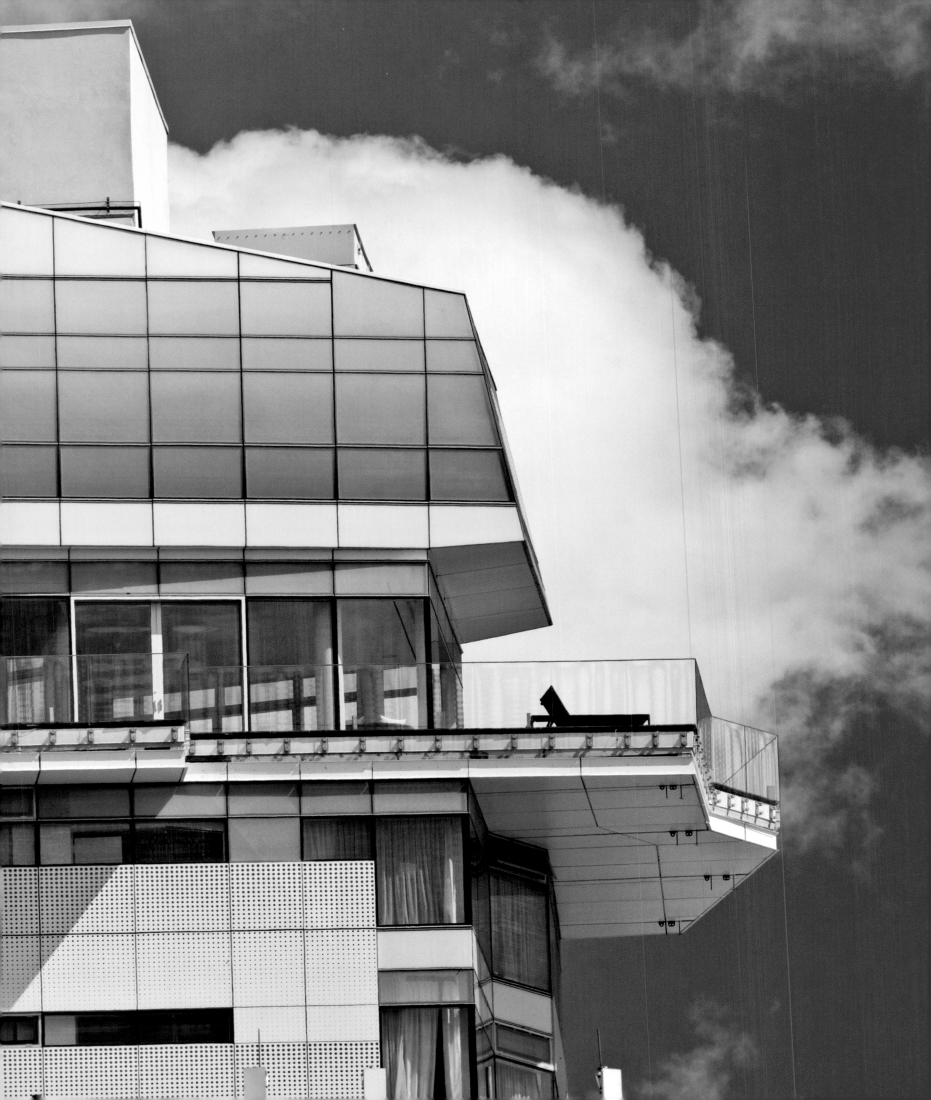

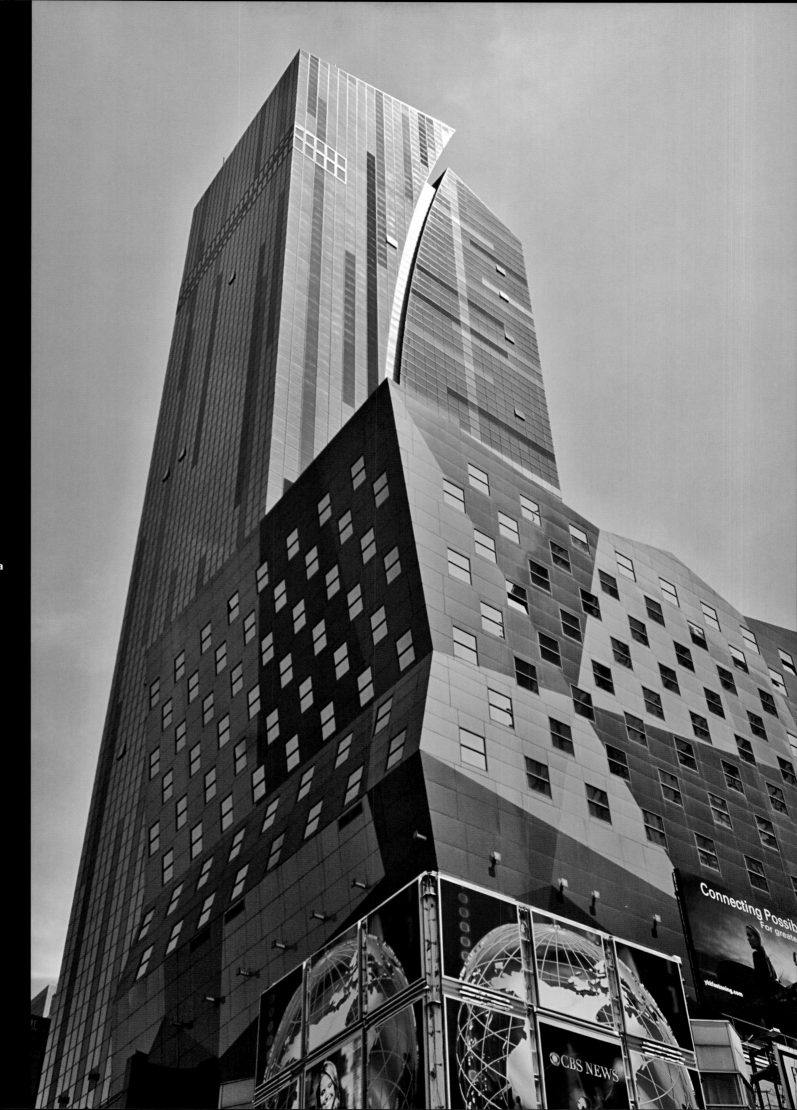

LEFT
Cooper Square
Hotel, Carlos Zapata
Studio.

RIGHT
Westin Hotel,
Times Square,
Arquitectonica.

OVERLEAF
Standard Hotel at
the High Line,
Kohn Pedersen Fox.

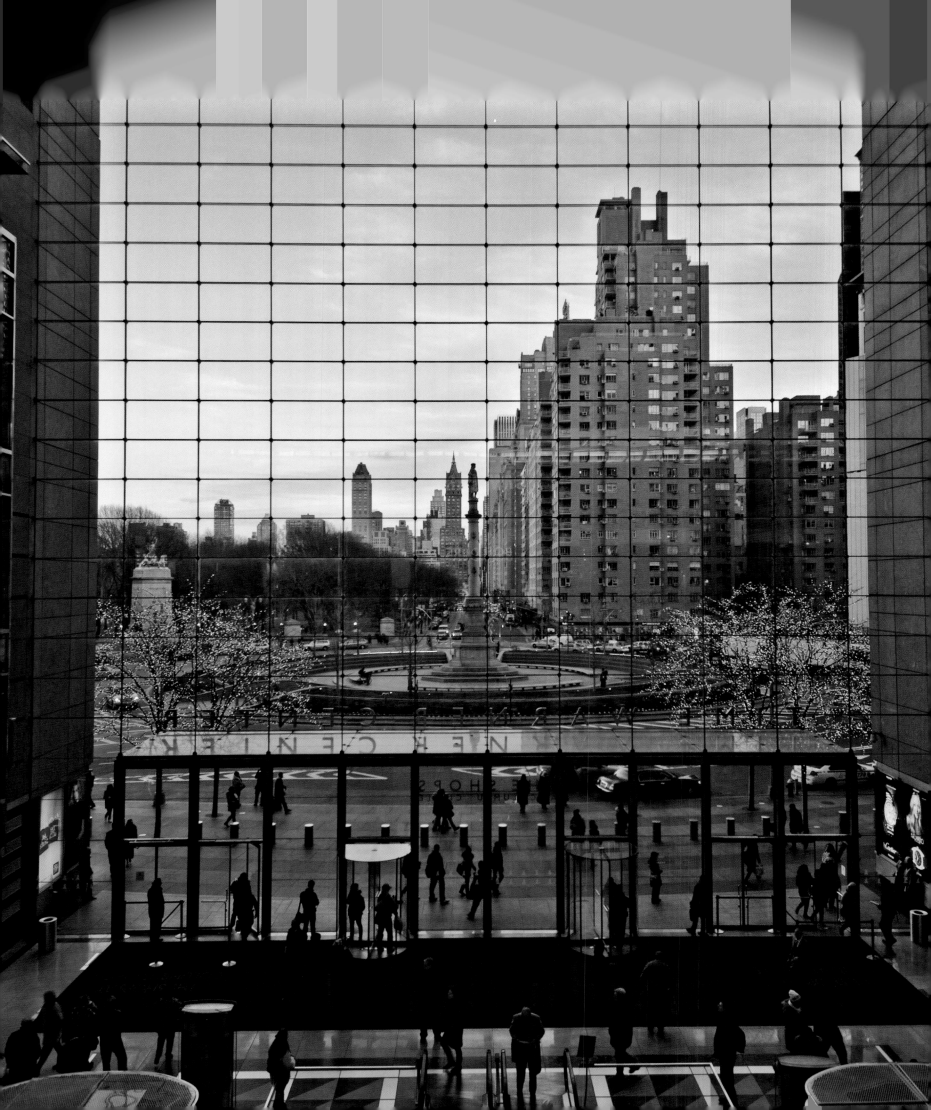

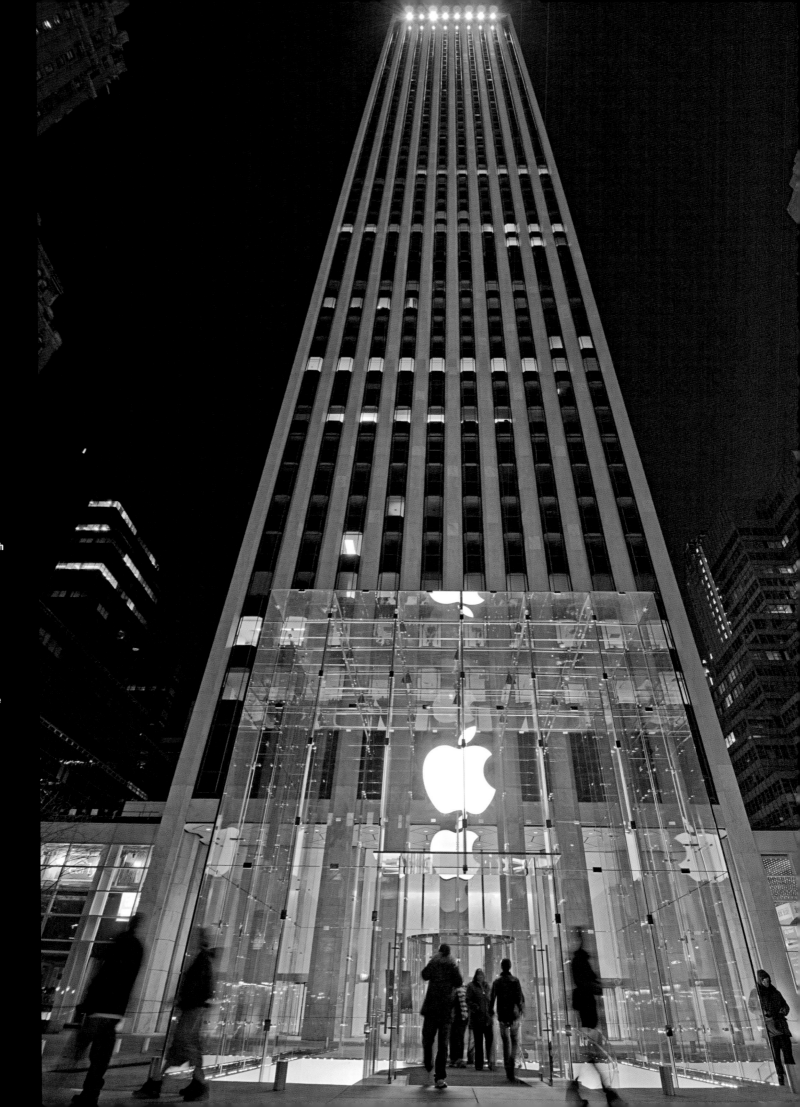

263

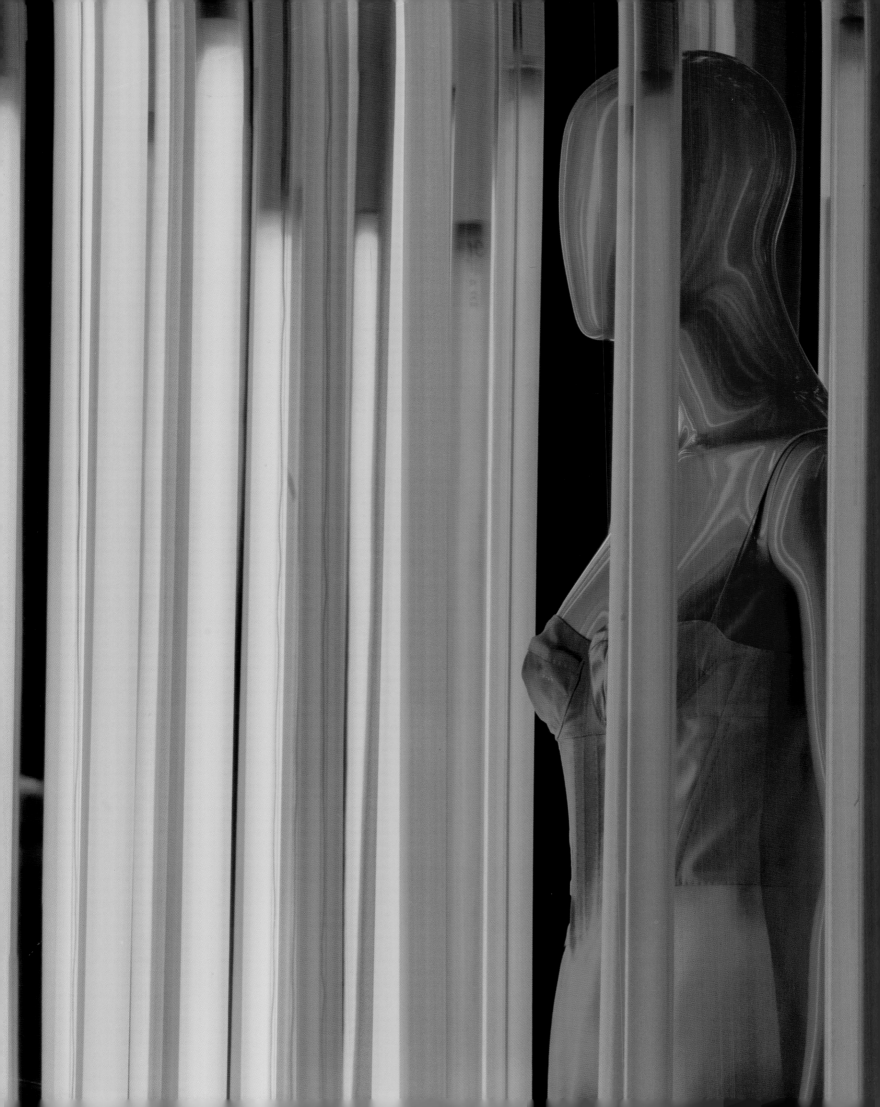

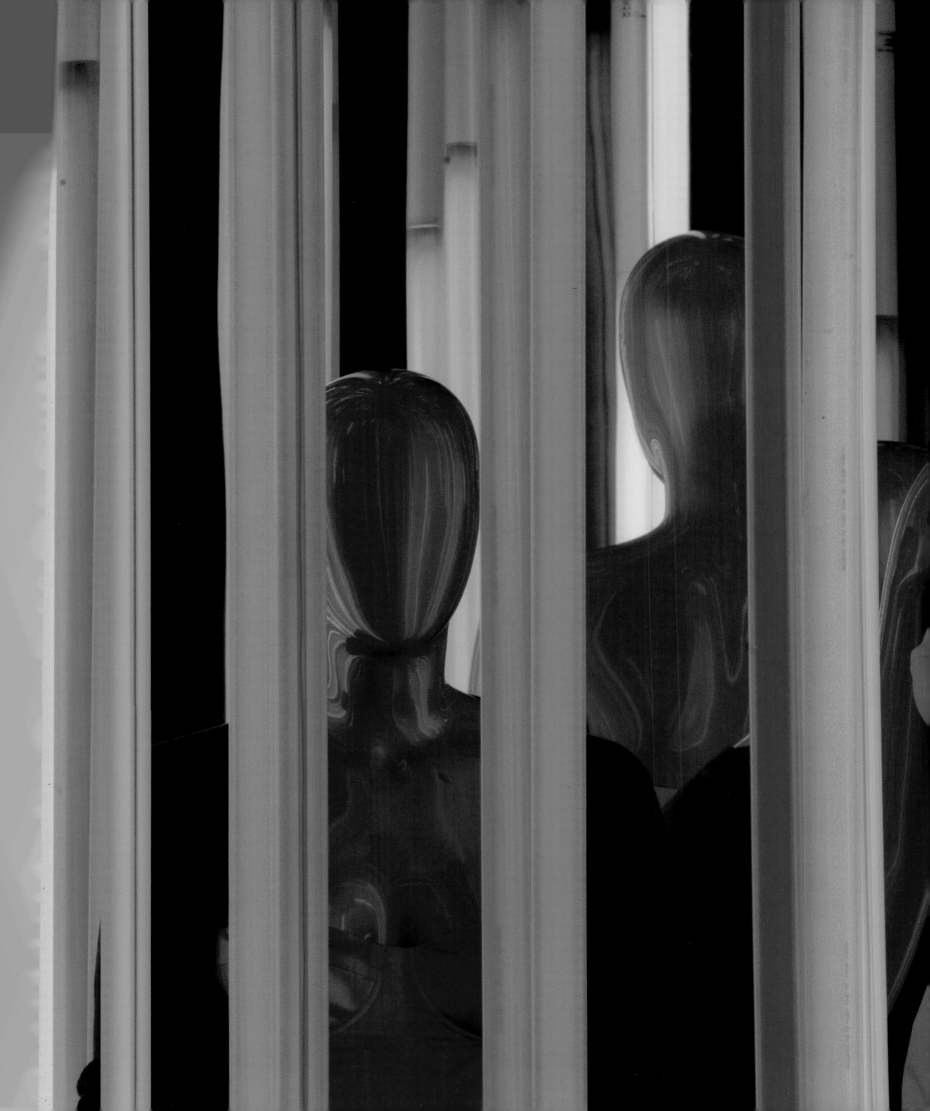

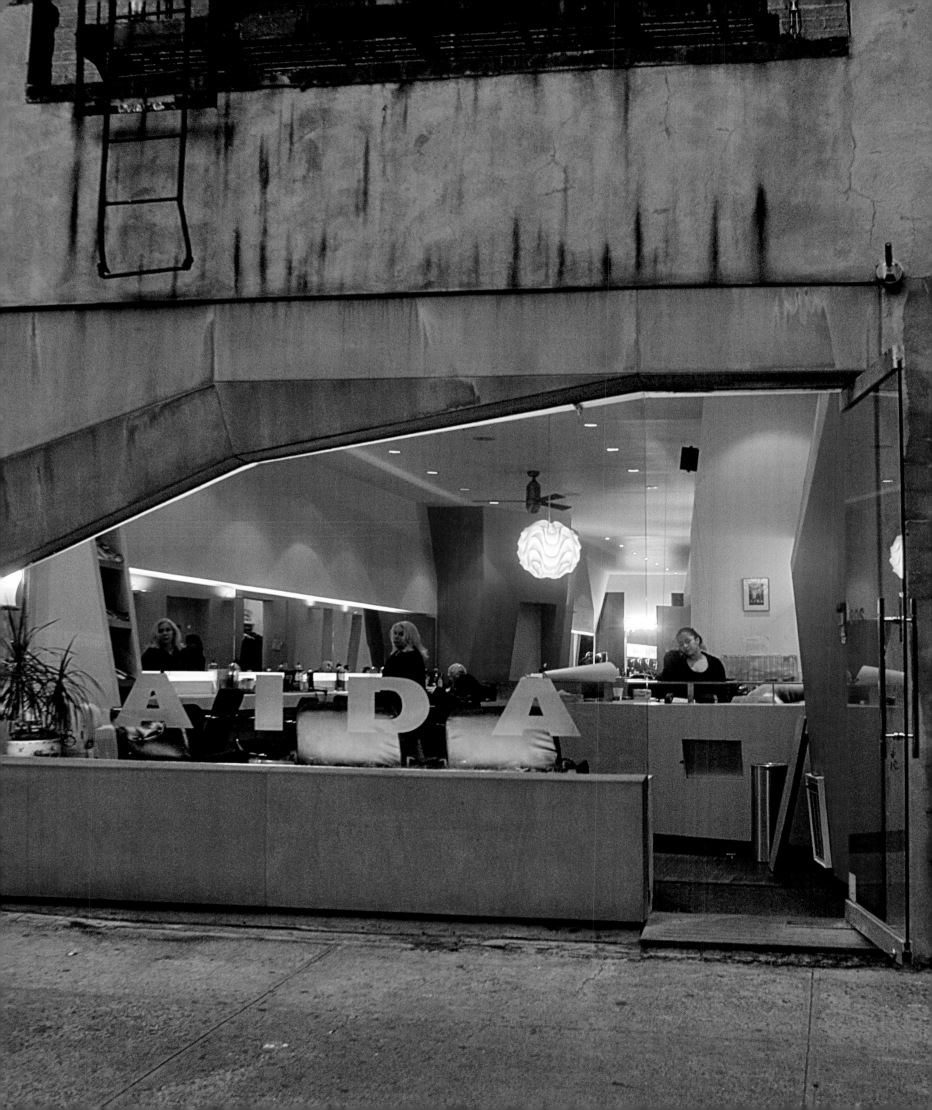

LEFT
Aida's House of Beauty, 209 East 76th Street, Archi-Tectonics and Winka Dubbeldam.

RIGHT
Louis Vuitton, One East 57th Street, Peter Marino.

OVERLEAF
Times Square.

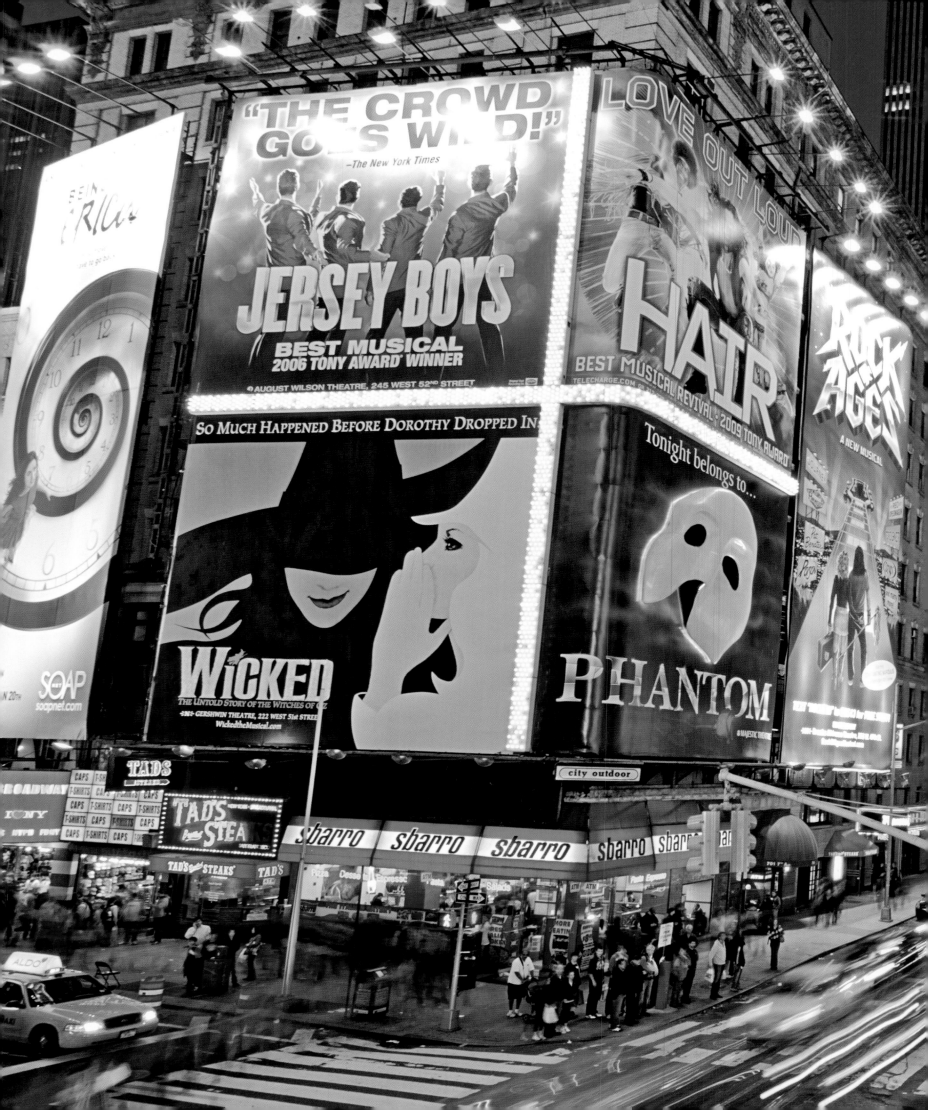

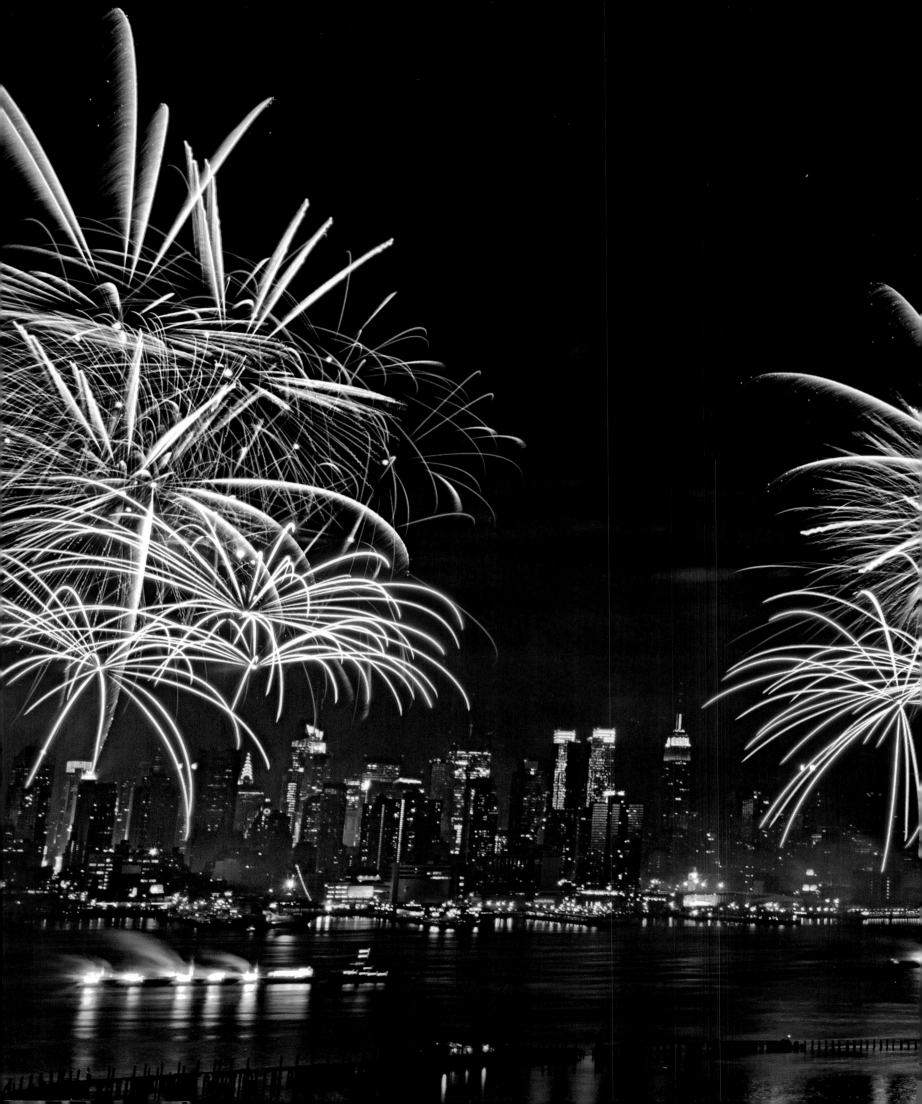

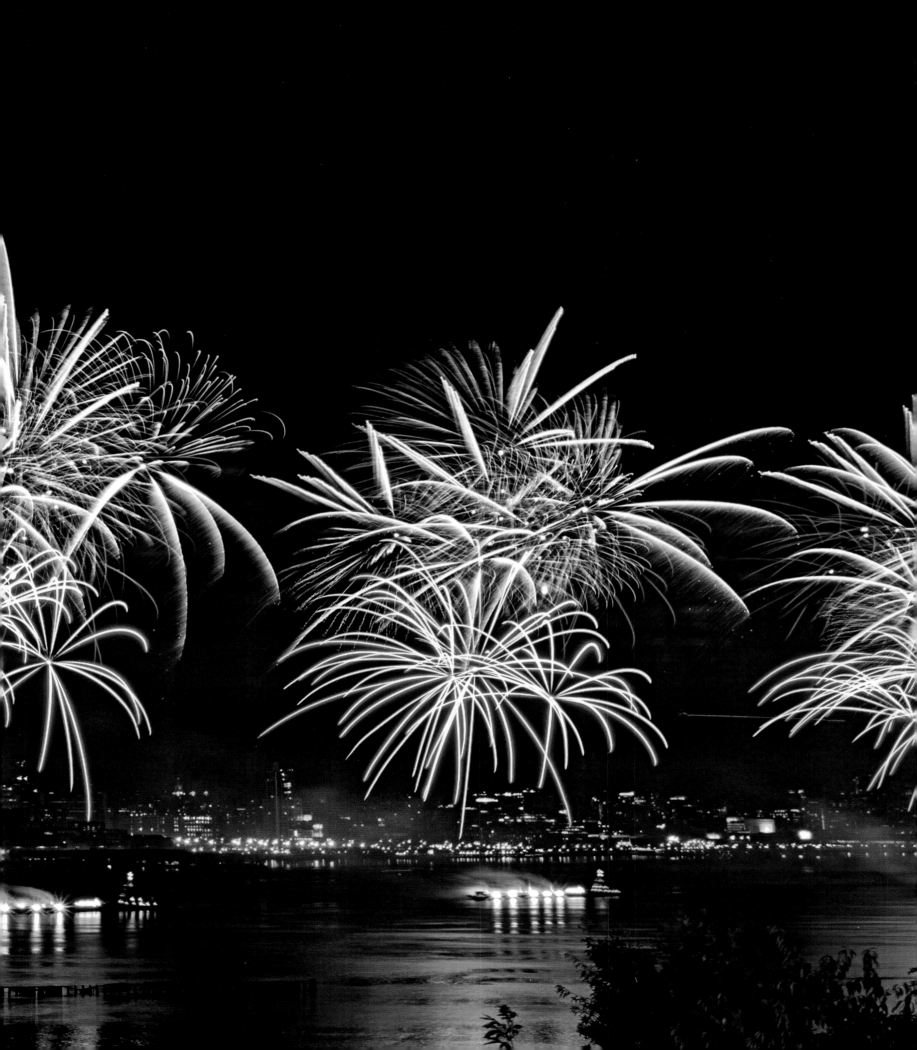

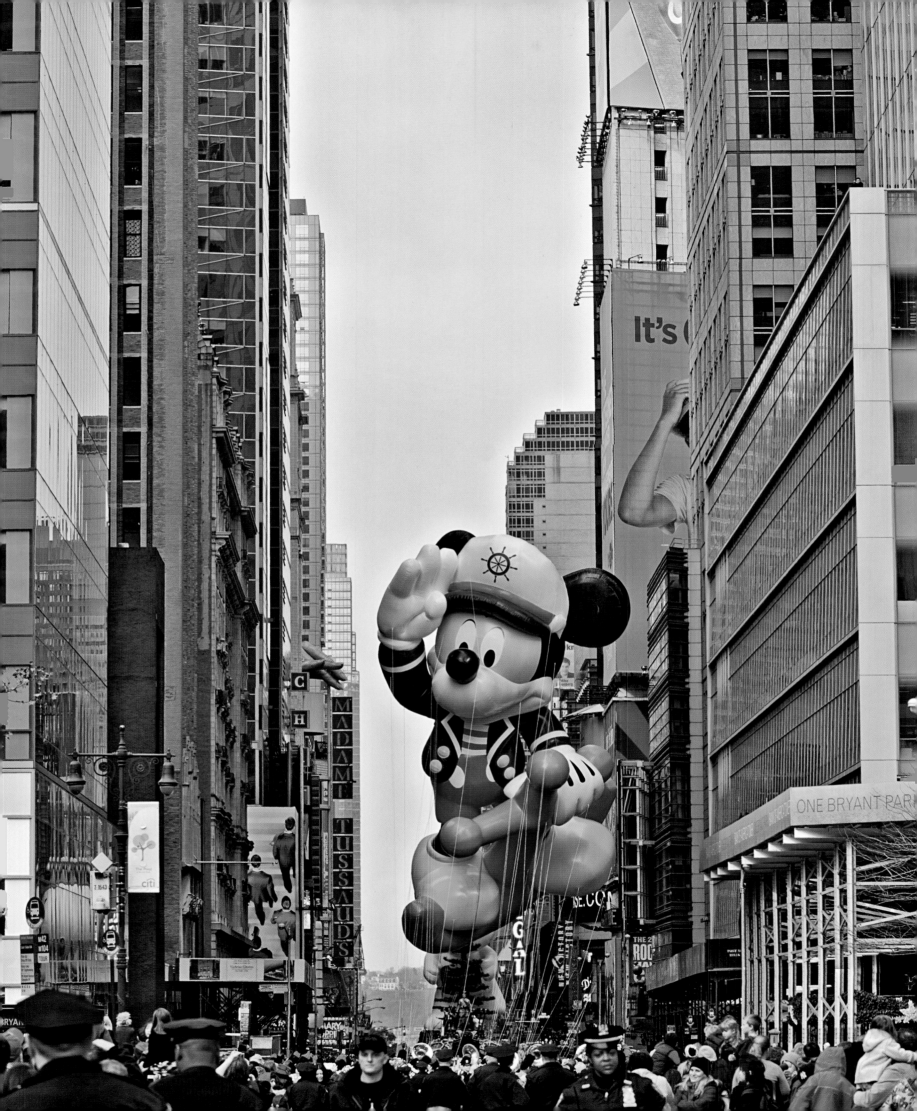